Impressionism in Britain

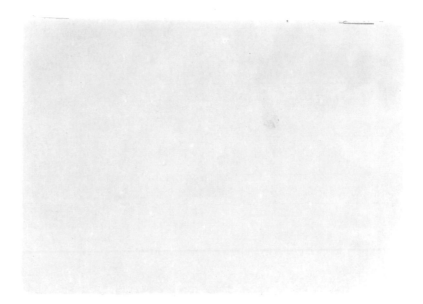

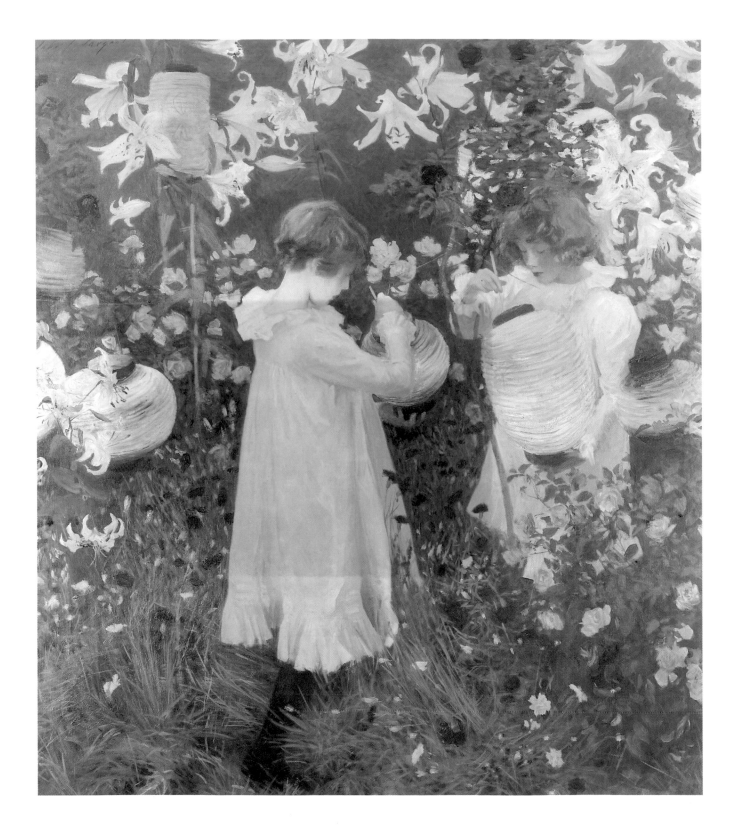

IMPRESSIONISM
IN BRITAIN

Kenneth McConkey

With an essay by
Anna Gruetzner Robins

Yale University Press
in association with
Barbican Art Gallery
1995

BARBICAN ART GALLERY

Copyright © 1995
Barbican Art Gallery, Corporation of London,
and the authors

Library of Congress Cataloguing-in-Publication Data
McConkey, Kenneth.
 Impressionism in Britain/Kenneth McConkey:
with an essay by Anna Gruetzner Robins.
 p. cm.
 "In association with Barbican Art Gallery."
 Includes bibliographical references and index.
 ISBN 0-300-06334-2 (hb). – ISBN 0-300-06335-0 (pb)
 1. Impressionism (Art) – Great Britain –
Exhibitions. 2. Painting, British – Exhibitions.
3. Painting, Modern – 19th century – Great Britain –
Exhibitions. I. Robins, Anna Gruetzner. II. Title.
ND467.5.I46M39 1995 94-41771
759.2'09'0340744212–dc20 CIP

A catalogue record for this book is available from
The British Library

Printed in Italy by
Amilcare Pizzi SpA, Milan

FLEMINGS

Exhibition sponsored in Britain by Flemings
19 January – 7 May 1995

GLEN DIMPLEX

Exhibition sponsored in Ireland by Glen Dimplex
1 June – 31 July 1995

This catalogue accompanies the exhibition
Impressionism in Britain

Barbican Art Gallery, London
19 January – 7 May 1995

Hugh Lane Municipal Gallery of Modern Art, Dublin
1 June – 31 July 1995

Exhibition selection:
Kenneth McConkey

Exhibition organisers:
Donna Loveday and Tomoko Sato

Exhibition consultant:
Anna Gruetzner Robins

Research assistant:
Ysanne Holt

Catalogue design:
Area, London

House editor:
Robyn Ayers

Frontispiece: **John Singer Sargent** *Carnation, Lily, Lily
Rose* 1887 (cat 190)

Contents

Sponsor's Preface 6

Foreword 8

Selector's Preface 9

Impressionism in Britain Kenneth McConkey 11

The London Impressionists at the Goupil Gallery Anna Gruetzner Robins 87

Catalogue Kenneth McConkey with Ysanne Holt 97

Endnotes 209

Bibliography 217

Index 219

List of Lenders 223

Acknowledgements 224

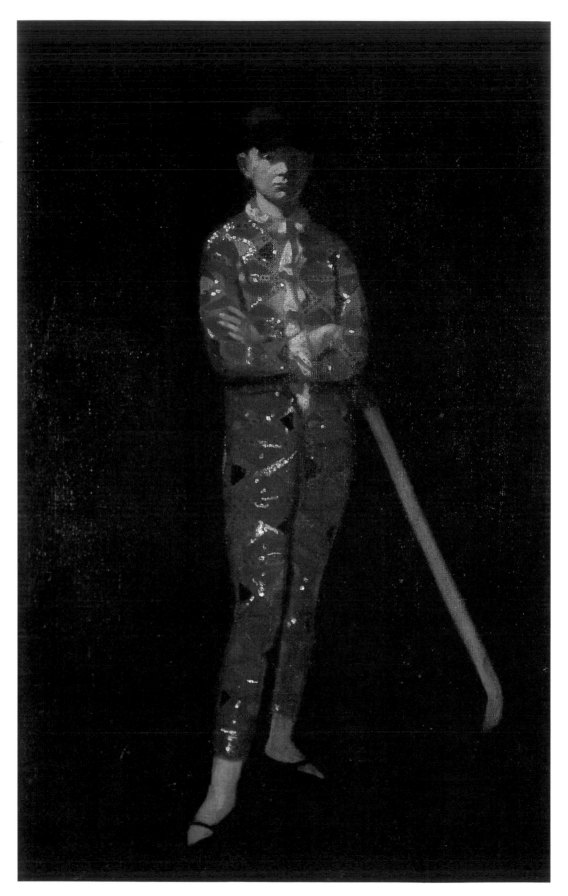

Mabel Pryde *The Artist's Daughter, Nancy, as Pierrot* c.1909 (cat 180)

Sponsor's Preface

Flemings is delighted to be associated with Barbican Art Gallery in this important exhibition. It is essential that the achievements of British Impressionist painters are not forgotten, overshadowed by their French counterparts.

Flemings was founded by my grandfather, Robert Fleming, who was born in Dundee in 1845. Today, it is a major investment banking group, offering a broad range of financial services to governments, companies large and small and, principally through Save & Prosper, to individuals. Flemings covers the globe, with important operations in Europe, the Middle East and the USA and, in partnership with Jardine Matheson, in Hong Kong, Japan and throughout the Pacific Basin.

However, we continue to cherish our Scottish roots and since 1968 have built up a fine collection of Scottish art, which today comprises over 800 oils and watercolours by around 350 artists, covering the period from c.1800 to the present day. The Glasgow Boys and the Scottish Colourists are particularly well represented.

Thus, it is entirely fitting that Flemings should sponsor *Impressionism in Britain* at Barbican Art Gallery. Scottish artists, particularly William McTaggart and Glasgow Boys such as John Lavery and E.A. Walton, played a not insignificant role in the development of Impressionism in Britain. Having had an office in the City of London since before 1900, it is also very appropriate that we should support a 'local' gallery.

Flemings wish Barbican Art Gallery well in this venture. I hope that you will enjoy the exhibition.

Robin Fleming
Chairman

FLEMINGS

Foreword

Because of the country of its origin, Impressionism has inevitably been seen as a French phenomenon. However, as this study illustrates, the desire to capture reality swiftly on canvas embodied a fresh, liberating approach towards painting that gained widespread international currency and found particular support among artists based in Britain. Political and economic developments encouraged the spread of this revolution. The upheaval of the Franco-Prussian War of 1870 caused Monet and Pissarro to travel to Britain for the first of a number of visits; Sisley followed for his first visit in 1874. Equally, with the economies of Northern Europe and America booming, an international array of art students eager to digest the latest ideas and styles swarmed to the honeypot of Paris and the French painting colonies like Grez-sur-Loing, once hostilities had ceased. A long list of the British devotees is contained in the catalogue, pages 97 to 208, and its length reveals the extent to which many British painters sought an escape from high Victorian narrative styles.

Impressionism was a truly revolutionary approach to painting and any perception that is currently promoted of its conservative nature is misleading. During the period of the movement's genesis, the Impressionists were greeted with derision. Ruskin's famously disparaging remark about Whistler 'flinging a pot of paint in the public's face' epitomised the reaction of many French and British critics to a radical new painting style that smacked of rushed technique and lack of finish. Echoes of Ruskin's remark still sound in our ears when contemporary art is reviewed in the popular press today. While the careers of some of the French proponents of Impressionism flourished under such critical attention, the combative Whistler found his position in London insecure, his work became the focus for litigation and he was bankrupted in 1879 by the ensuing courtcase. Under these circumstances, it is hardly surprising that adherents to Impressionism in this country were slow to embrace this new style.

Recently, some commentators have suggested that there have been too many exhibitions about Impressionism, that the style is unchallenging and predictable, and that the subject should be laid to rest. I make no excuses for this show, other than to say that this exhibition is the first major display in London devoted to all the Impressionist painters that worked in Britain and is therefore a long-overdue exposé of the manner in which a revolution in painting took place in this country.

Impressionism in Britain was commissioned to reveal the extensive research on the subject by Professor Kenneth McConkey and he has been ably supported in this by Dr Anna Gruetzner Robins. The exhibition follows a number of earlier survey exhibitions at Barbican Art Gallery that have studied overlooked or under-assessed areas of British art over the last hundred or more years and so marks a further, but not final, step in our progress towards a thorough re-examination of late 19th and 20th-century British art history.

Impressionism in Britain would not have happened without the contribution of many private and public lenders and also the considerable sponsorship of Flemings, whose generous support has been crucial to the development of the exhibition. For their sponsorship of this exhibition, Flemings have also received an award through the Government's Business Sponsorship Incentive Scheme. This prestigious award, administered by the Association for Business Sponsorship of the Arts, has brought enhanced benefits both to the sponsor and to the exhibition itself.

John Hoole
Curator
Barbican Art Gallery

Selector's Preface

The appreciation of the work of British and Irish Impressionists is a relatively recent phenomenon. For over fifty years critical opinion in the British Isles tended to follow Roger Fry's repudiation of the painting of his youth. For writers of the 1950s the art of the late Victorian and Edwardian era lacked all intensity. Only with the heroic research of Bruce Laughton, Richard Ormond and Wendy Baron, whose monographs of Philip Wilson Steer, John Singer Sargent and Walter Sickert appeared in the early 1970s, did attitudes begin to change. By the end of that decade, even the British followers of Bastien-Lepage had begun to be redeemed in notable museum exhibitions of the work of Fred Jackson, Edward Stott and William Stott of Oldham, Henry Herbert La Thangue, William Orpen, George Clausen, John Lavery and the painters of Newlyn and the west of Scotland. These made possible the more general surveys in book and exhibition form of the work of the Irish Impressionists, the Glasgow Boys and the Barbican Art Gallery's own *Painting in Newlyn, 1880-1930*. At one level, the organizer of the exhibition on the theme of Impressionism in Britain is like a pirate, stealing and recasting the ideas and information which others have produced.

This exhibition has been supported by curators and keepers of fine art in Great Britain, Ireland, Portugal and the United States. In many instances they have taken the trouble to supply detailed documentation for the works on loan. In the case of notable French Impressionist pictures this is often voluminous and cannot be replicated here in full. I am, nevertheless, profoundly grateful to all of these gallery staff and to their trustees.

It would, however, be inaccurate to claim that historians and curators were in the forefront of this revival. Perspicacious dealers took an early lead. My own introduction to the painting of the period 1880-1910 occurred as an art student visiting the Fine Art Society in the late 1960s. Shows such as *The Early Years of the New English Art Club* (1968) and *Channel Packet* (1969) broke new ground. Within a few years, Michael Parkin and David Messum were staging exhibitions of the work of the London Impressionists and the painters of the Newlyn School, and in the early 1980s these areas of interest were developed in British, Scottish and Irish Impressionist shows by Pyms Gallery, Browse and Darby, Whitford and Hughes and Richard Green. No serious historian of British art of the period can afford to ignore the lively trade in British Impressionist pictures in the salerooms. A notable feature of the present exhibition has been the willingness of the members of the art trade to pass on loan requests with their personal endorsement to clients. To collectors and dealers alike, I am extremely grateful.

I have, however, particular debts of gratitude to Anna Gruetzner Robins and Ysanne Holt. Having conferred with the former intermittently over fifteen years, it has been a pleasure to call upon her specialist knowledge in the preparation of the exhibition. I also acknowledge the support of the latter in the preparation of many of the artists' biographies which appear in the catalogue section. Finally, I pay tribute to John Hoole and the staff of the Barbican Art Gallery who have made the exhibition possible. Tomoko Sato and Donna Loveday have been excellent collaborators who have assiduously pursued loan requests, coordinated the production of the catalogue and maintained good humour in adversity.

Kenneth McConkey
University of Northumbria at Newcastle

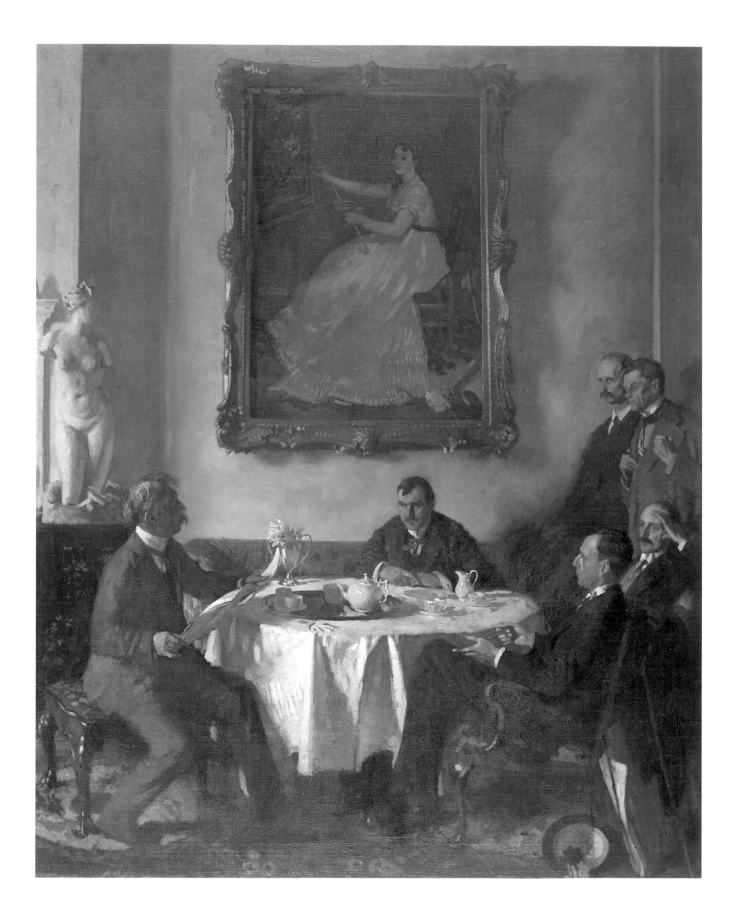

Impressionism in Britain

Kenneth McConkey

Homage to Manet

In 1909 William Orpen's *Homage to Manet* (cat 157) was shown at the New English Art Club. The picture's title is a reminder of other group portraits by Henri Fantin-Latour which, in the 1860s, stood as a visual record of the alliances and allegiances underpinning the avant-garde in France. In his *Hommage à Delacroix*, 1864 (fig 1), artists and writers are arranged on either side of a portrait of Delacroix. In *Un atelier aux batignolles*, 1870, admirers are watching attentively as Edouard Manet conducts a demonstration. The concept behind Orpen's painting was therefore not new. The figures are listening to one of their number; they are grouped around a picture. On the whole, however, there is a more leisurely ambiance in *Homage to Manet*. Orpen began to plan the picture in 1906, the year in which Hugh Lane, seated on the far right of the composition, had purchased Manet's portrait of *Eva Gonzales* (fig 2) prominently placed on the wall in the background of the picture. The acquisition was vociferously supported by George Moore, seated on the left of the painting, a now ageing critic and novelist who had known Manet thirty years earlier. In 1906, in Dublin, Moore had published his *Reminiscences of the Impressionist Painters*, a

slim volume which not only recalls the vivid experiences of his youth, but also captures his lifelong enthusiasm for the work of the Impressionists. Moore was aware of Lane's mission, to form a superlative collection of modern painting to raise the standard of art practice in Dublin. 'Mademoiselle Gonzales is what Dublin needs', he declared.

Throughout the three years in which the painting was planned and replanned, Orpen considered the appropriate individuals to be included. He contemplated including John Singer Sargent and Augustus John; Sargent would have been particularly appropriate since he had been one of the first artists working in Britain to express an enthusiasm for Claude Monet. Unwilling to settle to the comfortable routine of portrait painting, he had visited Monet at Giverny and, watching him at work, had observed the direct colour relationship between what the painter was seeing and the marks he made upon the canvas. Now, around 1907, with fifteen years of popular success as a portraitist behind him, Sargent was returning to these roots.

Orpen could have looked elsewhere for his protagonists, to the likes of George Clausen, Henry Herbert La Thangue and Edward Stott. These painters had been early supporters of the New English Art Club. They were among the first wave

of British art students to be trained in Paris and, now resident in the home counties, they were painting pictures of rural labour which could hang comfortably beside the work of French, Belgian or German Impressionist painters. Equally, Orpen could have included representatives of the Newlyn and Glasgow Schools in his celebration of Manet. Stanhope Forbes and John Lavery were now involved in large exhibition-pieces which drew upon Impressionist techniques. Alternatively he could have looked to landscapists such as Alfred East, who as a youth had worked at Barbizon, and now spent much of his time painting in the Seine valley. There were also Lucien Pissarro, Wynford Dewhurst, Laura Knight and Alexander Jamieson among the younger generation who might have claimed his attention. However, in many instances these painters were no longer directly associated with the New English Art Club. They had either been absorbed into the Royal Academy or showed with other societies. They did not suit his programme, which was to pay homage specifically to Manet, an urban painter like Orpen himself.

In the end he settled upon Philip Wilson Steer, Walter Sickert, Henry Tonks and D.S. MacColl as more likely recipients of Moore's afternoon tea. The selection was not coincidental. Sickert and Steer represented advanced painting in Britain as 'London Impressionists'. Steer, the central figure in Orpen's composition, had been an even more daring exponent of advanced techniques than Sargent.

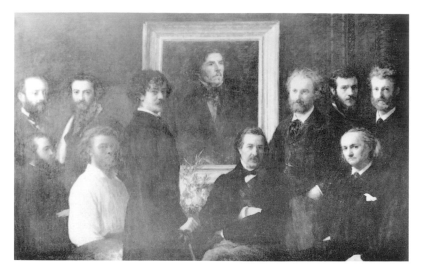

Although he had recently reverted to classic English landscape formulae, he had thoroughly absorbed the lessons of Monet and had experimented with divisionism. Included as an afterthought, Sickert also had impeccable credentials as a former pupil of James McNeill Whistler and as an apologist for Edgar Degas, and his current work showed no retreat from the first principles of London Impressionism. Of the others in the group, MacColl and Moore stood for art criticism in support of Impressionism, Tonks was the leading progressive art educator and Lane the philanthropic collector.

Unlike Fantin-Latour's pictures, however, Orpen's painting is a postscript rather than a declaration of new principles. Its protagonists were already seasoned campaigners. They had been crucial to the development of an understanding of Impressionism in Britain at all levels – whether as practitioners, promoters or prospective purchasers. They represent all the levels at which the study of Impressionism in Britain and Ireland from the 1870s onwards has to be tackled.

During the final quarter of the nineteenth century a series of seemingly unrelated events conspired to change the character of Victorian painting. While great Academicians of the standing of Frederic Leighton, John Everett Millais, Lawrence Alma Tadema and their numerous acolytes continued to dominate the official exhibitions, there were suddenly tensions of a kind not experienced before. This was the result of widespread dissatisfaction with art education, which led students in unprecedented numbers to take the channel packet-boat to learn their craft in Paris. There was dissatisfaction with the Royal Academy and a desire to see its exhibition practices overhauled. There were broader questions of style and subject matter, and new patrons whose taste had to be educated. All of this occurred at a time when images of all types were proliferating,

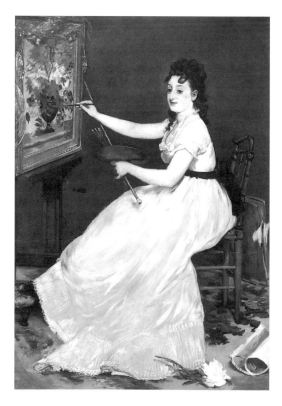

when photography was claiming the status of fine art, and when it was technically possible for a painting exhibited in one country to be faithfully reproduced and widely distributed in another. The increased curiosity for the special prestige of Paris drew French art of all types to London, where it was absorbed by young painters. Impressionist and Salon Naturalist painters like Claude Monet, Camille Pissarro, Alfred Sisley and Jules Bastien-Lepage all worked in London, and the display of their work was an occasion for critical dispute in the community of young painters. More than in previous decades there is a sense of a whole generation physically pressing against its fathers.

In recent years these issues and events have been re-examined in a series of separate narratives. There have been studies of the activities of the French Impressionists to Britain and of the critical responses to their work. In the cases of Manet, Degas, Monet, Pissarro, Sisley and Whistler, separate literatures are generated. Thus Monet in London is an important part of the history of French Impressionism; Whistler, mistakenly interpreted as an Impressionist in the wake of his controversial lawsuit against Ruskin, is re-examined; Degas, favoured as a 'painter of modern life' is used by his British followers to correct the emphasis on pure landscape. English, Irish and Scottish painters who espoused the Impressionist manner have been studied, as have some of the British collectors of Impressionist painting. The work of Irish painters becomes bound up with the burgeoning of national consciousness; the Glasgow School defines itself vis-à-vis Paris, rather than London or Edinburgh. The subject is seen in the context of other topics, such as the revival of past styles, the inter-relationship of art and craft, the broader cultural setting and the imported experience of other cultures such as that of artist-travellers to Japan. Furthermore, other studies take critical and theoretical perspectives which attempt to open new possibilities of interpretation, sometimes by considering iconographic issues in greater depth.

It is important to realize that the sequential development of Impressionism was far from inevitable. For young painters of the turn of the century, the clear trajectory from Impressionism to Modernism was much less obvious than it has been made to seem in late twentieth-century accounts. In the artifice of history, dilemmas of indecision seem in retrospect like logical choice. A full examination of the work of artists of the British Impressionist generation, that is, those born in the twenty years after the mid-century, reveals diverse approaches, in parallel with those found in a survey of French painting at the same period. The diversity of the late Victorian and Edwardian Academies should not be ignored. Even within more tightly determined artists' groups such as the New English Art Club there is, at its inception at least, a healthy heterogeneity. It is worth recalling that French Impressionism was not one formal, absolute artistic phenomenon, and that ideas of what it was changed at the time and have changed ever since. The character of British Impressionism changed, and it is often necessary therefore to asses the quality and depth of understanding of contemporary debates by treating pictures as works of critical commentary, as expressions of the current state of thinking.

Exiles and Art Schools

In the 1880s, as a result of debates about art education and the presence of progressive art in London, there was, among recently graduated students, an emerging consensus on good practice, which has never been satisfactorily described. As museums expanded, and styles and periods of art became accessible, C.R. Leslie described the conditions in which many young artists learned their craft in his lectures to students at the Royal Academy. 'The very wealth of Art creates one source of embarrassment', Leslie declared. 'The student is apt to be so impressed with awe by the works of the great masters now congregated in galleries, that any attempt to rival or combine their excellences seems utterly hopeless'.[1] The master/pupil relationship had gone, although James McNeill Whistler affected to revive it in the 1880s by emulating the practice still common in Salon catalogues of young artists indicating whose pupil they were.[2] A fascination for the Primitives in the first phase of Pre-Raphaelitism was followed by the adulation of sixteenth-century Venetian painting. Contemporary discoveries from the past provoked intense curiosity. Excavations at Tanagra in Asia Minor, for instance, revealed sources for a revival of classical painting which spanned the cosmopolitan mythology of Leighton, the daily-life genre of Alma-Tadema and the aestheticism of Whistler and Albert Moore. For a time, in the 1860s and 1870s, any period or style was acceptable provided the picture contained a strong narrative which could be 'read' by an increasingly literate public. In Grub Street the demands of popular journalism and illustrated novels opened the full panorama of history and contemporary life.

At the same time the art school curriculum was becoming more academic and complicated. Art history lectures were introduced. Those at the Government Art Training School in the 1870s concentrated upon the decorative aspects of period style.[3] They were thorough and sophisticated in

presenting students with a distillation of the current state of knowledge.[4] Elementary principles of recognition were enshrined in demonstrated examples of the most characteristic artefacts of a particular period. Although conducted to high academic standards, such courses, at a basic level, informed the circumstantial authenticity of history paintings. It was no longer simply a matter of handing on accredited craft skills. [5] Nor were ideas about these skills unchanging and absolute. Different art schools took different approaches. Edward Poynter, Slade Professor of Fine Art until 1875 and then Principal of the National Art Training School in South Kensington, for instance, produced a series of technical recipes, christened by his students as 'The Laws of the Medes and Persians'. A student should work from a correct outline drawing, completing each part, modulating abrupt transitions of tone as he or she advanced.[6] Drawing itself was a matter of much debate, although Poynter's view was generally held, that by constant study of the life model the student would eventually arrive at an understanding of the beauty of nature.[7] Beyond this the field was open. After Poynter's departure from the Slade School his position was taken by the French painter Alphonse Legros, against strong competition from W.F. Yeames, a painter of Royalists and Roundheads. In contrast to Poynter and Frederic Leighton, whose lectures were published, Legros taught by example. Ascetic and alienated, his strong views about *métier* were expressed through demonstrations known as 'time studies' in which, typically, the head of a model might be painted by a strict procedure.[8]

Legros had begun his career in Paris in the 1850s at the 'Ecole royale et speciale de dessin et de mathematique', known as the 'Petite école', a school run by a revolutionary teacher of drawing, Horace Lecoq de Boisbaudran. Lecoq stressed the training of the visual memory; he taught students to learn a scene by rote before trying to reproduce it. He would illustrate the defects of visual memory by asking pupils like Legros to go to the Louvre and memorize celebrated masterpieces, before returning to reproduce them from memory in the studio. This discipline was thought to be an aid to the expression of individuality. A student must learn to be able to recognize the characteristics of his own visual language. Through anglophile French painters such as Fantin-Latour, Jean-Charles Cazin, Frederic Régamey and Leon Lhermitte, and principally through Legros, Lecoq's ideas gained a particular appeal in England. His treatise was translated by a devotee, L.D. Luard, and published.[9]

Legros' other credentials were impressive, although not necessarily to the British art esta-

blishment. His work was favoured by Baudelaire, and with Manet and Carolus-Duran he had been classed as one of the second generation realists and a potential heir of Courbet. Transposed into an English context, however, Legros' paintings were regarded as bizarre. Small scale naturalistic Pre-Raphaelitism, exemplifying Ruskinian precepts derived from the fourth volume of the critic's influential *Modern Painters,* had little in common with large sub-Courbet realist works like *l'Ex-Voto* (fig 3), extracted from the Salon of 1861 and implanted into the Royal Academy of 1864.[10] Nevertheless, his initial friendship with Whistler and absorption into the francophile group which included George du Maurier, Thomas Armstrong, Val Prinsep and Edward Poynter, under the benevolent patronage of Mr and Mrs Edwin Edwards, assured Legros of a footing in England.[11]

Despite these concerted efforts at absorption, Legros refused to be naturalized. His range of subject matter – French peasant devotions, legends and fables – consistently underscored the difference between his work and that of his British contemporaries. The realism of his youth was academicized in pictures such as *Le repas des pauvres* and *The Close of Day*, but its essential derivation was clear. There was no room for rich pageant history in his work.

The Slade School of Fine Art, when Legros began to teach there in 1876, was still relatively small. As he worked to establish a curriculum, rival institutions were noted for their laxness. At the Government Art Training School, for instance, students had minimal support from their tutors.[12]

Fig 3 **Alphonse Legros**
l'Ex-Voto, 1860-01
Musée des Beaux Arts, Dijon

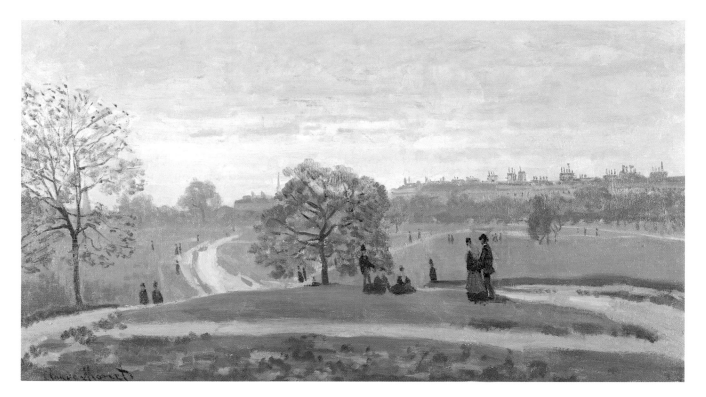

Cat 138 **Claude-Oscar Monet**
Hyde Park, London c.1871
Museum of Art, Rhode Island
School of Design, Gift of
Mrs Murray S. Danforth

The Royal Academy was slated in a celebrated indictment in 1885 from W.E. Henley in *The Magazine of Art:* 'As an educational institution its influence is practically non-existent', he declared, 'it has little or nothing to teach; and its students, as soon as they have passed the curriculum it imposes on them, make haste ... to France, to learn not only how to paint and draw, but to forget as much as they can of the practice and theory acquired in its schools'.[13] Art students had become some of the most frequent users of the channel packet boat.

The possibility of English patronage of avant-garde art had been a growing attraction since the 1860s. The fact that members of the group portrayed in Fantin-Latour's *Hommage à Delacroix* were apparently surviving in London may have prompted Manet's two-day visit in the summer of 1868. He clearly hoped that it would be possible to set up an exhibition for the 'next season'.[14]

Following the outbreak of the Franco-Prussian War and the siege of Paris which commenced in September 1870, Claude Monet, Camille Pissarro and Charles-François Daubigny fled to London. Monet produced two important cityscapes. His panoramas of Hyde Park and Green Park dotted with strollers (cat 138, 139), recall Manet's view of Paris painted at the time of the Exposition Universelle of 1867, but where Manet becomes preoccupied with foreground activity – a boy with his dog, a gardener at work – Monet's treatment of London is more atmospheric. He reacts to the light and to the overall harmony.

Pissarro, by contrast, was more apparently industrious, but he remained in the suburb of Upper Norwood and its immediate vicinity (cat 170).[15] His pictures have been regarded as a 'paradigm of the realist's earthly paradise', although he grew increasingly unhappy with the lack of interest shown by the British art establishment.[16] He had met Monet through the dealer Paul Durand-Ruel by the beginning of 1871, and they visited the London museums together. The exact significance of these perambulations became a matter of conjecture and, to some extent, remains so.[17] Nevertheless Pissarro's growing anxiety to return to France increased as the summer of 1871 approached and his views of the current state of British art were reinforced by Theodore Duret, who visited him on his way to the United States. Duret informed Manet that 'things here are the way they were twenty-five years ago in Paris'.[18] Given Dante Gabriel Rossetti's uncharitable views on French painting, it seems there was much mutual chauvinism and no international avant-garde consensus. Paris was not yet the undisputed capital of art.

During 1870 Durand-Ruel was in London with some of his stock which he showed in a gallery hired for the purpose at 168 New Bond Street.[19] Over a four year period, he staged ten exhibitions at the gallery, under the somewhat spurious title 'Society of French Artists'.[20]

Two works by Monet and two by Pissarro were entered in the International Exhibition of 1871.[21] The early exhibitions of the 1870s demonstrate

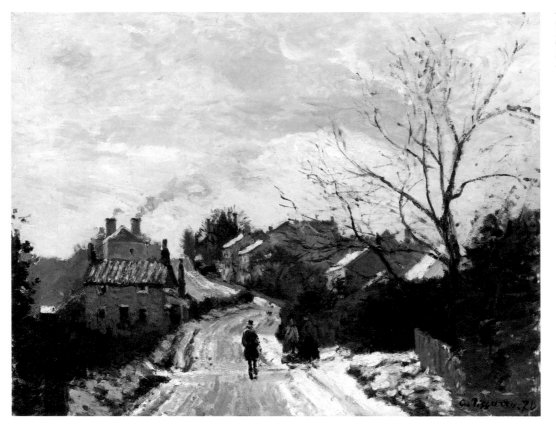

Durand-Ruel's growing commitment to newer avant-garde as distinct from Barbizon, painting. After the first show, with one painting by Monet and two by Pissarro, he began to deal directly with Monet. He is reported to have met him in London, after he had encountered Daubigny painting on the banks of the Thames. However, he developed a growing preference for Manet and Degas, who featured more prominently in the later London shows[22] which were to include, for example, Manet's *Woman with a Parrot* and *The Fifer,* and Degas' *The Ballet from 'Robert le Diable'* and *Dance Class at the Opéra.*[23]

There was, perhaps in the enthusiasm generated by the Legros circle, a general belief that French painters would succeed in London, particularly with the avaricious collectors of the industrial north. Like Manet, Degas was in increasing financial difficulties and hoped for a new market, and he referred to these collectors in his letters to James Tissot. Passing through London on his way to the United States he checked out the dealers' galleries.[24] Writing in 1872 and 1873 from New Orleans, he hoped to sell his most recent work through the agency of Agnew to 'a wealthy spinner, de Cotterel, who has a famous picture gallery'.[25] Despite the fact that Durand-Ruel, and some of his painters, believed that there was a market in Britain, it was slow to materialize. He succeeded in

selling works to Louis Huth, Samuel Barlow and Henry Hill before closing his gallery in 1875.[26] Hill, the most important of these, owned Degas' celebrated *The Dance Class,* 1873, (Corcoran Gallery of Art, Washington DC), *The Dance Class,* 1873-76

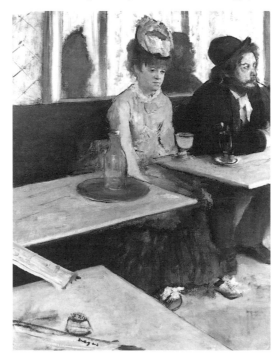

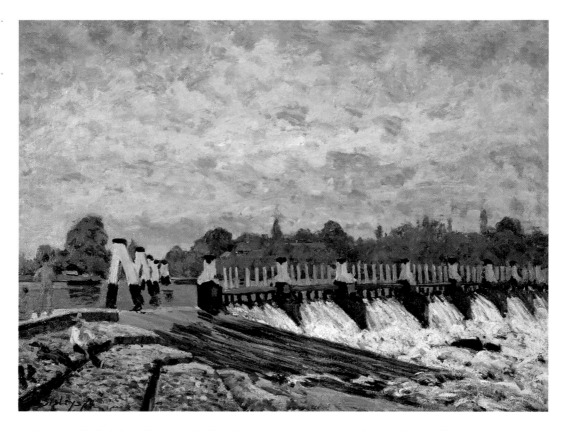

and *In a Café*, 1876, later known as *l'Absinthe* (fig 4) both Musée d'Orsay, Paris.[27]

Alice Meynell, who visited Hill's collection in 1881, after describing the 'peculiar cool cruelty' of these works, noted hanging above one of them, 'a charming garden-orchard scene by Monet, full of blossoms and spring feeling'.[28]

These early sales preceded a comprehensive understanding of Impressionism in Britain, which only became possible after the first Impressionist Exhibition at Nadar's studio on the Boulevard des Capucines in April 1874. In gathering the group together Degas, anxious to cement relationships with London-based associates, invited Whistler and Tissot to send work.[29] His understanding of what he was about at this time – prior to the coining of the word 'Impressionist' – is revealed in his letter to Tissot. 'The realist movement', he declared, 'no longer needs to fight with the others it already *is*, it *exists*, it must show itself as *something distinct*, there must be a *salon of the realists*'.[30] Changes in the character of the movement have been noted and the multiplicity of conflicting definitions has been stressed in recent studies.[31]

The debate within the spectrum 'realism/ naturalism/impressionism' became as much part of its history in Britain as it was in France. The 1874 exhibition would have passed unnoticed in the British press, were it not for the reviews in *The Academy* by the extraordinary critic, Philippe

Burty.[32] An ardent enthusiast for Japonisme, Burty wrote art criticism for the Gambettiste *La République Française*. He was a confidante of the principal exhibitors in the Boulevard des Capucines in 1874. His article in the English journal, published shortly after the exhibition closed, took the opportunity to reflect upon the responses of others who had written about the show, notably Ernest Chesneau and Jules-Antoine de Castagnary. Burty was therefore an informed insider who made no apologies for his support for the Impressionists. In contrast to critics of a realist/naturalist derivation like Castagnary and Edmund Duranty, Burty liked the decorative and colouristic aspects of the new method. Its interest was 'not social or human', it was contained in 'lightness of colouring, boldness of masses, blunt naturalness of impression'.[33] This new group was pulling French painting away from the dogmas of the past; its central tenet was personal freedom. 'It is a band of artists floating down a rapid river, drinking in the intoxicating effects of the sun, the shade, the verdure, the freshness, the perfumes that wander over the water and the banks, and never casting anchor or bringing their bark back to land.'[34] Metaphor and motif were mixed together in these perspicacious remarks.

For the remainder of the decade Britain continued to attract Impressionist painters and the English press retained a distant curiosity. In the

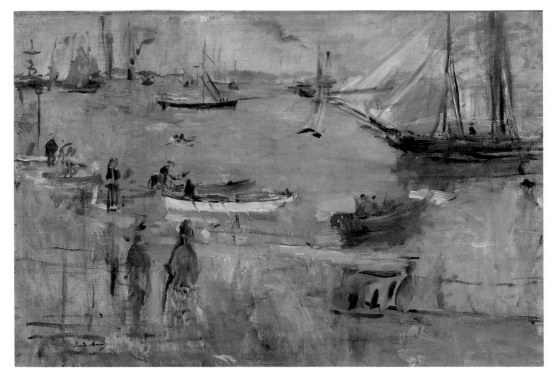

Cat 144 **Berthe Morisot**
Harbour Scene, Isle of Wight
1875
The Newark Museum,
New Jersey

summer of 1874 Alfred Sisley made an important visit to London in the company of his patron, the opera singer Jean-Baptiste Faure.[35] He stayed at the Castle Inn, on the riverside, and produced a sequence of canvases of views between East Molesey and Hampton Court (cat 203, 204) which have been regarded as a high-point of Impressionism.[36] These begin with a series of calm centralized compositions of the riverbank pathway. During Sisley's stay, however, the regatta at Molesey was staged and this resulted in several brilliant canvases, less structured than the others, but responding spontaneously to the flurry of flags and the excitement of the boat races.[37] Such pictures evidently convey the enthusiasm felt by Impressionist painters for the English scene. They were often accompanied by notes describing the vagaries of English costumes and customs. They give a sense of a new world which is being reported upon for the first time.

In 1875 Berthe Morisot committed perceptions of this sort to paper in a letter to her sister: 'Nothing is nicer than the children in the streets, bare-armed, in their English clothes'. She and her husband, Eugène Manet were staying at Cowes (cat 144) where she was immediately filled with enthusiasm for the life and movement of the busy shipping channel visible from the windows of her boarding house.[38] Her work, which was sketchy and incoherent, dissatisfied her, but it does convey the vitality of the panorama. On one occasion, painting *en plein air*, in a field, she

magnetized about fifty children and caused a pitched battle. Cowes was followed by a visit to London which appears to have taken in Whistler and Tissot – 'he lives like a king' – and an unsuccessful reconnaissance of Charles Deschamps, 'Durand-Ruel's man in London'.[39]

Through Deschamps, Durand-Ruel retained a presence in London. His gallery became 'our favourite' for a group of young painters which included Fred Brown, Alfred Webster and George Clausen. The latter recalled, 'there was always something good to be seen there, [in Deschamps' gallery] and we were cordially welcomed, for he really was interested in art, and most encouraging to us students'.[40] One of the 'good things' which caused a critical storm was Manet's *Argenteuil (Les Canotiers)* (fig 5), a picture which *The Times* found 'coarse and ugly', but which must have seemed extraordinary to the student group.[41] So controversial did this painter seem, that *The Architect* dispatched a reporter to interview him in his studio the following year.[42] Although Manet's opinions are recorded, 'I draw things as they are; I paint nature', there is a sense of befuddlement on the reporter's part, coming as he or she did from a world conditioned by Ruskinian morality.

This distinction between modern British and modern French painting was seen all too clearly from the outside by Henry James, who at this point was writing for the *New York Tribune*. James found himself in difficulties when confronted with works by the Impressionists. Having

encountered the 'first fresh fruits of the Pre-Raphaelite efflorescence' as a youth, he was hostile, and he saw the difference as 'very characteristic of the moral differences of the French and English races'.

When the English realists 'went in', as the phrase is, for hard truth and stern fact, an irresistible instinct of righteousness caused them to try and purchase forgiveness for their infidelity to the old more or less moral proprieties and conventionalities, by an exquisite, patient, virtuous manipulation – by being above all things laborious. But the Impressionists, who, I think, are more consistent, abjure virtue altogether, and declare that a subject which has been crudely chosen shall be loosely treated. They send detail to the dogs and concentrate themselves on general expression ... The Englishmen, in a word, were pedants, and the Frenchmen are cynics.[43]

Young artists had formidable hurdles to jump if they wished to align themselves with the most daring French art. James' indication of the battle lines was prophetic. To some extent the aesthetic grounds were cleared more immediately than could be expected in the Whistler/Ruskin trial of 1878. Questions of morality associated with virtuous labour were here to the fore. Whistler was, according to Ruskin, asking two hundred guineas for 'flinging a pot of paint in the public's face', for presenting pictures which were, in the words of the Attorney-General, 'knocked off' in a

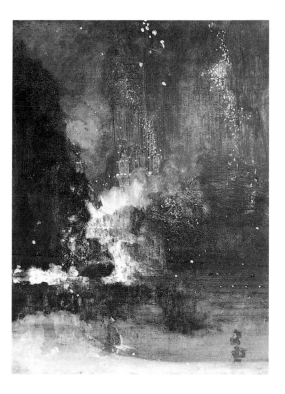

day.[44] Attention concentrated upon *Nocturne in Black and Gold; the Falling Rocket* (fig 6).

How was Whistler's securing of the right to do this, in a pyrrhic victory, interpreted by young artists? For many critics, Henry James included, Whistler was included in their hostility to French art. Despite the fact that cautious collecting continued, and that the mutual support for official masters was evident in the Exposition Universelle of 1878, there was, by the end of the 1870s, no discernable possibility of an *entente cordiale*.[45] There was as yet no marked effect upon British painting by the Durand-Ruel shows in London. The strong trend towards recording society, prompted in part by the growth of illustrated journalism, created occasional similarities of subject matter and treatment. Edward John Gregory's ballet pictures, for instance, were more acceptably anecdotal than Captain Hill's Degas. Landscape painting, as in Cecil Lawson's *The Minister's Garden, Sandhurst*, shown at the Royal Academy in 1878, remained tied to notions of finish and sentiment which relegated on-the-spot impressions to supplementary studies and sketches. Rural life was represented through consultation with accepted Salon masters such as Jules Breton.

By the end of the decade, however, the pace of exchange had increased. The Durand-Ruel and Deschamps shows had not gone entirely unnoticed by art students, who had begun to realize *en masse* that a more sophisticated and better informed approach to painting was emerging from the Paris ateliers.

Plein-air painting

It was by no means unusual for British and Irish painters to study in Paris in the second half of the nineteenth century. Since the 1840s French expertise in certain artistic specialisms, such as mural painting, had been recognized. In the following decade students such as Edward Poynter and Nathaniel Hone registered at the ateliers of Charles Gleyre and Thomas Couture.[1] Attempts to form an international avant-garde in which Rossetti might share the same stage as Manet foundered in the 1860s.[2] By the following decade, however, the art training systems of the two cities were being compared, and Paris suddenly became a kind of Mecca. The Hon. John Collier in his *Manual of Oil Painting* thought it worth comparing the British system with atelier practice. He quoted a friend who had studied at one of the most radical studios, that of Emile Carolus-Duran. Here there were few preliminaries; after light sketching of the figure in charcoal the process of blocking-in commenced, starting with the background and placing the figure on top in broad areas, working over the whole surface. Unlike Poynter and earlier French mentors, Duran discouraged modulation, or the blending of one colour or tone into another. He 'wished us to actually make and match each bit to the tone of the surface'.[3] This was not atypical but, taken with Duran's apparent neglect of drawing, it began to seem risky. For this reason alone Clausen rejected the atelier in 1876.[4] Duran advocated the ceaseless study of Spanish painting, Velázquez in particular, which exemplified precepts generally held by second generation realists.[5] This provoked the curiosity of the other *chefs d'atelier*, who 'looked askance' upon this new-fangled studio. Adolphe Bouguereau, for instance, newly appointed to the atelier Julian around this time, enquired of a student, 'Does M.Duran ever make you draw?'[6] It is not surprising that the effect of this 'hideous and pitiless' logic on 'the Ruskinian' was 'terrible'.[7]

Masters in the Paris ateliers entertained no superficial notions about finish. The painter should be able to leave all his touches of paint – the record of separate perceptions – visible on the surface. This came as something of a revelation. Students from Poynter's system were ill-prepared for the withering derision which their efforts to produce sophisticated finish were likely to provoke.[8] Once they had unlearned their British training, these new practices were not so easily dislodged. The new methods did not contradict the ambition to achieve verisimilitude, on the contrary they supplied a more direct way of attaining it. Working broadly across the forms seemed to acknowledge the flatness of the surface upon which the painter worked. Henry La Thangue, for instance, would paint on unstretched pieces of canvas attached to board in order to achieve a more systematic appearance. Practitioners of this method, according to Morley Roberts, '... leave the brush marks and do not smooth away the evidence of method, thus sometimes insisting on the way the picture is painted ...'[9] This method did, however, bring problems: it clearly removed layers of mystification; the public was denied *tableau vivant* verisimilitude; and autonomous paint marks began to stand for themselves.

The radical implications of the methods of the ateliers were compounded in the student *mêlée*. In the cheap hotels and cafés of the *quartier latin* a feverish debate raged about the heroes of the Salon. One group which assembled at the Hôtel de Saxe in the rue Jacob comprised the leaders of the nascent Glasgow School, John Lavery, Alexander Roche, William Kennedy and Thomas Millie Dow, and in their discussions 'ardour and tobacco burned freely at the shrines of Puvis de Chavannes and Jules Bastien-Lepage'.[10] These were the most radical painters to be seen in the Salons. Puvis had been exhibiting for nearly thirty years and was now at last being appreciated, while Bastien-Lepage, about ten years older than the painters he inspired, had had a meteoric rise to prominence. His controversial Salon exhibits confirmed the opinions which had already formed in London. Like the Impressionists and other young Salon painters, Bastien believed that London was fertile ground.

London had already lionized James Tissot. Works by his contemporaries, painters of the *beau-monde* such as Ernest-Ange Duez and Henri Gervex were noted with appreciation, and sometimes acquired.[11] Dealers increasingly imported star pictures from the Salon in the hope of creating a climate of interest. In about 1880 it became technically possible for works exhibited in one country to be accurately reproduced and disseminated in another. Provincial centres like Glasgow vied for examples of the most up-to-date French painting.[12] In the increasing range of exhibitions in London, painters outside the Academy began to occupy influential positions. Their support was often sought for new ventures, such as the Grosvenor Gallery. It was this drive for the new and controversial which led the owners of the Grosvenor Gallery, Sir Coutts and Lady Blanche Lindsay, to stage a small retrospective of the work of Bastien-Lepage within their summer exhibition of 1880. Sir Coutts Lindsay undoubtedly knew that the French painter had been to London the previous summer, had been invited to Windsor

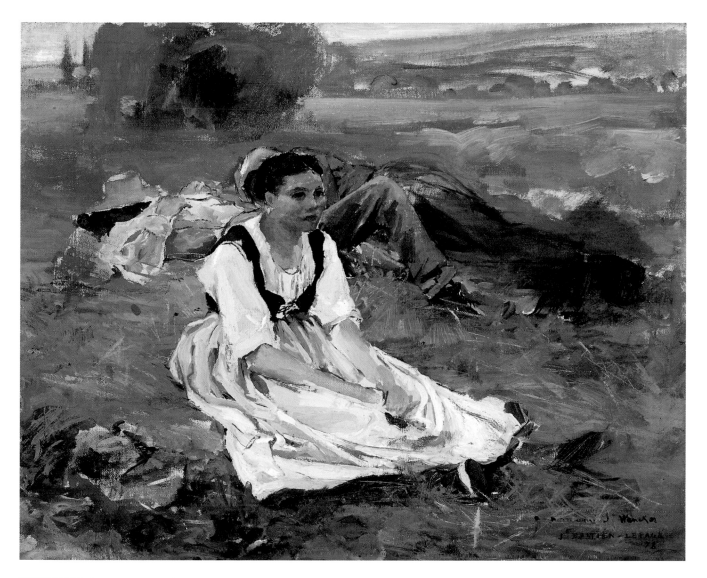

and had produced a series of studies from which his portrait of the Prince of Wales in the current Royal Academy show was painted.[13] Bastien's prominence in Britain dates from this point.[14] Although he showed mostly portraits, his contentious Salon painting of 1878, *Les Foins*, (cat 4) was included in the exhibition. Around it regularly gathered, as *The Spectator* noted, 'a little knot of worshippers or scoffers, admiring or condemning in the most vehement manner'.[15]

It was clear that the visual authority of Bastien-Lepage's work lay in the convincing rendering of real people and places under actual conditions of climate. At the moment when Impressionist painting was scarcely understood it was overtaken by what appeared to be a more sophisticated approach. Readers of the influential criticism of Emile Zola were informed that Bastien-Lepage's superiority over the Impressionists lay in his ability to realize his impressions.[16] Thus the

French art increasingly available through the Salon and the London picture trade was that of the rustic naturalists rather than the Impressionists. The values which this work asserted were those of a return to provincial roots. Millet's peasants were upgraded by acute observation supported, in a number of cases, by the use of photography.[17] Bastien-Lepage, the new mentor, stressed complete fidelity to visual facts. There were numerous testimonials to the way in which, in Elizabeth Stanhope Forbes' words, he had '... taken the world by storm'.[18] In front of nature, Bastien-Lepage managed 'to somehow rid himself of all personal feeling, and to turn himself into an artist's photographic apparatus'.[19] So it was that in the enthusiastic discussions in the rue Jacob, Puvis de Chavannes was dismissed and 'the favourite topics were Bastien-Lepage and plein-air'.[20]

The experience of the ateliers was not isolated. Young artists went to Paris for more than instruc-

Cat 3 **William Henry Bartlett**
The Neighbours 1881
Collection Mr and Mrs
Malcolm Walker

tion. They might have relished the thought of the *vie de bohème*, but for the most part practical considerations ruled. Training was a means to an end. Spartan conditions prevailed. These in themselves became the subject for a picture in William Henry Bartlett's *The Neighbours* (cat 3). Two young artists in a garret are momentarily distracted by the appearance of a young woman watering plants on the window-sill opposite. The scene was very familiar to the reviewer of *The Graphic*:

> Busy with their masterpieces for the coming Salon, which are to bring them fame and wealth, they have, or rather one of them has – been attracted from his canvas to the prettier picture across the street. Doubtless she is *ma voisine,* with whom he interchanges many a greeting in the course of the day, and she is probably one of those light-hearted *ouvrières* on whose struggles and temptations so many *feuilleton* writers have loved to dwell ... The two young artists, rising geniuses such as Paul Mürger [*sic*] so admirably describes in *Vie de bôhème* and *Buveurs d'eau,* evidently share a garret studio *au cinquième,* in one of the few streets which still remain to the Quartier Latin, now being so rapidly 'improved' off the face of modern Haussmanized Paris.[21]

The picture implies complex social relationships. The working woman is the stuff of popular naturalist fiction, looking for social enhancement. The artists are young upwardly-mobile temporary residents, probably of lower middle-class origin. Some, like Stanhope Forbes, were looking over their shoulders at anxious, and potentially disapproving parents.[22] For others like John Lavery the Ulsterman atelier training signified, crudely, a market advantage with the *nouveaux riches*.[23] Part of the conditioning which sent them to Paris in the first place was a recognition of the superiority of French painting. In this, the Impressionists played little part. British painters and their potential patrons were attracted to the progressive art of the Salon.

The Scottish contingent in Paris was joined at times by William Stott of Oldham, a hero-figure. In 1882 Stott had been acclaimed at the Salon with two paintings, *Le Passeur (The Ferry)* (fig 7) and *La Baignade (The Bathers)*. These carried within them the seeds of the new sensibility. They showed that Bastien-Lepage's naturalistic effects could be achieved without the loss of poetic sentiment. At one level *Le Passeur* was a modernized version of Gleyre's celebrated *Le Soir (Les Illusions Perdus)*, of 1843. The classical context has been removed, and a frieze of grey

peasant houses encloses the river, across which the ferry-boat is observed by two girls who act as surrogate spectators. Life is passing on the empty stream.

In *La Baignade* the river is a haven of sensual pleasure. Boys swim under the thick foliage in what Alice Corkran described as 'a shady nook'. 'All the delicious vagueness', she continued, 'the still languor, the heat of the summer day are suggested here'. The ensemble was 'perfect as might be the words of a poem'.[24] This was what the new plein-air methods might achieve if the routines of the atelier were complemented by recourse to nature.

This confrontation with nature could not be found in the ateliers. Bastien's success and that of the other French painters of his generation provided the standard and sense of direction for all those hours in the studio. The environs of Paris, the Marne at Nogent, the Seine valley and south into Fontainebleau, were explored. Robert Louis Stevenson who, through his cousin, touched

upon the pleasures of sudden liberation from the drab over-crowded ateliers, adopted a tone of exhortation:

let the youth make haste to Fontainebleau, and once there let him address himself to the spirit of the place, he will learn more from sketching than from studies, although both are neccessary ... A spirit once well strung up to the concert-pitch of the primeaval out-of-doors will hardly dare to finish a study and magniloquently ticket it a picture. The incommunicable thrill of things, that is the tuning-fork by which we test the flatness of our art.[25]

Painters now decamped to the forest to experience nature at first hand. Among the first was that group with which Stevenson was connected, the pupils of Carolus-Duran, who made their first foray in 1875. Finding in the year of Jean-François Millet's death that Barbizon was already a tourist attraction, they moved on to Marlotte and Grez-sur-Loing. At that time Grez was off the beaten track, but the paintings produced within its immediate vicinity evoke the poetic langours of Stevenson's description. The river was choked with water plants which 'catch the dipped oar with long antennae'; there was a 'quaint' church, a ruined castle and an old bridge, 'anonymously famous', because it was so frequently painted. Around these familiar motifs the woods, which had been hunted in earlier times by members of the French court, still retained the 'breath of musk and bergamot', and the fir-trees breathed 'abroad their ozone'.[26] Frank O'Meara was among the first wave of Duran pupils who decamped to Grez and as one of its most regular inhabitants he saw painters like

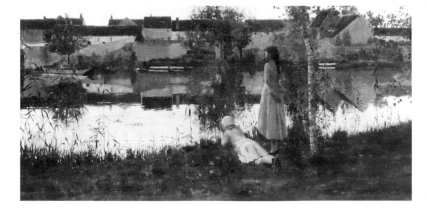

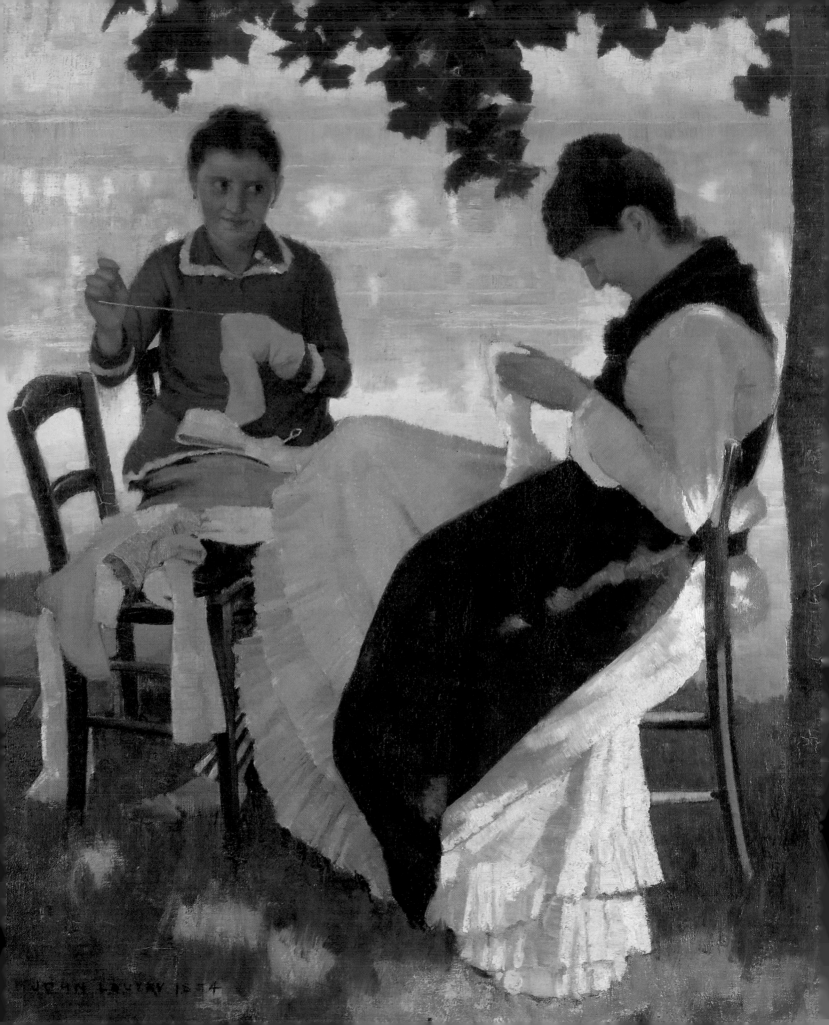

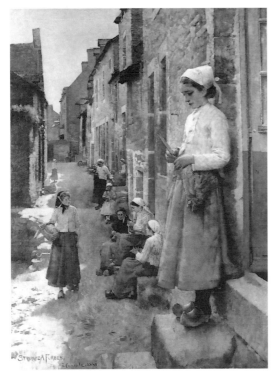

William Stott of Oldham, Louis Welden Hawkins, William Kennedy, Mouat Loudan and John Lavery pass through.[27] At times it seemed as if the place was so congested that the only thing one could see was other artists painting *en plein air*.

The moody pictures of O'Meara and Stott from the turn of the 1880s gave way to brighter, more ambitious compositons built up from small panel sketches. Lavery's *Sewing in the Shade* (cat 117) and *The Bridge at Grez* (cat 116) express the delectable ambiance of a village which was excessively pretty, and at the same time tinged with melancholy. No circumstantial evidence about the opening of the nearby Loing canal and the local economy quite explain the charm of this backwater. Although its heyday was between 1880 and 1885, Grez remained popular until the end of the century and saw successive waves of visitors, including Scandinavian painters such as Carl Larsson and Christian E. Skredswig, as well as Americans such as Willard Metcalf and Robert Vonnoh. Roderic O'Conor visited the village in 1889 and 1890, David Gauld in the late 1890s, and Lavery returned there for sentimental pilgrimages in 1897 and 1900. By this time it had been taken over by students of Impressionism who 'delighted in shadows of wonderful purple and violet hues'.[28]

While British painters were active in Grez in the early 1880s, the Seine valley, Normandy and Brittany were also popular haunts. Brittany was least contaminated by tourism at this time and perhaps because of this was commended to artists who were advised, nonetheless, to 'look well to the carriage springs' when exploring its as yet unmade roads.[29] Its fishing villages on the north coast had already been assessed by French painters before Stanhope Forbes and Henry Herbert La Thangue made their way to Cancale in the summer of 1881. Fired by the idea of painting in the open air, Forbes erected his easel in a narrow street and immediately began to experience the difficulties of fluctuations of light and the movement of figures.[30] The effect of the picture (fig 8) was nevertheless startling and its purchase by the Walker Art Gallery, Liverpool, confirmed the painter in the rightness of his approach, even though he was attacked by one critic for viewing the world through blue spectacles.[31] Critics were unprepared for the true rendering of strong sunlight, or for Forbes' ambition. In works such as *Preparations for the Market, Quimperlé* and *The Old Convent* he set the direction which other painters like Walter Osborne would follow in *Apple Gathering, Quimperlé* (fig 9).[32]

These impressively finished pictures were carried out *en plein air*. The painter might execute independent studies of figures or settings before attempting to combine them. The figure was not treated differently from its surroundings, the same method was applied to all. The more equable climate and availability of local models in northern France permitted working to a degree of finish which was not possible in England, Ireland or Scotland without the aid of a glass studio. The systematic brushwork of the atelier could be tested on life itself.

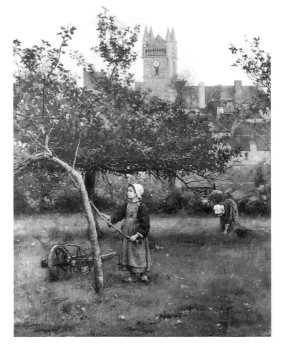

PLEIN-AIR PAINTING

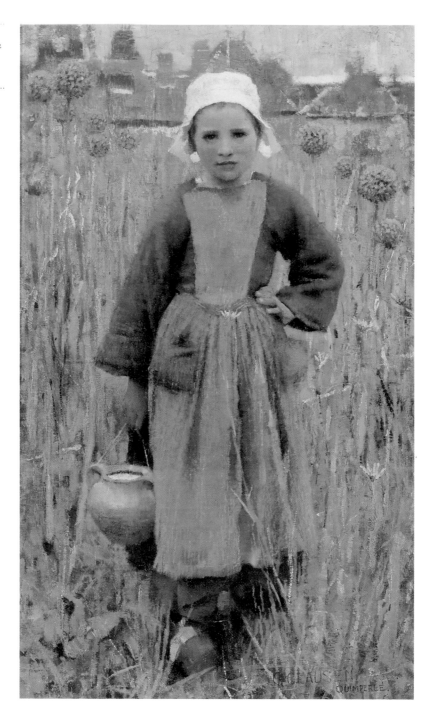

The archetypal work of this period was George
Clausen's *Breton Girl carrying a Jar,* 1882 (cat 26).[33]
This image has all the stark simplicity of Bastien-
Lepage. The girl simply advances towards the spec-
tator with eyes-to-camera. She is contained within
the upright rectangle; her surroundings indicate the
outskirts of the village of Quimperlé. There is no
'attitude' – something which Bastien-Lepage had
found hard to resist in canvases like *Pas Mèche*.[34]
There is no implied narrative, no vacuous

Amazonian facial features *à la* Jules Breton. The
iconic quality stems from the evident sense of
simple reality, honestly recorded. Or so we are
obliged to think. Naturalism by definition, to
paraphase Degas, was about conveying the idea of
the truth by means of the false. Working in the open
air gave a circumstantial authenticity which might
not otherwise be achieved, and in an era in which
instantaneous photography was becoming ever
more possible this was an important consideration.

What did plein-air painting mean to those who viewed it? These obvious features immediately signified foreign allegiances, and this itself was enough for the xenophobes of British art criticism. Did it create the seed-bed from which Impressionism might spring? This is inevitably a complicated issue, in that this form of painting was regarded initially as an end in itself. Plein-air painting in Britain had a basis in reasoning which intelligent painters like Clausen had to work through. Bastien-Lepage represented a kind of truth; his works were manifestly objective. 'All his personages are placed before us in the most satisfying completeness, without the appearance of artifice, but as they live; and without comment, as far as is possible on the author's part', Clausen noted in 1888.[35] The notion of an apparently styleless style, self-effacing, 'work effacing the footsteps of work', and at the same time devoted to the recording of the rural poor was of enormous appeal. You could, as Clausen noted when he moved to Childwick Green in 1881, observe 'people doing simple things under good conditions of lighting ... nothing was made easy for you: you had to dig out what you wanted'.[36]

A fundamentally similar approach was adopted by Stanhope Forbes, who brought back to Britain the belief that art was somehow improved or was more authentic if it was conceived in uncomfortable surroundings. His colleagues were not susceptible to commercial advice about the kind of picture the market required and by offering works produced in remote, almost unheard of fishing villages such as Newlyn in Cornwall and which, furthermore, occasionally sold, they posed a threat to the livelihoods of those who occupied fashionable studios in London. 'It may seem somewhat of a paradox', Forbes declared, 'but I have often found the success of a picture to be in inverse ratio to the degree of comfort in which it has been produced. I scarcely like to advance the theory that painting is more successful when carried out in discomfort, and with every thing conspiring to wreck it, for fear of rendering tenantless those comfortable studios the luxury of which my good friends in Melbury Road and St John's Wood enjoy'.[37] This challenge to the accepted means of production did not have to wait long for a riposte.

The drive in the years around 1884 to establish colonies in remote villages was not restricted to Newlyn. Glasgow-based painters worked at Cockburnspath, Helensburgh and Moniaive.[38] Others such as the Irish painter Walter Osborne and his friends Edward Stott and Blandford Fletcher worked in a succession of villages in Berkshire and Worcestershire.[39] A little later there were

Cat 210 **Philip Wilson Steer**
Knucklebones, Walberswick
1888-89
Ipswich Borough Museums
and Galleries

colonies at Cullercoats and Staithes on the north-east coast.[40] Osborne in 1885 was also working at Walberswick, Suffolk in a group which at different times included Blandford Fletcher, Philip Wilson Steer and the American painter, Willard Leroy Metcalf.[41] In Osborne's case the sojourn resulted in an important picture, *An October Morning* (cat 160), which in some respects looks forward to Steer's *Knucklebones, Walberswick* (cat 210). Although formidably naturalistic, it shows Osborne experimenting with what has been described as an 'almost divisionist' technique in the rendering of the shingly beach.[42] Such a practice would not, of course, be inconsistent with the tenets of naturalism.

The more innovative approach taken in East Anglia is further reflected in the development of naturalistic photography. In 1885 Peter Henry Emerson (cat 65-70), having completed his medical training, went on holiday in the Norfolk Broads with his brother.[43] It seems likely that he met a number of young artists who, like Thomas F. Goodall, were interested in using photography as Clausen had done, as an extension of drawing.[44] What emerged from this sojourn was a series of photographic portfolios and some of the most important theoretical statements about art and photography of the 1880s.[45] Goodall in *The Bow Net* (cat 89), for instance, replicates a photograph and it is tempting to assume as a result that many artists used photographs in this way. The instance is, however, unusual. More normally painters would employ photographs as if they were study drawings for parts of the composition. In his and Emerson's collaborative portfolio, *Life and Landscape on the Norfolk Broads*, published in 1886, photography aped fine art in attempting images which, unlike instantaneous photographs, were not fragmentary. Until then this had only been possible by means of complicated

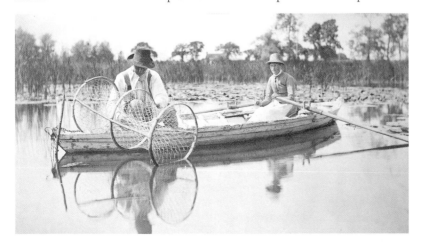

combination printing, which Emerson eschewed. He wished to give the effect of the whole picture as seen, even though in some cases it might have had to be posed. Emerson was aware of similar debates about naturalism in painting. In *Naturalistic Photography for Students of the Art,* 1889, it is clear that he thought fine art status depended as much for photography as it did for painting upon the truth of the ensemble and what he persistently referred to as 'the sentiment of nature'. The photographs he produced to exemplify his theories were presented for sale like fine prints which might be displayed alongside rustic naturalist paintings.

The relationship between sketching *sur-le-vif,* plein-air painting, photography and, eventually, Impressionism remains problematic. Impressionist paintings of landscape were, for the most part, completed *en plein air.* When a journalist named Taboureux asked in 1881 to be shown Monet's studio, the painter declared, 'My studio! But I never have had one, and personally I don't understand why anybody would want to shut themsleves up in some room. Maybe for drawing; but not for painting'. With a sweeping gesture he took in the entire Seine valley.[46] Monet may have been playing to the press, but he was in a real sense in nature, responding to its fluctuations with an intimate knowledge that led to the realization of the impression. Thus, in the 1880s Impressionist paintings were produced *en plein air,* but not all plein air painting can be described as Impressionist. Students, especially those from the atelier Julian, approached the motif with different methods and intentions. Brushwork, for instance, was systematic; they were encouraged to paint across the form to give breadth. They must see tonal rather than colouristic relationships, believing that local colour was less important than the solidity of the mass. They looked to simplify the composition rather than give a complete picture and, most important, their studies were subordinate to some greater conception. The universal appeal of this method which became confused with Impressionism offended George Moore. Writing in 1886 he described the 'great studio' of Julian as 'a sphinx and all the poor folk who go there for artistic education are devoured'.[47]

Here was an art student drop-out of the 1870s who spent the rest of his life clarifying, for the

benefit of others, the vivid experiences of his youth. Having abandoned the crumbling Moore Hall, Co. Mayo, George Moore had arrived in Paris in March 1873 on his twenty-first birthday, with his valet.[48] He enrolled at the Ecole des Beaux Arts under Alexandre Cabanel and for the next two years struggled to find a vestige of talent, realizing at length that he had more ability as a writer than as a painter. For a brief period at the end of the 1870s Moore gate-crashed into the exclusive artists' circle of the café of the Nouvelle Athènes. While other British and Irish students remained in the *quartier latin*, he graduated to become known as *l'anglais de Montmartre*. The meeting with Manet was a major event in his life and in later years he made a number of penetrating observations about the painter and his milieu.[49] Manet responded to him, not least because he had the pallor which suited Manet's palette. One of the three studies of him, in cursory strokes, expresses the ambiance of the café, and its concision is almost a metaphor for the acuity of the conversations which passed before him.[50]

It is not surprising that when confronting the student productions of the 1880s George Moore looked through eyes which had been attuned to Manet. For him the methods associated with plein-air painting were not absolute. We had not arrived at an ultimate statement about the world. Impressionism, especially that derived from the old Parisian bourgeoisie with its complex and, to an outsider, intriguing social codes, had something to add. This message was to take ten years to sink in. For the present, if they saw Impressionism at all British students might regard its landscape as an audacious extension of the tradition of Corot and the Barbizon painters. In their lack of system and regularity the Impressionists must have seemed to the student generation of British Impressionists as both old-fashioned and daringly avant-garde at the same time.

The National School in Peril

In 1884 the aged John Ruskin was asked to write an introduction to a survey volume, *The English School of Painting*, by the French critic, Ernest Chesneau. This, and its companion volume, *The Education of the Artist* (1886) were destined to become popular art school prizes. Ruskin could not resist the opportunity to pen a jeremiad. He declared that the British schools were in danger '... of losing their national character in their endeavour to become sentimentally German, dramatically Parisian or decoratively Asiatic'.[1]

Durand-Ruel had recently attempted to re-introduce Impressionist painting to London. In the spring of 1883, Dowdeswell's Galleries in New Bond Street mounted an exhibiton which included seven works by Degas, eight by Sisley, eleven by Camille Pissarro and half a dozen by Monet. The reviews were generally charitable. A long sympathetic essay setting out the tenets of the movement, by Frederick Wedmore, had blazed the trail a few months earlier in the *Fortnightly Review*. Wedmore was inaccurate about who had done what, but he had a good general grounding in the main preoccupations of the movement. 'Modern Life has spoken to them ... ', he declared, while recognizing colour and method in Monet and 'a science of draughtsmanship' in Degas.[2]

With so substantial a showing in London the French Impressionists renewed their curiosity for what was going on there. At the beginning of 1883 Pissarro's son, Lucien, had gone to London to learn English and was working for a music publisher in New Bond Street. Pissarro was anxious to receive his reactions to the Royal Academy, and Lucien duly reported that it was 'quite as depressing as the Paris Salon'. 'There are really only two painters who did not make me regret the money I had paid for admission, Mark Fisher, a landscapist, who draws trees in a very knowledgeable way, and paints freely – they are like some of the things you did at Piettes, amongst others a landscape where I posed lying under a large tree – and Millais who only exhi-bited figures, which frankly speaking I was not very taken with'. Pissarro, in reply, confessed that he did not know Fisher and concluded that he must be 'one of our imitators'.[3] This was slightly unfair to a painter who had impressive creden-tials. Fisher had been a student at the atelier Gleyre in the early 1860s where he had known Alfred Sisley. After completing his training he returned to his native Boston, but failed to esta-blish himself and found it necessary to return to Europe, taking up permanent residence in England in 1872. Thereafter he exhibited regularly at the Royal Academy and the Society of British Artists. Even in these conservative enclaves he was a consistent admirer of the work of the Impres-sionists, indeed he may have been one of their first serious artist-advocates.[4]

The dangerous reorientation of aesthetic sensibilities was already evident and it began to draw critical fire although, for the present, there was no distinction between Impressionism and plein-air painting.[5] Behind the debate about training and technique lay commercial questions concerning market share and the controlling cartels. Impressionism, as Sickert was to observe

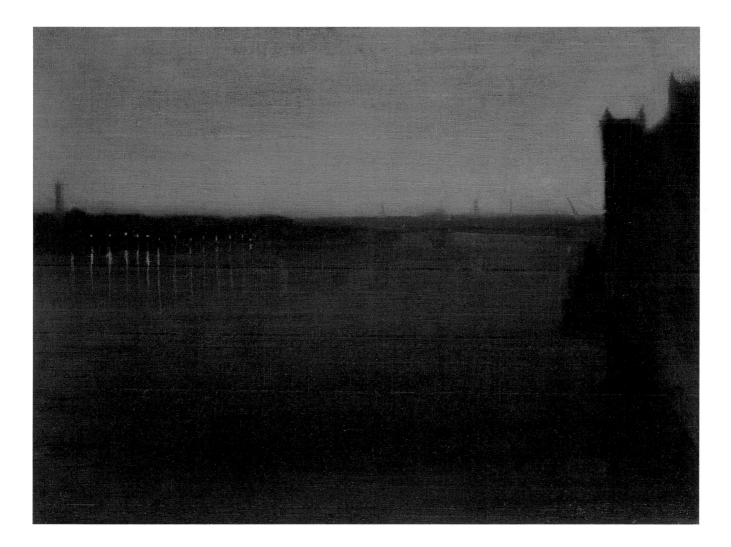

with hindsight, killed the exhibition picture. The Royal Academy was at the centre of this debate: depending on the critical stance it was either culpable and in dire need of reform, or the irreproachable custodian of absolute standards. Its defenders often laced their words with a xenophobia sanctioned by Ruskin. Even Chesneau, writing for an English audience in *The Education of the Artist*, had to be guarded in his comments about what was, in Parisian terms, already a familiar phenomenon. The Impressionist formula was 'harsh, summary, necessarily rapid, and it appears incomplete'. After praising works by Monet which were 'prodigious', he was compelled to add that 'the eye of the public – trained to exclusiveness by long intercourse with other, no less legitimate, readings of nature, and perverted in a great measure by the abuse of facile tricks of painting – refuses yet to recognise the purpose and merit of this school.'[6]

The discussion, however, was not to be confined to an extraordinary foreign group of painters who were not yet clearly on the English horizon. The climate of hostility was more generalized. Responding to Chesneau's book, James D. Linton sharpened the attack upon cosmopolitanism in art, slammed the superficialities of Paris education and declared that the followers of Bastien-Lepage were not producing pictures of English peasants but '*rechauffés* of Millet's and Jules Breton's peasants'.[7] Chesneau himself was compelled to enter the lists on this particular matter. Writing in 1887 it now seemed to him that the English school was in peril of losing its national identity.[8] Surveying the Salon of 1887 he observed the extent to which foreign exhibitors were now growing in number. This flattered the vanity of the French, but it was symptomatic of a growing cosmopolitanism which had its origins in the International Exhibitions which were being staged every eleven or twelve years. Agreeing with Linton's analysis, he declared that for 'certain technical qualities which, when all is said, are perhaps no more than dexterity of hand', the

'hapless' students from Britain had sacrificed their 'national identity'. Hogarth, Gainsborough, Reynolds and Turner constituted this identity.

It was necessary now for young artists to find their voice and make a rapid response. In his reply, George Clausen separated the attitudes from the arguments. 'Those who have no actual acquaintance with the working of the foreign studios speak as though their professors possessed some uncanny trick, some short and easy fallacious method of importing "superficial dexterity". '[9] On the contrary, skill was the result of 'laborious and persistent study of the nude, under the continuous personal influence of one of the best artists'. Clausen was of the opinion that the 'real cause of offence' was likely to be 'the latest departure, the "open-air school", and the development of impressionism'.[10]

The judgement here was acute. Younger painters, almost en masse, were convinced of the need to separate themselves from the establishment. By the time Clausen was making these observations they had already demonstrated their distinctiveness, principally in the formation of the aptly named New English Art Club.

In recent years London had seen the proliferation of art exhibitions of all types although, for the present, the Royal Academy remained the prime space in which to establish a reputation. Standing and commercial success were closely related, although the one did not automatically guarantee the other.[11] Since the mid-century there had been a growing community of art dealers dedicated to the cultivation of private clients, who might be impressed by a large Academy piece but who could only afford or house cabinet pictures, replicas, small variants and worked-up studies by important artists.[12] Dealers on occasion presented their stock as if it was that of an art society, and artists' groups on occasion secured the commercial backing of sympathetic dealers. The modern notion of an artist tied by contract to a dealer was less prevalent, partly because of the popularity of large mixed public exhibitions. With the New English Art Club, for example, support was initially supplied by Martin Colnaghi, although he pulled out before the first show opened its doors.[13]

The important precedent for new types of exhibition was set in the minds of the broader public with the establishment of the Grosvenor Gallery in 1877.[14] The motives behind this venture remain unclear, although they seem to combine a desire to provide a venue for distinguished Academy outsiders, with more complex social ambitions on the part of its organizers, Sir Coutts and Lady Blanche Lindsay. Public consciousness of the Grosvenor was a by-product of the Gallery, its decor, its clientele and the notoriety conferred upon it by the trial between Whistler and Ruskin, the *cause célèbre* which resulted from the very first exhibition. At one level, the organizers wished to retain an element of avant-garde controversy in their selections in future years, whether or not this was consciously structured into the policy of the Gallery. By the early 1880s, many of the artists who were later to be involved in the New English Art Club were already exhibiting at the Grosvenor, and many remained loyal to it throughout the early years of the Club and until its closure in 1890. These were painters, such as George Clausen and Henry Herbert La Thangue, whose work was associated with that of Bastien-Lepage.

During these years the Dudley Gallery continued to stage regular exhibitions demonstrating the broader range of painters outside the Academy. The United Arts Gallery came and went; the Royal Institute of Painters in Oil Colours opened in 1884, an offshoot from the Royal Institute of Painters in Watercolours. Again these attracted younger, less experienced exhibitors. Then, as now, there were essentially two seasons, spring and autumn, although with the opening of the Academy in the first week of May, the first of these was the more important. A winter's work might find its way into one or more exhibitions around this time. Many exhibition organizers actually competed for the best work, visiting studios in advance of the exhibition to ensure that an artist's best work would not be poached by rivals. Hearing that Sir Coutts Lindsay was doing this, even Frederic Leighton, President of the Royal Academy, was obliged to resort to the same practice. This could have fatal results for an artist; in the case of the New English Art Club a whole group was affected. Reputedly, when Colnaghi saw Henry Scott Tuke's *The Bathers* (cat 239) in the studio prior to the show, he got cold feet and withdrew from the whole venture. At short notice W.J. Laidlay, a wealthy member, agreed to underwrite the cost of hiring of the gallery and the show proceeded, albeit a week late.

Careful selection and staging underwrote the organizer or group of artists' sense of purpose. Having been set up by someone with late Pre-Raphaelite sympathies, the Grosvenor Gallery looked, according to reporters, like a Venetian palace. Its interiors were a pungent mixture of green marbling and red damask. The most concerted attempt to weld a society together under common exhibiting conditions was made, however, by Whistler when in 1886 he became President of the Society of British Artists. His influence in the Society had been growing for more than a year. He opposed what critics referred to as the gentle English spirit of the Suffolk Street artists. The circumstances here

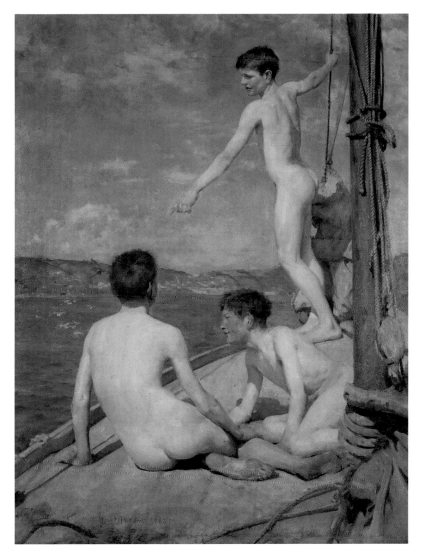

processes, giving pride of place to the work of his pupils and followers. 'We want clean spaces round our pictures. We want them to be seen. The British Artists' must cease to be a shop', he declared.[16] Throughout the next eighteen months a state of open war existed between the factions, even though Whistler hosted the visit of the Prince of Wales and secured, as part of the Jubilee celebrations, 'Royal' recognition for the Society. By the summer of 1888 he was ready to be voted out.

The organizers must surely have known what they were doing. Six months prior to the first approach Whistler had staged an exhibition entitled 'Notes – Harmonies – Nocturnes' at Dowdeswell's Galleries in New Bond Street. The catalogue for this show published his Proposition No. 2, in which he tilted at the Victorian taste for narrative, at the value implied in copious Pre-Raphaelite detail and at the notion that a picture should show evidence of the labour involved in its production: 'work alone will efface the footsteps of work'.[17] Before taking up the role of President Whistler had delivered his celebrated Ten O'Clock lecture in London. Again the shibboleths of Victorian philistinism were attacked, along with the more generally supported notion of truth to nature. Whistler set himself against nature, not in a symbolist sense, but in his desire to create a space for the work of art as something to be judged by its own standards rather than those derived from mere verisimilitude. He was polemical in his utterances. 'Nature is very rarely right ... Nature is usually wrong, that is to say, the condition of things that shall bring about the perfection of harmony worthy of a picture is rare, and not common at all'.[18]

Finally, to underline the point, in 1886 for his second Dowdeswell's exhibition he proposed a daring decorative scheme for the galleries in gold and brown. It seems inconceivable, given his frequent letters to the press to clarify his doctrinal position and dismiss his attackers, that Whistler's position could have been misunderstood. He must have been conscious of the role he occupied for the younger generation, even though he recognized that they were, for the most part, following false goals. Perhaps the British Artists afforded him the opportunity instantly to achieve the public standing which he felt he lacked. Through its agency he might draw the younger generation back from the mechanical plein-airism of the ateliers.[19] He did this by giving space to his pupils and followers. Jacques-Emile Blanche, Walter Sickert and his brother, Bernhard, had shown small on-the-spot sketches and still-life paintings in 1885; exhibitors who had been with the Society since the early 1880s, like Sidney Starr and Albert Ludovici jun. came into the Whistler fold; and Salon heroes such as William Stott of Oldham and Alexander

demonstrate the competition among the art societies for controversy. Back in November 1884 Whistler had been approached by members of this rather staid Society, whose attendances were falling. The rules of membership were quickly suspended and his work was introduced to the forthcoming winter exhibition. He showed again in the following spring and winter exhibitions, only to find himself elected President at the General Meeting of the Society on 1 June 1886.[15] What happened thereafter sets the scene for subsequent exhibitions of the New English.

Although elected in June, Whistler did not take up office until December 1886. The first exhibition to receive the full force of his radical overhaul was the winter show of that year. The jaded galleries were redecorated; the walls were hung with muslin and a velarium was inserted in order to diffuse the light evenly around the pictures. Whistler immediately introduced more selective

Harrison joined the Society temporarily.

The nascent radicalism in these circles became difficult for Whistler to control. Sydney Starr, for instance, in *Paddington* (fig 10), shown in 1886, addressed the modern metropolis. His picture is as different from the earlier representations of tearful farewells provided for *The Graphic* by Frank Holl as it is to Monet's renderings of the Gare Saint Lazare. There was a dim recognition of its naturalism in the words of one critic, who described it as 'a clever and novel piece of *impressionisme*'.[20] However the fact that Starr, unlike Osborne and Kennedy, both of whom tackled railway subject matter a few years later, had felt compelled to retain some anecdotal interest in the flower girl engaging a well-dressed young woman, indicates the residue of interest in narrative. By contrast the works shown by Stott and Harrison were more immediately in sympathy with Whistler's aims in that, although naturalistic, they excluded all narrative clutter. The boys in Stott's *A Summer's Day* (cat 226) were placed upon a large sweep of sandy beach, echoing the grand simplicity of Whistler's own beach scenes.

Whistler's immediate followers formed a semi-official group of seven, which first met at the home of Mortimer Menpes in Fulham. They looked at the map to decide upon a joint studio equidistant from their homes, and fixed on one in Baker Street, at a rent of six shillings a week.[21] The studio was decorated according to 'broad and simple' principles, with colours derived from those of the sea and sky. A special notepaper and stamp were designed; the latter represented a steam-engine advancing with a red light, 'a danger signal to the Philistines to warn them that reformers were on their track'.[22] There was a sense of excitement about all of this. They were interested in 'reducing nature to a system', in 'getting things to a state of absolute perfection'.

Through Sickert's good offices they were introduced to the work of Degas. Sickert and he had first met in 1883. Their acquaintance was renewed two years later in the summer of 1885 at Dieppe. Here was an artist who was not a careerist in the British sense; he was not looking for opportunities to move into commercial portraiture, although he regarded Sickert (*l'unglais*) as 'at last ... the Englishman who is going to buy all my pictures'.[23] The bourgeois Degas saw no contradiction in haunting circuses, café-concerts and other places of popular entertainment. To the Whistlerian study of shop-fronts was added the tent-interior of Pinder's circus. Low-toned ballet subjects were treated by other members of the group who now, inspired by reports of the depiction of street life, went around London trying to paint from the top of hansom cabs. For a time grey-primed

panels were preferred for such rapid on-the-spot sketches. Sickert favoured this practice and, in a famous photograph of him with Degas, taken in 1885, he is to be seen with what appears to be a *pochade* paintbox slung over his shoulder (fig 11). What could be produced in this way were no more than notes of colour which, supplemented by a more rigorous approach to drawing, might be translated into the modern urban naturalism.

Degas contributed greatly to Sickert's education. On a visit to Paris later in 1885, Sickert was shown around the dealers' galleries and brought to Degas' studio to admire his pastels of nudes and dancers.[24] His enthusiasm was mirrored in the first instance by Jacques-Emile Blanche, a young French painter with impeccable connections.[25] Dr Emile Blanche, the painter's father, entertained artists such as Degas, Renoir and Monet at his house at Auteuil. His son had been a pupil of Gervex and had got to know Manet in the years prior to his death.[26] Both Blanche and Sickert were so committed that over the following years they acquired examples of Degas' work.[27]

As he experimented with French art, Sickert found himself increasingly replaced in Whistler's affections by more orthodox tonalist painters. Theodore Roussel and his pupil Paul Maitland complied more readily with Whistler's sense of decorum. In Roussel, Whistler declared that he had found, 'a follower worthy of the Master'. His severe asceticism impressed everyone; he designed a series of mathematical instruments for matching the tones of nature and 'worked out a scheme for mixing perfectly pure pigment'. This in itself was an extension of Whistler's own methods. In advance of painting nocturnes, he would mix sufficient quantities of the dominant tones, label them in bottles and leave them standing for the moment of inspiration. The practice was taken further by these followers; at one time they became 'prismatic': 'we began to paint in spots and dots;

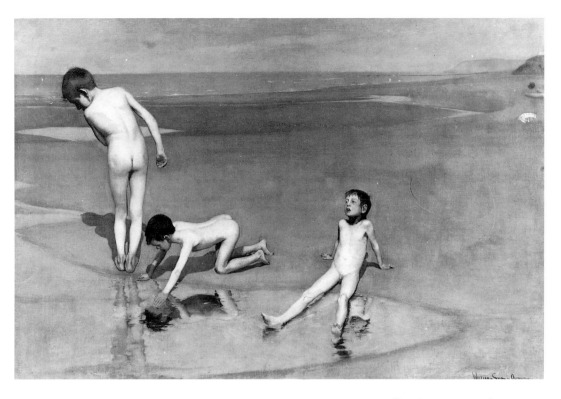

we painted also in stripes and bands', Menpes confessed. A portrait was a 'blot of colour'; nature 'a decorative patch'. Colour was more vividly seen from chinks in doorways and, as a final discovery, the prevailing conditions at a particular time of day were seen to be unique to that time.

We were continually asking one another to guess at what hour such-and-such a picture was painted. A Follower would suggest eleven-thirty. "Right you are – almost," the proud possessor would answer. Not eleven-thirty, but eleven-fifteen – because at that time the shadows were stealing round the hay-stack and forming a particular pattern. The school was becoming scientific. To be able to tell the time of day from a picture was astounding.[28]

There may be some blurring in Menpes' memory. Around 1886 the followers were, for a time, painting on grey panels. They did try to represent city life; they did paint low-toned dancers. However there is no evidence of the more daring experiments, panels depicting hay-ricks at different times of the day. All the efforts at prismatic notes of pure colour may now be attributed to Philip Wilson Steer.

There was some overlap between Whistler's followers and the membership of the New English Art Club, but it was not the same. Critics observed the common characteristics of the work on show in the Club, rather than the manner of its display. The catalogue announced that the fifty members of the Club were 'more or less united in their art sympathies' and that they hoped their annual exhibition might be of public interest and 'better explain the aim and methods of their art'.[29] The critics, to some extent, reiterated these points and expanded upon them. *The Pall Mall Gazette 'Extra'*

compared their efforts to the emergence of the Pre-Raphaelite Brotherhood forty years earlier. They aimed for 'the establishment of realism' and a raising of technical standards, 'our painters … are lamentably deficient in drawing, in the knowledge of "values", of colour and so forth', 'engrafting English feeling and sentiment upon what is known as French technique'.[30] This programme was enough to ensure that the New English, in one leap, attained 'a higher level of excellence than is to be found in the average Academy or Grosvenor Gallery'.[31]

Some sense of the appropriateness of epithets like 'Anglo-French', of a group observed to be 'more or less united in their art sympathies', may be obtained from examining some of the work on display in the first exhibition. One of the most popular pictures in the show was Arthur Hacker's *Cradle Song*, a genre scene showing a young mother, her bodice undone, a younger sister behind her, singing her new-born baby to sleep. It was reproduced in the *Art Journal*, where its lack of the 'tonal exaggeration' apparently found in Hacker's earlier work was approved.[32] *The Times* felt it was 'the best picture he has painted'.[33] Its subject matter was taken at face value. It mattered little whether or not Hacker was not committed to the plight of single parent families in rural England. There was nothing in *Cradle Song* that could not already have been found in the work of Frank Holl. What excited Victorian reviewers, for whom this was a new work, was its French handling. Hacker had painted in French fields in the Seine valley; he had lived in a Parisian garret next to Stanhope Forbes; he had imbibed the work of such French painters as Bastien-Lepage and Dagnan-Bouveret, although in *Cradle Song* their techniques were deployed upon more orthodox English sentiments.

The same tendency applies to many of the Newlyn contributors to the New English, such as Frank Bramley, Walter Langley, Fred Hall, Thomas Cooper Gotch, Albert Chevallier Tayler and Stanhope Forbes. All were torn between loyalty to the Club and the desire to achieve conventional success in the Royal Academy. Forbes' contributions to the first exhibition, *A Fisherman's Head* and *A Street in Newlyn*, suggest that he had already made up his mind to prioritize the Academy. The same could be said of a number of other first wave New English members, who became the Academicians of the 1890s, and who, like Hacker, were compelled to spend their careers on the improbable treadmill of scaling up small, precious Victorian ideas to the size of Salon pictures.

It would be wrong to derive from these examples an impression that the first New English was devoid of themes from literature and history,

treated in the new manner.[34] However, the most conscious attempts at modern reporting lay in the work of those who painted *en plein air*. The two most prominent members of this sub-set were George Clausen and Henry Herbert La Thangue. For the first exhibition Clausen borrowed back from its owner, industrialist John Maddocks, a work of the previous year entitled *The Shepherdess* (cat 27). This was part of an on-going series of portrayals of rural children. The orchard setting was carefully derived from studies and small pictures painted on the spot. It was regarded as an 'admirable specimen of Mr. Clausen's best manner'.[35] If Clausen's work demonstrated what could be achieved in terms of studio finish for the new manner, La Thangue's was regarded as dangerous for its lack of finish. *In the Dauphiné* was 'high bluish and open-air-like in colour'.[36] Its active paint surface and deliberate unfinish threw down a gauntlet. La Thangue swept the paint on to the canvas at speed with large flat varnish brushes. He wished to go further than his colleagues, to be more daring and to be recognized as a leader.

To some extent his confidence in doing this may have derived from the secure base which he seemed to have with Bradford collectors. His *Boat-Building Yard*, shown at the Grosvenor Gallery in 1882, for instance, had also been bought by John Maddocks. Maddocks was a self-made businessman, born in Cheshire in 1842, who left home at the age of sixteen to make his fortune in Manchester. He worked his way through a series of firms involved in the export of cloth, before setting up in Bradford in 1876. He was identified, early in his career, as someone with aesthetic inclinations. A visitor to his offices in the early 1890s remarked upon the quality of the furnishings and oil paintings, and reported their owner as saying that 'he wished he could derive as much pleasure from his business or public life, as he does from the contemplation of his art treasures, or from his intercourse with artists'.[37] So proud was he of his acumen in this regard that, as Chairman of the Free Libraries and Art Museum committee of Bradford local council, he was prepared to lead by example and stage an exhibition of his collection in the town in 1891.[38] Maddocks had made a point, perhaps upon the recommendation of La Thangue, of collecting works by prominent Salon naturalists such as Leon Lhermitte, Dagnan-Bouveret, Emile Claus and Firmin-Girard. He had no works by French Impressionists and no pictures with symbolist or 'idealist' tendencies.

The most popular artist in this and other Bradford collections was James Charles, also a New English exhibitor. In the sale of the remnants of the Maddocks collection in 1910

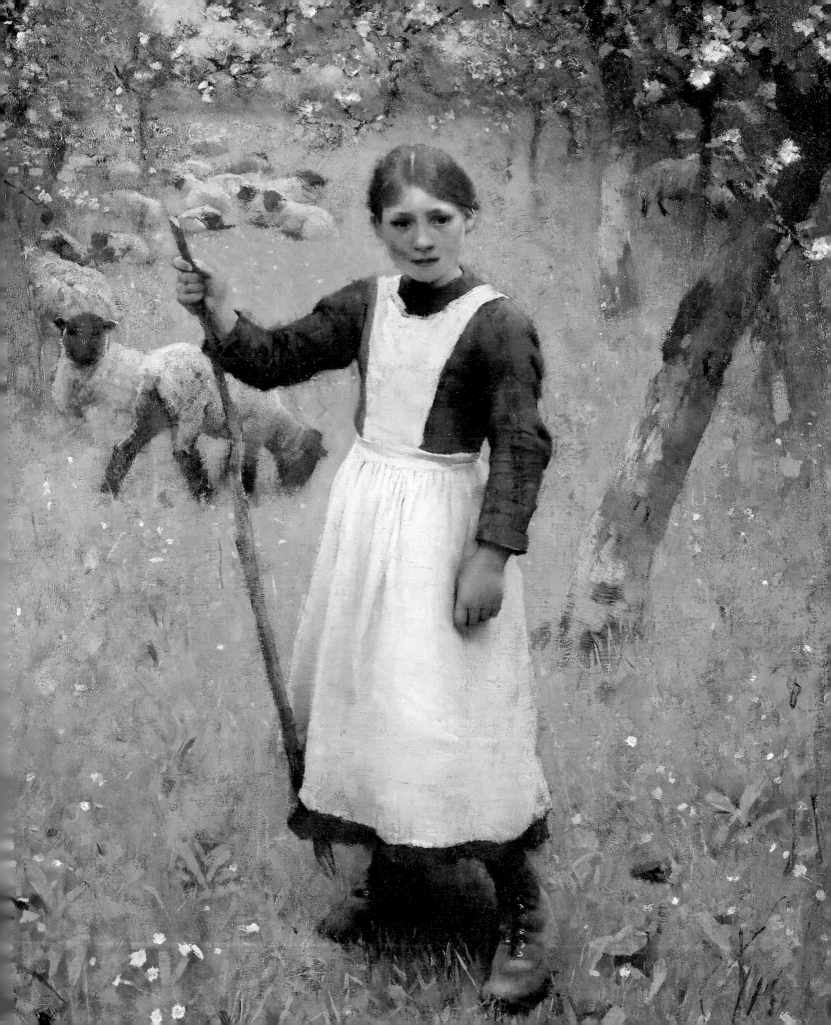

there were over twenty works by Charles.[39] To
some extent, this choice helps to explain the
character of 'democratic' collecting among the
self-made mill-owners of the north of England.
Immune to the temptations of worldly success,
Charles was regarded as austere and ascetic. His
work, by contrast, was gentle in its protrayal of
human character and atmospheric in its treatment
of landscape. T. Martin Wood, writing an appre-
ciation after his death, referred to his 'Whitman-
like qualities of mind ... He seems to enter an
assembly of jaded Londoners as an envoy from
the courts of nature'.[40]

Maddocks was one of a group of wealthy
manufacturers in the Liverpool-Leeds axis who
acquired works by New English artists. The names
Galloway, Smith and Ackroyd frequently recur as
patrons of the new art, although, from Henry
La Thangue's point of view the most important
were the members of the Mitchell family. Here
was a patriarch, Abraham Mitchell, a manufac-
turer of mohair, who was portrayed in 1887 in
his private gallery with a huge magnifying glass,
assessing the merits of a picture (fig 12).

His sons, Tom and Herbert were equally preco-
cious. Tom owned *In the Dauphiné* and lent it to
the Arcadian Art Club, founded in Bradford in
1886, of which La Thangue was President.[41]
This was a more exclusive group than the larger
Bradford Art Guild through which La Thangue,
Charles, Forbes and Fisher had achieved their
initial presence. It constituted La Thangue's
provincial power base and the sales made through
it assured him of a sympathetic hearing in the
early discussions about the direction of the Club.
It may have been this early success which promp-
ted him to attempt a coup at the New English just
as it was squeezing its way into the art calendar.

Even as it hung in the first exhibition of the
Club, *In the Dauphiné* was surrounded with a con-
troversy out of proportion even with its radical
appearance. Its author, insensitive to the problems
of underwriting the exhibition, objected to its appa-
rent exclusivity. Inspired by the efforts of French
artists to organize the annual Salon for themselves,
La Thangue advocated a much larger annual
exhibition, with committees elected by the uni-
versal suffrage of artists, that is 'the votes of every
artist in the British Isles'.[42] He swept along certain
key exhibitors like Clausen and Fred Brown with
his plans, but after two meetings in May 1886 the
Club's backer, the naturally cautious William
James Laidlay, who may have seen himself being
dragged into heavier financial commitments,
threatened resignation on the grounds that he
had agreed to stand guarantor if the Club stuck
together for two years. Finally, at a meeting on 12
June, a modest extension of the membership was

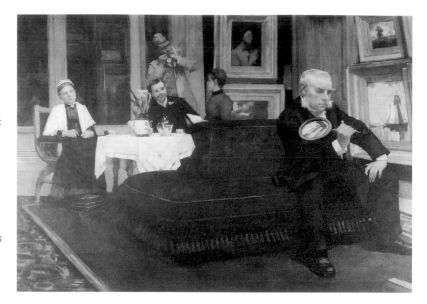

agreed for the following year and, in the words of
Laidlay's letter, 'those who believe in the [La
Thangue's] scheme should manage it'.[43] Thereafter
the debate about a large annual 'universal suffrage'
exhibition fermented inconclusively for two years.
Through the surrounding publicity the francophile
tendencies of modern British art were exposed.
The work itself was dangerous and subversive;
support for it was to be discouraged.

Looking at other genre pictures in the first
New English exhibition, one might be forgiven for
predicting the same fate for Fred Brown. His *Hard
Times* (cat 19) avoids the harshness of Hubert von
Herkomer's painting of the same title, shown at
the Academy in 1885, and Joseph Farquharson's
What Next?, 1883, both of which depicted the life
of indigents.[44] Brown was, however, already
beginning to review his position in relation to
grand narrative painting, and in subsequent years
he turned away from story-telling. He had, as D.S.
MacColl pointed out in *The Magazine of Art* in
1894, 'caught something of an infection of one
of those popular school methods of painting'
associated with the atelier Julian, 'a caricature
of the mannerisms of Bastien-Lepage'.[45]

In its extreme form this painting may be
recognized by a swaggering way of painting
across forms, by a choppy rendering of planes,
and by an attention to values at the expense of
colour ... prosaic and photographic ... it was
cheap way of looking at things, but attractive to
the student because of the ease with which ... a
picture could be constructed.[46]

Brown had successfully shed this practice by
1888, when he exhibited *When the Setting Sun is*

Fig 12 **Henry Herbert La
Thangue**
The Connoisseur 1887
Bradford Art Galleries and
Museums

Low (fig 13), but by that time he was beginning to be absorbed by art education. From his vantage point at the Slade School in the 1890s, he remained opposed to the Royal Academy, refusing until the very end of his career to acknowledge the advances made there by New English fellow-travellers like Clausen.[47] He was, even in 1886, already absorbed in the debates about Impressionism and Whistler, although he was slower than some of his contemporaries to move away from rustic naturalism. As we have seen, joining

Fig 13 **Frederick Brown**
When the Setting Sun is Low
1888
unlocated

the Whistler entourage at that time were Theodore Roussel and Paul Maitland, painters who had never really espoused plein-air naturalism.

As a new exhibitor at the Club in 1887, Roussel created the maximum effect by showing two figure pieces, *The Reading Girl* (cat 184) and the *Portrait of Mortimer Menpes*. These works reveal the extent of the Baker Street debates. The Menpes portrait is a reworking of Whistler's *Leyland*, *Theodore Duret* and *Sarasate* portraits, with a more astringent turquoise background. *The Reading Girl,* despite its Whistlerian decorum and Japanese accoutrements, owes a great deal to Manet's *Olympia*. Unlike *Olympia*, however, a work which derived its force from the quotation of a venerable source in Titian, *The Reading Girl* was determined by notions of taste derived from the Japanese. The kimono she has been wearing is dragged around into the front of the picture, to echo its general diagonal thrust and help establish the space around the figure. This is, however, no simple record of perceptions. It is a tableau vivant illuminated by a strong studio light, to which the artist permits access.[48]

The Japanese elements were ultimately derived from Whistler, but they are incorporated into *The Reading Girl* as little more than signs. The

kimono is a kimono and the girl's hairstyle is vaguely Japanese; for the rest, the picture is conceived according to second generation realist tenets. Whistler, on the other hand, had developed different procedures. He was very proud at this stage of what he termed his 'Japanese method of drawing'. In practice this meant achieving a kind of self-possession analogous to that of the Zen masters. There must be no hesitation when brush and canvas meet. So convincing was Whistler on these points that he prompted Mortimer Menpes to visit Japan in 1887, although this precipitated a rift between

them.[49] Menpes nevertheless took on the role of a populist for *japonisme*, providing the precedent for other, more conventional artist-reporters like Alfred East and Ernest Parton, and the joint visit of the Glasgow School artists George Henry and Edward Atkinson Hornel.[50]

The degree of self-conscious staging in *The Reading Girl* poses questions about direction and orientation. For all its daring, it is a recapitulation. It deals in the currency of an earlier era; it demonstrates that a necessary hurdle has been jumped, but it is one which leads to more complex questions about the

Cat 197 **Walter Richard Sickert**
The Red Shop c.1888
Norfolk Museums Service,
Norwich Castle Museum

manner of representing, rather than about that which was represented. The alternatives were simply contained in naturalistic practices which led, by accumulation, to the finished picture, and Whistlerian practices derived from Japan, by which the finished picture was realized first in the mind of the artist and then, by the most economic means, transferred to the canvas.

There was still a third possibility to be explored – that inherent in Impressionism – of creating the picture by means of many little sensations of colour, like a mosaic. Efforts to imbue what was seen with some sort of superior value were, for the present, doomed to failure. The inconsequentials of everyday living provided sufficient material. An indeterminate Chelsea or Dieppe became the artist's world. Whistler was not remotely interested in local trading conditions, but he passed on to his followers his passion for the abstract patterns made by shopfronts. Sickert's *The Red Shop* (cat 197) would have been impossible without

Whistler's example. Ruminating upon his career, Sickert once remarked to Jacques-Emile Blanche, 'I am perhaps only a rectangular painter'. Menpes took his fascination for laundry shops and street traders to Japan and then on to the souks and bazaars of the rest of the world. He, Roussel and Sickert had become attuned to looking in a particular way, to balancing rectangles intuitively within the rectangle, to the sparing use of local colour, to a range of recognizable harmonies.

But there was more to it than this. Naturalist, Whistlerian and Impressionist practices were controversial solutions to the whole complex question of the relationship between what was seen and the acts the painter performed in making the picture, between looking and the touch of the loaded brush on the canvas or panel. The performance of this innocent eye was, if you believed John Ruskin in 1884, simply a matter of stylistic choice; to be 'dramatically Parisian or decoratively Asiatic' was implicitly a betrayal of Englishness.

Photo-realism and Impressionist paint-marks

Durand-Ruel's exhibition at Dowdeswell's Gallery in 1883 presented a resumé of Monet's recent work. It was updated in the winter of 1887 when, at Whistler's invitation, he showed four pictures at the Society of British Artists.[1] With Monet before them, young British painters had a new exemplar. Monet sprang from a landscape tradition and his lapses into the realm of conceptual painting were, at the age of forty-seven, behind him. Now there was simply the battle to record impressions. Or so it seemed. Yet the thickly impasted surfaces of Monet's work of the mid-1880s, suggested a different kind of depth. In complex overlays and hatch-works of paint there was a density of meaning and intention which more than matched the historical research of the Salon painter. More precisely, in the words of one critic, Monet challenged the 'grey method' of Bastien-Lepage. 'Impressionism' was,

> the natural revolt against this grey painting, an attempt to be more true to the actual appear-ance of nature ... Impressionsim is chiefly remarkable as an attempt to deal frankly with colour, to paint things not as a translation in brown, not as a harmony in grey, but simply as we see them.[2]

Achieving this, however, was not so simple. The urban naturalist, the would-be painter of city life, could not easily operate on the motif. By 1890 Monet had stopped painting figures, whereas for the urban naturalist the human subject domina-ted the scene. If one wanted to paint the music hall or the ballet, one had to go there with nothing more than a notebook and somehow reconstitute the experience later in the studio. Acute observa-tion of the back of the head of the person sitting in the front stalls should reveal age and social standing. In the studio, the pigment flowing from the brush responded to an inner image which might or might not satisfactorily materialize.

Such problems preoccupied young painters, and with these objectives Sickert came to prefer Degas' procedures to those of Whistler and Monet, although his arrival at a characteristic *métier* was inevitably more complicated. At the same time, critics continued to hold up the comparison bet-ween the picture and what the subject looked like in reality as a criterion of judgement. For these the image community, the prevailing visual culture, with its in-built assumptions about what ought to be painted, remained a powerful determinant.

Of the group of radicals, Philip Wilson Steer

had been badly treated at the first New English exhibition. *Andante* (fig 14), a picture of a musical trio in a middle class home, had been skied. A study and the reproduction of the artist's own illustration of it in the *Pall Mall Gazette 'Extra'* are all that remain.[3] There is no reason to suppose that the picture was other than an exercise in the current idiom of Gervex, Duez and Tissot. For the following year Steer abandoned the bourgeois interior, although he remained interested in implied narrative, as *The Bridge,* shown at the Grosvenor Gallery in 1887, illustrates. For the New English he selected *On the Pierhead* and *Chatterboxes,* works which, like *The Bridge,* derived from his recent visit to Walberswick. On the face of it, given the Newlyn painters' proclivity for painting women looking anxiously out to sea, Steer's subject matter may not be surprising.

Nevertheless, it cannot have escaped attention that the whole principle behind Steer's approach was at variance with that of the Newlyn painters. He had moved to a more Whistlerian handling, employing thin washes of oil paint. He was interested in light effects, particularly those in which the figure is seen against a strong illum-ination. His girls on beaches and pierheads were not poor fishermen's daughters, but holiday-makers who had arrived by train.

The complexity of Steer's work in these years is almost unfathomable. Within a couple of years he ran through the gamut from Whistler to Monet, Pissarro and neo-Impressionism, in an effort to find his own coherent manner. He was affected by notions of the painting of modern life, an

Fig 14 **Philip Wilson Steer**
Line illustration of *Andante*
1886, destroyed

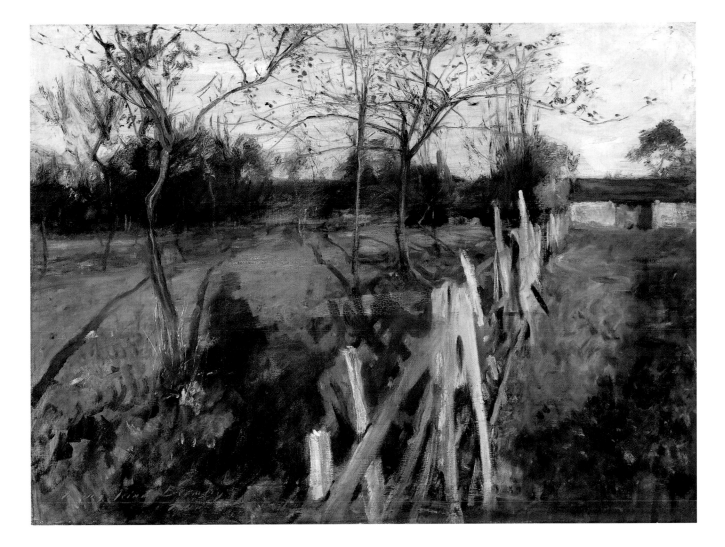

elusive set of values and assumptions which ebbed and flowed through his thoughts. An important catalyst in this was John Singer Sargent. Here apparently was a painter who was fleeing from one kind of 'French' reputation to cultivate another from the comparative safety of London. Sargent moved from Paris in the wake of the scandal which had greeted the exhibition of the portrait of *Mme Gautreau* at the Salon of 1884.[4] For the first New English Sargent produced a portrait of *Mrs Frederick Barnard*, the wife of the illustrator, and an unidentified *Study*, which *The Times* described as 'Impressionist'.[5] The degree to which this complied with current accepted understandings of the term cannot be affirmed. A picture like *Home Fields* (cat 189), for instance, might have been referred to in this way in the mid-1880s. Over the twelve months following the first New English exhibition, Sargent moved closer to his French mentor. His temporary withdrawal from portraiture may have had something to do with the reception of *The Misses*

Vickers, voted by visitors to the Royal Academy 'Worst Picture of the Year'.[6] In his landscapes Sargent left unmodulated touches of paint. He sought to derange his visual language at a time when all but Steer were making strident efforts to regulate theirs, either in the manner of the atelier *ébauche* with choppy angular strokes or, in the manner of Whistler, blotting the canvas or panel to remove excessive pigment.[7]

The process began at Broadway in Worcestershire, among a colony of American painters and illustrators regarded by Henry James as 'the perfection of the old English rural tradition'.[8] With the single exception of a painting of resting labourers, Sargent side-stepped the English rural tradition.[9] Moving on to Pangbourne and North Littleton, he built up studies for a large canvas which was to take its title from the refrain of a popular song, *Carnation, Lily, Lily, Rose* (cat 190).[10] The idea for the picture may well have derived from *Garden Study of the Vickers Children* (cat 188), a large sketch produced in 1884 when he was

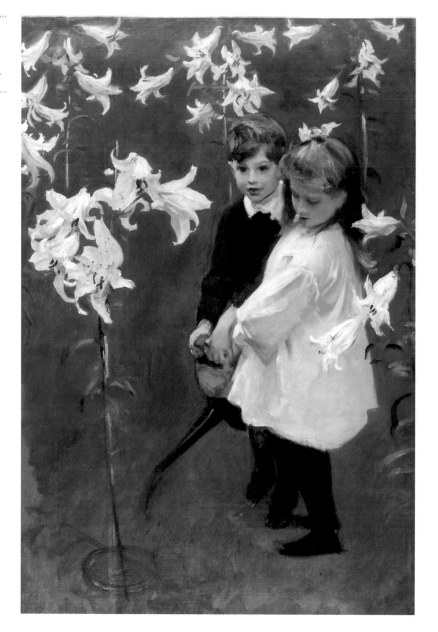

painting the portrait of Mrs Vickers. For
Carnation, Lily, Lily, Rose, Polly and Dorothy
Barnard were his models. Edmund Gosse recalled
the antics as Sargent frenetically ran back and
forth like a wagtail, placing his dabs and spots of
paint before the light faded. The degree of contri-
vance in the completion of the picture, its scale
and its consignment to the less than radical exhi-
biting forum of the Royal Academy, all qualify it
for the odd category of Salon Impressionism. For
the critic Roger Fry much of its authenticity was
removed in the process. It seemed, he declared,
'a new revelation of what colour could be and
what painting might attempt, and how it could be
at once decorative and realistic ... what thrilled us
all then was the fact that this picture was the first

feeble echo which came across the channel of
what Manet and his friends had been doing with a
far different intensity for ten years or more'.[11]
Fry's snootiness is a reflection of an aesthetic
superiority felt more by his Post-Impressionist
generation than by the painting's contemporaries
in 1887. The painting was surely enough to
provoke a reaction in one important Academy
exhibitor. 'The only thing that one can care about
is Sargent's picture', was Steer's response.[12]

 These works reveal the early attempts in
England to digest Monet's working methods,
which formed the basis of Steer's solidarity with
Sargent. Sargent had met Monet in 1876 at the
second Impressionist Exhibition.[13] They exhibited
together in 1883 at the Galerie Georges Petit in

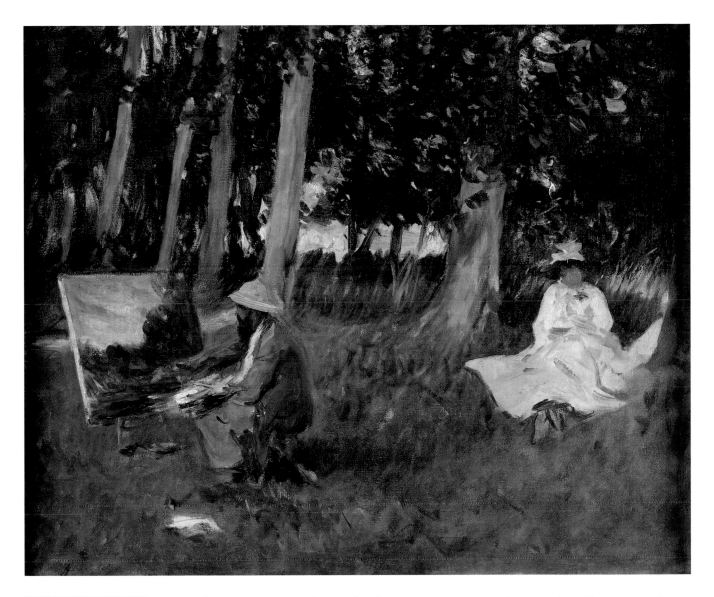

Paris. After Sargent's removal to London, he retained contact. He may have admired Monet's contributions to the Society of British Artists under Whistler's Presidency and around this time began to collect pictures by him.[14] He purchased Monet's *Rock at Treport* and wrote enthusiastically to its maker: 'I can hardly tear myself away from your exquisite painting ... I could spend hours looking at it in a state of stunned delight, or rapture, if that is a better word'.[15] In the summer of 1887 he visited Giverny for what was to be a revelatory trip. It was there he sketched *Claude Monet painting at the Edge of a Wood* (cat 191), a work which remained in his studio until his death and which Richard Ormond has described as 'a statement of artistic faith'.[16] Monet recalled Sargent's steep learning curve in these encounters. He remarked to René Gimpel, 'One day the American painter

Sargent came here to paint with me. I gave him my colours and he wanted black, and I told him: "But I haven't any." "Then I can't paint" he cried and added, "How do you do it?"'[17]

Sargent applied the lessons of Giverny to the upper reaches of the Thames. In the summer of 1888 there were seemingly endless boating parties and sunlit riverbank walks. He deployed his most vivid palette in support of these experiences, although he found it difficult to deny himself the use of black.

The opportunity for the public to judge Sargent's proximity to Monet was provided in the spring of 1889 when the New English Art Club coincided with the Monet exhibition at the Goupil Gallery. The principal characteristic of Monet's work was the daring use of colour; as *The Times* noted, he was painting 'in two colours, orange and purple'.[18] Sargent, exhibiting *A Morning Walk* (fig

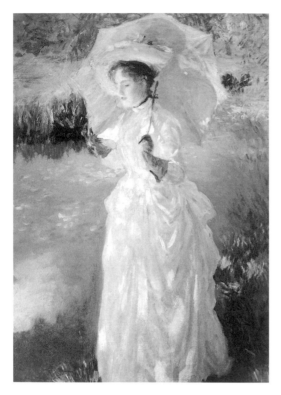

15) and *St Martin's Summer* was also deploying complementary colour contrasts – touches of blue and mauve in the shadows to intensify the brilliant dabs of white and cream in the dresses. Knowledge of Monet's celebrated sequence of *essaies de figure en plein air* may be assumed. The splintering of light over the passing figure, violet shadows and warm highlights had, by 1890, become the signal of Impressionism. As a pupil of Carolus-Duran, Sargent never adopted the square-brush plein-airism of his contemporaries. His handling was already more responsive and the process which led from the sketch to the finished work was more organic. At Broadway, Fladbury and Calcot, however, he found the creative milieu which others had found in Brittany and Grez. In *The Boating Party* (cat 193) and *Dennis Miller Bunker at Calcot* art and life seem to move in apparent harmony. Looking at *Paul Helleu sketching with his Wife, Alice,* and comparing this with Helleu's own sketches done at the time, there is an evident *jeu d'esprit,* a delight in living, in apparently seeing the world for the first time. This kind of challenge primed Sargent for the studio, and the serious commercial business of painting portraits.

By the time Sargent was retrenching, Steer was broadening his horizons. He turned over one of his pierhead sketches during the autumn of 1887 and began to experiment in divisionism, the most advanced form of Impressionism available. This

was elaborated in a large canvas which he may have been working on for several years, and which was intended for the New English in the following year. Painting *A Summer's Evening* (fig 16) he was aware of the changes which had taken place in Salon naturalism in recent years. He had seen the recent work of William Stott of Oldham and Alexander Harrison, both of whom had produced large canvases of groups of nudes. Stott's *A Summer's Day* (cat 226) 1886, shown in the winter exhibition of the Society of British Artists, was a riposte to Harrison's *Bords de Mer* at the previous Salon. The smooth handling of the figures, the wide expanse of sand, waveless sea and cloudless sky painted in unbroken bands of colour, project the simple Whistlerian divisions of the field of vision. They are almost an exemplification of the breadth and simplicity advocated by the 'followers' around 1885. Harrison's Salon painting of 1886 and New English exhibit of 1887, *En Arcadie* was somewhat more challenging. Here was a woodland scene, ostensibly painted by a river in Brittany, depicting four female nudes. Harrison tackled the problem of light filtering through the trees and falling irregularly upon the figures. More particularly, and this is clear from the oil sketch, they are seen in *contre jour,* almost disappearing into and out of the background. However, leaving aside these predictable observations, it is clear that an extraordinary convolution has occurred. Stott's naked boys are acceptable; Harrison's naked females, naturalistically portrayed 'in arcadia', verge on improbability. The attempt to re-engage with conceptual painting, seen elsewhere in Whistler's unsuccessful *Harmony in Blue and Gold*, at this moment had a significant effect upon Philip Wilson Steer.

Steer was interested in the struggles of his friend and fellow Walberswickian, Walter Osborne who in 1887 showed *October by the Sea* at

Fig 15 **John Singer Sargent**
A Morning Walk 1888
Private Collection

Fig 16 **Philip Wilson Steer**
A Summer's Evening 1888
Private Collection

Cat 193 **John Singer Sargent**
The Boating Party c.1889
Museum of Art, Rhode Island
School of Design, gift of Mrs
Houghton P. Metcalf in
memory of her husband,
Houghton P. Metcalf, 78-086

the New English. Although apparently painted two
years earlier, while consorting with other erst-
while followers of Bastien-Lepage, this canvas
tackled the problem of painting the texture of the
shingly beach in a way which would have
appealed to Steer. Over the winter, *A Summer's
Evening* began to look more and more like a Salon
machine. It was not, and never could be, a record
of impressions even though it might superficially
look like one. Its subject matter, more related to
the French tradition of *poesie* painting, of an
idyllic arcadia of sensual delight, was also a way of
declaring no subject matter – no narrative, no

contemporary Kodak picturing, no symbolic
theme beyond the most general notion of sensual
delight. There were obvious internal contradic-
tions, but in expressing them in this way the
painter effectively set a new agenda for the New
English, whose less committed Newlyn members
were increasingly disaffected. He reined himself
back in subsequent more orthodox impressionist
works like *Summer at Cowes, Knucklebones* (cat
210) and *Walberswick Beach,* but the direction
was nevertheless clear.

Steer was not completely isolated in these
endeavours. The radicalism of the Society of

British Artists had provided a launching pad, although by 1888 he, with the other two dozen progressive painters of the Society, was disenfranchised. With the debate about the integrity of the national school still raging, he was obliged to resign.[19] One of his co-exhibitors, Walter Sickert, was also made temporarily homeless, and it was apparent that the only engine of change left to them was the New English Art Club.

Sickert had behind him the formative experience of a major naturalist painter associated with the Impressionists. He now augmented the street scenes of his travels with his own café and music hall subjects.[20] In the spring of 1887 he had exhibited the *Lion Comique* at the British Artists, a work which presents the essential ingredients of a café-concert by Degas in simplified form.[21] The bustling activity of Degas, and Sickert's own later treatment of the theme, is reduced to a contrast between the animated performer on stage and the lone violin soloist who in passive concentration waits for his cue. Sickert toured all the possible venues – Bottings Marylebone Music Hall, Collins', Islington Green, Gatti's Hungerford Palace of Varieties – for snapshot sketches and notes which were to be translated into paintings, with more or less success. The method was important; it obliged Sickert to work from drawings and removed the trap into which Whistler had fallen, of seeing the small panel sketch as an end in itself.[22]

There were, nevertheless, genuine difficulties in translating furtive jottings on to canvas. In 1887 it was not possible to spring fully armed into the exhibiting arena with pictures equivalent to those of Degas and of the type which Sickert was beginning to acquire.[23] The sketches reveal his colossal effort to understand what was happening before his eyes in terms of spatial recession and light effects. Perhaps, as might befit a young painter, Sickert was too doctrinaire about this aspect of his practice. The tendency in pictures such as *Gatti's Hungerford Palace of Varieties: Second Turn of Miss Katie Lawrence* (cat 198), was to centralize the composition with an almost glowing centre-stage performer. The grand ideas which lay behind Degas' complicated view of humanity could not yet be addressed, even though from an anthropological and aesthetic point of view the depiction of artifical urban exchanges was wholly preferable to the despised world of rural sincerity perpetuated by the followers of J.F. Millet.

By now the sporadic discussions about Impressionism were beginning to take more tangible form. Bourgeois naturalism, as distinct from what has been termed 'Victorian Social Realism' was now more clearly evident.[24] Questions of style were highly relevant, but were being answered in different ways. The tensions which derived from the limitiations of rural or urban subject matter were vividly apparent. For Monet at Giverny the act of painting on the motif demanded an hermetic concentration. For Degas it was a matter of studio rituals. As he told George Moore, 'It is strange, for I assure you no art was ever less spontaneous than mine. What I do is the result of reflection and study of the great masters; of inspiration, spontaneity ... I know nothing'.[25] Such naturalist science, observation and reflection, led to the precision of which Edmond Duranty had written approvingly in *La Nouvelle Peinture* (1876): 'A back should reveal temperament, age and social position, a pair of hands should reveal the magistrate or the merchant, and a gesture should reveal an entire range of feelings'.[26] Sickert's, Starr's and Lucien Pissarro's backviews of the spectators in cafés, buses and music halls were variations on Duranty's thesis. In the case of Starr's *The City Atlas* (cat 208), the scumbled hatching and redrawing of the figure suggest efforts at pulling together the variety of Impressionist surface techniques.[27]

It was nevertheless apparent that Monet's technique was intrinsic to his subject matter. In the mass of dabs and spots of paint in Steer's *Knucklebones* (cat 210), the indolent offspring of the Victorian bourgeoisie could express little in the way of psychological intensity. There was a world, however, in which some sense of a life beyond appearances was apparent. This was in the sunlit bower portrayed by Sargent.

With the reassertion of traditional views in the British Artists, new alignments were necessary. The relationship between Whistler's followers, the New English Art Club and Impressionism was blurred. George Bernard Shaw, writing in the *World*, confirms this: 'Many art critics who passed from the exhibition at the Dudley Gallery of the New Art Club [a new organization of painters, most of whom had been influenced by the Impressionists] to that of the British Artists must have thought that it was the first of April, and that perhaps these 'impressionist' pictures would be spirited away during the night and replaced by more sensible ones'.[28] Fred Brown records that at this time Sickert was having regular meetings to establish the clique of erstwhile Whistler followers who would seek to dominate the New English. He wrote to Jacques-Emile Blanche recognizing that he was already being seen as a radical by some of the more conservative New English members:

Our friends, ie the impressionist nucleus in the NEAC, have all advised that *my name must not this year appear* much in proposing or seconding people, as my work is said to be most

unpopular with a dull but powerful section of the NEAC, the people whose touch is square, and who all paint alike and take their genealogy, I believe, from JP Laurens.[29]

It was not so much that Sickert's coterie was becoming more daring as that the Newlyn artists and La Thangue were now beginning to produce *machines de salon*, the only true place for which was the Academy. The watershed came with Frank Bramley's *A Hopeless Dawn*, 1888, a work which harnessed naturalist techniques to Victorian sentiment. This was a long way from the city-based subject matter of Sickert and Starr. The Impressionist nucleus may enter the New English, but it would still be necessary for it to be distinctly seen.

At this time, however, the fertility of Sickert's thinking outstripped that of his painting. He may have been prompted in his art politics by the presence of other tendencies. There was, for instance, a growing awareness of painters in Glasgow committed to the modern spectacle. They had begun to infiltrate the New English Art Club in 1887, and although they had been initially committed to kailyard subjects of a rustic natu-

ralist type, their range of subject matter had begun to broaden in interesting ways. George Henry's *River Landscape by Moonlight*, 1887, (fig 17) embraces the Whistlerian aesthetic while simultaneously revealing undeniable consonances with the early Monet.[30] A number of other notable canvases had extended their range in depicting the leisure pursuits of the moneyed middle classes. William Kennedy's military pictures of the late 1880s and his extraordinary *Stirling Station*, 1887 (cat 106), provided glimpses of contemporary life, while the domestic environment is recorded in a sequence of pastels by James Guthrie beginning in 1888.[31] The first and most important of these works, however, was Lavery's *The Tennis Party*, 1885.[32] An indication of his ambitions for this work is found in the fact that Lavery first sent it to the Royal Academy before showing it in Glasgow, his home territory. He also sent it to the Salon in 1888, where it caught the attention of George Moore. No work of the mid-1880s more succinctly encapsulates Degas' dictum that one gave the impression of the true by means of the false. Lavery trained himself to paint the picture. He studied figures in movement, he sought complete naturalism.[33] It was, however, the 'fine

harmony', the 'exquisite delicacy', the 'softness and superiority of tone' which commended the work to critics and fellow artists alike.

Beside this, *Stirling Station* is a work in a minor key, but it is equally important. The seeming randomness of Kennedy's crowd disembarking from the train gives an air of circumstancial authenticity to a picture which is almost as tightly composed as *The Tennis Party*. A small dog in the foreground leads the eye around the crowd and off to the departing train. The late afternoon light gives a unity of colour and tone to the proceedings.

West of Scotland painters such as these asserted their presence as a significant force at the Glasgow International Exhibition of 1888. Critical reviews devoted to their work were more than chauvinistic and the substantial display of foreign, particularly French, pictures in the exhibition made their lineage clear. Lavery painted a sequence of brilliant sketches of the temporary buildings erected to house the International, and the crowds attending it. Again, these pictures have an air of improvisation, but the training in spontaneous composing and the overall management of colour and tone reveal an artist who was now fully equiped to record 'impressions'. So important had the Glasgow group become by 1890 that they were accorded pride of place at what was to be the last Grosvenor Gallery exhibition in London. Thereafter, the rise to international recognition was meteoric. They were taken *en masse* and given a special room at the forthcoming Glaspalast exhibition in Munich; they were shown at the Chicago World's Fair; they were given good places in the Société Nationale Salons of the 1890s in which they were hailed as Impressionists; they became the mainstay of the International Society of Sculptors, Painters and Gravers.

Seeing such phenomena may well have prompted Sickert's desire to consolidate a group of like-minded individuals as distinctively 'London' Impressionists'. On 2 December 1889 *The Times* announced 'A collection of 70 Paintings in oil by a group of London Impressionists' at the Goupil Gallery. Criteria for inclusion were not systematically applied since relatively few of the works shown represented London, although all the exhibitors might have had London addresses. The artists included also diplayed differing degrees of understanding of Impressionism, and in the cases of the principal exhibitors, Steer and Sickert, this was both verbal and visual. Although Sickert was extremely literate and had been approached to write criticism for the *New York Herald*, he was compelled to resort to a vague language of qualities in defining London Impressionism in the catalogue. Nevertheless his perception of the current state of British art is interesting. In 1889

the biggest danger lay not so much with the Glasgow School painters who were all of the same generation, as with the followers of William Morris who, through the Century Guild and the newly formed Arts and Crafts Exhibition Society, were in danger of wall-papering over that classical simplicity in which a follower of Whistler, such as himself, had heavily invested. It was a matter of philosophy. Sickert had first encountered Degas' *Le Baisser du rideau*, a pastel of two dancers, in company with Burne-Jones who was cross with him for admiring 'a fag end of a ballet'.[34]

Impressionism was also in danger of being confused with realism – although here the plot thickens. What did Sickert mean by realism? Some painters who have been described as realists or naturalists Sickert valued highly, whereas of others he was seriously disapproving. Degas, for instance, in the 1870s at least thought of himself as a realist or naturalist. Yet there were those, like the Newlyn painters, who apparently had for their only goal fidelity to the facts of appearances; these increasingly popular Academy 'realists' are likely to be the ones he was thinking of. Impressionism was thus defined:

> Essentially and firstly it is not realism. It has no wish to record anything merely because it exists ... it accepts, as the aim of the picture, what Edgar Allan Poe asserts to be the sole legitimate province of the poem, beauty. It is ... strong in the belief that for those who live in the most wonderful city in the world, the most fruitful course of study lies in the persistent effort to render the magic and poetry which they daily see around them.[35]

Sickert had a fuller awareness of the issues than this suggests. He knew about the debates about violet shadows; he wanted to convey his respect for Degas, 'the greatest draughtsman since the time of Holbein'; he retained residual loyalty to Whistler whose theory increasingly emphasised tone over

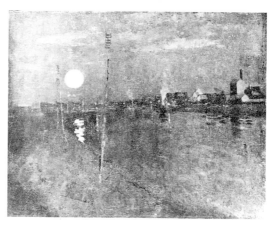

Fig 17 **George Henry**
River Landscape by Moonlight
1887
Hunterian Art Gallery,
University of Glasgow

colour, who disliked landscape painting and who was privately sceptical about Impressionism.[36] The complexities of being a new player in an old game were less pressing two years later, when he provided a clearer exposition of the faults of modern realism as he saw them.[37] In the Paris Exposition Universelle of 1889, which he visited, it was possible to compare the work of Bastien-Lepage with that of Millet and Manet, and to see clearly the degree to which painting had become subservient to the mechanical processes of photography. The 'modern photo-realists' were interchangable. Their work was analogous to the stenographic record of facts, language used for pedestrian reporting rather than for literature. It had led to a 'radical misconception of the nature and function of art', namely 'that if photography, instead of yielding little proofs on paper in black and white, could yield large proofs on canvas in oils, the occupation of the painter would be gone'.[38]

It was clear from the artist's point of view that painting had to be more than photography: from the photographer's point of view, however, the medium could not be simply itself, a mechanical process, it had to move closer to art. These aspirations expressed themselves in the contemporary debate about photography as a Fine Art. Emerson, who consorted as much with painters as with photographers, was familiar with the arguments about naturalism and his theoretical exposition of the tendency, signalled in his lecture at the Camera Club in 1886, dominates his treatise on *Naturalistic Photography for Students of the Art*, (1889).[39] In simple terms, Emerson was opposed to the complicated combination prints of Henry Peach Robinson, and wished to see greater spontaneity and differential focusing to give a more authentic, and ultimately naturalistic, effect.[40]

Emerson was unprepared for the logic which led to these technical innovations becoming a kind of Impressionism in photography. Although he dramatically retracted in 1890, other photographers such as George Davison were running with

the idea.[41] In the preceding year, in a lecture to the Royal Society of Arts, Davison described 'Impressionism in Photography', recapping Emerson's ideas.[42] Art conventions obscured truth to nature and the Impressionists had brought back into art the true appreciation of natural beauty. Certain subjects demanded certain characteristic techniques, and differential focussing was an essential tool in the recreation of the 'effect' of nature. To demonstrate his point he exhibited *The Onion Field (An Old Farmstead)* (cat 51) at the Photographic Society's Annual Exhibiton in 1890. This print was made by using a pin-hole lense. The intentional absence of sharp focus gives the effect of someone opening their eyes to the natural world. Davison immediately became the new rallying point for other photographers who saw their activity as an art form.

So different were their works that they followed the example of the New English painters in forming a secessionist society in 1892, known as 'The Linked Ring'. Its photographic Salons held at the Dudley Gallery aped Whistlerian aesthetics in that they were conducted with taste and hung with a velarium.[43] Their contents, balancing British photographs with those drawn from other similar foreign photo-secessions, reprised the rural and urban subject matter of painting and both, at a basic level, were preoccupied with demonstrating how human beings perceive the world. There were communal debates about what was going on in this process. In 1896 George Thomson, the London Impressionist, interviewed Henry Herbert La Thangue for *The Studio*. Questions of signification, 'sentiment' and perception arose, and La Thangue stated his belief that 'the student should learn to record his impressions with rapidity'. He held to the view that we all see the same thing.

> But some say that we do not see alike – even optically. As to that, I should advise the student to look upon the statement as being only very partially true. If a dozen of us painters produce studies from the same model, differing much from one another, I think it is because our expression is faulty. Our vision is, I think, very nearly alike, but alas the gift of expression in paint is given to so few! ... A dozen studies of the same object would vary, doubtless. But still, I think, we see it nearly alike. But how few of us can reproduce it beautifully? The talent to use paint in such a manner as will express the truth and beauty of colour is very rare indeed. You will find, moreover, almost absolute unanimity of appreciation among students or painters as to the one who has rendered the colour with the greatest truth.[44]

La Thangue clung to the idea, dear to the pupils of Gérôme, that the mechanism of the eye, like the mechanism of the camera, provides an absolute truth.[45] Photography and painting should tell us what we all see and this was their basic starting point. It was the fundamental principle of art education that the good teacher should be able to explain what the student was actually seeing and assist with the development of skill in representation. The basic assumption was that master and pupil were both seeing the same thing. Paradoxically, the closer a painter's work came to embodying the emerging consensus on this point, the more likely it was to be open to criticism from some quarters. When he tried to portray dramatic figure movement, a country woman breaking a stick, in *An Autumn Morning* (fig 18) in 1897, La Thangue found himself castigated by *The Speaker*: 'Even Mr. La Thangue's mastery does not convince me of the fitness for pictorial treatment of a moment which might more properly rank as one of a series of images in a kinetoscope'.[46] But what was fit for pictorial treatment? Was the criticism to do with the subject matter or the method, 'a kinetoscope', or both? Urban, from Sickert's point of view, was better than rural if one wished to avoid the clawing associations of a false arcadia. The more mechanical the method, the more like a sharp focus photograph of the earlier composite Henry Peach Robinson type. Sharp observation and tight definition in turn led Sickert to fly off back to the language of magic, 'to life and spirit, light and air'.[47]

Modern Life

For artists in France the phrase *'la moderne'* had rich associations. It meant more than looking out upon the present, upon the urban landscape, celebrating the worker-hero and documenting the sprawl of the suburbs. It signified a commitment to the world of fashion, to the depiction of delicate and sophisticated social exchange which preoccupied the eighteenth century *petits-maîtres*. It was in these terms that George Mooore lauded the work of Mark Fisher and Francis James.[1] In the wake of the London Impressionist exhibition it seemed unlikely that works of this type could emerge for a city which did not have its own fashionable café society. Sickert increasingly found that this world could be more easily invented at Dieppe where, in 1893, in front of the blank facade of l'Hôtel Royal he set an extraordinary caprice evoking a bygone world of courtly crinolines (cat 201).

By 1890, however, there were discerning amateurs who were developing a taste for aspects of *la moderne*. Sickert's entourage brought with it other members of the Cobden family, the Fisher Unwins and their friends. T. Cyprian Williams, Brandon Thomas and, a little later, Hugh Hammersley and Augustus Daniel, a compliant group with diverse financial interests, supported the direction of the New English along these loosely Impressionist lines. In 1890 Steer painted the portrait of Mrs Cyprian Williams (fig 19); Starr that of Mrs Brandon Thomas. The role of the female arbiters of taste remains to be explored. The battle was taken into the camp of the Art Workers' Guild in 1891 when Steer addressed the audience on 'Impressionism in Art'.[2]

The group was now being augmented by younger painters drawn mostly from Fred Brown's classes at the Royal Architectural Museum, Westminster, under the auspices of the Westminster School of Art. In the circle associated with Brown were students like Arthur Studd, William Rothenstein, Henry Tonks, David Muirhead, Fred Pegram, Charles Wellington Furse, William James Yule, Alfred Thornton, D.S. MacColl and Hugh Bellingham-Smith.[3] The Scots members of this group came from a different educational tradition; they used 'Scots' colour and practiced 'Orchardsonian' drawing which Brown gradually accepted.[4] His pre-eminence in the early 1890s was attested by Furse who favourably compared the work at Westminster with that of the Slade School, the Royal Academy Schools and

Cat 201 **Walter Richard Sickert**
l'Hôtel Royal, Dieppe c.1900-01
Ferens Art Gallery, Hull City
Museums, Art Galleries and
Archives

the Paris ateliers. Brown encouraged 'great simplicity' in line drawing rather than 'tickling' to a level of finish something which was flawed to begin with. He wanted robust fullness of colour rather than timid tonalities.[5]

Steer and Sickert, who had already become guides and mentors, convened metaphorically in the London street with members of the circle in Rothenstein's *Group Portrait* (fig 20). In every case these artists had been to Paris or had toured in Normandy or Brittany. Their experiences of France occurred at a time when plein-air painting no longer reigned supreme and when, as a result of active promotion, Impressionist landscape painting was gaining acceptance in London and Paris. Sickert's drive, however, to create a London-based group addressing London subject matter, was hanging in the air in the greetings being exchanged in *Group Portrait*. One of its protagonists summed up the state of affairs. 'The average layman or academician', wrote Furse in 1892,

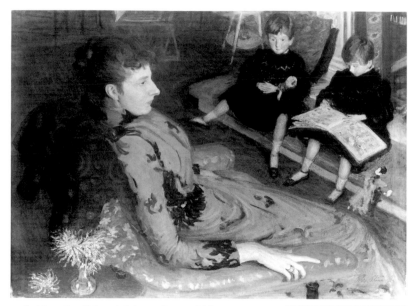

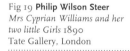

Fig 19 **Philip Wilson Steer**
Mrs Cyprian Williams and her two little Girls 1890
Tate Gallery, London

> is fond of picturing to himself the Impressionist as a young man, eager for a place in the vanguard of the movement, whose maxim is to find out what people most dislike and then to perpetuate it, who uses the public indignation and disgust as stepping stones to noteriety, choosing as his subjects the every-day vulgarities that surround him, provided they are sufficiently repulsive and ugly – ballet dancers, for instance, with their dreadfully short skirts and dubious morals; street scenes, hideous with top hat and funereal frock coats; London begrimed and sordid; the ocean as it appears when crossing the Channel in choppy weather, and nature generally suffering from internal disorders and so unlike herself as to be barely recognizable, and painting with lumps of neat colour and trowelfuls of paint, or else with a genial but aimless scratching and scrawling of a particularly bristly and over-sized brush on the roughest sail-cloth his colourman can provide him with.[6]

There were, following Sickert's lead in the London Impressionists exhibition catalogue, some serious efforts to find past precedents for contemporary practice. Steer quoted Reynolds and claimed that Impressionism was 'of no country and of no period', but had been 'from the beginning'.[7] There was nevertheless enough in this to appeal to the young Lucien Pissarro, who was looking for allies in London. Three years earlier, while on a visit to Paris, Pissarro had produced a number of drawings and paintings of café-concerts to which he applied divisionist techniques.[8] It is not surprising that Steer was the

only New English exhibitor who could be wholeheartedly commended to his father.[9]

The field was open for elaborate self-justification and special pleading, a role adopted by a few friendly critics who joined George Moore. The most important of these was MacColl, one of Brown's students who, in 1890, was appointed art critic of *The Spectator*. He tackled the New English at a time when there was a concerted effort to assimilate Degas and Monet around the London Impressionist nucleus.[10] MacColl was also not averse to quoting Reynolds, although he swiftly

Fig 20 **William Rothenstein**
Group Portrait 1893
unlocated, photo Sotheby's

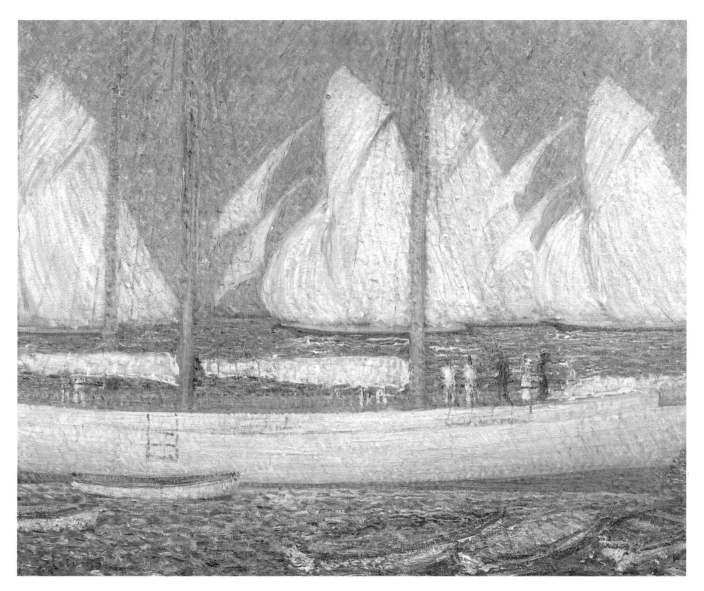

recognized that Turner was a more potent exemplar, and his critical stance was sharpened by the importation into the New English of Hercules Brabazon Brabazon in the winter of 1891. For forty years Brabazon Brabazon had been producing, on his extensive travels, watercolours of extraordinary freedom and freshness. When he staged his first solo exhibition in the autumn of 1892, at the age of seventy-one, MacColl and Moore hailed him as a new discovery and the lost successor of Turner.[11]

The link between Turner and the Impressionist painters was now a commonplace of art criticism confirmed, no less, by Camille Pissarro who in 1892 was quoted in *The Artist* as saying, 'It seems to me that we are descended from the English Turner. He was perhaps the first to make his colours shine with natural brilliancy. There is much for us to learn in the English School'.[12] Within a short time Brabazon Brabazon, now

ranked with Whistler, had become the acceptable face of Impressionism.[13]

The relationship of Constable and Turner to the emergent Impressionism of the 1890s is rich and fascinating. By the time of Steer's one man exhibition in 1894 the composite picture had changed. Steer was observed by George Moore to have transcended his mentors. *A Procession of Yachts, Cowes* (cat 215) was seen to 'owe something to Whistler ... but the debt is not distressing', a remark which, given the rich surface texture of the picture, seems extraordinary.[14] Elsewhere Steer's Impressionism had acquired overtones of sentiment with which Moore was in complete accord. *Children paddling, Walberswick* (cat 216) for instance, contained a 'happy opium blue, the blue of oblivion ... Happy sensations of daylight; a flower-like afternoon; little children paddling; the world is behind them

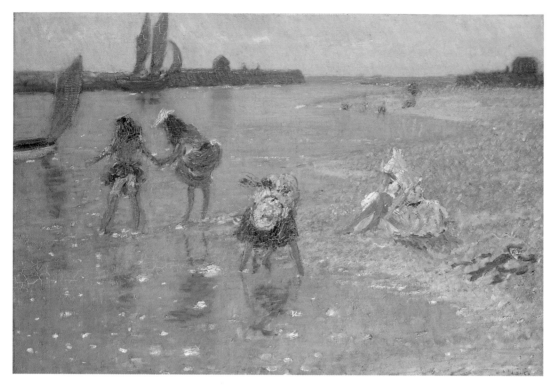

too; they are as flowers, they are conscious only of the benedictive influences of sand, sea and sky'.[15] Steer had created an atmospheric envelope for lost youthful innocence. A more striking example of this, unveiled in 1894, was *Girls running, Walberswick Pier* (cat 217), a work in which weightless butterfly figures glide in unison towards the spectator. MacColl was somewhat fazed by the steep perspective of the pier, which seems to throw the background figures forward towards the spectator and, in turn, to cause the foreground figures to levitate, creating an unnatural effect.[16] In later years this compression of the picture space was interpreted positively. It created an aura of 'visionary splendour'.[17]

In the same year Sickert showed *l'Hôtel Royal, Dieppe* at the New English Art Club. The picture was 'unquestionably the most interesting ... among the most purely impressionistic paintings', according to *The Saturday Review*.[18] It followed the painter's extraordinary experiment in which he painted crinoline doll-like figures in a bizarre evocation of an earlier age, for which he had been censured by critics (fig 21).[19] C.J. Holmes, who met him slightly later at The Vale, described him as 'boyish, clean-shaven, aureoled with a mass of blond hair, playing with a crinolined doll and flashing out now and then with some lively repartee'.[20] This subject matter in 1893-94 was particularly fascinating in the opportunity it afforded for different types of treatment. At first the dull facade acted as a backdrop, in front of which figures might perform.

Later, its stark angularity appealed in the evening light. Finally, later in the decade, it was observed from the side, across the flowerbeds. Sickert was struggling with atmospheric effects *en plein air* in 1894. Blanche recalled him beating off 'the rag-tag and bob-tail who were making fun of his painting' as he painted on into the evening light.[21] Newly inspired perhaps by Monet, he extended his pre-occupation with these effects on his first visit to Venice the following year.[22]

When Sickert's 1894 version of *l'Hôtel Royal, Dieppe* was shown at the New English, D.S.

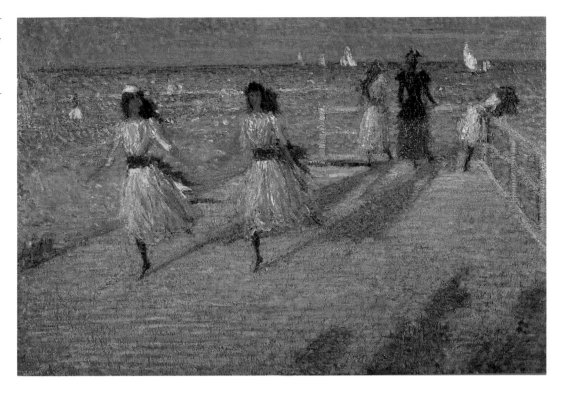

MacColl took the opportunity to deliberate upon the current status of Impressionism in England. 'The term impressionism', he wrote,

> like the term Pre-Raphaelitism has come to be applied to principles of art differing in many respects from those to which it was originally and more properly given. The word is now commonly associated with certain formulated methods, dealing with problems of tone and colour, which are eminently fitted to record some transitory impression of the moment. That the impression to be recorded should be distinct and vivid is, perhaps, even more necessary to the successful practice of these methods than other considerations of a purely technical kind.[23]

Ironically, the search for the distinct and vivid impression led the British Impressionists of the 1890s back to the rediscovery of earlier pictorial archetypes. This had already begun in Steer's *A Classic Landscape, Richmond* (cat 213). The tall clumps of trees, by comparison to those of Monet's Argenteuil, were now sunk in a pre-industrial haze, a crystalline Claudian humidity drawn less from Whistler than from Turner. By the turn of the century self-consciously British subjects derived from the great period of British landscape painting began to dominate Steer's production. Sickert cynically referred to the phenomenon as 'the august site motif'. Unconsciously, for a generation preoccupied with colonial wars, Steer was restating the majestic vision of the English countryside.

The process of assimilation, however, went into reverse when Captain Hill's most controversial Degas, *l'Absinthe*, was offered for sale at Christie's in 1893.[24] This *cause célèbre* flushed into the open the radical views of the new critics. To the hisses of the crowd the picture was knocked down to the Glasgow dealer, Alexander Reid, who quickly passed it to a client, Arthur Kay. This would have passed as no more than a minor incident had the picture not been lent to the new Grafton Galleries, where the original, less controversial title, *Au Café* was altered to the present more explicit one. The work was taken as an offence to public morals. Venerable Victorian academicians rallied to renounce it and the Impressionism it was taken to exemplify. Moore and MacColl defended it at length on technical and aesthetic grounds. The whole affair was confusing; it put the clock back; it raised doubts, fuelled by Moore, concerning Degas' status as an Impressionist, and ultimately led to the return to France of a major work.

The effect of this incident was most clearly felt among young painters. It consolidated views which had already been formed in Paris, a city now conditioned by easy familiarity with the Impressionists. The Exposition Universelle and related smaller shows had given them substantial exposure. It could readily be seen that the young artists of the atelier Julian, the Nabis, were erecting other gods.

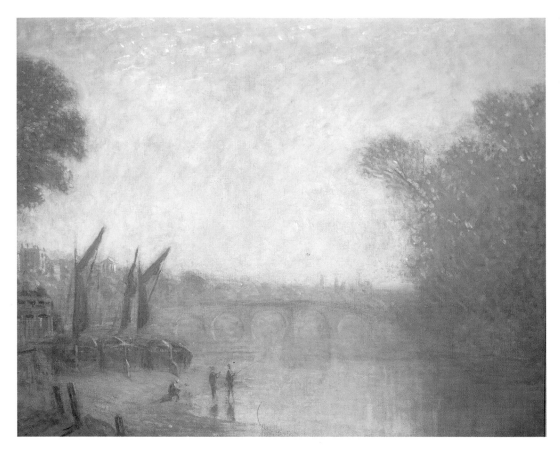

Cat 213 **Philip Wilson Steer**
A Classic Landscape, Richmond
c.1893
Chris Beetles Ltd., St. James's,
London

The British group, installed at the Hôtel
de France et de Lorraine on the Quai Voltaire
were more successfully integrated than their
predecessors of the early 1880s had been. William
Rothenstein, who had grown up in Bradford,
rapidly made the acquaintance of painters such
as Puvis de Chavannes, Albert Besnard, Louis
Anquetin, he ordered brown sketchbooks from
London for Jean-Louis Forain and conducted a
number of obligatory expeditions to Giverny
which were intense and revelatory. It 'brought
me nearer to understanding a religious attitude
to life ... one's very being seemed to be absorbed
into the fields, the trees and the walls one is
trying to paint'.[25] Simply by being in this cradle
of Impressionism, by breathing the ether, one
could instantly see the only possible direction
for progress.

In October 1890 Rothenstein's British circle
in Paris was augmented by the arrival of Charles
Conder, recently returned to Europe from Aust-
ralia where he had already been schooled in the
plein-air methodology.[26] Conder spirited Rothen-
stein away from the *quartier latin* to Montmartre,
where his womanizing instincts could more easily
be satisfied and where there were only two other
compatriots.[27] On one memorable occasion he
took Charles Rothenstein, William's elder brother,

to the Moulin Rouge, an event commemorated in
a small panel sketch (fig 22).[28] Within a short
while the two artists became friendly with
Toulouse-Lautrec, who painted Conder's portrait
(see cat 237) for inclusion in the background of
several works of the early 1890s.[29]

Conder followed Rothenstein to Giverny
and its immediate surroundings. In 1892 both

Fig 22 **Charles Conder**
The Moulin Rouge 1890
Manchester City Art Galleries

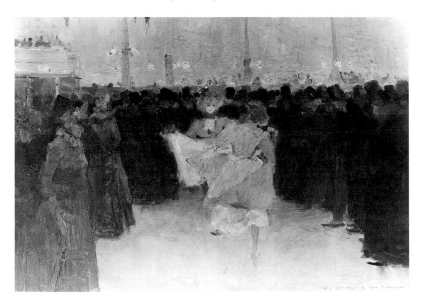

Rothenstein and he staged an exhibition on Lautrec's recommendation at Père Thomas' gallery in the Boulevard Malesherbes which attracted the attention of Camille Pissarro and Degas. By this time Rothenstein had moved away from landscape painting and could not be persuaded by Conder to leave Paris. Degas had, no doubt, been critical of Monet and pushed him in the direction of developing his drawing skills. Shortly after his return to London Rothenstein painted one of the most significant renderings of low-life, post-Sickert, in *The Coster Girls* (cat 182), which was shown at the New English Art Club in the winter of 1894. His precocity is evident. The *Pygmalion* types recall the long tradition of social observation in British art stretching back to Hogarth, but now enveloped by Whistler and Degas and given new impetus as a result. The painter almost implicates the spectator in their conversation. The young woman on the right calls, in broad cockney, from the balcony of a Thameside pub to an unseen lighterman

below. The whole rich vernacular of London trades and types is recalled, foreshadowing the poetry of Henley and Symons and the Paradise Walk heroines of William Nicholson and William Orpen.

Thus Rothenstein was not alone in tackling these themes. Henry Tonks, one of the more substantial Westminster pupils of Fred Brown, produced numerous interiors following the *intimiste* tendencies of James Guthrie during the 1890s. However, his major piece of Degas-inspired social observation was *The Hat Shop* (cat 235), a work of great ambition, which was acquired by Augustus Daniel, a friend of Roger Fry and patron of Steer. In this Tonks could not be closer to Degas. As his drawing style gradually acquired Degas' interpretive line, so here he swallows characteristic compositional methods, cutting the foreground with a bentwood chair and subdividing the background with tall windows draped in muslin. Tonal manipulation was essential to the success of the enterprise.

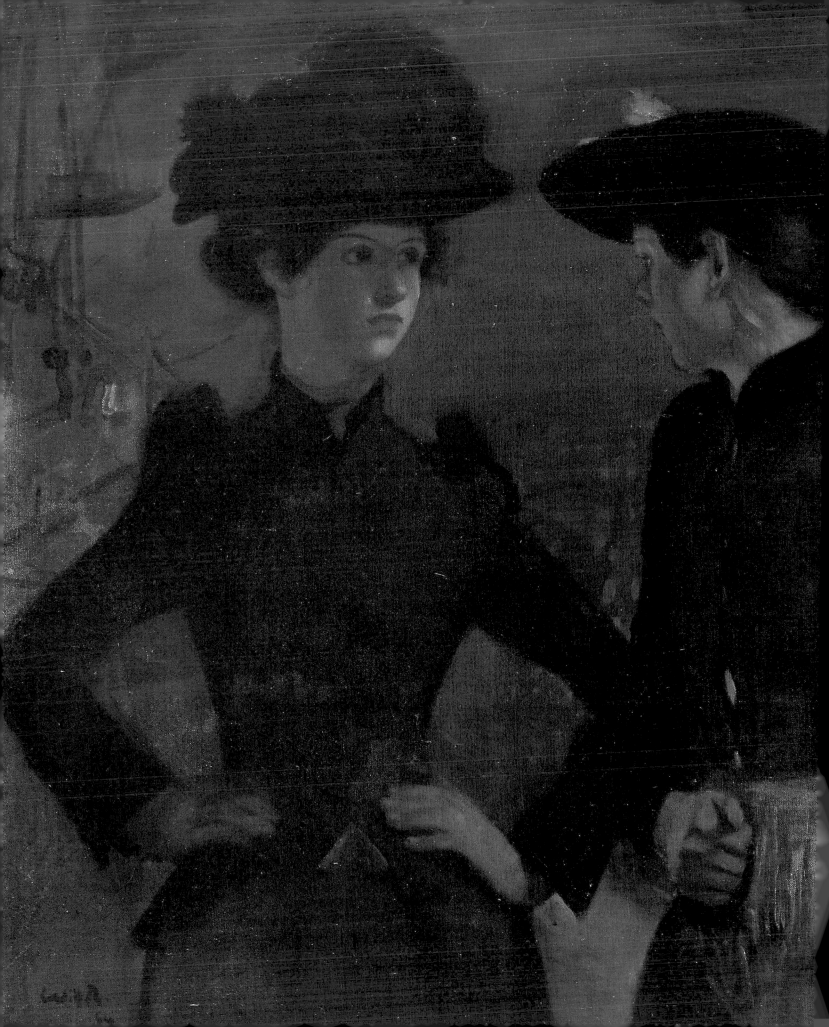

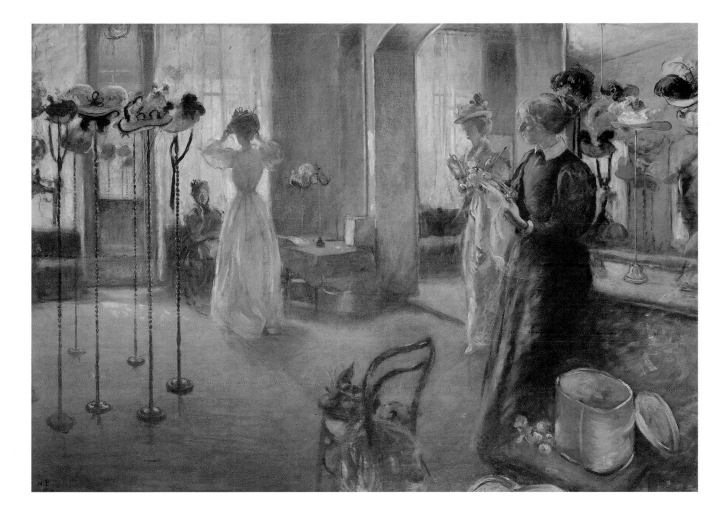

The return to tonality and drawing was conso-
nant with the reassessment of different Impres-
sionist roots. In 1895 Rothenstein produced a
number of Spanish full lengths coinciding with
R.A.M. Stevenson's seminal *Velásquez*. Stevenson,
critic of the *Pall Mall Gazette,* tipped towards
hispagnolisme in his judgements. He favoured
Whistler and, having been a pupil of Carolus-
Duran, the other second generation French realists.
His grasp of contemporary art was somewhat
undifferentiated in that he mentioned Monet,
Degas, Butin and Dagnan-Bouveret in the same
breath.[30] Manet, however, claimed 'the chief
honour of the initiation of the impressionistic
quality which characterises the new schools. Manet
is the great modern originator of that mosaic of just
open-air tones which finally supplanted lines and
object-painting'.[31] The closer he was to Divisionism,
the more uncomfortable Stevenson became. It was
logical, therefore, that by his definition the truth of
the ensemble should be paramount. This was the
essential lesson of plein-air painting. To avoid
remaining forever trapped in 'the ante-room of
preliminary changes', the painter must observe

every part of the scene 'in subservience to the imp-
ression of the whole'.[32] Seen in this way Velázquez
became 'the great Spanish impressionist'.

It is obvious that this was a force for conser-
vatism. The Steer praised by Stevenson was one
who sketched like Velázquez. Reviewing Steer's
contributions to the New English in April 1895 he
reflected that,

his impressionism has not always appeared
natural enough: here the method of suppressing
things has seemed more obtrusive than the
thing itself; here drawing and modelling of
essentials have been queer or inefficient; or here
the whole impression has been merely sugges-
ted, not rendered complete and finished, as in
the work of Velásquez. In fact, the style of Mr.
Steer's work has been often inconsistent, and
has resulted in a mere suggestion of the way he
saw things somewhat deformed by obtrusively
splashy handling, or by exaggerated hints of
expressiveness. I think Velásquez would have
liked *The Looking Glass*; it resembles his few
sketches for larger pictures, and speaking for

myself it possesses their fascinating power of forcing you to look out of the eyes of the painter. I hold it, therefore, to be genuine impressionism, as well as artisitic and decorative painting.[33]

What this meant for Steer was one thing; what it meant for the understanding of Impressionism in Britain is another. MacColl and Stevenson were substantially in accord. They wished to pull British painting back from the precipice of Divisionism. They saw more logical outcomes deriving from the acknowledgement of Manet and Degas. Steer's *The Looking Glass* held within it the possibility of narrative of the Zola-esque type favoured by George Moore. Ironically it is his portrait by Sickert, then in Steer's possession, which looks down from the wall in the background.

Moore was to regret the fact that Steer's subsequent direction took him back to the eighteenth century, but there was enough here to lead Rothenstein and others to paint a series of enigmatic interiors.[34] The context of contemporary drama and literature is obvious in the subject matter of *The Doll's House*, 1899, and *The Browning Readers*, 1900. Covert tensions were to be exploited by Orpen and McEvoy in pictures drawn from sources as diverse as Thackeray and the pulp serial novelists of the 1860s. But perhaps the most audacious statement of this kind was provided by Rothenstein's brother, Albert Rutherston, who engaged Zola head-on in *The Confessions of Claude*, 1901 (fig 23).[35] Such works provided the underpinning for the 'public' London which other painters recorded.

Nevertheless such thorough-going 'Degas-iste' pictures were relatively unusual. To consolidate London imagery more generally, painters such as William Lionel Wyllie, who already enjoyed the prestige of a Chantrey Bequest purchase, were enlisted.[36] Later in the 1890s views of London in a variety of crepuscular lights were supplied by Charles Edward Holloway and George Thomson, painters who were not publicly in the vanguard in the use of colour.[37]

The serenity of the London river with its majestic views of Westminster, St Paul's and the Pool of London gave way in the early years of the twentieth century to an Impressionism more truly equivalent to Pissarro's late cityscapes. A sociable painter like Blanche, whose French reputation depended upon his *style anglais*, celebrated the hedonistic pursuits of shoppers in Sloane Street and Piccadilly. Joseph Oppenheimer, an expatriate German artist, produced aerial views of London thoroughfares reminiscent of Monet's and Renoir's boulevard pictures of the 1870s. Algernon Talmage, who supplied large soporific landscapes to the Royal Academy, indulged in more radical experimentation with scenes of

Trafalgar Square by night. These began with *The Pillars of St Martin's* (cat 232) which he showed at the New English Art Club in 1907.[38]

The most surprising departures, however, were in the London scenes of prominent Academy painters. Arnesby Brown, for instance, tackled such sedate subjects as Marble Arch and Battersea Power Station and other industrial scenes in a systematic, Impressionist-derived manner. Arthur Hacker, a slick classicist by 1900, suddenly switched in 1911 to a series of canvases depicting the glow of the disgorging London Pavilion. Horse-drawn cabs do battle with motorized ones under the glare of incandescent street lamps. The subject matter stretched Hacker's technical reserves, at the same time as providing irrefutable evidence of the fact that for a representation of modernity some modified form of Impressionist technique was *sine qua non*.

The cityscape renewing itself amid the dull grime of winter was definitively portrayed, however, by one of the younger generation, Alexander Jamieson. Like other young Scots painters of the 1890s such as – Patrick William Adam and John Duncan Fergusson, Jamieson received his training in Paris. His Impressionist tendencies became apparent in vivid sketch-like compositions painted at Versailles and Dieppe. *The Studio* remarked that these displayed a 'highly trained power of selection and cultivated habit of vision that is characteristic of the best impressionist work'.[39] Some of the vital freshness of these pictures did not survive into his larger canvases, but in one monumental work he observed, in the winter rain, the looming dome of Brompton Oratory challenged by the scaffolding of the builders of the Victoria and Albert Museum (cat 104). The traffic of Cromwell Road continues on its way.

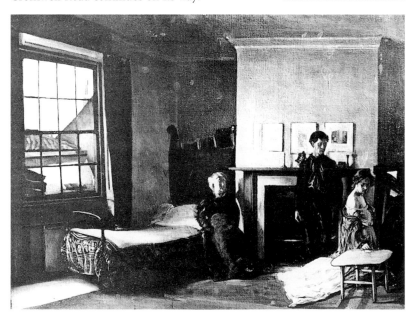

Fig. 23 **Albert Rutherston**
The Confessions of Claude 1901
University College, London

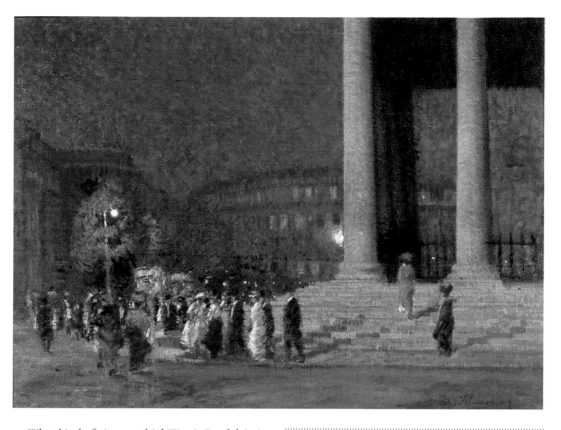

What kind of city was this? Was it Baudelaire's *'fourmillante cité, cité pleine de rêves'*, transposed; was it the 'unreal' metropolis of Eliot in the 'brown fog of a winter dawn'? The beauty of such images by London Impressionists lay in the fact that potentially they addressed everything. London lay in the quality of the ether through which its occupants, their activities, their milieu, might be observed. It was this which appealed to Whistler, returning in twilight to Lindsay Row.[40] It was this which supplied Monet's extraordinary vision of the Thames, recreated, largely in reverie, at Giverny.[41] It was the London light, different from that of Paris, which captivated Bastien-Lepage.[42] Painters might be attracted to this and engage almost by coincidence in the symbols of Empire, commerce and Christianity. Nothing was so powerfully emblematic as architecture. These concepts were glancingly touched on in the poetry of Richard Le Gallienne and Lord Alfred Douglas, in Henley's *London Voluntaries* and *London Types*, and in the juvenilia of Kipling. But the subject of an image was not what it was about. It was rather that abstract notion of 'quality' dear to Sickert. The atmosphere, the passing show, the spectacle, the river god provided more universal metaphors. As Vivian observed in Oscar Wilde's *The Decay of Lying*, 'the extraordinary change that has taken place in the climate of London during the past ten years is entirely due to a particular school of Art'.

Edwardian Arcadia

Direct contacts between British and French Impressionist painters were more substantial than they at first appear. By the end of 1890 both Rothenstein and Conder had been to Giverny, and although they may not have got as close to Monet as Sargent had done, they nevertheless would have consorted with the colony of American painters who had congregated there. The central figures in this group were Theodore Robinson and Lilah Cabot Perry, although there were many others who came and went between the late 1880s and 1900.[1] One or two British painters, such as Sterling Dyce, John Noble Barlow and Ernest Parton, stayed at the Hotel Baudy in Giverny around 1890.[2] The most important British painter of the group, however, was Dawson Dawson-Watson, a young painter from London who had trained under Mark Fisher before going to Giverny in 1888 at the age of twenty-four. His early landscape sketches immediately took on an Impressionist palette, although in larger works like *Harvest-time* (fig 24) he reverted to a more conventional plein-airisme.[3] Scale and the insertion of the figure, often dependent upon the ready supply of photographs, led to a less spontaneous approach.

Conder's first paintings from France have more in common with the muted plein-air

tonalities of the earlier Robinson than with Monet. There was, however, an obvious kinship between his and Dawson-Watson's smaller studies. At the same time he reported enthusiastically upon Monet in long rambling letters to his Australian mentor, Tom Roberts:

Fig 24 **Dawson Dawson-Watson**
Harvest-time c.1891
Pfeil Collection

Monet seems to have made a great stride this year and won over the Philisitines – I only wish you could have seen some of his landscapes they lived & he does them in the funniest way – he paints a good deal still with pure colour but you quite lose the paint at three or four yards (less). He takes you among hayricks and sunsets in a most natural way – & then lets you see it as you have been used – not in his but in your own way.[4]

Within a short time Conder was painting grainstacks himself in works such as *Haystacks, Giverny* (fig 25). In a group which included MacColl, Louise Kinsella and Mr and Mrs Arthur Blunt he began revisiting Monet's haunts. His canvases at Yport, Vetheuil and Dennemont reveal a progress towards bright colour and more animated paintmarks. In a series of canvases of blossoming trees he reacted to the flattening, and hence more decorative, effects of strong sunlight.

By 1890 the news was out that the val de Seine was an artists' tourist trail. Roger Fry is likely to have made forays in this direction while studying at the atelier Julian in 1892. He enthused over the work of Rothenstein and Conder at the New English the following spring, and could not understand the apparent lack of response to their efforts.[5] In later years painters such as Alfred East, Alexander Jamieson, Wynford Dewhurst, Wilfrid de Glehn and Philip Connard all painted along the banks of the Seine and were more or less inspired by Monet. The effect, in general terms, was to introduce blond tonalities relieved by strident notes of colour. It was even the case that under the towering presence of Château Gaillard, at Les Andelys, painters like East and Connard found a world of sensual delight, of nude bathers cavorting under the shade of spreading, foliate beech trees. By the turn of the century Normandy and the Seine valley were almost an extension of England.

It could nevertheless be argued that landscape painting, into which Impressionism was thoroughly integrated by 1905, was the most eclectic genre. There was, as one writer on Buxton Knight observed, 'a Constable group, a Corot group, a Monet group, a Dutch group' as well as those who closely cloned the work of Alfred East and Benjamin Williams Leader.[6] These diffuse tendencies characterized landscape painting in the Edwardian era. By concentrating upon scenery,

upon striking romantic visual effects in nature, it could be argued that landscapists turned their back upon realities which were sometimes harsh. The boom years of high Victorian farming were lost in popular memory. A population which had grown since the turn of the nineteenth century was now no longer fed exclusively from English fields.[7] The patterns of cultivation did not change rapidly enough, and when new methods were introduced they had been accompanied by agricultural unrest. Nothing could halt the relentless population drift to the cities. Impressionism appeared, according to one set of criteria, to extend and support a false arcadianism by encouraging the concentration wholly on light, colour and the purity of life in the country.

This was more clearly evident in the work of rustic naturalist painters who had become prominent in the 1880s. In most instances these artists moved from a strict adherence to the dogma of Bastien-Lepage to a more personal style which exhibited some of the features of Impressionism. Edward Stott, who continued exhibiting at the New English Art Club until 1895, is interesting in this regard.[8] Pictures such as *The Gleaners* and *In an Orchard,* shown at the New Gallery in 1892, engage directly with prevailing atmospherics in creating a surface texture which has much in common with

Fig 25 **Charles Conder**
Haystacks, Giverny c.1891
unlocated, photo Sotheby's

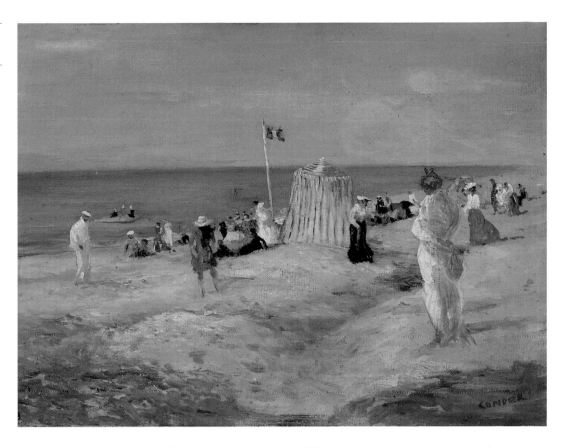

contemporary 'impressionist' photographs. Stott, as his critics pointed out, had shrugged off the methods of the ateliers.[9] From the start of his career he eschewed the grand bombast of the Academy. He was always the archetypal *petit maître*. It was not Impressionism *per se* that was the issue in criticism of his work, but his preoccupation with sentiment. In this complicated notion, critics recognized the importance of the atmospheric envelope in which his motif was suspended, but they were content to leave it there.

Of the rustic naturalists of the 1880s, Henry Herbert La Thangue was slower to abandon the idea of large subject pictures. Like Stanhope Forbes and erstwhile Newlyn painters such as Henry Scott Tuke and Fred Hall, he remained tied to the idea of the Academy or the Salon conferring a kind of importance to what he was doing. Meunier, Friant and Dagnan-Bouveret were role models in France. La Thangue continued to issue interesting ideas which were often at odds with the contemporary cant. He maintained, for instance, that because the mechanisms of the eye were essentially the same for everyone, we all had the capacity to see the same thing; he tried to articulate notions of 'sentiment'.[10]

There were no absolute conventions of representation, but certainly by the turn of the century a much less lugubrious palette prevailed

and blue/violet shadows were commonly employed to give the effect of sunlight. Painters such as Tuke and Hall adopted a looser, much more self-confident handling. At a simple level this may have been the unavoidable result of maturation, but it also had complex social and aesthetic determinants.

Perhaps the most impressive reappraisal of former allegiances in the early 1890s occurred in the work of George Clausen, a painter who was ever convinced of the veracity of on-the-spot sketches. With tiny panels such as *Souvenir of Marlow Regatta* (cat 29), and in vigorous larger pastels of hayricks and grainstacks produced in

Fig 26 **George Clausen**
Evening Song 1892
unlocated

Cat 30 **George Clausen**
The Mowers 1891
Lincolnshire County Council,
Usher Gallery, Lincoln

the environs of his home at Cookham Dean, Clausen moved towards a colourful and more expressive handling. The process was only completed with the exhibition in 1892 of *The Mowers* (cat 30), a reprise of an earlier water-colour but now tackled with a much richer range of colour and texture.[11] The strong sunburnt mowers move across the meadow, cutting a swathe through the tall grasses and wild flowers. The canvas, for George Moore 'exhaled a deep sensation of life'.[12] The flowers assume almost symbolic proportions in slightly later canvases such as *The Little Flowers of the Field* (cat 31) and *Evening Song* (fig 26). When the second of these

was shown at the Royal Academy, Clausen was taken to have abandoned the inspiration of Bastien-Lepage for that of Monet.[13] By 1893, however, Monet had forsaken the representation of the human figure. His series of pictures of grainstacks, despite the claims made by some contemporary writers, were at one level a denial of the significance of subject matter. Rural inno-cence and the abundance of nature had no place in his scheme of things.

The idea that nature provided an envelope, a closed and stable world which the painter could observe, was essential to this way of thinking. It had been an obvious feature of Sargent's pictures

at Broadway and Fladbury. It was the aspect of Guthrie's *Midsummer* (cat 92) which greatly appealed to George Moore. When this large sketch of afternoon tea in the garden at Thornton Lodge, Helensburgh was exhibited at Liverpool in 1892 Moore hailed it as 'Summer's very moment of complete efflorescence; a bower of limpid green, here and there interwoven with red flowers. And three ladies are there with their tiny Japanese tea-table. One dress – that on the left – is white, like a lily, drenched with green shadows; the dress on the right is purple, beautiful as deep foxglove bells. A delicate and yet full sensation of the beauty of modern life, from which all grossness has been omitted'[14] Moore's hyperbole had its basis in a concept of modern life which was not conditioned by harsh social realism. Guthrie's *mise-en-scène* is assembled in a deliberately 'thin' and sketchy way. In contrast to his earlier sculpted plein-air peasants, these young ladies are almost as insubstantial as those depicted in Helleu's Fladbury sketches. Dappled sunlight, flowers and other forms intermingle in a shimmering palette of warm greens, strong yellows and blue/purple

shadows. Where La Thangue treating a similar subject, *In the Orchard*, 1893 (cat 112), insisted upon drawing and definition in hands and faces, Guthrie submerges Maggie Hamilton, Hannah Walton and their companion in a sunlit garden.[15]

Other Glasgow painters were preoccupied with this floral idyll, but none so insistently as John Lavery. In smaller works painted at Paisley Lawn Tennis Club around 1890 he elaborated the theme of the garden in blossom. This was realized on a grand scale in *A Garden in France*, 1897 (cat 119).[16] Here again the figures are surrounded by rich vegetation, through which shafts of sunlight break in irregular patches of pure colour. Lavery's palette is cooler than Guthrie's, giving a deeper space, but the effect is equally rich. In the artist's terms these pictures signalled a new direction. In 1900, in order to measure the distance he had travelled since his youth, Lavery returned to the banks of the Loing in order to reconstruct his original *Bridge at Grez* composition of 1883.[17] Quickly dispensing with the original idea of the 'passing salute', he painted a single rowing boat, half in sunlight, passing under the bridge. In both

Cat 31 **George Clausen**
The Little Flowers of the Field
1893
Private Collection, courtesy of
The Fine Art Society

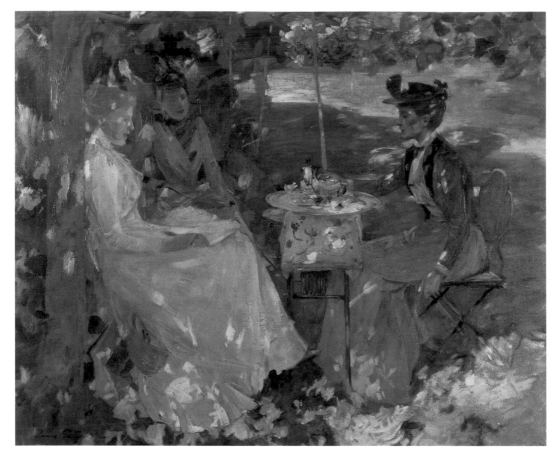

Cat 92 **James Guthrie**
Midsummer 1892
Royal Scottish Academy,
Diploma Collection,
Edinburgh

pictures the bridge articulates the pictorial space, although in the second version the even light and tonality have been rejected.

Both pictures in their times were *tours de force*. Recognizing Lavery's objectives, critics were more willing to applaud the second than they had been to recognize the first. Percy Bate echoes some of Moore's phraseology in a description which typifies the over-written prose of art columnists of the period: 'skilful and free rendering of the limpid water and masterly treatment of the transparent shadows, being as worthy of praise as the dexterous use of the chance gleam of sunlight on the overhanging trees and the beautiful placing on the canvas of the brilliant white of the parasol carried by the lady in the boat'.[18] It is simply evident that the lessons of Impressionism had been absorbed fully. The element of spontaneity was fully integrated into the process. In this sense even apparently unfinished works made complete statements. Walter Osborne's *Tea in the Garden*, 1902, (cat 164) is an example of the process at work, with the painter responding consistently to separate visual stimuli in the scene taking place before his eyes.[19]

Sargent was poised to return to this world of *Dolce far Niente* (cat 194) in about 1905, when he

began to complain of the drudgery of painting portraits. His regular holidays at Purtud in the Val d'Aosta became more serious affairs, in that he began to employ the ménage which on occasion included his nieces and at other times Wilfrid and Jane Emmet de Glehn (cat 86) as models for an exotic evocation of the Orient.[20] In the resulting oils and watercolours Delacroix's *Femmes d'Alger* have been taken out of doors, placed by a babbling stream and painted in a renewed Impressionist manner. The message was not lost on de Glehn, who had until now been struggling with larger conceptualised canvases of nudes sporting themselves in Elysian fields.[21] Sargent delighted in correcting and overpainting. The sheer complexity of the subject was what appealed. 'Mastery', as Sickert once observed, 'is avid of complications'.

It was nevertheless the case that Sargent had learned his Impressionist technique at the feet of Monet. He had noted the fact that Monet had transposed the hero peasant figures of an earlier generation – who were habitually seen against the sky – with young women visitors to the countryside, carrying parasols. These simple juxtapositions had opened Sargent's eyes to a world of colour which seldom penetrated the tenebrous corners of the portrait painter's studio. Literal-

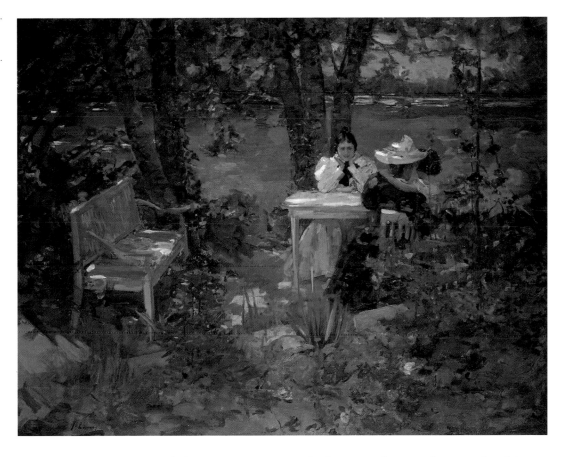

minded critics often wondered about meaning when faced with works of this kind, although increasingly they conceded that such pictures were possible. The young Charles Sims, for instance, re-learned these lessons in the early years of the twentieth century to almost rhapsodic critical applause. '*The Top of the Hill*', (fig 27) wrote one critic, 'has almost a right to be called a work of genius. It has no subject worthy of the name – it is merely a little study of a piece of sloping ground with the figure of a girl relieved against a light sky and two young children running in the foreground – but as a record of sunlight and breezy atmosphere, as a suggestion of the very movement of wind and the actual gleam of the sun, it is altogether perfect'.[22]

In Walter Osborne's case this direct notation of colour had developed consistently after his permanent return to Ireland in 1892. One of his first Irish works, painted in the garden of his house at Foxrock, was the portrait of *J.B.S. MacIlwaine*, the landscape painter and old student friend.[23] The picture, like Munnings' *Daniel Tomkins and his Dog*, 1898, (cat 145) is at once splendidly naturalistic at the same time as conveying elements of spontaneity. A visual shorthand was nascent in both portraits, which would emerge to a fuller extent in works of the early twentieth century. Munnings in particular developed a swift notation which in his early works portraying gypsies and horse-fairs restated the rural arcadia, although it failed in some instances to avoid cliché.

In essence the full richness of the rural vision was left to painters such as Clausen, La Thangue, Stanhope Forbes, Henry Scott Tuke and Arnesby

Brown. The high point was reached in the Royal Academy summer exhibitions of the first five years of the new century. Clausen and La Thangue had by this stage scaled down their offerings and abandoned all vestiges of narrative. They were increasingly preoccupied with prevailing atmospherics and with the totality of the image, with an idea of overall unity within which the incidentals of the motif were submerged. Forbes, although he continued to celebrate the activities of the Newlyn fisherfolk, had overhauled his palette and in pictures such as *The Seine Boat* (cat 79) he revealed that he too had studied the colour in shadows. Newlyn was now attracting a new generation of painters who, like Harold and Laura Knight, came to Newlyn for the express purpose of renovating their practice along Impressionist lines. The resulting canvases concentrated exclusively upon summer holiday pursuits.

Arnesby Brown in 1902, showing *Full Summer* (cat 00) and *The River Bank* (cat 00), received the most generous support from critics who saw both pictures as 'splendid records of nature, largely and simply felt, and set down with the sureness of a man who knows exactly what he intends to accomplish'.[24] Of the two, there were deeper resonances in *Full Summer*, a picture of a leafy lane down which a young cowherd passes with his cattle. Clausen, Edward Stott and La Thangue had already tackled this subject, which also provided one of the most resonant themes in contemporary poetry from Hardy to Housman. This countryside, with its calm rural rhythms, was blissfully unproblematic. For those involved in imperial adventures, who were holed up in ambushes on the Modder River or the Hindu Kush, this became the essential England. It was, to the reviewer of *The Magazine of Art*, simply 'one of the great pictures of the year'.[25]

Other factors, however, also made this universal image of the countryside and rural life so

Cat 164 **Walter Osborne**
Tea in the Garden 1902
Hugh Lane Municipal Gallery of Modern Art, Dublin

Cat 163 **Walter Osborne**
J.B.S. MacIlwaine (detail) 1892
National Gallery of Ireland, Dublin

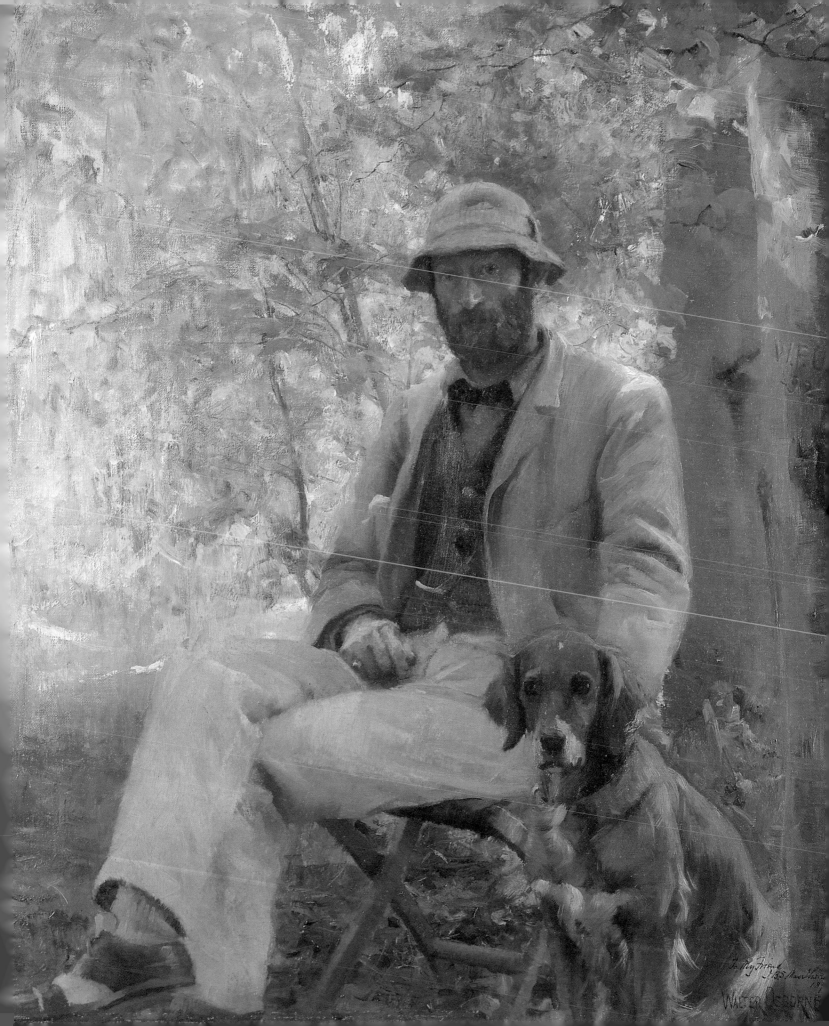

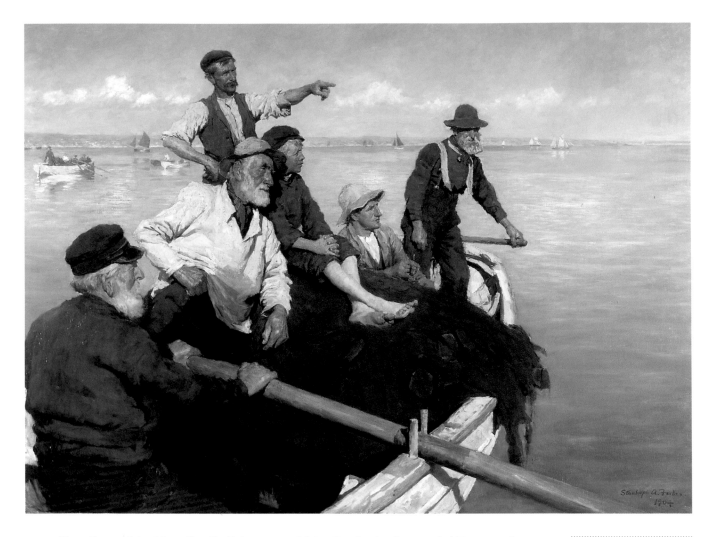

Cat 79 **Stanhope Alexander Forbes**
The Seine Boat 1904
Private Collection, courtesy
Pyms Gallery, London

compelling. Constable's vision of an English arcadia was already being revived in the early 1890s and the reasons for this are profound and complex.[26] Some were purely circumstantial, although at a more profound level, perhaps in the light of Impressionism, neglected traditions had to be reassessed. It became obvious to artists and writers alike that the freshness of Constable's vision, his naturalism, had not been fully appreciated by Victorian landscape painters.[27] Ruskin had found little to commend in Constable's work and it did not mean much to the Pre-Raphaelites.[28] By the end of the 1880s, however, critics became aware of Constable's seminal role in helping to form the attitudes of the Barbizon School.[29] The main rush of Constable scholarship occurred around the turn of the century, with monographs by C.J. Holmes and Lord Windsor.[30] Of these, the Holmes study had a more immediate impact in that it acknowledged Constable's influence on contemporary art. It discussed this influence on the level of the visual, and its case was accepted and repeated by more influential writers like Julius

Meier-Graefe who downgraded Turner and wrote extensively about Constable in *Modern Art*.[31] There was therefore ample justification for a regrouping of English landscapists around Constable's 'stiles and stumps' in the early years of the century. What was created as a result of this corporate reverie?

There were new attitudes to the manner of representing as well as to the subject represented. It is nevertheless true that critics who were looking for something new often expressed disappointment. M.H. Spielmann's prefaces to the volumes of *Royal Academy Pictures* reveal an evident difficulty in conceptualizing what might be regarded as a low content genre. In 1896 he reported that the visitor would find high standards in the landscapes, 'where we are accustomed to look for excellence'.[32] By 1903, however, there were 'few surprises', yet the example reflected 'the breadth and tenderness, the love in the British soul for every aspect and humour of nature'.[33] These anodyne images informed the late Victorian impulse to return to rusticity and are seen as much in the impressive rearguard action of

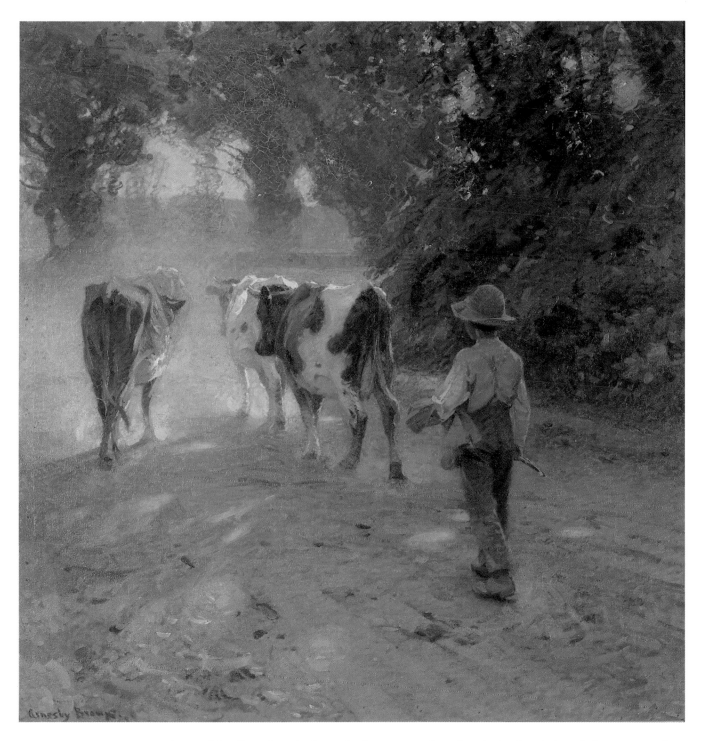

Cat 15 **John Arnesby Brown**
Full Summer 1902
City of Nottingham Museums;
Castle Museum and Art
Gallery

writers and intellectuals as in the work of
painters. Guilds and pressure groups grew apace
with industrialization.[34] It is therefore legitimate
to ask what kind of landscape the dwellers in the
new garden suburbs envisioned? For whom were
the grand panoramas created which Spielmann
declined to describe in detail?

To some extent the description of Academy
Impressionism in landscape painting prior to the

Great War is the description of who it was made
for. The producers of the great rural vistas seen
annually at the Royal Academy were looking for
corporate patrons. Their work was designed for
the collective eye of the purchasing committee of
the new municipal gallery, located in the midst of,
and created from the wealth of, the new industrial
age. The irony is therefore that these grand
pictures of England's fields, by East and Murray,

were hung surrounded by monuments to capital and labour. This pastoral vision was the ultimate expression of Edwardian materialism. The degree to which it was disseminated is attested by the increasing attempts on the part of artists to market small versions, replicas or worked up studies, through solo exhibitions, to the middle classes.

What motivated these collectors? Did they collect to delight or to instruct? Did aldermen and local worthies make their selections in order to produce a representative collection of the best of British art, for reasons of local pride and prestige? The motives behind competing committees have not been examined, although obviously they were not only buying landscapes. The policy of the newly opened galleries of the midlands and north, in so far as it can be articulated, was to favour artists who were making a name for themselves, who had been trained in France and were now mature painters submitting regularly to the Academy. Chantrey or Tate purchases confirmed the profile which may already have been predicted by astute local businessmen. Some collections took more risks than others. Bradford, for instance, as we have seen, had some of the most daring patrons; elsewhere, tastes were more conservative or eclectic. In a typical modern private collection the occasional French picture might hang side-by-side with contemporary British paintings from the Grosvenor Gallery, the New Gallery or the Royal Academy. When these same collectors went into committee to buy for the municipality, they became more chauvinistic and favoured familiar subjects which were remodelled in the light of Impressionism.

Alfred Parsons, working on *When Nature painted all things gay*, 1887, (fig 28) alongside his friend John Singer Sargent as he painted *Carnation, Lily, Lily, Rose*, was unaffected by radical tendencies. In this work Bastien-Lepage's exhausted haymaker has produced an indolent son with Holman Hunt's *Hireling Shepherd*. He inhabits an arcadia reminiscent of that lovingly portrayed by Helen Allingham and Myles Birket Foster. His blossoming orchard England is less rigorously structured than that of Clausen's *Shepherdess*, a work already acquired by Mr Maddocks for his Bradford villa. Parsons produced a sophisticated compromise acceptable to the Chantrey Bequest. He was, nevertheless, a modern painter who stayed well clear of Impressionism; although he illustrated Fontainebleau for a series of articles by Robert Louis Stevenson, *Bredon on the Avon*, one of his Academy-pieces of 1912, typifies his entire production.

The synthesis achieved in *When Nature painted all things gay* was highly significant and Parsons was unable to escape its inevitable consequences.

The painting's title concealed the fact that the setting was derived from the fields around Broadway in Worcestershire, a prosperous area of fruit cultivation which had been protected from the sweeping changes affecting British agriculture elsewhere. However, for the viewer these literal truths were less important than the general effect of a day in spring, somewhere in England. It was this rediscovery of a cottage-orchard England which held the popular imagination through to the Edwardian years. Its most salient expression was found in the poet-laureate Alfred Austin's *Haunts of Ancient Peace*, 1908.[35] This abstraction, a fresh, vibrant but generalized landscape, assured phenomenal success to painters such as Alfred East.

Fig 28 **Alfred Parsons**
When Nature painted all things gay 1887
Tate Gallery, London

Fig 29 **Alfred East**
Golden Autumn c.1900
Tate Gallery, London

Like Parsons, East was updating the grand Victorian exhibition-piece landscape which had been defined for an earlier generation by George Vicat Cole's *The Heart of Surrey* and Benjamin William Leader's *February Fill Dyke*. To some extent his success in adding a small increment to the sum of Victorian landscape ensnared him. He confessed his admiration for the tonal subtlety of Cazin rather than the strident colour of Monet.[36] Until his death in 1913 the Academy regularly received three or four examples of his work, some of which were painted on the Somme or the Seine. But even when he worked in France or Spain, East followed similar procedures and even these landscapes were translated into a species of *Golden Autumn* (fig 29). His horizons were always low and his trees were always magnificent specimens in full bloom seen against the sky. The atmosphere, which for others was in a state of flux, for him was always still. It was the endless insistence upon these conditions which frustrated later writers. For all his prodigious industry – he wrote several books, numerous articles, lectured and conducted painting tours – the 'lasting unforgettable picture' eluded him.[37] Yet so forceful was the generalization contained in East's work that, universally present in municipal and imperial collections, it was etched deeply in the Edwardian mind.

It was thus inevitable that when he wished to escape from the treadmill of portrait-painting around 1907, John Singer Sargent did not return to Worcestershire. He had as much to break free from all the preconceptions of English landscape painting for a startling explosion of energy in works like *Dolce far Niente* (cat 194), which over spilled into the paintings of his companions, Wilfrid and Jane de Glehn.

Such originality was, however, unusual since the East formula was so pervasive. Within its bland assumptions the forces of the New English Art Club and the Royal Academy were united. Although they might, for political and historic reasons, wish to preserve their distinctness, there was in practice little difference between the ambitions of a young New English landscapist like David Muirhead and a young Academy one like Algernon Talmage. The Slade lay behind the one and the Royal Academy Schools reinforced the other. The absurdity of the division was illustrated by Mark Fisher who was, as Sickert observed, 'on the side of the angels' when showing at the New English and producing 'works of damnation' at the Royal Academy.[38] A solo exhibition in the Dutch Gallery in 1895 necessitated the reappraisal of Fisher's work and he profited momentarily by being regarded as a forerunner, like Brabazon Brabazon. He drew a eulogy from R.A.M. Stevenson in *The Saturday Review* in which comparisons were made to Constable, Corot and Monet.[39] There were times in Fisher's work when

drawing was abandoned in favour of a debauch of soft sunlight passing through foliage to fall upon bathers in shady pools. It is easy to see why Lucien Pissarro had admired his work twelve years earlier. As he resumed painting at Eragny in 1893, these were some of the effects which he too was trying to create.

In the New English, Steer continued to occupy a dominant position and, like East, he was making regular painting tours, rediscovering the 'august-sites' of the eighteenth century.[40] Steer arrived at this position absorbing more than Impressionism, Constable and Turner. His eclecticism at times extended to rococo painting, from which the Cythera ideal had been appropriated by Adolphe Monticelli, an artist for whom there was great enthusiasm in the early years of the century.[41] Monticelli was a yet further example of the British tendency to look for precedents and forerunners before taking on fully the message of the Impressionists. His work was even more densely impasted than that of Fisher, although it had a similar syncopation of light and shade. It was he who inspired the agitated impasto of Steer's *The Embarkment* (fig 30), a *sous bois* picnic scene owned by Sargent. As in earlier years, Steer was able simultaneously to work in apparently divergent styles, hence the fluidity of *Ludlow Walks* (cat 218). From these Steer graduated to panoramic vistas of the Severn and to views of Richmond and Chepstow castles, seen from vantage points derived from Turner's *Liber Studiorum*. The results were often misinterpreted as unfinished, or lacking the surface veneer of detail which Constable had added specifically for his Academy audiences. Yet as Lewis Hind later observed, 'If you were so irreverent to take Chepstow Castle on your knee, you would see nothing but blobs of paint and smears of palette scrapings; but retire to the other end of the room and half-close your eyes – lo it comes together. The paint disappears, the vision of the artist may be yours'.[42]

Clearly the *mélange optique* referred to in this passage bore little resemblance to the experiments with Divisionism which Steer had conducted in the 1880s. Although there was enough of the idea for him to appear radical in some quarters, even in the 1920s, there was no escaping the fact that by 1910 the New English represented a sort of establishment Impressionism, producing 'a composite product' in which 'an educated colour vision has been applied to themes already long approved and accepted'.[43]

The attempt to add scale and grandeur was, in Sickert's eyes, a failure. Inevitably the studio light took over from the natural light and the traditional attributes of picture-making transcended those of perception. Sickert wished to dispel the notion that the painters of the New English could be considered Impressionist. Taking Monet, Pissarro and Sisley as his examples, he noted that 'light', not noble ruins or English oaks, was their subject. The 'immense majority' of their work was on a small scale,

and we may be certain, not for nothing are they so. Theirs is an art closely conditioned by incessant readjustment and restatement of the message sent from the eye to the hand. I doubt if you are free to alter the size of the stitches in this tapestry of sensibility as you please. Certain relations in nature are stable ... So I am inclined to think that, whereever we have been tempted to do Impressionism on the scale of the Exhibition picture, we have run considerable risk of being losers of the sense of what we have learnt from the French Impressionists.[44]

What exactly had been learned from the French Impressionists? Was Sickert merely observing differences and failing to accept a legitimate form of painting because it did not conform to a narrow set of criteria? He was coming from a more intimate knowledge of French painting than many of his British and Irish contemporaries. Setting up the opposition did not hasten the demise of the exhibition-piece any faster than would naturally have occurred in a world in the imperial stability which it expressed was being slowly and then suddenly eroded.

Throughout this period British painters looked to Impressionism to provide the ingredients of a grand manner. The rustic walked through the gloaming; landscape was a noble panorama.

Fig 30 **Philip Wilson Steer**
The Embarkment c.1900
Manchester City Art Galleries

Priestmann's *In the Heart of the West Riding*, exhibited at the Royal Academy in the year of the first Battle of the Somme contains a range of arches reminiscent of those in Cézanne's various renderings of St Victoire. In the one they represent a Roman viaduct; in the other they evoke an industrial revolution which has transformed the landscape into an inferno. Bradford, viewed from Baillif Bridge, provided an essay in light and atmosphere which, in the words of one commentator, transcended Impressionism. 'The painting goes deeper than impressionism ... This is no surface impression, but the summarized record of many days' observation of the works of man's industrial activity brought into unison with nature's harmonies.'[45] In an age challenged by war, there must be more than the quasi-science of the notation of shimmering light.

Impressionism and Modernism

Reading the accounts of the debate that raged around Degas' *l'Absinthe* in 1893 one would be tempted to conclude that there was enormous hostility to French Impressionist painting in Britain. Public controversy, however, masked the growing acceptance of innovation. It did not restrain Sisley, Pissarro and Monet from visiting Britain in the 1890s,[1] and throughout the decade their works and those of Degas, Morisot and Renoir continued to be shown regularly in Britain. The New English Art Club included occasional examples, but these did not constitute a consolidated body of work. In June 1898 the Corporation of London held an exhibition of French art at the Guildhall and included two Monets, a Pissarro and a Renoir. The most prominent pictures in the

popular press, however, were Dagnan-Bouveret's *Bretonnes au pardon*, 1889 and Lhermitte's *La Mort et le bûcheron*, 1893. Anyone viewing the exhibition might be forgiven for concluding that Impressionism was of little importance, partly because, despite its ubiquity, its prominence was scarcely yet acknowledged by the French state.[2]

There was a more formidable presence in the International Society of Sculptors, Painters and Gravers' first exhibition in that year. This was a vital new painters' society composed of those who had been excluded from both the New English and the Academy. At its forefront were members of the Glasgow School who, while they retained their avant-garde pretensions, were now, for the most part, successful London-based painters. Many luminaries of the International were or had become followers of Whistler, who was approached to act as President. His pompous biographers recalled that he had once described the New English Art Club as 'only a raft', but the new society was 'a fighting ship of which he as captain had taken command'.[3] There is perhaps an important sense in which the ambitions of the International Society differed radically from those of the New English. Whistler insisted that those who were members of academies already should

not be involved. There were problems with this, but it generally assured the Society of support from more radical painters than even the Impressionists must have seemed by 1898. The International Society had an important mission which did not explicitly favour the Impressionists. In some senses it modelled itself upon other conspectus shows which were springing up in Europe and America.

The first exhibition included pictures by Toulouse-Lautrec, Puvis de Chavannes, Redon, Bonnard, Vuillard, Vallaton, Zorn, Muhrman and Khnopff, as well as six works by Degas and others from Monet, Renoir and Sisley. A notable feature was the inclusion of Manet's *The Execution of the Emperor Maximilian* (Mannheim version) and *Vagabond Musicians* (*Vieux Musicien*, National Gallery of Art, Washington), both of which were lent by Durand-Ruel.

This tradition of catholicity, repeating in some respects the policy of the Glasgow Institute of Fine Arts exhibitions of the early 1880s, was maintained for subsequent shows up to 1904, by which time other more concerted efforts were being made on the Impressionists' behalf in Britain.[4]

Leading Impressionist painters retained their interest in Britain. Sisley, on an advance from the

IMPRESSIONISM IN BRITAIN

Cat 143 **Claude-Oscar Monet**
The *Houses of Parliament,
effect of Fog* 1904
Museum of Fine Arts,
St. Petersburg, Florida.
Gift of Charles and Margaret
Stevenson Henderson and
Friends of Art

collector François Dupeaux, spent four months in the south of England and South Wales in the summer of 1897. When staying at Penarth he produced a number of canvases overlooking Cardiff Bay to the east and Sully Island to the west (cat 205).[5] Pissarro visited his son Lucien on several occasions during the 1890s and produced a further series of suburban landscapes at Kew in 1892 and Bedford Park in 1897.[6] The most substantial engagement with London, however, occurred as a result of Monet's three visits in 1899, 1900 and 1901.[7] Monet's ambitions to paint the London fogs, expressed at the time of Whistler's invitation to exhibit with the Society of British Artists, had never been realized. Now, twelve years on, he found himself in London visiting his son, Michel, and staying at the Savoy Hotel with its splendid views of Waterloo (cat 142) and Charing Cross bridges and up river to the Houses of Parliament (cat 143). Three essential motifs held his attention, and as with the earlier series he worked on numerous canvases in succession, demonstrating the different effects of daylight, twilight and fog. The mutability of the

scenes before him meant that he returned to Giverny with numerous slightly stated notes which, as he worked up to the exhibition of London pictures at Durand-Ruel's in Paris in 1904, gave him considerable difficulty. The fog, the London ether, was his real subject, as it had been, on occasion, for Whistler and the London Impressionists. When the young René Gimpel visited Giverny for the second time in 1919, it was this aspect of the experience which Monet looked back upon. 'I love London', he declared, 'much more than the English countryside; I adore London, it's a mass, a whole, and it's so simple. But what I love more than anything in London is the fog. How could the nineteenth-century English painters render houses brick by brick? They had to paint bricks which they couldn't and didn't see'.[8] His view of the capital, although much more extensive than that of any of his compatriots, was essentially a fabricated vision. How many times, examining the swift notes produced during those three trips, must he have asked himself what in fact he had seen? The mental image, pre-existent in the mind, had taken

over from reality. One of the central tenets of Impressionism was being re-shaped.

Sadly Monet's intention to exhibit the finished London pictures in London was never realized. Even though he was pleased with the high regard he received on his trips and enthused over Durand-Ruel's efforts to establish a new British market for French Impressionist pictures, it is doubtful that, given the deplorable debacle over the National Gallery's first Impressionist acquisition, his work would have been received with universal acclaim. Frank Rutter, who agitated for an Impressionist picture to be bought for the national collection, wanted to buy Monet's *Vétheuil: Sunshine and Snow* (cat 140), but had to withdraw from the purchase when he realized that the National Gallery would not accept a work by a living painter.[9]

This was the predecessor of a further London effort on Durand-Ruel's part. In 1905 the dealer brought to the Grafton Gallery 55 works by Monet, 49 by Pissarro, 35 by Degas and a large selection of other Impressionist pictures. Although critics appear to have been generally kind, the exhibition was not a commercial success.[10] Rutter records overhearing a lady 'trembling on the verge of buying a Monet' being dissuaded by an elderly Academician with the words, 'These are not paintings, my dear lady, they are only sketches, and very rough sketches at that. Why, we all have sketches like these in our studios, but we should never dream of exhibiting them'.[11]

Nevertheless, Durand-Ruel netted one important client in 1905, Hugh Lane. The son of a clergyman, Hugh Percy Lane was born in Ireland in 1875.[12] Rutter recalled Lane's early career as a brilliant dealer in Old Masters with Colnaghi's of Bond Street.[13] In around 1903 he began to be interested in contemporary art, writing to painters of Irish origin to solicit support for a show of modern Irish painting to be staged at the Guild-hall the following year.[14] Lane was passionately committed to the idea of creating a modern Irish school and his way of doing this was to acquire a collection of the best contemporary art for presentation to the city of Dublin. He felt that the opportunity to study good modern painting had been denied to art students in Ireland and for this reason painters such as Lavery, Osborne and Orpen, who had been obliged to leave the country in order to obtain recognition, were canvassed. Thereafter he became a close friend of William Orpen and was probably guided by him in his acquisition of Impressionist pictures.[15] The chequered history of Lane's attempt to give his Impressionists to Dublin makes sad and predictable reading.[16] At one point an opponent of the scheme on the Dublin Corporation declared that, 'fresh air was a more desirable asset for the people than French art'.[17]

None of this dulled Lane's appetite, and if the burghers of Dublin were generally not supportive, there were others who were. Perhaps the most succinct celebration of Lane's activities is contained in Orpen's canvas, *Homage to Manet* (cat 157), which was shown at the New English Art Club in 1909. The evolution and eventual reception of this project has been extensively documented.[18] The painting restates the centrality of Manet and *hispagnolisme* to British and Irish Impressionism prior to 1910. It is apparent in the style, as much as in the content of this particular *sacra conversazione*. At one level it justified the visual shorthand of Edwardian portraiture. At another it provided the underpinning for more esoteric investigations, following Monet into a more structured and fundamentally Post-Impressionist use of colour.

Eva Gonzales at work on a flower painting also captured ideas about handling and manner which were highly valued, and there may even be more to it than this. George Moore, if he is regaling the convocation with his recently published *Reminiscences of the Impressionist Painters*, dedicated to Steer, may well be declaring 'an article of faith ... There are Manets I like more, but the portrait of Mademoiselle Gonzales is what Dublin needs ... he who admires that picture is already half free – the shackles are broken, and will fall presently'.[19] Precisely what Moore meant by these utterances is unclear; it is just possible that he was equating the Dublin debates about freedom with the appreciation of a work of art.

The renewed emphasis upon Manet, a neglected associate of the Impressionists by 1906, is worth pausing over. Moore, like his other immediate colleagues in the *Homage to Manet,* had difficulty in accepting the direction which French art had taken after Impressionism. This was a view commonly expressed by some of the leading writers on art who were now in or approaching middle age.[20] It is an indication that the ground was beginning to shift. His infatuation with Manet, 'perhaps it was his dress – his clean-cut clothes and figure. That figure! Those square shoulders that swaggered as he went across the room ... obliged for the sake of his genius to separate himself from his class', may also have been a way of pulling Impressionism back to legibility from the indecipherable mapping of *'petits sensations'* in Cézanne.[21] This was certainly the second generation realist/Spanish Caravaggesque tack taken by Orpen in the painting of *Homage to Manet*. But it poses broader questions about the growth of understanding of Impressionist practice in Britain and Ireland.

In the early years of the century, knowledge and appreciation of Impressionism could be relatively easily acquired. The historical moment has to be understood, however. It was not simply a matter of reading MacColl, Moore or R.A.M. Stevenson. Substantial studies began to appear which demonstrated the desire, experienced throughout western Europe and America, to make sense of the art of the recent past. There were surveys of the century which was passing, in the form of grand exhibitions with commemorative publications. The goal was now to provide a coherent account of the recent history of painting which stressed developmental principles. In English these accounts were provided by writers such as William E. Henley, Philip G. Hamerton, Walter C. Brownell, Mrs Arthur Bell, J.E. Phythian, Haldane MacFall, MacColl and Moore, and a volume of essays on modern French painters under the editorship of John van Dyke.[22] There were translations from the original German of Richard Muther's monumental three volume *History of Modern Painting* and Julius Meire-

Graefe's *Modern Art*.[23] French authors such as Leonce Bénédité and Camille Mauclair were also translated, the latter of whom published two books in 1903, *The Great French Painters* and *The French Impressionists*.[24]

In each publication a slightly different story is told: there are different groupings, different patterns of influence and different centres of gravity. Dipping into each in turn, in quick succession, gives an exciting sense of history being formed, of the recent past being fashioned into a sensible and apparently logical progression. The historiography of Impressionism is particularly fascinating. Durand-Ruel is acknowledged as a collector, rather than a dealer, and is thanked for supplying the photographs. Having a powerful interest in the fiduciary value of the work of the Impressionists, he was naturally concerned about this history. The critics who were grappling with the recent past were, at one level, underwriting his stock. Nevertheless the relative coherence of the popular understanding of Impressionism in Britain was important in other respects. It clearly

supported avant-garde practice among British painters, gave them confidence in their work and, hopefully, extended British taste to the work of French painters.

What composite picture of modern French painting emerged in the early years of the century? The painters who were important to Muther, Van Dyke and Mrs Arthur Bell were supplanted around 1900. Mauclair in 1903 attempted a narrative which excludes the likes of Dagnan-Bouveret, Jean-Paul Laurens and Emile Carolus-Duran.[25] His account, although occasionally marred by factual errors, gives due prominence to Monet.[26] 'A radiant colorist', his work 'excels ... in suggesting the drawing of light'. Monet's recent studies of the Thames were 'thrillingly truthful visions of fairy mists, where showers of silver and gold sparkle through rosy vapours; and at the same time Monet combines in this series the dream-landscapes of Turner with Monticelli's accumulation of precious stones'.[27]

As Mauclair's books appeared, Wynford Dewhurst's was already in gestation. He followed Mauclair in his admiration for Monet, although his interest in Impressionist painting had first been generated as a result of seeing the work of Emile Claus in the Maddocks Collection in Bradford.[28] He had retraced Monet's steps, confessing that his most important artistic revelations as a painter occured in the val de Seine. There, for instance, at Les Andelys he discovered the violet light found in Monet's mid-day canvases. 'I remember distinctly, during the summer of 1901, at Les Andelys-on-Seine, that upon two days and for two hours in the afternoons of those days all Nature, animate and inanimate, bore the aspect of things seen under a strong glare of violet light, exactly as though a tinted glass were suspended between the sun's rays and the earth. The effect was most curious and disturbing. Nature appears to be toneless and flat. Highlights and shadows are attenuated almost to extinction, whilst in this dull purple glare the heat became more intense than ever, possibly through lack of wind, for all was still'.[29] Dewhurst's appreciation of these qualities in Monet's recent work is evident in his own. Not only did he position himself before Monet's motifs, he imitated Monet's style and at times, in such works as *The Picnic* (cat 57), in the juxtaposition of dabs of bright pigment achieved the palpable density of Monet's ether.

Dewhurst's book on Impressionism is an expanded version of four articles which had already appeared.[30] Its central thesis was that the Impressionists merely extended tendencies which had already been signalled in the work of Constable and Turner. This theory was not new, but it was given to Dewhurst to try to prove it. He

wrote to Pissarro in 1902, delving into his first London visit of 1870-71 when he and Monet had toured the museums. Yes, Pissarro replied, 'Monet and I were very enthusiastic over the London landscapes. Monet worked in the parks, whilst I, living in Lower Norwood, ... studied the effect of fog, snow and springtime. ... We also visited the museums. The watercolours and paintings of Turner and of Constable, the canvases of Old Crome, have certainly had influence upon us ... we were struck chiefly by the landscape painters, who shared more in our aim with regard to plein-air, light and fugitive effects'.[31] Pissarro recoiled from the over-emphasis Dewhurst placed upon this innocently expressed opinion. In May 1903 he wrote to Lucien, 'This Mr Dewhurst understands nothing of the impressionist movement, he sees only a mode of execution and confuses the names of the artists'[32] Monet and he did not rely upon Turner and Constable's 'conception of light ... in fact they had no understanding of the analysis of shadow'. Pissarro also wrote to Dewhurst pointing to the Impressionists' reliance on the French tradition of 'Clouet, Nicolas Poussin, Claude Lorrain, the eighteenth century with Chardin, and 1830 with Corot'.[33] But Dewhurst stuck to his guns and even summoned his friends Emile Claus and Maxime Maufra to underscore what Pissarro wanted to play down.[34] His theme was taken up by others as various as Clausen, John Rothenstein and Kenneth Clark.[35]

In the following years Dewhurst redoubled his striving to show that Impressionism was really British in origin. Perhaps aware of the current French affection for Ruskin, then being translated laboriously by Marcel Proust, he addressed the question 'What is Impressionism?' in a further article of 1911 in an effort to show that 'ninety per cent of the theory of impressionist painting is clearly and unmistakably embodied in one book alone of all Ruskin's voluminous output, namely, his *Elements of Drawing*'.[36] These valiant efforts to reconcile contradictions do not remove the authenticity of Dewhurst's painting which, if anything, became more vibrant as the First World War approached. He tried to retain his role as a polemicist, writing in *The Art Chronicle* as late as 1913 in an effort to reform the art establishment along French lines, much as La Thangue had endeavoured to do a quarter of a century earlier. He wrote more warmly of British Impressionists such as Clausen, La Thangue and Arnesby Brown, perhaps recognizing in their work a more structured approach to the problems of rendering open air light than could be found in the work of Sickert and Steer.

He may also have seen that there were new British Impressionists to come to terms with.

After years of experimentation and vacillation, Lucien Pissarro finally resumed his painting career in about 1903, producing landscapes at Southminster, Finchingfield (cat 177, 178) and Acton.[37] His friendships with James Brown, James Bolivar Manson and Spencer Gore were also productive.[38] His orthodox Impressionism was regarded as authentic, and for this he earned the encomium of Sickert.[39] Dewhurst had more sympathizers than he perhaps realized.

By this stage, however, Steer had espoused an almost archaic visual style while Sickert, on the other hand, remained convinced of the fertility of the broad approach to recording sensation which Impressionism had left. 'I have tried to recast my painting entirely and to observe colour in the shadows', he declared in 1910.[40] Although he recognized Ruskin in the distance, the struggle to elevate him to the present was not for him. For Sickert there was 'good painting', *la bonne peinture'*, practised to perfection in France, which avoided the timidity of watercolour and the tricks of glazing. It was 'fresh and clean in colour as a fresh herring'. It had begun in the generation of Géricault and its inheritors were Courbet, Manet and Whistler.[41] For Sickert this represented an absolute value and movements, tendencies and schools were less important. To Frederick Wedmore, Sickert was entitled to his 'benevolently autocratic' views, although it was clear that he liked the idea that there had been a moment in time when *la bonne peinture'* had been practised.[42] The important point derived from this was that there was a direct and clean one-to-one relationship between what was observed, the sensation, and the paint-mark on the canvas. From this a whole range of individual practices might emerge, although Sickert did not approve of them all.

Cat 177 **Lucien Pissarro**
Grey Weather, Finchingfield
1905
Southampton City Art Gallery

By the time the artist and critic Roger Fry entered the lists it was no longer possible to exclude Cézanne, Seurat, Gauguin, Van Gogh and a host of minor European modernists from the debate. The question was how far one should go in receiving these new visual ideas. Fry had been exhibiting with the New English since 1894, but following his conversion to Cézanne he began to reassess his position. His views were first expressed in 1908 when *The Burlington Magazine* published a review of the current International Society exhibition entitled 'The Last Phase of Impressionism'. The writer was generally approving of the three works by Monet in the show, but those of Signac and Gauguin began to strain the senses. With Matisse 'the movement reaches its second childhood'.[43] The writer implied that with these painters we were seeing a decadence which must now be overturned to make way for something new.

There was a kind of modernist dialectic here, but it was too much for Fry. He dashed off a letter in which he tried to demonstrate the continuity of thought between the original Impressionists and their younger followers. To do this he had to show how Cézanne, Signac and the others had developed the original ideas. There was a lot of fuzzy thinking to sort out. Impressionism had not been concerned with the rendering of form so much as 'that aspect of appearance in which separate forms are lost in the whole continuum of sensation'. He elaborated upon this in *An Essay in Aesthetics* which followed in 1909. Commenting upon the degree to which critical opinion was formed by convention, by the 'specialization of vision', he concluded that 'ordinary people have almost no idea of what things really look like' and 'the moment an artist who has looked at nature brings to them a clear report of something definitely seen by him, they are wildly indignant

at its untruth to nature'. This had been Monet's role, 'but his really naive innocence and sincerity were taken by the public to be the most audacious humbug'. It required the 'teaching of men like Bastien-Lepage' to mediate this faithful rendering of sensation for it to gain acceptance at all.[44]

From 1906 onwards, however, Fry was conscious of the need to articulate new goals which ultimately took the debate away from Impressionism and, by exposing its deficiencies, created that ground which would be occupied by Cézanne and the Post-Impressionists. If one was to compare Cézanne's 'still-life in the International Exhibition with Monet's, I think it will be admitted that it marks a great advance in intellectual content. It leaves far less to the casual dictation of natural appearance. The relations of every tone and colour are deliberately chosen and stated in unmistakable terms'.[45] For Fry this painter was clearly ahead; he was making something more than a mere reflection of 'the continuum of sensation'.

This starting point for the discussion was accepted. The Impressionists were not concerned with separate forms, three dimensionality and verisimilitude. They were articulators of the 'whole continuum' to such an extent that artists and photographers of the period believed that what they actually saw was the 'whole continuum'. This radicalism, this desire, in Rothenstein's terms, 'to free the eye from the corruption of knowledge', displacing the hierarchies of intellect and the accumulated baggage of picture making, expressed the ambition of Impressionists throughout Europe and America.[46] With this as the starting point there was a new way forward. The modernist progression was clear.

The London Impressionists at the Goupil Gallery
Modernist Strategies and Modern Life

Anna Gruetzner Robins

The London Impressionists exhibition opened at the Goupil Gallery, 116-117 New Bond Street, on 2 December 1889. Plans for the show had in mid-August been released to the press where they received a mixed reception, from interest to derision. In September Sickert, interviewed by Herbert Vivian (the future editor of the *Whirlwind*) on Impressionist art for the *Sun*, gave a list of the exhibitors.[1] He named them as they were to appear: Francis Bate, Fred Brown, Francis James, Paul Maitland, Theodore Roussel, Bernhard and Walter Sickert, Sidney Starr, Philip Wilson Steer, and George Thomson. D. Croal Thomson, the manager of the Goupil Gallery, invited them to show.

Although some critics expressed surprise that Sickert should accept an invitation from a dealer, the exhibition was clearly a coup. The artists were given the larger of the gallery's two rooms, the same room where twenty *Impressions by Claude Monet* had been shown the previous April, as many reviewers pointed out.[2] Some London Impressionists had been recognized as 'impressionists' at the Royal Society of British Artists. This core group of Roussel, Sickert and Starr joined forces with Steer, and Brown, Steer's inseparable friend and ally, when they went to the New English Art Club.

The Impressionist clique, as they were called by the New English critics, needed another exhibition forum after their plans to take over the

Club were opposed. The five other members of the London Impressionists group had joined for a variety of reasons. James was a member of Whistler's group whose choice of the watercolour medium meant that his work had gone virtually unnoticed in exhibitions dominated by oil paintings. 'I don't suppose that one of the forty [referring to the forty Royal Academicians] has ever heard of the watercolours of Francis James?', said Sickert.[3] Maitland, a pupil of Roussel, was brought in at Roussel's suggestion: '*Si vous saviez comme le petit Maitland est content d'en être* [sic],' Sickert recalled Roussel saying.[4] Bate, the newly elected N.E.A.C. secretary, was sympathetic to plein-air Impressionism and held the view that modern artists should be mutually supportive and organized in groups as a way of combating 'the cold indifference or antagonism of older custom'.[5] Sickert's brother Bernhard was an obvious choice. Thomson had a studio in Trafalgar Studios, Manresa Road, Chelsea, in the same complex of purpose-built artists' studios where Steer worked.

What of women artists? Sickert and his wife Ellen Cobden had courted Elizabeth Armstrong, who painted impressionistic modern life scenes of children, and asked her to their soirées, much to the annoyance of her fiancé Stanhope Forbes who was not invited. Florence Pash ran an art school where Sickert taught, she sketched with him in the

music-hall and had her pictures illustrated in the *Pall Mall Gazette* 'Pictures of the Year' (fig 31), in company with the London Impressionists. Bate, who ran a school for Impressionists which included women, declared that 'there is no question of sex either in the artist [who paints] or the person who sees the [Impressionist] picture.'[6] Later, as secretary to the N.E.A.C., he invited Berthe Morisot to exhibit.[7] Nevertheless, at this stage the London Impressionists' Goupil show did not include women.

Working from the left of the entrance to the Goupil Gallery, the sixty-nine pictures were hung by artist, with individual groups of pictures in the following order: Starr, James, Thomson, Bernhard Sickert, Steer, Brown, Maitland, Roussel, Bate and Walter Sickert.

The press coverage was extensive. To date forty-nine reviews have been traced, many of them appearing on the opening day, two days after the private view (fig 32). By the end of the week, 'Goupil's [was] crowded – absolutely blocked'.[8] The consensus was that the show was one of the highlights of the autumn season in the London art world.

The majority of the press reviews were comparable in length to those covering the New English shows, but the London Impressionists had competed with two pictures at the New English. The club's consititution allowed each member to send two works to its annual spring exhibition. At the Goupil, Starr showed nine works, James twelve, Thomson six (two drawings were ex-catalogue), Bernhard Sickert six, Steer eight, Brown five, Maitland six, Roussel seven, Bate five and Walter Sickert four, (Sickert's *Trefolium*, although listed in the catalogue, was not mentioned by any of the critics).

Twenty-three critics were against the show; sixteen wrote more or less favourably; and a small group emerged who remained firm supporters of the London Impressionists. They were Alfred Lys Baldry, George Moore, Elizabeth Robins Pennell and Frederick Wedmore. Baldry was a pupil of the painter Albert Moore, an exponent of art for art's sake and critic of the *Artist and Journal of Home Culture*; Moore was an enthusiastic supporter of the London Impressionists who had reputedly been asked to write the catalogue preface for this show, although in the event this was done by Sickert. Moore had reviewed the eighth and last Impressionist exhibition in Paris in 1886 for the *Bat*, a gossip rag for the man-about-town. Moore reviewed the Goupil show for the *Hawk*, a short-lived periodical edited by Augustus Moore before he was appointed critic to the *Speaker* in 1890. In the 1880s Moore moved in literary Symbolist circles, and was praised by the Symbolist writer Gustav Kahn in *La Revue Indépendante* (1888), for

introducing Manet, Degas and other less well-known figures to the English.[9] Elizabeth Robins Pennell wrote for the *Star*, and held a 'salon' with her husband Joseph Pennell which the London Impressionists attended. Her contribution to the New Art criticism has frequently been overlooked. Wedmore was a long-time enthusiast of the French Impressionists who wrote signed reviews for the weekly journal, *The Academy* and more popular criticism for the *Standard*, a daily newspaper.[10]

The London Impressionists could also rely on Sickert's art criticism, interviews and catalogue prefaces to proselytize on the group's behalf. As the *Artist* commented: 'the quickest way (now-a-days) of reaching the greatest number, is by the penny press.'[11] All this secured the reputation of even the lesser known exhibitors, introduced the London Impressionists to the public and thrust them into the limelight.

Since only ten of the sixty-nine Goupil exhibits can be positively identified, with four more existing in reproduction, the descriptions in press reviews of untraced pictures provide useful information about the Impressionists' subjects and their painting techniques. There were many more paintings of modern London life than previously thought, indicating a strong group commitment to the theme. There was also what was perceived by the critics as a wider dependance on Degas and Monet than has been recognized. When Sickert was asked whether the London Impressionists should be compared to the Société des Impressionistes, the artist, who had seen several of their exhibitions, emphatically declared: 'Although that society has been and is the means of exhibiting some of the very finest work of modern times, we should certainly demur to a definition of Impressionism drawn from its exhibition as a whole'.[12] Although he denied that the London Impressionists had a close affinity with the French, he was aware of the historical and political meaning of Impressionism. 'Impressionist', he said, 'was a name they will give us in the papers', meaning they would be dubbed as such by

a critic, just as the French Impressionists were labelled by a critic who saw Monet's *Impression, Sunrise* in the first exhibition in 1874.

The very word Impressionist sparked the critics. Fourteen of them told a story of the Impressionist movement, with Degas and Monet as key players. Few spared any reference to the French. The details of the story varied, but whether they gave a partial account or conflicting views of it the story was told, and it clearly played a part in the myth-making about Impressionism in the English-speaking world.[13]

A comparison of the following three stories confirms that labelling in art was as hazardous a business then as it is today. The critic of the *Leeds Mercury* gave a potted history of the French Impressionists which was quickly becoming a cliché. They were 'a certain clique of young Frenchmen, revolting from tradition and seeking liberty at any cost ... to attract notice ... by startling eccentricity and unblushing charlatanism'.[14] The critic in the *Saturday Review* who was probably

R.A.M Stevenson, a former art student in Paris and an outspoken critic of the Royal Academy in his regular column, stressed the links between the original Impressionists and their Salon followers: 'The French group which formed itself around Manet, and which taught so much to Bastien LePage, Duez, Dagnan Bouveret, and others who never belonged to it, has now enlarged and become a power in art-life'.[15] George Moore in the *Hawk* stressed that contemporary French art, far from being characterized in one seamless definition as Impressionism implied, was distinguished by many new movements. 'France is honeycombed with schools of art ... Decadents, Symbolists, Impressionists, Sensationists, Intentionists, &c. – flit across my mind like visions'.[16]

The term Impressionist was a useful label but Sickert, who had heard Degas speak out in favour of national schools and who was not immune to the debates about Englishness that were circulating, did not wish the London Impressionists to be too closely compared to the French.[17] Hence his wilful statement to Vivian in their September interview that Velázquez, the illustrator John Leech and Holbein were all Impressionists.[18] Thomson played the same card in the London Impressionist manifesto, published in the *Pall Mall Gazette*, where the list of Impressionists is exclusively English: Gainsborough, Hogarth, Wilson, Crome, Constable, 'that arch-Impressionist Turner', Whistler and Charles Keene, an illustrator admired by Degas and Sickert.[19] Steer, too, later stressed their English and Old Master antecedents when he gave an address on Impressionism to the Art Workers' Guild in 1891, saying Phidias, Giotto, Veronese, Velázquez, Gainsborough and Reynolds were all Impressionists.[20]

Fig 32 *Private View Invitation, The London Impressionists* Tate Gallery Archive 739.1

The debate about originality was a central aspect of the critical commentary on the London Impressionist show. Whether discussed by favourable critics or the negative, less partisan, conservative press, the question of influence was an issue. It was clear to the reviewers of the London Impressionist show that Degas and Monet were the mentors for the majority of the group, while Sickert and Thomson's English and Old Master precursors were more difficult to detect. When we consider that Sickert took a lively interest in Degas and that Thomson was looking closely at Monet, then their lack of reference to these artists must be seen as an attempt to avoid comparison with the French Impressionists in what was an increasingly Francophile climate. Faced with a contradiction between what they had been told and what they saw on the gallery walls, most trusted the evidence of their eyes and discussed, compared and complained about these French influences. And so the London Impressionists were frequently cast as simple imitators of the French Impressionists, which was probably their greatest fear.

Most critics shared an underlying anxiety about the influence of Degas and Monet on these London artists. Most had seen the recent Monet show at the same gallery, and they used this as a touchstone to determine the originality of Steer, Bernhard Sickert and Thomson; all three were seen to be Monet imitators. Sickert and Starr were compared to Degas. Maitland and Roussel were identified as followers of Whistler. There were complaints about Steer being a Monet 'pasticher' who painted Monet 'manqué' pictures. His *Knucklebones* (cat 210) was not compared to Monet, but Elizabeth Robins Pennell said his other London Impressionist seascapes 'mastered his method' and 'appropriated Monet's subjects'. Unfortunately these works have not been identified. Pennell also identified Thomson as a student of Monet and complained that Bernhard Sickert, Steer and Thomson had leaned too heavily on Monet, who 'has thrown his tremendously powerful influence over the whole Continent'.[21] They had stopped seeing for themselves. Bernhard Sickert's *The Top of the Morning* and *In Dunford Roughs*, Thomson's *By the Sea* and *In Kew Gardens* and Steer's *The Beach, Walberswick*, *The Outer Wall*, and *The Mill Stream* were all compared to Monet, and all are untraced. The consensus was that the recent Monet show in London had been an important stimulus.

Whether these assessments were correct, or even necessary, is not the point. The critical debate, which centred on the issue of borrowing and influence and the role of originality, was later recognized as a key issue of modernist art practice.

This lost history adds yet another dimension to the Goupil show and to our assessment of the response to Impressionism in England. In spite of the historical evidence, it does not validate an interpretation of Steer's seascapes as simply evidence of French influences. Steer's painting was a sophisticated amalgam where a variety of experimental brushstrokes represented a painterly expressiveness. Only rarely do the brush techniques have a coherent structure which corresponds to the form and textures of beach and sea. This explains why Steer could introduce a dotting technique into his painting programme as an interesting-looking painterly addition, without strictly adhering to the *pointilliste* technique of neo-Impressionism. Most of Steer's seascapes included young girls or women but, as Sickert recognized when writing about *Knucklebones*, the image was a synthesis of 'child-nature',[22] rather than a simple casual grouping of children. By the 1890s the expressive brushstrokes, bright colour and children in Steer's seascapes were symbolic of innocent pleasure.

French Impressionism, of course, was not simply about new painting techniques, startling chromatic colour contrast and unusual compositions. It was also the painting of modern life. Recent scholars have shown that both form and meaning were perceived as radical, and that they were mutually supportive in their challenge to established pictorial convention.[23] Whether this occurs in London Impressionist painting is more problematic, but one thing is certain. When painting modern life the London Impressionists looked to their own milieu and culture. As Sickert pointed out, 'We don't go back to other days, our history is of today'.[24]

Fig 33 **Walter Richard Sickert**
The Oxford Music Hall
c.1888-89
Art Gallery of New South Wales, Sydney

The Painting of Modern London

'In its search through visible nature ... it does not
admit the narrow interpretation of the word
"Nature" which would stop short outside the four
mile radius. It is ... strong in the belief that for
those who live in the most wonderful and complex
city in the world, the most fruitful course of study
lies in a persistent effort to render the magic and
poetry which they daily see around them'.[25] Sickert
said subsequently that his preface to the London
Impressionist catalogue gave 'a partial and
negative definition of Impressionism'.[26] However,
he expressed no change of heart about painting
his own capital city. His project to paint the 'four
mile radius' of London was a reference to London
in its most up-to-date form.

In 1888 a new governing body, the London
County Council, was forced to give administrative
shape to London's increasing geographic sprawl
and ever-expanding population, which had
reached an estimated four million. The L.C.C.
absorbed a patchwork of sixty old parish councils.
Its outer boundary was determined by the four
mile radius from the geographic centre of

London, the statue of Charles I standing directly
south of Trafalgar Square at Charing Cross. The
new boundary encompassed a vast area, skirting
south of the river to Wandsworth in the west and
Greenwich in the east, north past Hackney to
Islington and Camden and west to
Hammersmith.

Charing Cross was the heart of late nineteenth-
century London's consumer and entertainment
district. Along the Strand running east from
Charing Cross were seven theatres, a number of
music-halls and endless restaurants, (*Baedeker's
Guide*, 1889, recommended twenty-one in the
immediate area). After the new 'monster' hotels
were built in the 1880s, symbols of capitalist
luxury and consumption on a grand scale,
Charing Cross was the recognized hotel centre
of London.

But the London Impressionists for the most
part avoided painting the centre of the 'largest,
most populous and wealthy city' in the world. Most
commentators described the overwhelming sense
of confusion in the city centre.[27] To be a *flâneur*
among the London crowd was no easy business.
Sickert's *Gatti's Hungerford Palace of Varieties* (cat
198) depicts a segment of the Charing Cross

crowd, but it is contained by the cramped, darkened interior space (the hall was in a side street running up from Charing Cross Station).[28] The three music-hall pictures Sickert sent to the Goupil depicted halls further north. *The Oxford Music Hall*, (fig 33) was at the corner of Tottenham Court Road and Oxford Street. *Little Dot Hetherington at the Bedford* and *The P.S. Wings in the O.P. Mirror* depicted the Bedford music-hall a mile directly north of the Oxford in Camden Town.

Different music-halls had different reputations. The Oxford was an immense hall known as a place where 'respectable, hard working family men and women assemble in their hundreds to enjoy a programme void of offence and pleasing to the eye and ear'.[29] This may explain the broad panoramic view that Sickert gives of this large hall and its respectable audience. The two mirror reflections and complex spatial organization in *Little Dot,* and the play between the mirror reflection and the real space of the stage in a version of *The P.S. Wings*, illustrate two different, less than straightforward relationships between the performers and their audience. In an uknown version of *The P.S. Wings* (fig 34) the contrast between the 'real' audience and the artificial reflection is even more noticeable.

Nineteenth-century observers compared London to a labyrinth, an image which took form in Arthur Conan Doyle's detective stories where Sherlock Holmes confronts the mystery of the maze, made more obscure by the ever-present dense fog. The centre of the labyrinth and the key to a route out was at Charing Cross, which Charles Alvin Gillig's *London Guide* (1890) advised was the 'intersecting point of the principal omnibus lines, the underground and railway stations, and the steamboat piers'.[30] London's vast size, chaotic traffic and disparate street plans made it virtually unnegotiable to a pedestrian, and all London guidebooks advised visitors to use some form of transport. The route map of London's two hundred omnibus lines, with 1,600 omnibuses (1888), made its own criss-crossing web. The dark green city atlas belonged to a group of thirty-three London omnibuses distinguished by different names and colours. In Starr's *The City Atlas* (cat 208) the omnibus is seen travelling up the Finchley Road in St John's Wood, with one lone female passenger, who is possibly a servant, on top. (It had only just become acceptable for women to sit there.) The omnibus is nearing the end of its route between Swiss Cottage north of St John's Wood and Bank in the City. In contrast to the leafy aspect of a London suburb on a summer's evening, Starr's *The Marble Arch* (untraced) showed a bird's-eye view of the scurrying London crowd on Oxford Street at

Marble Arch, and an empty Hyde Park beyond at the end of a bleak winter afternoon. Starr continued the theme of modern transport in *Weybridge Station* (untraced), a railway station used by London commuters. Thomson's *Kew Gardens* (untraced) of the botanical gardens on the western outskirts of London, soon also to be painted by Camille Pissarro, showed another spot which improved the transportation network made accessible to Londoners.

Hyde Park was frequented by the rich and privileged, the daily parade of whom was a much discussed feature in the London guidebooks. Entrance was restricted to those who travelled in their own carriage, so public cabs were barred. Ordinary pedestrians were relegated to being onlookers of the spectacle. Monet's views of Hyde Park and the adjacent *Green Park*, (cat 139), where the lower middle classes relaxed, do not specifically allude to the class difference of these two public spaces. As these paintings cannot be found it is difficult to assess how George Thomson's *A Spring Evening in the Row, An October Day in the Row* and Roussel's *Rotten Row* (started but not finished in time for the Goupil show) reflected these social structures.[32] But the reviews show that Thomson's atmospheric views of Hyde Park in different seasons and at different times of the day complemented Starr's wintry early evening

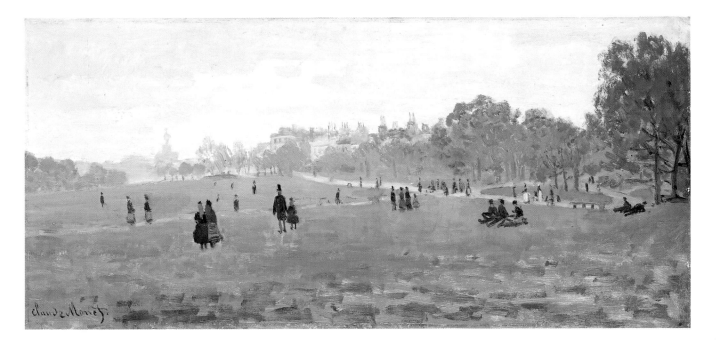

view of Hyde Park seen in *The Marble Arch*.

Painting out-of-doors at specific times of the day in different weather conditions and seasons has become a commonplace way to define Impressionist landscape painting. This was a key issue for some London Impressionists, who questioned the more contrived methods of obtaining plein-air effects used by some of their contemporaries such as Stanhope Forbes. Bate explained: 'When you look at the picture of an Impressionist you ought at once to be able to tell whether it is indoors or out-of-doors, the weather, and the time of day'.[33]

Some of the London Impressionists depicted more peripheral areas of London such as Battersea, Chelsea, Fulham and St John's Wood. Like Whistler, both Roussel and Maitland depicted Chelsea and the less glamourous Battersea directly across the river. Chelsea had been an eighteenth-century village with pottery works and a market garden economy, and numerous coffee houses which brought visitors by river from the metropolitan centre. By the late nineteenth century it had become another pocket in the vast residential sprawl of London. Guidebooks still praised its picturesque charm, noted old architecture and other beauty spots, but neither Whistler nor Roussel and Maitland depicted these pretty aspects. Baudelaire had praised Whistler's first London etchings of the industrial riverside in the East End. At Chelsea Whistler sought out modern contrasts to the largely eighteenth-century architecture on the north side of the river. His *Nocturnes* frequently show the slagheaps, warehouses and factories with smoking chimneys in

what Henry James called 'the dreary waste of Battersea'.[34] Across the river from Lindsey House, where Whistler lived for a time, were the graphite-burning chimneys of Morgan's Patent Plumbago Crucible Co., with its distinctive 100-foot clock tower.[35] The factory rapidly expanded during Whistler's lifetime, adding chimney after chimney that belched smoke so poisonous that the company was prosecuted several times for air pollution.

While the *Nocturnes* portrayed industrial Battersea through an atmospheric veil, Roussel and Maitland brought the shoreline into sharper focus, by concentrating on single motifs – a factory, a wharf, a warehouse or a barge carrying raw supplies or waste. Sickert's engraving after Roussel's untraced *Plumbago Works, Raining Evening*, shows a close up view of the bleak facade of the Morgan Crucible Co. Invoking a Baudelairian view of modern urban life, Sickert praised the beauty of its industrial motif and the sensational atmospheric effect of 'the sulphurous break in the leaden London sky'.[36] *Blue Thames, End of a Summer Afternoon* (cat 185), of Chelsea Reach with rivercraft and a messy group of factories in the distance, Roussel's *The Barge* and Maitland's *A Vestry Dust Wharf* (untraced) all showed industrial aspects of the Thames.

In the 1880s Whistler found a new motif of the prosaic, everyday aspect of London life: the shopfronts of greengrocers, butchers, beer retailers and other provision merchants. Whistler's London shopfronts were painted mostly in his own Chelsea neighbourhood, where a large number of the London poor lived, but of course they could be

Cat 185 **Theodore Roussel**
*Blue Thames, End of a Summer
Afternoon, Chelsea* (detail)
1889
Private Collection

Fig 35 **Paul Fordyce Maitland**
*Three Public Houses, Morning
Sunlight* 1889
Tate Gallery, London

found all over London. Windows stacked with groceries and other staples interrupted the monotonous uniformity of residential streets. To the London poor, they must have appeared as ostentatious displays of luxury. George Sim's sensational journalistic exposé, *How the Poor Live*, [37] and other sociological surveys, showed that poverty put even staple foods beyond reach. It was revealed that the very poor lived mainly on a diet of bread and dripping. It was also alleged that any disposable income was spent on alcohol.

Maitland's *Three Public Houses, Morning Sunlight*, (fig 35) is a Chelsea shop scene, but the title, which refers to the King's Arms, a public house carrying an advertising sign for Combe's

Fig 36 **Bernhard Sickert**
Drawing after *The Cinder
Path*, reproduced *The Sunday
Chronicle* 15 December 1889

THE CINDER PATH.

Ales, and the two beer retailers at each end of one small section of Cheyne Walk (nos. 113 to 117), confirmed the public's worst fears about the lure of alcohol. 'His choice of subject is beneath contempt', said the *Echo*.[38] Whistler had painted another Chelsea public house at night and then declared the subject meaningless, but Maitland's images made the public house too visible to be ignored. A map produced by the National Temperance League in 1884 showed the proliferation of public houses throughout London, with the highest concentrations in the West End and in poor areas. No respectable middle class person would have frequented these popular establishments. Roussel also sent a public house subject, *The Pub, Cheyne Walk* (untraced), to the Goupil show and both he and Maitland were chastised for their lack of taste. Public houses, said the *Star*, were 'an eyesore to the respectable Briton, and a thing of horror to the average artist'. [39]

Other London landscapes in the Goupil show depicted unsightly views and motifs that challenged established pictorial conventions. Bernhard Sickert's *The Cinder Path* (fig 36), of two cyclists at the Stamford or Lillie Bridge in Fulham, was said to be a perverse example of beauty. Maitland's *The Budding Tree* which 'buds audaciously in no country coppice but in front of a

town residence genteel and commonplace',[40] Steer's *The Tannery* (untraced) which may have been of a London industrial subject; and Francis Bate's *By an Old Mill Stream* (untraced), a rural scene at Christchurch, Hampshire, with a 'squat bulgy tubby little fishing punt ... (a) floating abomination', were all castigated for their 'sheer unmitigated ugliness'.[41]

The London Impressionists' preference for whatever is 'mesquin in ordinary eyes' was dismissed contemptuously by their hostile critics. What their supporters said demonstrates how the debate about form versus meaning, which emerged in the new art criticism when Degas' *L'Absinthe* was shown in London in 1893, had its origins in the response to the London Impressionist subjects. Sickert's *Twilight*, which a sketch in the *Sunday Chronicle* (fig 37) shows to be York City Art Gallery's *The Butcher's Shop* (fig 38), illustrates their dilemma. Whistler had said that London's atmospheric veils of fog and twilight turned his industrial subjects into images of beauty. In Sickert's *Twilight* the tension between the aestheticizing effect of the London atmosphere and the 'lofty theme of a row of dead pigs outside a butcher's shop'[42] is more overt, and made deliberately so by Sickert's title.

Baldry, Elizabeth Robins Pennell, Moore and Wedmore all took the view that light effects, whether real or artificial , and the arrangement of form and colour took precedence over what they still recognized as being suspect subject matter. They would be joined by D.S. MacColl in 1890 when he reviewed the London Impressionists at the N.E.A.C. for the *Spectator*. The new critics took this view each time a London Impressionist sent a 'questionable' modern London subject to the

Fig 38 **Walter Richard Sickert**
The Butcher's Shop 1884
City Art Gallery, York

N.E.A.C. As London, the modern Babylon, became increasingly associated in the respectable middle class imagination with poverty, disease and moral contagion, the new critics asked if these modern London subjects were really necessary. As a result, these *flâneurs* of the London suburbs settled for less controversial images.

The Goupil records for the London Impressionists Exhibition have not survived. The fact that the group did not exhibit at the gallery again suggests that it had not been a profitable venture. Instead, they held regular shows in Sickert's studio and advertised them in *The Whirlwind*. Their main exhibition venue was the New English, where they took control of the club's committee after ousting the Newlyn group and the Glasgow Boys. Their quarrel with these groups concerned differing versions of 'impressionism'.

In 1892 the London Impressionists lost some of their own members. Starr emigrated to America; Roussel resigned from the New English and took Maitland with him following an argument with Sickert over club policy. It must have been a heated disagreement because the following year Sickert exhibited a highly satiric portrait of Roussel at the club, which most critics thought took the art of caricature too far. The group identity which they had established between 1889 and 1892 quickly dissolved. However, their calculated manoeuvres to establish themselves as the dominant Impressionist group has a place in the development of British modernism.

TWILIGHT!

Fig 37 **Walter Richard Sickert**
Drawing after *Twilight*,
reproduced *The Sunday
Chronicle* 15 December 1889

Catalogue

Kenneth McConkey with Ysanne Holt

Dimensions in the catalogue are given as height preceding width

Patrick William Adam 1854-1929

Adam was born in Edinburgh and attended the Edinburgh Academy. He studied at the RSA schools under William McTaggart and George Chalmers, and was awarded the Melanie Walters medal for best painting from life. In 1878 he was elected ARSA and in 1897 RSA. Initially Adam worked as a portrait painter, but he turned increasingly to the study of interiors for which he is best remembered. He travelled to Venice on several occasions between 1889 and 1894, and painted views of the Seine in Paris towards the end of that period. These were followed by a group of landscapes depicting wintry scenes from around 1896. Adam settled finally in North Berwick in 1908. There he continued to produce his studies of interiors, working in pastel as well as oil and developing a reputation for pictures which were charming, if slightly sentimental.

Patrick J. Ford, *Interior Paintings by Patrick W. Adam*, 1920

1 **THE KEEPER'S HOME** (ill. p.98)
1895
oil on canvas, 45 x 26 in / 114.3 x 66 cm
inscribed bottom left, P.W. Adam, 1895
DUNCAN R. MILLER FINE ARTS, LONDON

Adam painted *The Keeper's Home* shortly after his return from Paris. It may be assumed that the experience of the previous year had made him thoroughly familiar with the work of the Impressionists. The audacious handling of colour owes something to the work of the Glasgow Boys, who acted as Adam's mentors in the early 1890s.

James Craig Annan 1864-1946

James Craig Annan had an established family background in photography; his father was Thomas Annan, who was well-known in Scottish photographic and artistic circles. The family firm, T. & R. Annan and Sons, built its reputation largely on its skilled photogravure printing which was a relatively new technique in the 1880s. Annan was largely responsible for that side of the business after his father's death, as well as for much of the portrait photography. He was also an early devotee of the hand camera, which he used particularly when travelling. By 1893 some contact with Whistler had been established, and the latter described examples of his work as very fine pictures rather than simply photographs. In the same year Annan became a member of the Linked Ring, achieving an international audience as a result.

William Buchanan, 'James Craig Annan, Brave Days in Glasgow', *The Golden Age of British Photography*, catalogue of an exhibition at the Victoria and Albert Museum, London, 1984, pp.170-73.

2 **IL REDENTORE (THE FRANCISCAN), VENICE** (ill. p.98)
1907
gravure print, 7½ x 5½ / 19 x 14 cm
THE ROYAL PHOTOGRAPHIC SOCIETY, BATH, GIFT OF
ALVIN LANGDON COBURN, 1930

5 Jules Bastien-Lepage
Going to School (La petite coquette) 1882

regarded as particularly successful. In 1886, along with his art dealer father, Bartlett was heavily involved on the committee of the newly formed New English Art Club, but he resigned after La Thangue's plan for reorganization failed. He travelled frequently, in search of his ideal painting sites, to France, Italy and Ireland. He was also a regular summer visitor to St Ives, whose 'old-world charm' he described in 1887 in a lengthy illustrated article in *The Art Journal*. The Fine Art Society staged a one-man exhibition of his pictures, 'The Basse Seine', in 1892. Bartlett lived mostly in London, but also in Kent and at Ventnor on the Isle of Wight.

The Art Journal, 1894, pp.247-51.
The Art Journal, 1897, pp.292-95.

> 3 **THE NEIGHBOURS** (ill. p.22)
> 1881
> oil on canvas, 39 x 50¹/₈ in / 99.1 x 128.3 cm
> inscribed bottom left, W.H. Bartlett, 1881
> COLLECTION MR AND MRS MALCOLM WALKER

The Neighbours provides a valuable insight into the life of art students in Paris in the early 1880s. While documenting their way of life in graphic detail, Bartlett adds anecdotal romantic interest by inserting the young woman neighbour in the garret opposite. Art students were socially equivalent to this working girl, even though they may have come from solid middle class families.

Jules Bastien-Lepage 1848-1884

Bastien-Lepage came from Damvillers, a village in north-eastern France, of a farming family. Initially he was directed by his parents to a career in the civil service, but his success as a part-time student of drawing led him to study full time at the atelier of Cabanel in Paris. His career was, however, retarded by wounds sustained in the Franco-Prussian War, and he did not achieve critical acclaim at the Salon until 1874 when his *Portrait de mon grandpère* was shown. In 1875 he was on the point of winning the Prix de Rome when the award was wrested from him by Léon Commere, an older and hence more worthy, but less gifted, pupil of Cabanel. This failure to win official approval had a significant effect. Bastien returned to his home village and henceforth painted only peasant subjects, which often aroused hostility with their apparently blatant objectivity. However, as a naturalist painter concerned with the individual in a quite specific location, Bastien sought to extend rather than restrict his range of subject matter. Accordingly he applied the same principles of observation to his 1880 Salon entry *Joan of Arc listening to the Voices*. This uncomfortable blend of realistic truth and legend initiated a further storm which only abated when he seemed to return to the contemporary peasant in works such as *The Mendiant* and *Le Père Jacques*. Many of these later pictures contain a covert symbolism which was not lost on contemporary reviewers. In addition to portraying local characters from Damvillers Bastien also exhibited one or two significant paintings made in London in the summer of 1882. He died prematurely in 1884 of stomach cancer. By that time his influence was extensive, with painters of all nationalities imitating his style. He was therefore

Craig Annan was as critically aware of the artistic debate as P.H. Emerson, but was not a polemicist to the same degree. Although his visual sources are related to Scottish art, his abstract sensibility in images such as *Il Redentore* was strikingly original. While references to Crawhall and Melville are appropriate, they do not fully explain Annan's acuity of observation.

William Henry Bartlett 1858-1932

Bartlett studied in Paris in the mid 1870s at the Ecole des Beaux-Arts under Gérôme, and at the Académie Julian under Bouguereau. His painting *The Neighbours*, 1881, is a memoir of those student days. He returned to London around 1880 and exhibited at the Royal Academy from that date. In 1889 he was awarded a silver medal at the Paris exhibition. As a result of his training in France, Bartlett developed particular interests in genre and pastoral themes which were influenced by Bastien-Lepage. Subjects associated with the sea also featured regularly in his paintings and these were

perhaps the most significant of all the later French naturalist artists.

André Theuriet, *Jules Bastien-Lepage and his Art*, 1892.
Kenneth McConkey, 'The Bouguereau of the Naturalists: Bastien-Lepage and British Art', *Art History*, vol. 1, no. 3, pp.371-82.

4 STUDY FOR 'LES FOINS' (ill. p.21)
1878
oil on canvas, 15¼ x 19¾ in / 40 x 50.2 cm
inscribed lower right, à mon ami J. Wencker –
J. BASTIEN-LEPAGE '78
PRIVATE COLLECTION, COURTESY PYMS GALLERY, LONDON

This study of a pair of exhausted field workers in the haze of a mid-summer hay harvest was painted on Bastien-Lepage's return to his home village of Damvillers after his failure to win the Prix de Rome in 1875. As such it signals his new resolve to paint only peasant subjects. The obvious fidelity to actual conditions seen here provoked much harsh criticism, but it is symptomatic of Bastien-Lepage's naturalist aim to observe and record particular individuals in particular situations.

5 GOING TO SCHOOL (LA PETITE COQUETTE) (ill. p.99)
1882
oil on canvas, 31¾ x 23½ in / 80.6 x 59.7 cm
inscribed bottom right, J. Bastien-Lepage, Damvillers, 1882
CITY OF ABERDEEN ART GALLERY AND MUSEUMS COLLECTIONS

Exhibitions
1896 London, Royal Academy of Arts,
 Winter Exhibition.
1981 Cleveland, Ohio, Cleveland Museum of Art, *The Realist Tradition, French Painting and Drawing 1830-1900*.

This painting of a young girl on her way to school was exhibited at the Academy mistakenly under the title *Portrait of Marie Bashkirtseff*, thereby causing much confusion. The subject may originally have been intended to accompany a piece of writing by André Theuriet, which appeared after Bastien-Lepage's death as *Les Mois Rustiques*. This contained a chapter on village childhood, describing the new phenomenon of French children from the age of eight trudging along country lanes to school early every morning. The demure schoolgirl seen here contrasts with the attitude of the ragged urchin who appears in *Pas Mêche*, dated that same year, but in both works the use of diagonals within the composition firmly relates the figure and setting and gives the impression of individuals firmly rooted in their specific milieu. There is, however, an element of ambivalence in this. *Going to School* was originally exhibited in the United Arts Gallery in London as *La Petite coquette*.

Francis Bate 1853-1950

Bate trained at the Government Art Training School, for which he received a scholarship, and in 1883 at Verlat's

6 **Francis Bate**
The Weeping Ash c.1895

Academy in Antwerp. Established largely as a genre and landscape painter, he exhibited from the mid 1880s at the Grosvenor Gallery, at Suffolk Street and, more frequently, at the New English Art Club, where he was honorary secretary and treasurer from the early days until 1919. Contemporaries there praised his sound business sense, and several credited him with keeping the Club afloat during its difficult early years. He was represented at the London Impressionists exhibition with five paintings in 1889. In 1887 Bate had published *The Naturalistic School of Painting*, in which he stressed the importance of judging a work of art by 'the integrity of the first impression'. At the same time he praised Whistler's reformation of the Royal Society of British Artists for bringing good and careful art forward for serious attention. In the 1890s Bate was one of those keen to point out that British Impressionism was rooted in the traditions of painting in this country and was no mere pastiche of French art. From 1895 he taught at the Applegate Studio, a small art school in Hammersmith where his most notable pupil was Roger Fry. Much of Bate's later life was spent in Berkshire.

Francis Bate, *The Naturalistic School of Painting*, 1887.
A. Lys Baldry, 'Private Schools of Art. The Studio of Mr Francis Bate and the South West London Polytechnic Art School', *The Studio*, vol. 7, 1896. pp.226-35.

6 THE WEEPING ASH (ill. p.100)
c.1895
oil on canvas, 17¹⁄₂ x 23¹⁄₄ in / 44.4 x 60.3 cm
inscribed and dated bottom left
MUSEUM OF READING

Exhibitions
1895 London, N.E.A.C. (74).
1905 London, N.E.A.C. (62).
1989 Nottingham, Castle Museum,
 British Impressionism (57).

A study of two women seated under a shady tree
occupied with sewing and reading, *The Weeping Ash* is

typical of the quiet and restrained style of landscape that
Bate produced up to the end of the century. These
reflect his interests in depicting the changing light
effects at different times of the year. Shortly after this
date he was to turn increasingly to portraiture and he
ceased to exhibit at the N.E.A.C. in 1906.

Hugh Bellingham-Smith 1866-1922

The son of a Fabian Socialist, Bellingham-Smith was
born in London. He enrolled first at the Slade School,
where he trained under Legros, and later studied in
Paris with Benjamin Constant. He travelled to Brittany
in 1890, painting with Arthur Studd, Alfred Thornton
and a group of Americans at Le Pouldu near Finistère.
There they enjoyed a bohemian existence, living cheaply
in sailors lodgings, mixing with the local community
and visiting village festivals at weekends. Thornton
recalls that the group were united in their revolt against
the pretty and anecdotal nature of the work at home, and
full of enthusiasm for both Monet and Manet. Their
slogan, he wrote, was effects not facts. On his return to
London around 1892 Bellingham-Smith showed at the
Royal Academy and at the New English Art Club from
1893-94 until 1916. He developed a particularly fluid
technique in his oil paintings, which consisted mostly of
genre scenes and landscapes, and many were painted on
expeditions to Sussex and Yorkshire. He lived in London
until his death in 1922.

Alfred Thornton, *The Diary of an Art Student in the
 Nineties*, 1938, pp.6-8.

7 **ON THE SANDS** (ill. p 101)
c.1905
oil on canvas, 20 x 30¼ in / 50.8 x 76.8 cm
inscribed bottom right, H. Bellingham-Smith
RICHARD GREEN, LONDON

8 **A TEA PARTY** (ill. p.101)
c.1904
oil on canvas, 24½ x 36¼ in / 62 x 92 cm
inscribed, bottom left, Bellingham-Smith
HUGH LANE MUNICIPAL GALLERY OF MODERN
ART, DUBLIN

In *On the Sands* Bellingham-Smith provides an
Edwardian reworking of Steer's beach scenes. Like
Oppenheimer and Laura Knight he observes colour in
shadows, although his surface textures are more densely
worked than theirs, at times with the use of a palette
knife. This density is equally apparent in *A Tea Party*, in
which the painter creates a central glowing pool of light
in which to locate his models. More preoccupied with
managing light in a conventional setting than with
character, Bellingham-Smith typifies British
Impressionists of the period.

Walter Benington died c.1935

Benington was a member of the Linked Ring and exhibi-
ted his work widely under the pseudonym Housetopper,
referring to his predilection for photographing the
London scene from rooftops and other unusual vantage
points. His technique in these photographs was impres-
sionistic and he used soft focus lenses, but he worked in
a bolder and more conventional manner with his portrait
photography. Benington often wrote for journals such as
Amateur Photographer, and in one article in 1904 he
stated that the role of the photographer should not be
simply to present facts, but to convey an idea, which was
the greatest aim of art. He also gave his support to the
notion of painters and photographers using the resources
of each other's media to mutual advantage.

Margaret F. Harker, *The Linked Ring, The Secession in
Photography, 1892-1910*, 1979.

9 **THE CAB RANK** (ill. above)
1909
gum platinum print, 5 x 4 in / 12.7. x 10.2 cm
THE ROYAL PHOTOGRAPHIC SOCIETY, BATH, GIFT OF
ALVIN LANGDON COBURN, 1930

Benington's photograph corresponds to impressionistic
paintings of the bustle of crowds in busy streets and
public places like railway stations, by painters such as
Kennedy and Jamieson. His intention was to provide a
sense of the atmosphere of these urban scenes.

Jacques-Emile Blanche 1861-1942

Jacques-Emile Blanche was the premier portraitist of the
Third Republic. Much of his success depended upon his
English style. He was in his own lifetime accused by

9 **Walter Benington**
The Cab Rank 1909

French critics of plagiarizing Reynolds, Gainsborough and
Lawrence. In England in the mood of approval which
greeted the revitalization of eighteenth-century traditions,
Blanche was accepted without question. He was born in
Paris and studied under Gervex and Humbert, though he
was most influenced by Manet and Whistler. He also
knew Degas and painted his portrait in later years.
Blanche was one of those who extended the membership
of the New English Art Club in 1887. He exhibited
regularly at the Paris Salon and like many portraitists
supplemented commissioned works with light and
vivacious studies of artist friends, many painted at his villa
outside Dieppe. In the early years of this century Blanche
operated a teaching atelier in Paris which attracted many
British students. One of his great successes at this time

10 **Jacques-Emile Blanche**
*Piccadilly Circus: London
Pavilion (June Morning)* 1912

was a portrait of Nijinsky, which was shown at the Salon of 1910. Inactive during the First World War, Blanche executed the War Memorial at the church of Offranville in 1919. During the inter-war period his style modified to incorporate elements of Post-Impressionism. His sitters included D.H. Lawrence, Jean Cocteau and James Joyce. In these years he concentrated on producing two volumes of memoirs, which have become an invaluable source of information on the period.

Jacques-Emile Blanche, *Portraits of a Lifetime*, 1937.
Jacques-Emile Blanche, *More Portraits of a Lifetime, 1918-1938*, 1939.
Henri Frantz, 'Jacques-Emile Blanche: Portrait Painter', *The Studio*, vol. 30, 1903, p.191.
Pierre Bazin, *J.-E. Blanche*, catalogue of an exhibition at the Musée de Dieppe, 1993.

10 PICCADILLY CIRCUS: LONDON PAVILION (JUNE MORNING)
(ill. p.102)
1912
oil on canvas, 27³/₄ x 37¹/₂ in / 70.5 x 95.2 cm
inscribed, lower right, J.E. Blanche
YORK CITY ART GALLERY (PRESENTED BY THE FRIENDS OF YORK CITY ART GALLERY)

Exhibitions
1927 Paris, Hôtel de Jean Charpentier, *Cent Paysages de Jacques-Emile Blanche* (4, as *Piccadilly Circus, Pavillon de Londres, matinée du juin*).
1929 Paris, Galerie Jean Charpentier, *Jacques-Emile Blanche* (32, as *Piccadilly Circus, juin 1912*).
1987 London, Barbican Art Gallery, *The Image of London* (226).
1989 Nottingham, Castle Museum, *British Impressionism* (42).

The comparison between Blanche's rendition of the London Pavilion and Hacker's (cat 94) is instructive. Where Hacker dissolves objects into one another, stressing the ebb and flow of traffic on a rainy evening, Blanche records the scene in an Impressionist manner with blobs of paint standing for busy crowds and carriages. Both artists were attracted to movement and colour, and both take a relatively detached viewpoint

looking down from a window rather than working at street level. Comparison with Monet's views of Paris painted in the early 1870s seem inevitable. Blanche's recourse to scenes of this kind may indicate a conscious striving to extend his range. By the early years of the century he had been virtually typecast as a portrait painter, whose reputation in England rested upon his 'Frenchness', while in France he was seen as the prime exponent of *'le style anglais'*.

Hercules Brabazon Brabazon 1821-1906

Brabazon Brabazon's earliest years were spent in Paris. He came to England to read mathematics at Cambridge University in about 1840. Later he studied painting at the Accademia di San Lucca in Rome for three years and in the 1860s he began to paint watercolours. Brabazon Brabazon travelled widely, on one occasion with Ruskin who greatly admired his work. He was also an accomplished pianist and friend of Liszt. His reputation developed markedly towards the end of his life in the 1890s, when his loosely handled and atmospheric watercolours of picturesque scenes in Venice were of particular significance to Steer, Sargent and Sickert. These were often a synthesis of observation, imagination and reference to the work of past masters. The first of a series of exhibitions of his work held at the Goupil Gallery in 1892 was widely praised. Sargent provided the foreword to the catalogue and D.S. MacColl named him 'the best watercolour painter we have since Turner'. As a result, Brabazon Brabazon was regarded as an important precursor to Impressionism in this country and had a direct influence on several younger artists, such as Francis James who was one of his pupils for a time.

C. Lewis Hind, *Hercules Brabazon Brabazon*, 1912.
Al Weil and Martin Kisch, *Hercules Brabazon Brabazon*, catalogue of an exhibition at The Fine Art Society, London, 1974.
Fiona Halpin and Al Weil, *Hercules Brabazon Brabazon, 1821-1906*, catalogue of an exhibition, Chris Beetles Ltd, St James's, London, 1989.

11 VENICE MOONRISE
undated
watercolour with bodycolour on paper,
8¹/₂ x 11¹/₂ in / 21.6 x 29.2 cm
CHRIS BEETLES LTD, ST JAMES'S, LONDON

12 APULIA (ill. left)
c.1885
watercolour on tinted paper,
8 x 12 in / 20.3 x 30.5 cm
CHRIS BEETLES LTD, ST JAMES'S, LONDON

13 VENICE
undated
watercolour with pencil on paper,
8¹/₄ x 10 in / 20.9 x 25.4 cm
CHRIS BEETLES LTD, ST JAMES'S, LONDON

14 RIVA SCHIAVONI, VENICE
undated
watercolour and bodycolour on tinted paper,

12 **Hercules Brabazon Brabazon**
Apulia c.1885

6¹/₄ x 9¹/₄ in / 15.9 x 24.8 cm
CHRIS BEETLES LTD, ST JAMES'S, LONDON

Brabazon Brabazon's work developed and changed during the latter part of his career in ways which complement, but do not relate directly to, the enthusiasm he inspired in others. It was evident in works like *Apulia* that his intimate knowledge of the medium enabled him to respond to the limpid effects of crepuscular light. Nature – or the familiar sights of Venice – hung like a veil before his eyes. A sensibility schooled by long experience made it possible for him to react quickly and with complete economy of means to the scene before his eyes. It was this which virtually converted Sargent to the watercolour medium in the mid 1880s.

John Arnesby Brown 1866-1955

Arnesby Brown trained first at art school in his home town of Nottingham, and then at Hubert von Herkomer's art school at Bushey, in Surrey, from 1889 to 1892. Brown painted landscapes and pastoral subjects, often including cattle grazing peacefully at evening, at sites in Norfolk and St Ives, Cornwall. These works showed the influence both of the Barbizon painters and of Impressionism. He exhibited at the Royal Academy to wide acclaim from 1891. Two of his paintings were purchased through the Chantrey Bequest, in 1901 and 1910 respectively, and a successful one-man exhibition was held at the Leicester Galleries in 1901. Throughout these years, his paintings epitomized that Edwardian nostalgia for an ideal of the English countryside, blissfully unsullied by the intrusions of modern life, and they were praised for their dignified composition and restful qualities. Brown lived for a time in Chelsea and also at Hadiscoe with his wife, the painter Mia Edwards. He was elected an RA in 1915, and he continued to exhibit at the Academy until 1942, after which time increasing blindness brought his career to a close. In 1934 his work was included in the British section of the Venice Biennale and the following year a retrospective was held at Norwich Castle Museum.

Anon., 'The Work of Arnesby Brown', *The Studio*,
 vol. 20, 1900, pp.211-16.
The Studio, vol. 71, pp.129-37.

15 FULL SUMMER (ill. p.73)
c.1902
oil on canvas, 45¹/₂ x 44 in / 115.6 x 111.8 cm
inscribed bottom left, Arnesby Brown
CITY OF NOTTINGHAM MUSEUMS, CASTLE MUSEUM
AND ART GALLERY

Exhibitions
1902 London, Royal Academy of Arts (770).
1908 London, *Franco British Exhibition* (156).

By 1900 Arnesby Brown's position as the best representative of a new romantic movement was recognized. A reviewer in *The Studio* (vol. 20, 1900, pp.214-15), regarded him as a notable example among the British School of a tendency to substitute for pure realism a certain naturalistic sentiment. Works such as *Full Summer*, painted two years after this review and exhibi-

ted to much acclaim at the Academy, epitomize what the critic saw as Arnesby Brown's ability to render the larger subtleties of the open air, rather than the facts and commonplaces of modern life.

16 THE RIVER BANK
1902
oil on canvas, 50 x 72 in / 127 x 182.9 cm
inscribed, bottom left, Arnesby Brown
GUILDHALL ART GALLERY, CORPORATION OF LONDON

Exhibitions
1902 London, Royal Academy of Arts (253).

The River Bank was painted on the Norfolk Broads and illustrates Arnesby Brown's particular skill at depicting restful scenes of grazing cattle, combined with a fascination for the effects of atmosphere and changing weather conditions. Here, four young calves are grouped peacefully around a river bank and a rainbow, the result of an October thunderstorm, appears in the sky behind. The picture reflects the artist's desire to capture a particular moment when the evening light is low, making the colours more intense and highlighting even the drops of rain, which cling to the grass around the animals' hooves.

17 THE SIGNAL BOX (ill. above)
1910
oil on canvas, 12¹/₈ x 15¹/₄ in / 30.5 x 38.7 cm_
inscribed bottom left, Arnesby Brown
PYMS GALLERY, LONDON

Industrial scenes and cityscapes became Brown's new preoccupation around 1905. Living close to The Wash, he frequently observed the industrial traffic moving around the railyards and brickworks in the vicinity of King's Lynn. For such pictures he employed a neo-Impressionist discipline which avoided the Academy bravura of his landscapes. The resulting compositions are more static and contemplative.

17 **John Arnesby Brown**
The Signal Box 1910

Thomas Austen Brown 1857-1924

The son of a drawing master, Brown was born in Edinburgh and attended the Royal Scottish Academy where he was highly regarded. His pastoral subjects of that time were reminiscent of both Macbeth and Orchardson in character. The sweet sentimentality of those early paintings was tempered considerably by his encounter with the works of Israels and Millet at the Edinburgh International Exhibition in 1886, and he began to imitate their mood of sorrowful resignation in his depictions of the community around Cambuskenneth. It was at this point in the late 1880s that Austen Brown made contact with Glasgow painters such as Guthrie and Roche and became, somewhat tenuously, associated with that group. In 1889 he was elected ARSA, although he soon after moved to London where he exhibited at the Royal Academy, as well as the Leicester and Grafton Galleries. In 1896 he began a series of international successes by winning a first class medal at the Munich exhibition. In later years he painted frequently in northern France.

James L. Caw, *Scottish Painting Past and Present, 1620-1908*, 1908 (Kingsmead reprint, 1975).

18 **PLOUGHING** (ill. below)
1887
oil on panel, 9³/₄ x 14 in / 24.8 x 35.6 cm
inscribed T. Austen Brown 1887
LAING ART GALLERY, NEWCASTLE UPON TYNE (TYNE AND WEAR MUSEUMS)

This vivid sketch by the young Austen Brown indicates the work of a painter who was already familiar with the innovations of the Glasgow School. Unlike the older Glasgow 'Boys', Brown retained his commitment to the depiction of rural life.

18 Thomas Austen Brown
Ploughing 1887

Frederick Brown 1851-1941

Brown's father was an art teacher and worked at Chelmsford in Essex, where Brown himself was born. From 1868 to 1877 he trained at the South Kensington Schools where, as he later recalled, every natural instinct of the student was perverted or frustrated. From 1883-84 he studied at the Académie Julian under Bouguereau and Robert Fleury. From 1877-92 Brown taught at the Westminster School of Art, where he was remembered for creating an intelligent and stimulating atmosphere, in contrast to the oppressive regimes at the Academy schools. He was a founder member of the New English Art Club, at which time his work was heavily influenced by rustic naturalism. *Hard Times*, shown at the first exhibition, was a clear demonstration of that approach and was purchased by the Walker Art Gallery, Liverpool the same year. His style was soon to develop in the direction of Whistler and then from his close association with Steer and Henry Tonks. In 1888 Brown was involved with Sickert's clique in plans to take control of the N.E.A.C. from the rustic naturalists, and his work was included in the London Impressionists exhibition the following year. In 1892 he was selected as Legros' successor at the Slade School in preference to at least two Academicians and, supported by his friends Tonks and Steer, Brown remained in that post throughout the years of the Slade's dominance until his retirement in 1918. He painted frequently with Steer on summer expeditions to favoured sites in Yorkshire or the Severn and Wye valleys and, like Steer, was increasingly drawn to the examples of Turner and Constable.

Professor Fred Brown, 'Recollections', *Artwork*, vol. 5, Autumn 1930, pp.149-60, 249-78.

19 **HARD TIMES** (ill. p.39)
1886
oil on canvas, 28³/₈ x 36⁵/₈ in / 72 x 93 cm
inscribed bottom right, F. Brown, 1886
BOARD OF TRUSTEES OF THE NATIONAL MUSEUMS AND GALLERIES ON MERSEYSIDE: WALKER ART GALLERY, LIVERPOOL

Exhibition
1886 London, New English Art Club (51).
1889 Paris, Exposition Universelle (13)

On first view this painting of a down at heel, probably itinerant, unemployed worker, and a younger girl, possibly the daughter of the landlord of the inn, appears to be a prime example of rustic naturalism. However, there is a suggestion that one source of influence on Brown here may have been Degas' *l'Absinthe*, (Julian Treuherz, *Hard Times, Social Realism in Victorian Art*, 1987, p.114). Brown may have been shown a reproduction of Degas' painting by Sickert, and this could account for the similarities between the male figures and the general diagonal viewpoint in the composition. This is, of course, conjecture and the work is certainly representative of much that appeared in the first showings of the N.E.A.C., bearing similarities in style and subject to several of the Newlyn painters, with their rustic themes and concerns for social realism.

Francis Campbell Boileau Cadell 1883-1937

Cadell studied at the Edinburgh Academy and, between 1899 and 1903, at the Académie Julian. From 1909 he based himself in Edinburgh but he holidayed regularly at Iona with Peploe. His work during these years ranged in style from Impressionism to the Fauvism of Matisse, displayed most often in still-lifes and portraits. In 1912 Cadell was a member of the Society of Eight, which included Patrick Adam, Lavery and later Peploe. By the eve of the First World War he had developed the intense colour and vigorous handling associated with the Scottish Colourists, whose work was exhibited in the 1920s. He was unable to serve in the war at its outbreak due to a heart condition and instead worked on a farm in Galloway, until recovery allowed him to join the Argyll and Sutherland Highlanders as an officer. Throughout the 1920s Cadell's style became more formally structured with flat, bright areas of colour laid on more smoothly than in pre-war paintings. His still-lifes from this point reflect his absorbing interest in those of Cézanne. He was elected RSA in 1936.

Tom Hewlett, *Cadell, The Life and Works of a Scottish Colourist*, 1988.
Roger Billcliffe, *The Scottish Colourists*, 1989.

20 GRAND CANAL, SANTA MARIA DELLA SALUTE (ill. right)
1910
oil on board, 14¾ x 17¾ in / 37.5 x 45.1 cm
inscribed bottom left, F.C.B. Cadell, Venice
DUNCAN R. MILLER FINE ARTS, LONDON

21 CANAL DI GUIDECCA, VENICE
1910
oil on panel, 14¾ x 17¾ in / 37.5 x 45.1 cm
signed and dated 1910, inscribed with title verso
DUNCAN R. MILLER FINE ARTS, LONDON

In 1910 Cadell received a commission from his patron, Sir Patrick Ford, to paint in Venice. Ford gave him £150 for the trip and claimed the right to purchase pictures to an equivalent value on Cadell's return. In effect this translated into six pictures and Ford purchased a further four, prior to exhibition of the entire suite at Aitken Dott's Gallery in Edinburgh. The two examples here, however, reveal the stimulus provided by a city which had received Whistler, Monet, Sickert and Brabazon Brabazon. Cadell's sketches are swift notes which respond to the Venetian light as much as to its architecture. Their vivid coloration and freedom of handling provide the essential underpinning for his later interiors.

Jean-Charles Cazin 1841-1901

The son of a doctor, Cazin was born at Samer, near Boulogne. In about 1862 he went to Paris to study art at the Petite Ecole du Dessin under Lecoq de Boisbaudran. He exhibited at the Salons of 1865 and 1866 and in 1868 took up the Directorship of the Museum and Art School at Tours. The calm of this provincial existence was shattered when the Franco-Prussian War broke out in 1870, and subsequent events led Cazin to abandon his position for the speculative venture of opening an art

school in London with Legros. This was a failure, and Cazin briefly took up the post of drawing master at the Government Art Training School. He then turned his attention to ceramics and worked at the Fulham Pottery until the summer of 1874. At this point he left London and travelled in Italy, beginning to exhibit at the Salon again from 1876. He achieved particular success there in 1880 with *Hagar and Ishmael* and *Tobias*, whose blond tonality greatly appealed to contemporary taste. From 1884 Cazin travelled once more in Italy and the Low Countries, returning to devote himself to pure landscape in which the figure occupies only a minor role. His sensitivity to atmosphere in these late works has led some critics to regard him as the true successor to Corot.

Marie van Vorst, *Modern French Masters*, 1904, pp.33-59.
Henri Frantz, 'A Great French Landscape Painter: Jean Charles Cazin', *The Studio*, vol. 54, 1911, pp.3-16.

20 **Francis Campbell Boileau Cadell**
Grand Canal, Santa Maria della Salute 1910

22 **Jean-Charles Cazin**
Gathering Seaweed c.1890

23 **James Charles**
*Returning from the First
Communion* c.1881

Frank Gibson, *Six French Artists of the 19th Century*, 1925, pp.49-55.

22 **GATHERING SEAWEED** (ill. p.106)
c.1890
oil on canvas, 17¹/₄ x 25¹/₄ in / 43.8 x 64.1 cm
inscribed bottom right, JCC
KIRKCALDY MUSEUM AND ART GALLERY

Exhibition
1981 Newcastle upon Tyne Polytechnic Art Gallery, *Peasantries* (31).

Despite the fact that pictures such as *Gathering Seaweed* appear to be on-the-spot renditions of an actual scene, Cazin more probably executed such works in the studio from drawings. Having been copiously schooled by Lecoq de Boisbaudran, he memorized his pictures and random sketchbook notes were sufficient to prompt total recall. This often resulted in muted evocations of landscape which others instantly recognized as containing the 'Cazin effect'. The Normandy coast was observed in a silvery twilight. Cazin was seldom seen, according to Alexander Harrison, at work during daylight, 'but belated fishermen, returning in the small hours of late night, would find him wandering along the shore, or pondering as he paced the high sand dunes'. Cazin's work, perhaps because of its tonal restraint, was particularly admired in England by painters such as Alfred East.

James Charles 1851-1906

24 **James Charles**
The Picnic 1904

Charles moved from Warrington in Lancashire to London in 1865, working for a time as a lithographer. After a brief period at Heatherley's he studied at the Royal Academy in 1872 under Luke Fildes, and subsequently at the Académie Julian where, like Clausen, he was influenced by plein-airism. At some point in his early career it is assumed that Charles also took lessons from Brabazon Brabazon. By 1875 he was living in London and he exhibited his first picture at the Royal Academy, *An Italian Youth in Armour*. He

showed regularly at the Academy from that date until 1906. Throughout the late 1870s he produced landscape and pastoral subjects in Hampshire and Sussex, many of which were bought by the Bradford collector John Maddocks, although it was felt that Charles never achieved the recognition he deserved in this country during his lifetime. His successes continued abroad, however, in the 1880s and 1890s with the award of medals at the Paris Exposition in 1889, and the Chicago World's Fair in 1893. In London he exhibited at the Grosvenor Gallery, the New Gallery and the New English Art Club. Charles settled in Chichester and continued to concentrate on southern landscapes, although he did travel on several occasions and painted in Italy in later years. A successful memorial exhibition of his work was held at the Leicester Galleries in 1907.

T. Martin Wood, 'The Paintings of James Charles', *The Studio*, vol. 40, 1907, pp.43-49

23 **RETURNING FROM THE FIRST COMMUNION** (ill. above)
c.1881
oil on canvas, 28⁵/₈ x 21¹/₈ in / 72.8 x 53.6 cm
inscribed bottom right, J. Charles
HUGH LANE MUNICIPAL GALLERY OF MODERN ART, DUBLIN

The theme of the first communion was particularly rich in French art. For Salon visitors it combined piety with youthful innocence. The most modern examples were provided by Jules Breton, whose *Communiantes* was shown at the Salon of 1884. British painters such as P.R. Morris had already tackled the subject by this date. However, while these were studied exhibition pictures, Charles' treatment of the theme combined elements of plein-air observation in a Normandy village, to which the figure has been added as an incidental detail.

24 THE PICNIC (ill. p.107)
1904
oil on canvas, 14^1/$_2$ x 21^3/$_4$ in / 36.8 x 55.2 cm
inscribed bottom right, J. Charles 1904
WARRINGTON MUSEUM AND ART GALLERY

Near the end of his life Charles' work took on a rich impasto which, although brightly coloured, lacked the system of neo-Impressionism. Idyllic scenes of children playing in blossoming orchards painted near his home at Bosham in Sussex were his most frequent subject matter. In more orthodox landscapes produced in northern France he reverts to Barbizon tonalities which echo Harpignies more than Monet.

25 AT MONTREUIL
c.1907
oil on canvas, 15^1/$_4$ x 20 in / 38.7 x 50.8 cm
inscribed
LEEDS CITY ART GALLERIES

George Clausen 1852-1944

George Clausen was born in London in 1852, his mother was Scottish and his Danish father was an interior decorator. At first he followed his father's trade, but early instruction at the South Kensington Schools convinced him that he should become a painter. After having seen the work of Bastien-Lepage around 1881, Clausen established a lifelong commitment to painting scenes of rural life. His controversial *Labourers after Dinner* was savagely attacked when it was shown at the Royal Academy in 1884. This led Clausen to become a founder member of the New English Art Club. With his friend Henry Herbert La Thangue he became a keen advocate of Royal Academy reform. After the purchase of *The Girl at the Gate*, 1889, for the national collection, Clausen returned to regular exhibiting at the Academy, and his reforming zeal continued when, in 1904, he became its most radical Professor of Painting. By that stage Clausen's reputation was international and his work was collected by all the major galleries in the British colonies. He had also developed away from the mechanical brushwork of the followers of Bastien, towards his own type of Impressionism. He continued throughout the 1890s to live in the Essex countryside. In 1902, 1904 and 1909 Clausen staged solo exhibitions in London, and these brought his work to a wider audience who were increasingly willing to accept Impressionism. During the First World War he was an Official War Artist, producing paintings and lithographs of gun manufacture at Woolwich Arsenal. In 1928 he produced a mural for the palace of Westminster, and he was knighted that same year. Throughout this period he continued to paint in the open air and keep up a house in Essex. Retrospective exhibitions of his work were staged at Barbizon House, London in 1928 and 1933, and he continued to exhibit at the Royal Academy until his death in 1944.

Bradford Museums and Art Galleries and Tyne and Wear County Council Museums, *Sir George Clausen RA, 1852-1944*, catalogue of an exhibition by Kenneth McConkey, 1980.

26 Breton Girl carrying a Jar (ill. p.26)
1882
oil on canvas, 18^1/$_8$ x 10^7/$_8$ in / 46 x 27.5 cm
inscribed bottom right, G. Clausen, Quimperlé
THE BOARD OF TRUSTEES OF THE VICTORIA AND ALBERT MUSEUM, LONDON

28 George Clausen
Orchard Scene c.1885

Exhibition
1980 Bradford, London, Bristol and Newcastle, *Sir George Clausen RA 1852-1944* (31).

Breton Girl carrying a Jar is almost a thesis picture. It is evident that Clausen has posed the model in the field and painted her in natural light. In the general handling of form and space the work might be compared to those of Guthrie, Osborne, La Thangue and Stanhope Forbes. This latter artist was staying at Quimperlé at the time of Clausen's visit and regarded him as one of 'the sacred band' of British followers of Bastien-Lepage. Clausen's subject and treatment carry the general inspiration of Bastien, and a notable point of comparison between this and Bastien's work might be in the use of the tall seed heads which surround the girl and which have been directly compared to the use of thistles in paintings such as Bastien's *Pauvre fauvette*.

27 THE SHEPHERDESS (ill. p.37)
1885
oil on canvas, 25^1/$_2$ x 18^1/$_8$ in / 64.8 x 45.7 cm
inscribed bottom left, G. Clausen, 1885

Board of Trustees of the National Museums and Galleries on Merseyside: Walker Art Gallery, Liverpool

Exhibitions
1886 London, New English Art Club (43).
1980 Bradford, London, Bristol, Newcastle, *Sir George Clausen RA 1852-1944* (38).

28 **ORCHARD SCENE** (ill. p.108)
c.1885
oil on canvas, 13 x 11³/₈ in / 33 x 29 cm
inscribed bottom right, G. Clausen
LINCOLNSHIRE COUNTY COUNCIL, USHER GALLERY, LINCOLN

Exhibition
1980 Bradford, London, Bristol and Newcastle, *Sir George Clausen RA 1852-1944* (40).

Numerous oil studies and drawings attest to Clausen's preoccupation in the spring of 1885 with portraying peasant figures in blossoming orchards. He may have been attempting to move away from the brutal naturalism of *Labourers after Dinner* which had met with a cool reception at the Royal Academy of 1884. The studies for *The Shepherdess* drew him into a broader treatment of colour than had been possible in the previous year. Perhaps because of its more agreeable subject matter, the picture was instantly purchased by John Maddocks of Bradford and was praised by later writers as an example of Clausen's best manner.

29 **SOUVENIR OF MARLOW REGATTA** (ill. above)
c.1889
oil on panel, 6¹/₂ x 9⁵/₈ in / 16.5 x 24.1 cm
inscribed bottom right, G. Clausen
LEEDS CITY ART GALLERIES

Exhibition
1980 Bradford, London, Bristol and Newcastle, *Sir George Clausen RA 1852-1944* (57).

In its surprising fluidity *Marlow Regatta* might be compared to the work of Philip Wilson Steer. Unusually for Clausen it presents a modern life rather than a rustic theme, in which the figures almost dissolve into the background. The evening light and lanterns evoke the world of Sargent and Whistler, although in the context of Clausen's *oeuvre* the picture is an aberration.

30 **THE MOWERS** (ill. p.66)
1891
oil on canvas, 40 x 34 in / 101.6 x 86.4 cm
inscribed bottom right, G. Clausen, 1891
LINCOLNSHIRE COUNTY COUNCIL, USHER GALLERY, LINCOLN

Exhibitions
1892 London, Royal Academy of Arts (8).
1901 Glasgow, International Exhibition (358).
1910 Manchester, Autumn Exhibition (91).
1980 Bradford, London, Bristol and Newcastle, *Sir George Clausen RA 1852-1944*, (72).
1994 Nottingham, University Art Gallery, *Toil and Plenty* (39).

From 1891 onwards Clausen radically overhauled his rustic naturalism. The force of this reappraisal was seen for the first time in *The Mowers*, a Millet-esque theme which had first been treated in a watercolour of 1885. Clausen simply reprised the format and arrangement of figures in this earlier work, although in the large oil version he abandoned the square brush method of the ateliers in order to substitute a more complex handling closer to Impressionism and derived in part from his use of pastel.

31 **THE LITTLE FLOWERS OF THE FIELD** (ill. p.67)
1893
oil on canvas, 16¹/₄ x 22¹/₄ in / 41.3 x 56.5 cm
inscribed bottom left, G. Clausen, 1893
PRIVATE COLLECTION, COURTESY OF THE FINE ART SOCIETY, LONDON

Exhibition
1979 London, Royal Academy of Arts, *Post-Impressionism* (282).

32 THE SHY CHILD (ill. cover)
1897-1907
oil on canvas, 20 x 16 in / 50.8 x 40.6 cm
inscribed bottom right, G. Clausen 1897-1907
LEEDS CITY ART GALLERIES

The logical development of the new approaches clearly
seen in *The Mowers* was noted in works of 1892 and
1893 in which the painter adopted what might be
described as a 'luminist' palette. Sharp bright compli-
mentary contrasts predominate in pictures such as
Evening Song (unlocated) and *The Little Flowers of the
Field*. The freshness and vigour of Clausen's new
manner became more formulaic in later head studies,
such as *The Shy Child*.

33 SONS OF THE SOIL (ill. p.109)
1901
oil on canvas, 27¹/₄ x 30¹/₄ in / 69.2 x 76.8 cm
inscribed lower right, G. Clausen 1901
PRIVATE COLLECTION, COURTESY PYMS GALLERY,
LONDON

Exhibitions
1901 London, Royal Academy of Arts (24).
1970 London, Whitechapel Art Gallery, *Twenty Years
 of British Art, 1890-1910.*

Clausen's engagement with the theme of gang labour
dates back to the 1880s, and such Bastien-Lepage-
inspired pictures as *Winter Work*. However, these
generally more static images were rejected when it came
to depicting the more coordinated activities of a small
field gang. The phenomenon of gang labour had
disappeared by the turn of the century, although small
groups such as this might still be employed on the land.
Clausen wishes to show that they might typically involve
all generations of a family and, despite contemporary
reports that labourers were unruly and often drunken, he
wished to see them as the British equivalents of Millet's
peasants. The mood of the landscape was particularly
important to reviewers, who recognized its English
colours, and if there were now clear indications of
Impressionism in Clausen's style, these were acceptable.

34 DUSK (ill. above)
1903
oil on canvas, 24¹/₂ x 29 in / 62.2 x 73.7 cm
inscribed, bottom right, G. Clausen 1903
LAING ART GALLERY, NEWCASTLE UPON TYNE
(TYNE AND WEAR MUSEUMS)

Exhibitions
1903 London, Royal Academy of Arts (66).
1974 London, Royal Academy of Arts, *Impressionism*
 (114).
1980 Bradford, London, Bristol and Newcastle,
 Sir George Clausen RA 1852-1944 (92).

With pictures like *Dusk* Clausen moved closer to Monet.
It seems likely that in the 1890s the painter might well
have studied Monet's recent series of canvases
portraying hayricks, although his own first drawings and
pastels of this subject date from the late 1880s. Like
Monet, Clausen was sensitive to fluctuating light effects
and was often forced to abandon work which he had

34 **George Clausen**
Dusk 1903

begun in the open air as a result of changes of climate.
In the early years of this century he produced numerous
canvases, drawings and several etchings on the theme of
rickyards. These differ from Monet's work in that the
painter always sought to surround the hayricks with
some kind of activity. In some instances farmworkers
are shown propping up collapsing ricks, in others they
are seen building them. *Dusk* reduces this peripheral
activity to a minimum by contrasting the strong shapes
of the trees and the rick with a foreground figure
drawing water from a stream.

Alvin Langdon Coburn 1882-1966

From his early years, Coburn frequently travelled to
England from his native America with his mother,
herself a keen amateur photographer. In the late 1890s,
he and his cousin, F. Holland Day, were renting a studio
and darkroom in London, and from then on he was
closely associated with artistic and photographic circles
on either side of the Atlantic. In 1902 he became a
member of the Photo-Secession in New York, and the
following year he joined the Linked Ring. An important
early patron was George Bernard Shaw, who introduced
him to famous artists and writers many of whom
became his sitters, including Shaw himself. Coburn's
photographs aimed not at a rendering of clearly defined
details, but at the creation of mood and atmosphere. In
1909 he set up his own printing presses in Hammer-
smith, producing the photogravure illustrations for his
own books. After 1908 he began to make colour
photographs, having acquired the art from Steichen.
Slightly later he was preoccupied with images of New
York and California, which bear formal analogies to
Cubism and later to Vorticism.

Margaret F. Harker, *The Linked Ring, The Secession in
 Photography, 1892-1910, 1979.*

35 WAPPING (ill. right)
c.1905-10
gravure print, 8¼ x 6¼ in / 20.9 x 15.9 cm
THE ROYAL PHOTOGRAPHIC SOCIETY, BATH, GIFT OF
ALVIN LANGDON COBURN, 1930

The subject of this photograph, together with its
asymmetrical arrangement, high horizon and overall
flatness, clearly refers to Whistler's nocturnes of the
1870s. Made just after Coburn began his regular visits to
London, this image belongs to the series that aimed at
the creation of atmospheric mood and broad effects,
rather than sharply defined detail.

Christabel Cockerell 1863-1951

Christabel Cockerell trained at the Royal Academy
Schools from 1882 onwards. As a student she met her
future husband, the sculptor George Frampton. One
of her pictures of 1903, *Bluebells*, shown at the Royal
Academy, was reproduced in Shaw Sparrow's survey of
women painters in 1905. She ceased to exhibit after 1910.

Walter Shaw Sparrow, *Women Painters of the World*,
1905, p.136.

36 IN THE HAYFIELD (ill. below)
c.1890
oil on panel 14½ x 18 in / 36.8 x 45.7 cm
BERKSHIRE ASSOCIATES, LONDON

Foreground child gleaners act as a foil to the large hayricks
which tower above the horizon. It would be tempting to
deduce from this that Cockerell has taken her motif from
Millet's *Autumn, The Haystacks* (Metropolitan Museum of
Art, New York), shown at the Exposition Universelle in
1889, and recast it in an English idiom. In this case,

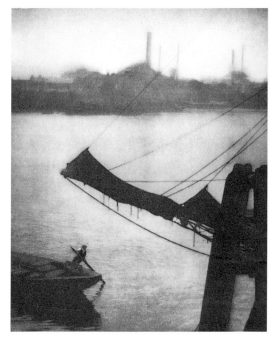

however, the engagement with French art, particularly the
tonalism of Cazin, is more profound. Cockerell's treatment
of the little group of children shuns anecdote. She avoids
surface detail for the sake of overall pictorial harmony.

Charles Conder 1868-1909

Born in London, Conder studied art in New South
Wales, Australia, where he worked with Roberts and
Streeton. His training continued in Paris from 1890
when he attended the Académie Julian and the Atelier
Cormon. Friendships with Louis Anquetin, Toulouse-
Lautrec and William Rothenstein developed from that
time. In 1895 Conder designed wall decorations in a
room for Samuel Bing's 'Maison de l'Art Nouveau'.
Although he continued to travel abroad, he settled in
London in 1897 and was associated with the *fin-de-siècle*
decadence of Whistler and Beardsley, developing his
reputation for watercolour paintings on silk and on
fans. These were produced in the elegant rococo manner,
reminiscent of Watteau, which was then undergoing a
revival and was a particular fascination for Conder, who
tended to regard the eighteenth century as his spiritual
home. He exhibited regularly at the New English Art
Club from 1893 to 1902 and staged a one-man show at
Robert Ross's Carfax Gallery in 1899. His oil paintings,
though recognized for their delicacy in colour and
handling, were never so highly regarded as his decora-
tive schemes. Ill health in the later years of his life
meant that his output was quite small. In 1909, as
Rutter put it, alcohol and amorousness hurried him into
an asylum and an early death.

Frank Gibson, *Charles Conder, His life and Work*, 1914.
John Rothenstein, *The Life and Death of Conder*, 1938.
David Rodgers, *Charles Conder, 1868-1909*, catalogue of
an exhibition at Graves Art Gallery, Sheffield, 1967.

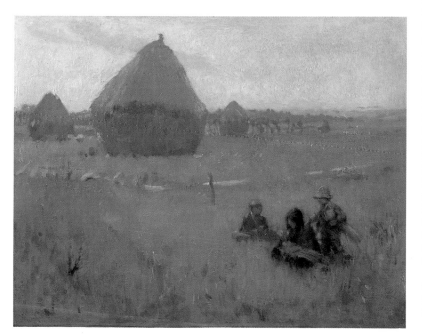

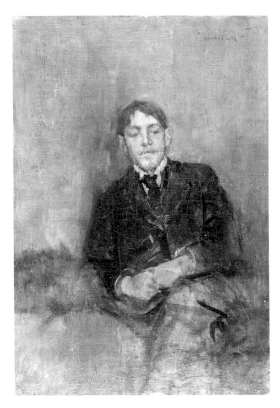

37 SELF-PORTRAIT (ill. above)
c.1890
oil on canvas, 22¼ x 15¼ in / 56.2 x 38.5 cm
inscribed top right, Charles Conder
TULLIE HOUSE, CITY MUSEUM AND ART GALLERY,
CARLISLE

As a student Conder painted a number of portrait sketches of his colleagues, and he in turn was painted by them. The present picture is thought to have been executed shortly after his arrival in Paris and prior to his appearance in works by Rothenstein and Toulouse-Lautrec.

38 THE PLUM TREE
1891
oil on canvas, 31½ x 17¾ in / 80 x 45.1 cm
inscribed, to my friend Arthur Studd
TRUSTEES OF THE TATE GALLERY, LONDON,
BEQUEATHED BY ARTHUR STUDD, 1919

Friendship between Conder and Rothenstein blossomed instantly in the final months of 1890. Both artists visited Giverny on successive occasions in the following years, although in Conder's case dates cannot be pinpointed since his name does not appear in the register of the Hotel Baudy. Taking into account the relationship of buildings and undulating hillside, it may be assumed that the present picture was painted in the environs of Giverny. Similar configurations are found in the work of American Impressionists, however Conder's painting differs from that of Theodore Robinson, for instance, in its fluid tonalist handling. It is possible, in view of the inscription, that Conder's companion on this particular visit was Arthur Haythorne Studd.

39 YPORT (ill. below)
1892
oil on canvas, 19¼ x 23½ in / 48.9 x 59.7 cm
inscribed, bottom right, Yport/Charles Conder 1892
YORK CITY ART GALLERY, PRESENTED BY THE VERY
REVEREND ERIC MILNER-WHITE, DEAN OF YORK

Exhibitions
1967 Sheffield, Graves Art Gallery, *Charles Conder
 1868-1909* (19).
1974 London, Royal Academy of Arts, *Impressionism*
 (116).

40 SPRINGTIME
1892
oil on canvas, 28¾ x 23¾ in / 73 x 60.3 cm
inscribed
TRUSTEES OF THE TATE GALLERY, LONDON,
PURCHASED 1926

Although he consistently abjured the thick paste of Monet's broken brushwork, Conder admired the grainstack pictures which he noted in 1891. At this time his palette brightened and his handling became more varied and colourful. This is seen in a series of canvases showing trees in blossom which were painted in 1892. In that year he also visited Yport, and it may be assumed from the works produced there that he was now fully familiar with Monet's most recent practice. The distinguising feature, however, aside from the insertion of a single bather, is that Conder's light palette never assumes the density of Monet's.

41 BEACH SCENE, DIEPPE (ill. p.65)
1895
oil on panel, 13¼ x 18¼ in / 33.6 x 46.3 cm
inscribed, bottom right, Conder
SHEFFIELD CITY ART GALLERIES

37 **Charles Conder**
Self-portrait c.1890

39 **Charles Conder**
Yport 1892

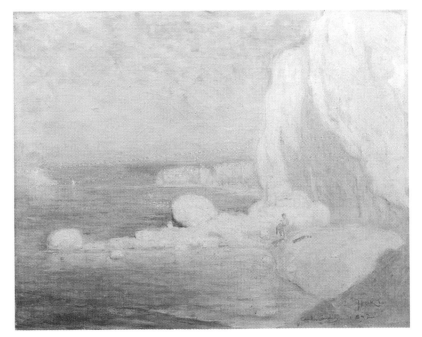

Conder was an enthusiastic adherent of Dieppe throughout the 1890s. He enjoyed the circle of friends who congregated there as much as the place itself. *Beach Scene* may be compared to similar canvases and panel studies by Blanche, with whom he was particularly friendly. Conder had a special affinity for places of public entertainment. He wished, in Blanche's words, to be 'the Watteau, the Rowlandson, the Guys of the twentieth century'. He was less interested in nature's effects than in spectacle. Fireworks, a subject dear to Whistler and later handled with great assurance by Fergusson, attracted him for these reasons.

Philip Connard 1875-1958

Connard came from Southport in Lancashire and worked originally as a house painter. Part-time evening classes resulted in a scholarship to the Royal College of Art in 1896, to study textile design. His training as a painter began in 1898 when, with the aid of a British Institute travelling scholarship, he enrolled at the atelier Julian. On his return to London Connard earned an income as an illustrator for Bodley Head, and from teaching at Lambeth School of Art. From 1906 he became a regular exhibitor at the New English Art Club, and at this point he developed his close friendship with Steer, later accompanying him on summer painting expeditions. No modernist, Connard developed as a landscape painter of often striking, brilliant effects, and also as a portraitist; he was a founder-member of the National Portrait Society in 1911. In 1914 he joined the army but was invalided home after the battle of the Somme in 1916. He then served as an Official War Artist in the Royal Navy in 1918. Most exhibitions of his work were staged at Croal Thompson's Barbizon House, where Steer also exhibited. Unlike his friend, however, Connard willingly entered the Royal Academy, becoming ARA in 1918 and RA in 1925. His successes in the 1920s led to commissions for murals at Windsor and for the Viceroy's ballroom in Delhi. In later years, Connard like Steer, developed an interest in watercolour and its ability to capture light and atmosphere. From 1945-49, he was Keeper of the Royal Academy. He lived in Richmond from 1932 until his death.

Frederick Wedmore, 'Philip Connard', *The Art Journal*, 1909, pp.73-78
Jessica Walker Stephens, 'The Paintings of Philip Connard, ARA', *The Studio*, vol. 85, 1923, pp.303-11.
Studio One Gallery, Oxford, *Watercolours and Drawings by Philip Connard*, 1975.

42 Charles Conder
Watching the Fireworks St. Cloud c.1897

Exhibitions

1967 Sheffield, Graves Art Gallery, *Charles Conder 1868-1909* (35).

1992 Brighton Museum and Art Gallery, *The Dieppe Connection* (16).

42 **WATCHING THE FIREWORKS, ST. CLOUD** (ill. above) c.1897
oil on canvas, 20¼ x 24 in / 51.4 x 61 cm
inscribed, Conder
SHEFFIELD CITY ART GALLERIES

43 Philip Connard
Young Sunbathers 1914

Exhibition

1967 Sheffield, Graves Art Gallery, *Charles Conder 1868-1909* (39).

43 **YOUNG SUNBATHERS** (ill. left)
1914
oil on canvas, 20 x 24 in / 50.8 x 61 cm
inscribed, PC, 1914
RICHARD GREEN, LONDON

Prior to the First World War Philip Connard concentrated on sunlit scenes of mothers and children on holiday. *The River Tang* (Manchester City Art Galleries) typifies a sequence of pictures which at times might be compared to strikingly similar ones by Orpen and Tonks. The innocent sensual pleasure, devoid of

voyeurism, expressed in *Young Sunbathers* became Connard's stock-in-trade in more conceptual *poésies* in the 1920s.

Joseph Crawhall 1861-1913

Crawhall's family lived in Morpeth in Northumberland. He received early training from his father, an amateur artist, and from Charles Keene, a family friend. Crawhall continued his studies in Glasgow for the most part, with a brief period at Aimé Morot's atelier in Paris in 1882. In 1879 and 1881 Crawhall painted alongside Walton, his sister's brother-in-law, and Guthrie and Henry at Brig O'Turk, and later in Lincolnshire. After his time in Paris, he painted with the Glasgow Boys at Cockburnspath, turning back from working in oils to watercolour and making rapid wash drawings on paper. In 1884 he visited Lavery in Tangier, where he himself lived for a time in later years. In the mid 1890s, Crawhall was much interested in the Japanese style and became associated with the Aesthetic Movement. These influences resulted in simple, striking studies of animals and birds executed on linen or silk. Apart from these, his subject matter was wide-ranging but his output was small, for he destroyed much of his own work. Crawhall never needed to be concerned with selling his paintings, but he exhibited quite widely. He first showed alone at Alex Reid's Glasgow gallery in 1894, and he was represented at many RSA and RSW exhibitions after 1900. He had a second solo exhibition at Paterson's Gallery in London in 1912, and was a member of the New English Art Club from 1909 to 1913. Constantly ill at ease with fashionable artistic society, Crawhall always preferred the country life and he settled in Brandsby, Yorkshire towards the end of his life.

Vivien Hamilton, *Joseph Crawhall, One of the Glasgow Boys*, 1990.

44 A LINCOLNSHIRE PASTURE (ill. above)
c.1882-83
oil on canvas, 36 x 50 in / 91.4 x 127 cm
inscribed, lower left, J. Crawhall
DUNDEE ART GALLERIES AND MUSEUMS

Exhibition
1883 London, Royal Academy of Arts (161).

Reference
Hamilton, 1990, p.28

A Lincolnshire Pasture is one of two very similar landscapes which resulted from Crawhall's sojourn at Crowland in Lincolnshire with Guthrie and Walton. Fresh from a brief trip to Paris, Crawhall found himself working closely with those who had similar francophile sympathies. Perhaps in emulation of Stott of Oldham's *The Ferry*, both Guthrie and Crawhall painted frieze-like compositions in which the main motif was arranged parallel to the plane of the picture. This led naturally to the rendition of space by clear tonal transitions and alterations of handling. Dried out grasses in the foreground are given weight and detail in order to lead the eye into the picture.

45 THE RACE
1890
watercolour on paper, 9¼ x 5½ in / 23.3 x 14.2
GLASGOW MUSEUMS, THE BURRELL COLLECTION

Reference
Hamilton, 1990, p.138

46 BARNET FAIR
1894
gouache on linen, 14½ x 23½ in / 36.9 x 59.5 cm
inscribed
GLASGOW MUSEUMS, THE BURRELL COLLECTION

Exhibitions
1894 Glasgow, Société des Beaux-Arts, *Works of Joseph Crawhall (Jnr)* (23).
1901 London, International Society of Sculptors, Painters and Gravers (23).
1915 Paisley, Art Institute (223).

Reference
Hamilton 1990, p. 131

44 **Joseph Crawhall**
A Lincolnshire Pasture
c.1882-83

47 **Joseph Crawhall**
The Race Course c.1894-1900

48 **Joseph Crawhall**
American Jockeys c.1900

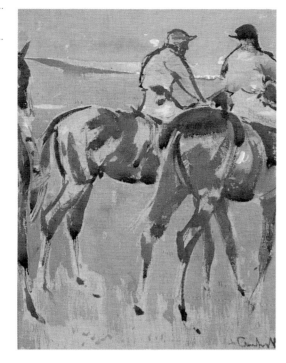

The Magazine of Art in 1890 (p.424). Given Crawhall's predilection for sharp delineation and simplified planes, earlier racecourse oils by Degas might be a more appropriate source than later pastels. A number of these contain incidental details, such as grandstands and spectators, which liken them to *The Race Course*. The relative precision of this work contrasts with the confident freedom of *American Jockeys,* a picture in which the figures are dramatically cut by the edges of the rectangle.

Herbert Dalzeil 1853-1941

Dalzeil was born in London. His father, Thomas, a painter and illustrator, was the youngest member of the Dalzeil Brothers family firm. Herbert Dalzeil studied in Paris at the Ecole des Beaux-Arts under Cabanel from 1882-83, was a member of the New English Art Club and exhibited landscape and pastoral subjects widely, notably at Suffolk Street, the Royal Academy and the Grosvenor Gallery. His *The Cow-Girl*, shown at the Royal Academy in 1885, revealed a clear understanding of the rustic naturalism of Bastien-Lepage. Also his career was dogged by illness, and persistent problems with his eyesight ensured that his *oeuvre* was small.

Sotheby's, Studio Sale Catalogue, with an introduction by Simon Houfe, 1978.

49 **DEPARTING DAY** (ill. below)
c.1910
oil on canvas, 10 x 14 in / 25.4 x 35.6 cm
inscribed bottom right, Herbert Dalzeil
MARTYN GREGORY GALLERY, LONDON

50 **THE STREAM**
c.1910
pastel and oil on paper on board, 6 x 8 in /
15.2 x 20.3 cm
PRIVATE COLLECTION

In an extraordinary departure, around 1910, Herbert Dalzeil abandoned his conservative style and produced a number of jewel-like landscapes which adopt a sophisticated divisionism. In *Departing Day* a Whistlerian nocturne is translated into this idiom. At face value these might be regarded as belated emulations of Seurat, although the sense of atmosphere and weird luminosity draws comparisons with contemporary photography and the mystic landscapes of Khnopff.

Crawhall was one of the first painters to begin to extend rural imagery beyond Millet-esque peasant subject matter. Before Munnings and Knight, he painted country fairs and rural race meetings. After his family moved to London in 1890, Crawhall attended Barnet Fair on successive occasions and a number of pictures resulted. For two years from 1893 he ran a small stud farm at Wheathampstead in Hertfordshire with the illustrator George Denholm Armour, and this provided him with the opportunity to study horses at close quarters. He appears to have begun working in gouache on linen, a notoriously difficult medium, around this time.

47 **THE RACE COURSE** (ill. p.114)
c.1894-1900
gouache on linen, 11½ x 12⅝ in / 29.2 x 31.7 cm
inscribed bottom right, J. Crawhall
GLASGOW MUSEUMS, ART GALLERY AND MUSEUM, KELVINGROVE

Reference
Hamilton, 1990, p.132

48 **AMERICAN JOCKEYS** (ill. above)
c.1900
gouache on linen, 16¼ x 12½ in / 41.3 x 31.7 cm
inscribed bottom right, J. Crawhall
RICHARD NAGY, DOVER STREET GALLERY, LONDON

Reference
Hamilton, 1990, p.117

Degas is conventionally invoked as inspiration for Crawhall's racing pictures. Hamilton (p.137) speculates that Crawhall would have seen Degas' pastels of jockeys in Alexander Reid's gallery in Glasgow in the early 1890s. There were other opportunities south of the border to study such works, and one such was illustrated to accompany George Moore's article on the painter in

49 **Herbert Dalzeil**
Departing Day c.1910

George Davison 1856-1930

George Davison had an influential supporter in Stieglitz, who published his Impressionist photographs in several editions of *Camera Work*. Active in several ways in photographic circles, he was the first secretary of the Camera Club, a member of the Linked Ring and by the end of the 1890s he had amassed a considerable fortune from his presidency of the Kodak Company. He appeared to find little conflict between his personal wealth and his firm Christian Socialist beliefs. Davison developed two approaches to his own photography, a straightforward, descriptive style for his promotional work for Kodak, and a pictorial Impressionism for his personal exhibtion work. Just before the First World War he turned his house in North Wales into an instruction centre for Socialist Party workers; during the War it was used as a children's home.

Margaret F. Harker, *The Linked Ring, The Secession in Photography, 1892-1910*, 1979.

51 **THE ONION FIELD (AN OLD FARMSTEAD)** (ill. p.51)
1890
gravure print, 6 x 8 in / 15.2 x 20.3 cm
THE ROYAL PHOTOGRAPHIC SOCIETY, BATH, GIFT OF
PAUL MARTIN, 1934

One of Davison's best known photographs, *The Onion Field* caused a stir when shown at the Photographic society of Britain's exhibition of 1890. The image was taken with a pin hole in a small plate of sheet metal rather than a lens, and helped to establish Davison's reputation as a leader of what emerged as the Impressionistic photography group. Harker (p.31) suggests that the success of this particular work was in encouraging other photographers to experiment with techniques so as to achieve broad and diffuse tonal areas, rather than specific details.

Hilaire-Germain-Edgar Degas 1834-1917

Degas was born into an affluent Parisian family associated with banking. He studied in Italy in the later 1850s, and at the Ecole des Beaux-Arts where he was trained in the academic tradition of Ingres, for whom he held great respect. Throughout the 1860s, he steadily abandoned his academic training and subject matter, adopting instead the modern life themes advocated by Baudelaire and practised by Manet. He showed infrequently at the Salon during this period. With apparently casual compositions and unusual viewpoints largely influenced by Japanese art, Degas developed his own range of imagery which included, typically, women at work or bathing, seemingly unaware of the artist's gaze, and preparations for the ballet, racecourses and portraiture. From the mid 1870s in particular he experimented with technique, and increasingly used pastel as his eyesight began to deteriorate towards the end of the decade. By this stage he stayed clear of the Salon, and he exhibited in seven of the eight Impressionist exhibitions from 1874, and also with his dealer Durand-Ruel. His wealthy background guaranteed him the financial independence to withstand the criticism that the Impressionist group received. Degas' influence on young painters in Britain worked largely through Blanche and Sickert. As a result, he was important in developing naturalist urban subjects in Britain. He was also, however, to receive much hostility from conservative critics in London, notably in the remarkable row that developed over the exhibition of *l'Absinthe* at the Grafton Galleries in 1893. In a broader sense Degas acted as a catalyst for the debate on iconography and on the criteria for critical interpretation. Having been favourably disposed to developing a clientèle in London in the 1870s, he took a more jaundiced view by the end of the 1890s, refusing to be courted into the International Society of Sculptors, Painters and Gravers and reacting with hostility when his work was shown without his permission. By now, as a result of the efforts of Moore and Sickert, he had a dedicated following among collectors such as Sir William Eden, James Staats Forbes and Edward Martyn.

Paul André Lemoisne, *Degas et son oeuvre*, 4 vol., 1984 (reprint).
Roy McMullen, *Degas: His Life, Times and Work*, 1984.
Jean Sutherland Boggs, et al., *Degas*, catalogue of an exhibition at Paris, New York, Ottawa, 1988.

52 **WOMAN LOOKING THROUGH FIELDGLASSES** (ill. p.117)
c.1865
oil on paper on canvas, 12³/₄ x 5¹/₂ in / 32.4 x 14 cm
GLASGOW MUSEUMS, THE BURRELL COLLECTION

Principal Exhibitions

1976 Newcastle and other venues, *The Burrell Collection, 19th Century French Paintings* (38).
1979 Edinburgh, National Gallery of Scotland, *Degas 1879*, catalogue by Ronald Pickvance (3).
1986 Manchester City Art Gallery and Cambridge, Fitzwilliam Museum, *The Private Degas*, catalogue by Richard Thomson (34).

Principal References
Benedict Nicholson, *Burlington Magazine*, vol. 102 December 1960, p.536.
William Wells, 'Who was Degas's Lydia?', *Apollo*, vol., 95, 1972, pp.129-34.

One of a number of related studies of a model looking through fieldglasses, this one was originally known as *Girl looking through Opera Glasses*. On cleaning at the National Gallery in 1960, it was established as a study for *Aux Courses, les jockeys* and was retitled. This painting was the first Degas to be acquired by Sir William Burrell, via Alexander Reid, at the turn of the century. The model is now assumed to be Lydia, the elder sister of Mary Cassatt and a friend of Degas' brother Achille. Wells has established that Lydia was an invalid who died prematurely but who modelled occasionally if the pose was not demanding, as in this case where she appears to be supported by a shooting stick. The fact that Degas made so many versions of this subject, with only slight variations of pose or costume, illustrates his determination to achieve an exact balance between the ideal and the particular.

52 **Hilaire-Germain-Edgar Degas**
Woman looking through Fieldglasses c.1865

53 **The Rehearsal** (ill. p.118)
1874
oil on canvas, 23 x 33 in / 58.4 x 83.8 cm
inscribed bottom left, Degas
Glasgow Museums, The Burrell Collection

Principal Exhibitions

1977 Newcastle and other venues, *The Burrell Collection, 19th Century French Paintings* (39).
1979 Edinburgh, National Gallery of Scotland, *Degas 1879*, catalogue by Ronald Pickvance (15).
1986 Manchester City Art Gallery and Cambridge, Fitzwilliam Museum, *The Private Degas*, Catalogue by Richard Thomson (44).

Principal References

Robert Baldick trans. and ed., *Pages From The Goncourt Journal*, 1978, p.206.
Keith Roberts, 'The Date of Degas's *The Rehearsal*', *Burlington Magazine*, vol. 105, June 1963, pp.280-81.
Denys Sutton, *Edgar Degas, Life and Work*, 1986, pp.168-69.

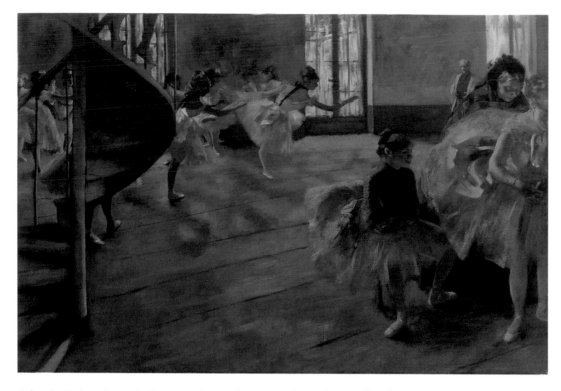

53 **Hilaire-Germain-Edgar Degas**
The Rehearsal 1874

Robert L. Herbert, *Impressionism, Art, Leisure and Parisian Society*, 1988, pp.121-24.

It may be assumed that *The Rehearsal* became familiar to members of the circle of Jacques-Emile Blanche since it was acquired by him at the end of November 1888. It has always been regarded as one of Degas' most daring compositions, on account of the cropping of figures on either side of the picture and the large empty area of floor in the centre. Several writers have noted the interesting quality of light, filtered around the rehearsal room through gauze curtains. In some works from the series a silvery diffusion suggests that the practice is taking place during the morning, while other pictures such as *The Rehearsal* have a more golden cast, enhanced in this case by juxtapositions of brilliant red and green, noted by Edmond de Goncourt. Others have commented upon the *tour de force* in the painting of the spiral staircase, a model of which Degas retained in his studio. The elderly woman on the right, who appears in other ballet pictures of the period, has been identified as Degas' Dutch housekeeper, Sabine Neyt. The dance master has been conclusively identified from an earlier photograph as Jules Perrot, although Sutton has suggested that he may possibly be Ernest Pluque. Herbert states that Perrot had been retired as *maître de ballet* for ten years and may have been sought out by Degas on account of his great reputation.

By a curious coincidence, Blanche's friends would have had the opportunity to compare his recent acquisition with *The Dance Class*, (Corcoran Gallery of Art, Washington DC) when it appeared in the first sale of Henry Hill's collection at Chrisite's on 25 May 1889. Although a much darker work, this too contains a spiral staircase to the left of the picture and a seated dancer with a shawl wrapped around her shoulders on the right. The sombre tonalities of this picture, which predates

that in the Burrell Collection, may have been read in terms of Degas' growing commitment to the use of bright colour.

Robert Demachy 1859-1936

Demachy came from an affluent family of bankers in Paris. This allowed him freely to pursue a wide range of interests in painting and music as well as photography.

54 **Robert Demachy**
Behind the Scenes, the Shoestring c.1900

He was an original member and, in effect, a leader of the Photo-Club de Paris. His photographs were often characterized by a combination of mood and imagination, with a particular concern for arrangement and for decorative qualities. He was also a respected writer on both technical matters and aesthetic issues. His subject matter was diverse, including portraits, landscape and street scenes, but the results were often controversial and several critics felt he departed too much from the essential qualities of the medium in search of artistic effects. Demachy himself maintained the opinion that a photographer should employ any means in order to achieve an original piece of work.

Margaret F. Harker, *The Linked Ring, The Secession in Photography, 1892-1910*, 1979.

58 **Wynford Dewhurst**
Summer Mist, Valley of la Creuse c.1920

54 BEHIND THE SCENES, THE SHOESTRING (ill. p.118)
c.1900
oil transfer print, 7¹/₂ x 4¹/₂ in / 19 x 11.4 cm
THE ROYAL PHOTOGRAPHIC SOCIETY, BATH, GIFT OF
ROBERT DEMACHY, 1936

Demachy's studies of young ballet dancers are clearly photographic equivalents of Degas' paintings. With this image in particular, Demachy has established a similar type of composition and has aimed to achieve the same degree of apparent spontaneity and natural effect.

55 EN BRETAGNE (ill. left)
c.1900
bromoil print, 7³/₄ x 10¹/₂ in / 19.7 x 26.7 cm
THE ROYAL PHOTOGRAPHIC SOCIETY, BATH, GIFT OF
ROBERT DEMACHY, 1936

The doubt and suspicion on the faces of these Breton peasant girls adds to the truthful and seemingly unposed quality of this photograph. Nevertheless, Harker notes that the print is a composite of at least four negatives, which accounts for the almost surreal character of the final image (p.99). The balance between apparent naturalness and extreme contrivance is a feature of much of Demachy's work, the result of his determination to use whatever means to achieve the desired effect.

Wynford Dewhurst 1864-1941

Dewhurst's childhood was spent in Manchester. He studied at the Ecole des Beaux-Arts under Gérôme around 1891 and later at the Académie Julian. He then returned to England, but continued to spend much time in France where he had established a particular friendship with Guillaumin. Dewhurst painted regularly in the Seine valley, and his landscapes from that region show the marked influence of Monet's colour and broken handling, with a similar attempt to capture atmospheric conditions. In 1904 he published his account of the development of Impressionism, the first important study of the French painters to appear in this country. This work is also of note for being among the first of many contemporary efforts to demonstrate that the primary ancestors of the Impressionists were Turner and Constable, a view not wholly shared however, by painters such as Pissarro. From 1901 Dewhurst was living in Hampstead and exhibiting frequently at the Royal Society of British Artists, the New English Art Club from 1909 to 1910, and at the Royal Academy from 1914 to 1926. In this last year he held an exhibition of his pastels at the Fine Art Society.

Wynford Dewhurst, *Impressionist Painting: Its Genesis and Development*, 1904.

56 FRENCH LANDSCAPE
1895
oil on canvas, 15 x 18¹/₄ in / 38.1 x 46 cm
inscribed, Dewhurst '95
NATIONAL MUSEUM OF WALES, CARDIFF

57 THE PICNIC (ill. p.83)
1908
oil on canvas, 32¼ x 39½ in / 82 x 100.7 cm
inscribed, bottom right, Wynford Dewhurst/1908
MANCHESTER CITY ART GALLERIES

Exhibition
1989 Cologne, Wallraf-Richartz Museum, *Landschaft
 im Licht* (41).

Although instantly attracted to Impressionism when
he viewed the work of Emile Claus in the Maddocks
Collection in Bradford, Dewhurst swiftly progressed to
his most important mentor, Claude Monet. In the early
years of the century contact with Claus and Maxime
Maufra was equally important, and in pictures like
The Picnic he appears to have thoroughly accepted the
principle of representing the visible world by the optical
mixing of small dabs of colour.

58 SUMMER MIST, VALLEY OF LA CREUSE (ill. p.119)
c.1920
oil on canvas, 25 x 32 in / 63.5 x 81.3 cm
inscribed, Dewhurst
NATIONAL MUSEUM OF WALES, CARDIFF

59 AN ANCIENT STRONGHOLD IN FRANCE (ill. right)
c.1920
oil on canvas, 32¾ x 39¼ in / 81 x 101 cm
inscribed, lower left, Dewhurst
BRADFORD ART GALLERIES AND MUSEUMS

Exhibition
1978 Bradford, Cartwright Hall and Hull, Ferens Art
 Gallery, *English Impressions* (10).

In later years Dewhurst's handling became more
expressive, especially in a series of works produced in
the valley of La Creuse. Here the bright, almost garish
colours again echo Monet, although in some instances
they achieve an unintended Fauvist intensity.

Alfred East 1849-1913

The youngest of eleven children, East was born in
Kettering. On leaving school he began work in his
brother's shoe factory, despite an established interest in
painting. A business trip to Glasgow resulted in his
enrolment in evening classes at the Government Art
School and, for a time, at Glasgow School of Art. His
commitment as a painter grew and in 1880 he went to
Paris to train at the Ecole des Beaux-Arts and the Acadé-
mie Julien. Influences on his work at that time were the
Barbizon painters, and he painted at Grez-sur-Loing
before his return to England around 1883. At Grez he
was particularly attracted by the ability of painters like
Charles Jacque to convey a sense of their intimacy with
the natural scene, regardless of the scale on which they
were working. East continued to travel, to Europe and
later to Japan, where he made studies of Mount Fuji, but
increasingly his inspiration was to be drawn from the
English landscape. Throughout the 1890s his popularity
grew, and he exhibited consistently at the Royal
Academy, where the grand evocations of his native coun-

tryside found a receptive audience. His obvious success
in expressing the Edwardian sentiment and nostalgia for
rural imagery led to his election as an ARA in 1899 and
a knighthood in 1910. In 1906 he published his book
The Art of Landscape Painting in Oil Colour, in which he
developed his view that a painter should not be content
simply to state the obvious in painting. A picture should
be the considered product of that individual's experience
and imagination, while still retaining something of the
spontaneity of the sketch. East was elected a full
Academician in 1913, but died three months later.

Sir Alfred East RA, *The Art of Landscape Painting in Oil
 Colour*, 1919 ed.
Peyton Skipwith, 'An Enlightened Artist in Japan',
 Country Life, 5 January 1984, pp.24-25.
Kenneth McConkey, 'Haunts of Ancient Peace,
 Landscapes by Sir Alfred East RA', in Alfred East
 Gallery, Kettering, *75th Anniversary Exhibition, 1913-
 1988*, catalogue of an exhibition, 1988.

60 DAWN ON THE SACRED MOUNTAIN (ill. p.121)
1889
oil on canvas, 22 x 36¼ in / 55.9 x 92.1 cm
inscribed lower left, Alfred East
PRIVATE COLLECTION, COURTESY OF THE FINE ART
SOCIETY, LONDON

61 KYOTO SCENE
1889
oil on canvas, 9 x 12½ in / 23.5 x 31.7 cm
inscribed lower left, Alfred East
ALFRED EAST GALLERY, KETTERING

East visited Japan in 1889 on a commission from the
Fine Art Society's Japanophile manager, Marcus B.
Huish. He travelled out with Sir Arthur and Lady
Liberty. Although the results of his trip are generally
more conventional than those of Menpes, who had
returned a year earlier, East produced a number of

60 **Alfred East**
Dawn on the Sacred Mountain
1889

classic landscapes which resume familar motifs in a western manner. Of these *Dawn on the Sacred Mountain* directly confirms a knowledge of Japanese graphic art, in that it closely parallels a celebrated print by Hokusai.

62 CHÂTEAU GAILLARD

c.1900
oil on canvas, 47 x 59 in / 119.4 x 149.9 cm
inscribed lower left, Alfred East
NORTHAMPTON MUSEUMS AND ART GALLERY

Exhibition

1903 London, Royal Academy of Arts (761).

64 **Alfred East**
A Pastoral c.1900

Reference

East, 1919, ed., illus. opp. p.83.

East painted Château Gaillard at Les Andelys on a number of occasions. *Autumn on the Valley of the Seine* (Leicester Museum and Art Gallery) contains its unmistakable profile from a slightly different angle, while in his book on landscape painting East illustrates a further example (p.32). In each of these the promontary is viewed from low-lying fields or from the road which skirts the Seine. In every case the castle is seen in sunlight from under the shade of tall trees and its scale dwarfs any figures or houses which might be found in the foreground. The site was such an impressive one that it inspired many British painters who were drawn to the val de Seine in the early years of the century. Most prominent among these was Connard, who redeployed East's favourite motif as the backdrop for poetic renderings of semi-classical nude bathing scenes (cat 43).

63 IN THE WATER MEADOWS

c.1900
oil on canvas, 20¼ x 25½ in / 53 x 65 cm
inscribed bottom right, Alfred East
MCLEAN MUSEUM AND ART GALLERY, INVERCLYDE DISTRICT COUNCIL

64 A PASTORAL

c.1900
oil on canvas, 23¼ x 29½ in / 60 x 75 cm
inscribed bottom right, Alfred East
MCLEAN MUSEUM AND ART GALLERY, INVERCLYDE DISTRICT COUNCIL

These two canvases express the essence of East's approach to landscape. Diffident about Impressionism he identified strongly with the native tradition of Constable in pictures like *In the Water Meadows*. He was prepared to concentrate more on abstraction in some of his French pictures, and it may be assumed that *A Pastoral* derives from these experiences. Although the palette remains tonalist, the sandy roadways and monochrome skies are suggestive of northern France. In this setting East was more inspired by Cazin than by Monet.

Peter Henry Emerson 1856-1936

Emerson was of English and American descent and was born in Cuba, where his father owned a sugar plantation. He came to England to school and then to study medicine. After qualifying he practised as a doctor until 1886, by which time photography had become an all-consuming interest. By this date Emerson had already visited East Anglia, which was to be his favoured locale, and had taken a cottage at Southwold in 1885. There he experimented with photographic techniques, and was largely responsible for a shift away from previously accepted pictorialist traditions towards a naturalistic approach. This was revealed in the book of platinum prints he produced in 1886 with his friend, the painter and naturalist T. F. Goodall, entitled *Life and Landscape on the Norfolk Broads*. Closely related were published works such as *Idylls of the Norfolk Broads* and *Pictures of East Anglian Life*, of the following year. At this point Emerson had evolved his idiosyncratic soft-focus technique, claiming that the eye was incapable of seeing as sharply as the photographic lens. In 1890 he appeared to retract his earlier views with the publication of *The Death of Naturalistic Photography*. From then on his work grew increasingly contrived and idyllic, often based on literary sources, and in 1892 he became one of the earliest members of the Linked Ring.

Peter Turner and Richard Wood, *P.H. Emerson, Photographer of Norfolk*, 1974.
Nancy Newhall, *P.H. Emerson*, 1975.
Ian Jeffrey, 'Peter Henry Emerson, Art and Solitude', *The Golden Age of British Photography, 1839-1900*, catalogue of an exhibition at the Victoria and Albert Museum, London, 1984, pp.154-62
Veronica Sekules and Neil MacWilliam eds., *Life and Landscape, P.H. Emerson, Art and Photography in East Anglia, 1885-1900*, catalogue of an exhibition at the Sainsbury Centre, University of East Anglia, 1986.

65 **COMING HOME FROM THE MARSHES** (ill. above)
1886
platinum print
THE ROYAL PHOTOGRAPHIC SOCIETY, BATH

Reference
P.H. Emerson, *Life and Landscape on the Norfolk Broads*, 1886, plate 1.

66 **SETTING THE BOW NET** (ill. p.29)
1886
platinum print
THE ROYAL PHOTOGRAPHIC SOCIETY, BATH

Reference
P.H. Emerson, *Life and Landscape on the Norfolk Broads*, 1886, plate 2.

67 **A SPRING IDYLL** (ill. right)
1887
gravure print
THE ROYAL PHOTOGRAPHIC SOCIETY, BATH

Reference
P.H. Emerson, *Pictures from Life in Field and Fen*, 1887, plate 3.

68 **THE FAGGOT CUTTERS**
1887
gravure print
THE ROYAL PHOTOGRAPHIC SOCIETY, BATH

Reference
P.H. Emerson, *Pictures from Life in Field and Fen*, 1887, plate 19.

69 **AUTUMN FLOODS**
1887
gravure print
THE ROYAL PHOTOGRAPHIC SOCIETY, BATH

65 **Peter Henry Emerson**
Coming Home from the Marshes 1886

67 **Peter Henry Emerson**
A Spring Idyll 1887

70 **Peter Henry Emerson**
Water Babies 1887

status. They were, however, published as illustrations rather than as independent prints.

Frederick Henry Evans 1853-1943

Evans worked until the late 1890s as a book seller in a shop in Cheapside, frequented by his friend George Bernard Shaw. On his retirement he became increasingly absorbed by photography, beginning with images of shells taken through a microscope. In 1905 he adopted the art professionally, working on commissions for *Country Life* magazine. He developed a reputation as a purist within the field, with a great regard for his own particular conceptions of the beautiful. His architectural photographs were especially well received, one writer admiring his ability to 'combine precision of definition with a softness and delicacy of graduation and an extraordinary sense of scale and of light' (Harker, p.151). By 1900 he had been elected to the Linked Ring, becoming closely involved with that group's publishing and exhibition activities. He also exhibited internationally and was a highly respected portrait photographer.

Margaret F. Harker, *The Linked Ring, The Secession in Photography, 1892-1910*, 1979.

Reference
P.H. Emerson, *Idyls of the Norfolk Broads*, 1887, plate 5.

 70 **WATER BABIES** (ill. above)
 1887
 gravure print
 THE ROYAL PHOTOGRAPHIC SOCIETY, BATH

Reference
P.H. Emerson, *Idyls of the Norfolk Broads*, 1887, plate 6.

 71 **CREPUSCULE AU PRINTEMPS** (ill. below)
 1906
 platinum print, 5¼ x 3½ in / 13.3. x 8.9cm
 THE ROYAL PHOTOGRAPHIC SOCIETY, BATH, GIFT OF
 FREDERICK HENRY EVANS, 1933

Peter Henry Emerson valued his friendships with painters of the New English Art Club. Goodall, Charles and Clausen were initially his mentors although at times, looking at his photographs, it is impossible not to be reminded of La Thangue and Osborne. It is clear from his first albums and his early writings that he revered Bastien-Lepage, and works like *Coming Home from the Marshes* display pictorial strategies advocated by Bastien and adopted by the New English painters. There are occasions when it seems almost as though Emerson was employing the same models as those of La Thangue. However in *Setting the Bow Net* and other early photographs he was working closely with the reclusive Goodall. Surprisingly little is known about this collaboration, apart from the fact that they collaborated in 1891 on a pamphlet entitled *Perspective Drawing and Vision*. Goodall is referred to with approval in an earlier letter from Charles.

 The range of Emerson's work, however, encompasses that of other painters. At times, for instance, he is close to W.J. Laidlay, while in photogravures such as *The Water Babies* the paintings of Tuke might be regarded as inspiration. In his early albums Emerson was anxious to claim art status for his images. They were photogravured and issued as if they were fine prints. In the 1890s, after he had come to reject the idea that photography should be presented as an art form, Emerson continued to produce photographs. These were paradoxically more influenced by Whistler, an artist preoccupied with the issue of art

71 **Frederick Henry Evans**
Crepuscule au printemps 1906

Evans himself documented this contact print as 'An example of so-called "straight" photography – No aid in development – no aid in printing', (Harker, p.115). As a result, as Harker points out, the print was a precedent for Edward Weston's F.64 Group in America. Despite the straightforward process, however, Evans produced an atmospheric and faintly nostalgic image of pure landscape that had its equivalent in popular Academy paintings by artists such as Alfred East.

John Duncan Fergusson 1874-1961

Fergusson came originally from Leith in Scotland and briefly pursued medical studies in Edinburgh. He quickly abandoned plans to become a naval surgeon and decided to turn to painting, although he undertook little formal training. From the mid 1890s he had taken a studio in Edinburgh and begun to travel, particularly to France. In Paris he studied the Impressionist paintings in the Luxembourg and at Durand-Ruel's, as well as attending life classes at the Académie Colarossi. He also came into contact with Peploe and painted with him at sites on the Normandy coast. From 1907 to 1914 Fergusson lived in Paris, where he developed a circle of friends among mostly British and American artists and writers. From this point he began to establish great interest in the work of Matisse and the Fauves, and later in Cubism. In 1911 an illustration of one of his paintings appeared in Middleton-Murray and Katherine Mansfield's literary journal *Rhythm*, and this led to Fergusson's appointment as art editor. His paintings of this time reflect, beyond purely painterly sources, his interest in fashionable developments in music and in the visual revolution presented by the Ballet Russes. From 1914 to 1929 he settled in London, where he had already started to exhibit. Four of his paintings had been included in Roger Fry's second Post-Impressionist exhibition in 1912. His paintings remained intensely coloured with rhythmic, geometric forms, and increasingly he turned to depictions of the nude. In the 1920s Fergusson exhibited with the Scottish Colourists and painted landscapes in the Scottish highlands. From 1925 to 1939 he again lived in Paris, and he settled finally in Scotland in 1940. He was a founder member of the New Art Club in that year, and in 1943 he published his *Modern Scottish Painting*.

Margaret Morris, *The Art of J.D. Fergusson*, 1974.
Haldane MacFall, 'The Paintings of J.D. Fergusson', *The Studio*, vol. 40, 1907, pp.207.
Roger Billcliffe, *J.D. Fergusson*, catalogue of an exhibition at The Fine Art Society, London, 1974.

72 LUXEMBOURG GARDENS (ill. right)
c.1907
oil on panel, 7¹/₂ x 9 in / 19 x 22.9 cm
MR R.B. ANDERSON

Fergusson painted numerous small panels in the gardens and thoroughfares of Paris. They indicate a direct response to visual circumstances and have an agreeable element of spontaneity. Fergusson saw such pictures as ends in themselves. As his style developed in

rapport with Fauvism and Cubism they were less necessary as an underpinning. In their freedom of handling, however, they extend the informal notes of painters like Ludovici and Studd.

William Mark Fisher 1841-1923

Of English and American parents, Fisher was born in Boston. He studied at the Lowell Institute there and began his career by painting portraits and figure subjects. In 1861 he travelled to Paris to Gleyre's studio, where he met Sisley and perhaps Monet. In 1872 he settled in London, although he continued to travel abroad, notably to Algiers and Morocco. In the same year he began to exhibit the landscapes which became his favoured subject, at the Royal Academy. These were inspired at first by Corot and the Barbizon painters and later by Impressionism, in particular by Monet and Sisley. The initial reaction to his work at the Academy was disappointing, and from 1887 he also began to exhibit at the New English Art Club, on the advice of Fred Brown. He became a member in 1892. His ability to capture the immediacy of the effects of light and shadow on a plein-air landscape was recognized increasingly by many, including Walter Sickert. Fisher was the father of the painter Margaret Fisher Prout.

Vincent Lines, *Mark Fisher and Margaret Fisher Prout*, catalogue of an exhibition at the Leicester Galleries, London, 1924.

73 THE BATHERS (ill. p.125)
c.1900
oil on canvas, 23 x 29⁵/₈ in / 58.4 x 74.9 cm
inscribed, bottom right, Mark Fisher
HUGH LANE MUNICIPAL GALLERY OF MODERN ART, DUBLIN

72 **John Duncan Fergusson**
Luxembourg Gardens c.1907

74 **HILL AND DALE** (ill. below)
c.1902
oil on canvas, 51¼ x 72½ in / 131.5 x 184 cm
inscribed, lower left, W. Mark Fisher
BRADFORD ART GALLERIES AND MUSEUMS

Fisher was something of a rediscovery for the 'New Critics' of the 1890s. He was belatedly recognized as an authentic French-trained painter of the Impressionist generation who had important connections. Like Nathaniel Hone his starting point as a landscapist was in

Barbizon, rather than post-Pre-Raphaelite painting. In the 1890s his style became more staccato and he engaged with themes of bathers in a manner comparable to that of Edward Stott. Around this time he was taken up by the New English Art Club.

Elizabeth Adela Forbes 1859-1912

A Canadian, Elizabeth Armstrong was born in Ottawa. After the death of her father she moved to London with her mother and enrolled at the South Kensington Schools for a short while. By about 1877 she and her mother were in New York where, from her teachers at the Art Student's League, Armstrong learned of the techniques of the rustic naturalists. This doubtless fuelled her decision to travel to Brittany in 1882, still accompanied by her mother, where she stayed at Pont-Aven before returning to London the following year. In the same year she made her début at the Royal Academy with *Summer* and began to practice etching, an activity which brought her into contact with Whistler and Sickert at exhibitions of the Royal Society of Painter Etchers. Armstrong and her mother settled in Newlyn in 1885 where soon afterwards she met Stanhope Forbes. The couple married in 1889 and until that time she painted often at St Ives and in London. In 1890 she became a member of the New English Art Club, although she continued to send to the Royal Academy. Increasingly, she developed her preference for figure subjects, mostly of children, which she produced not only in oil but also in watercolour and pastel. She remained consistently faithful to the principles of plein-airism, working from a

74 **William Mark Fisher**
Hill and Dale c.1902

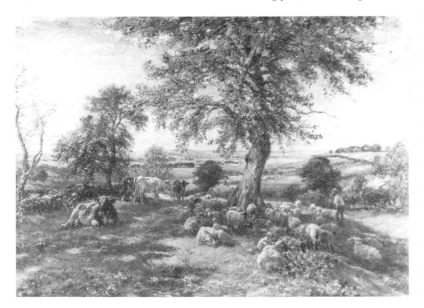

specially constructed, movable studio. Apart from the Academy her work was hung at exhibitions of the RWS, and she had solo shows at the Fine Art Society and the Leicester Galleries in 1900 and 1904 respectively. With Stanhope Forbes, Elizabeth revisited Brittany to paint in 1891 and she taught at the Newlyn School of Art from its foundation in 1899.

Caroline Fox and Francis Greenacre, *Painting in Newlyn, 1880-1930*, catalogue of an exhibition at the Barbican Art Gallery, London, 1985.

> 75 **Critics** (ill. below)
> c.1883-85
> oil on canvas, 9¼ x 5½ in / 23.5 x 14 cm
> inscribed, bottom left, with monogram, E.A.
> Private Collection

Exhibition
1985 London, Barbican Art Gallery, *Painting in Newlyn, 1880-1930* (50).

Critics is an example of Elizabeth Forbes' predilection for studies of children, with which she established her reputation in the later 1880s. That affinity developed while the artist was in France at Pont-Aven, where this work may have been started. In this picture a small boy's drawing receives the critical attention of a little girl and a discerning goose. The composition of the work, the full-length, close-up depictions of the figures as well as the emphasis on a diagonal arrangement of forms, reveal the influence of Bastien-Lepage, as does the handling and the use of the square brush technique.

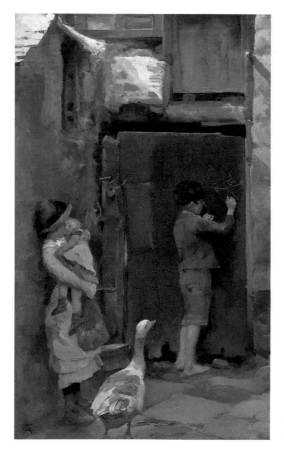

Her enthusiasm for the subject of children formed the basis of several of her solo exhibitions, starting at the Fine Art Society in 1900 with 'Children and Child Lore'.

Stanhope Alexander Forbes 1857-1947

Forbes originated in Dublin. His mother was French and his father, an Englishman, was a railway manager. On moving to England he attended Dulwich College and then Lambeth College of Art. From 1876 to 1878, Forbes was a contemporary of La Thangue at the Royal Academy Schools, a period which he interspersed with portrait commissions and landscapes painted in Galway. For a time portraits formed a significant part of his output and were exhibited at the Royal Academy for the first time in 1878. In 1880 Forbes enrolled at Bonnat's studio in Paris along with Arthur Hacker, and the following year he travelled to Brittany with La Thangue. At this point he developed his enthusiasm for plein-airism, much encouraged by La Thangue, and painted *A Street in Brittany*, which demonstrated all the clarity and directness of the new technique. The picture was bought by the Walker Art Gallery, Liverpool, a year later. After a brief return to Bonnat's studio Forbes continued to paint in Brittany, at Concarneau and at Quimperlé near Pont-Aven, but by 1884 he had joined Langley and Gotch at Newlyn, which he described as 'a sort of English Concarneau'. Shortly after his arrival he began *A Fish Sale on a Cornish Beach*, which proved a success at the Royal Academy in 1885 and was the encouragement for larger numbers of artists, including Bramley, to settle in Newlyn. The following year Forbes was a founder member of the New English Art Club, which for several years was largely dominated by the Newlyn School, who were initially united in their antipathy to the Royal Academy. Forbes certainly shared this view despite his own successes there and the fact that he continued to exhibit. In 1889 he married Elizabeth Armstrong which strengthened his commitment to staying in Newlyn, and ten years later they opened their School of Painting. By that date Forbes' personal reputation was well established and he had been elected an ARA in 1892. By the time he was made a full RA in 1910 his style had lightened, becoming increasingly colourful and less tonal, and he produced fewer large figure paintings as time passed. As far as was possible, however, he maintained his devotion to the principle of painting out of doors.

Mrs Lionel Birch, *Stanhope A. Forbes ARA and Elizabeth Stanhope Forbes ARWS*, 1906.
Barbican Art Gallery. London, *Painting in Newlyn, 1880-1930*, exhibition catalogue, by Caroline Fox and Francis Greenacre, 1985.
Caroline Fox, *Stanhope Forbes and the Newlyn School*, 1993.

> 76 Study for **A Fish Sale on a Cornish beach**
> 1884
> oil on canvas, 14 x 18 in / 35.6 x 45.7 cm
> inscribed, bottom right, Stanhope A. Forbes/1884
> Collection Mr and Mrs Malcolm Walker

Forbes' initial attraction to this subject stemmed partly from the sheer difficulty of its execution. He appears to have been of the view that the greater hardship and discomfort

75 **Elizabeth Adela Forbes**
Critics c.1883-85

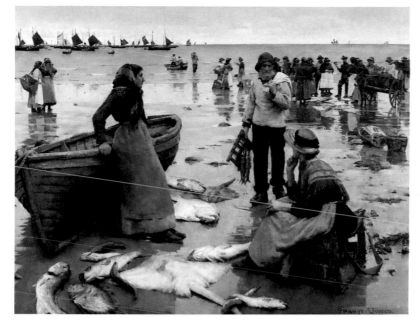

77 **Stanhope Alexander Forbes**
A Fish Sale on a Cornish Beach
1885

78 **Stanhope Alexander Forbes**
Beach Scene, St. Ives 1886

inherent in the painting of a picture, the more likely the work was to succeed. Coupled with this was his belief that the daily activities of the Newlyn community were naturally picturesque, the people seem to fall naturally into their place and to harmonize with their surroundings.

77 **A Fish Sale on a Cornish beach** (ill. above)
1885
oil on canvas, 47³/₄ x 61 in / 121.3 x 154.9 cm
inscribed bottom right, Stanhope A. Forbes/1885
Plymouth City Museum and Art Gallery

Exhibitions
1885 London, Royal Academy of Arts (1093).
1985 London, Barbican Art Gallery, *Painting in Newlyn, 1880-1930* (3).

References
Fox and Greenacre, 1985, pp.108-09.

This was the first major ambitious work to be produced by Forbes on arrival in Newlyn, and was followed closely by *Off to the Fishing Ground*, shown at the Royal Academy the next year. Painted with the square brush technique he had acquired in France, and in the open air amid much difficulty due to weather conditions and the length of time required, Forbes himself was delighted with the result and regarded it as the best picture he had ever produced. This view was widely shared. According to the critic Wilfred Meynell, writing several years later, 'if it did not make an era in British painting, it began to make one' (*Art Journal*, 1892). Critics admired the even quality of the grey, pearl-like light, the effects of light on the wet sand at low tide and the ease with which the figures fitted into their surroundings.

78 **Beach Scene, St Ives** (ill. below)
1886
canvas, 7¹/₂ x 11¹/₂ in / 19 x 29 cm
inscribed bottom right, Stanhope A. Forbes/St Ives 1886
Bristol Museums and Art Gallery

References
Fox and Greenacre, 1985, p.109.

Painted during the summer of 1886 at St Ives, where Forbes was staying with his family, this small study of bathing tents on the beach marks a contrast to the large scale figure studies he was then producing for the Royal Academy. In smaller paintings like this Forbes concentrated on mapping simple relationships between figures and setting and was less concerned with documenting specific details. *Beach Scene, St Ives* bears similarities to some of the work of Walter Osborne and even pre-dates Steer's paintings of the beaches in northern France and Walberswick from the later 1880s.

79 **The Seine Boat** (ill. p.72)
1904
oil on canvas, 45 x 62 in / 106.7 x 157.5 cm
inscribed bottom right, Stanhope A. Forbes/1904
Private Collection, courtesy Pyms Gallery, London

Exhibition
1904 London, Royal Academy of Arts (167).

The Seine Boat reveals a departure from the straightforward naturalism of previous large scale compositions, and has more immediacy and vitality than earlier works such as *Off to the Fishing Ground*, which has the same theme. The title of the work relates to the specific type of fishing net depicted. Here, the brilliant blues of the sky and sea, and the intensity with which the sunlight strikes the faces of the fishermen, demonstrate a move towards Impressionism and away from the ever-present greys of his naturalist paintings. In this respect the picture is characteristic of a general shift in his work after 1900 towards a brighter and less tonal style.

80 **Gala Day at Newlyn** (ill. p.128)
1907
oil on canvas, 42 x 54 in 106.7 x 137.2 cm
inscribed bottom left, Stanhope A. Forbes/1907
Hartlepool Museum Service

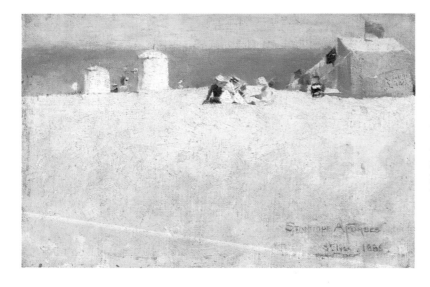

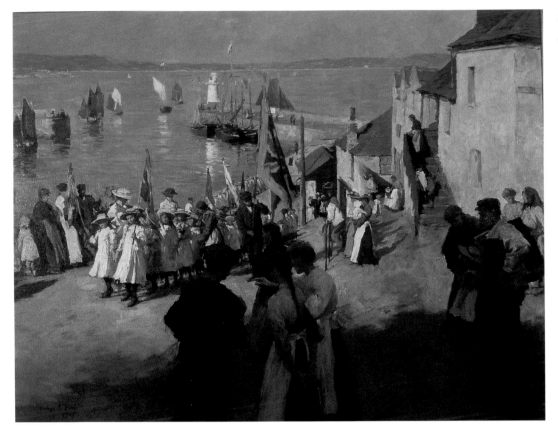

Exhibition

1985 London, Barbican Art Gallery, *Painting in Newlyn, 1880-1930* (11).

This picture of the annual village Gala, held every Whit Monday, depicts the gathering procession of children and villagers that marched through the town of Newlyn up to the house of a local landowner, under a banner designed with the help of Frank Bramley. The foreground, with the adult onlookers in shadow, gives way to a view down the steep cobbled street where the bright sunlight is cast on the faces of the small children, with a clear still blue sea in the background. It is in effect a happy carefree vision of Newlyn, that appeared increasingly in paintings after the turn of the century. The same theme was taken up by Harold Harvey, in his *Fête Champêtre* of 1934.

Roger Fry 1866-1934

Born in London, Roger Fry studied natural sciences at Cambridge University. Having decided to become a painter, he at first took lessons at Francis Bate's Applegate Studio in Hammersmith, before travelling to Paris and enrolling at the Académie Julian in 1891. On his return, he continued to develop his academic interests by writing for the Athenaeum and, between 1910 and 1919, as editor of the *Burlington Magazine*. Fry's scholarship at this point rested on his expertise on the Italian Renaissance, and he had published his *Giovanni Bellini* earlier in 1899. In 1906 he had been appointed Curator of Paintings at the Metropolitan Museum of Art in New York, although this was a short appointment, ending in 1910. By this date Fry was clearly out of sympathy with the ideals of the New English Art Club, which he had joined in 1893; his tastes now lay with more recent developments in French art which were too advanced for the old guard of that institution to accept. Increasingly Fry became absorbed in the Bloomsbury circle of Clive and Vanessa Bell and Duncan Grant, sharing their enthusiasm for the art of Matisse and, for Fry especially, of Cézanne. In 1910 he staged the first of the two Post-Impressionist exhibitions at the Grafton Galleries, London. The controversy which surrounded his gathering together of paintings by Gauguin, Cézanne and Van Gogh effectively cast Fry at the centre of critical debates about modernism. From this date onwards he regarded it as his role to expand on his essentially form-alist views and to convince the public of the merits of what he termed 'Post-Impressionist' painting. He published widely. A collection of some of his essays appeared in 1920 as *Vision and Design* and his monograph on Cézanne came out in 1927. He also continued to paint. His works consistently demonstrated his concern for structure and formal relationships, although the colour of his paintings became less intense as the years passed.

Frances Spalding, *Roger Fry Art and Life*, 1980.
Denys Sutton ed., *Letters of Roger Fry*, 1972.
Quentin Bell, *Roger Fry*, 1964.

81 **HARVEST TIME, GATHERING STORM** (ill. p.129)
c.1895
oil on canvas, 21¹/₂ x 26 in / 54.6 x 66 cm
PRIVATE COLLECTION

81 **Roger Fry**
Harvest Time, Gathering Storm
c.1895

Early works by Roger Fry are rare but, as this picture shows, sometimes extremely accomplished. They reveal a young painter attempting to absorb Impressionism while on visits to France in 1892 and 1893. Although Fry's movements are difficult to pin down, it seems likely that he travelled through the val de Seine, where the present picture may have been painted. Late in the 1890s his work became more Italianate in character, and correspondingly less atmospheric than the present work.

Norman Garstin 1847-1926

82 **Norman Garstin**
Artichokes, Hyères 1883

Garstin was brought up by his grandparents in Ireland following his father's death and his mother's illness. He attempted several careers before deciding on painting, including time spent in the South African diamond

fields around 1872. In 1878 he studied at Verlat's Academy in Antwerp at the same time as Frank Bramley and Fred Hall. He then travelled to Paris where he spent three years with Carolus-Duran between 1880 and 1883. After Paris Garstin continued to travel, to Italy and Morocco, before settling at first in Newlyn and then from 1886, in Penzance. Even then he made trips abroad, notably to America in 1892, when he visited the Saskatchewan plains and the Rockies, and sent an illustrated article on his journey to the *Art Journal*. In later writings Garstin cited as influences on his own painting such diverse sources as Bastien-Lepage, Whistler, Manet and the Japanese print. He also declared his distaste for the sentimental narrative scenes that were particularly in evidence at the Academy. Nevertheless, in later years Garstin himself produced several such works, possibly only through financial necessity. His best known painting, *The Rain it Raineth Every Day*, 1889, was accepted at the Royal Academy that year although not hung. He did show at the Academy on other occasions between 1883 and 1923 and was a member of the New English Art Club from 1887 until his resignation in 1890.

Penwith Gallery, St Ives, *Norman and Alethea Garstin*, catalogue of an exhibition, 1978.
Caroline Fox and Francis Greenacre, *Painting in Newlyn 1880-1930*, catalogue of an exhibition at the Barbican Art Gallery, London, 1985, pp.73-75.

82 ARTICHOKES, HYÈRES (ill. below)
1883
oil on panel, 5½ x 9 in / 14 x 22.9 cm
inscribed verso, painted by Norman Garstin at Hyères, South of France, 1883 and given by him to Dochie Jones
BRISTOL MUSEUMS AND ART GALLERY

Exhibition

1985 London, Barbican Art Gallery, *Painting in Newlyn, 1880-1930* (54).

Artichokes, Hyères was painted shortly after Garstin had left Carolus-Duran's atelier and before his visit to Italy. The simple composition, the slight asymmetry of the arrangement and the concern for light and air in this work may in part be a reflection of his enthusiasm for Manet, whose outdoor work he praised in an article of the following year. In this the French artist's pictures at the Salon were said to have the appearance of 'patches of sunlight on the prison wall'.

David Gauld 1865-1936

Gauld was a second generation Glasgow School painter. He began his career as a lithographer and in the late 1880s made a reputation for himself with illustrated stories which appeared in the *Glasgow Weekly Citizen*. He also spent time designing stained glass for church and domestic commissions, most notably for St Andrew's Church in Buenos Aires. Between 1882 and 1885 and later in 1889, he attended the Glasgow School of Art and afterwards painted in France. From 1885 he exhibited regularly in Scotland and at the Vienna Secession in the

84 **David Gauld**
A Breton Village c.1900

1890s. Gauld's early work bore the influence of Henry and Hornel, and he was also a particular friend of Charles Rennie Mackintosh. His *St Agnes*, 1890, is an extraordinary anticipation of Art Nouveau. Around 1895 he abandoned symbolism and in successive years made trips to Grez, Normandy and Brittany. Late in his career he became noted as a painter of landscape and cattle, more especially of Ayrshire calves. These were painted directly in simple, atmospheric settings and with a delicate and refined use of colour. Gauld was elected an ARSA in 1918, an RSA in 1924, and became Director of Design Studies at Glasgow School of Art in 1935.

James L. Caw, *Scottish Painting, 1620-1908*, 1908, (Kingsmead reprint 1975), pp.450-51.
David Martin, *The Glasgow School of Painting*, 1897, (1976 reprint), pp.15-16.

83 GREZ FROM THE RIVER
c.1896-97
oil on canvas, 24 x 26 in / 61 x 66 cm
inscribed bottom left, David Gauld
ANDREW McINTOSH PATRICK

84 A BRETON VILLAGE (ill. above)
c. 1900
oil on canvas, 19¼ x 23¼ in / 50.2 x 60.3 cm
inscribed bottom right, D. Gauld
ROBERT FLEMING HOLDINGS LIMITED

Gauld's experience of working at Grez-sur-Loing in the late 1890s converted him to poetic naturalism. Martin commented at the time upon his pale schemes of colour which were regarded as 'very beautiful'. It was the simplicity of design contained in these works – later extended to Normandy and Brittany – villages which commended him to the selectors of the International Society, with whom he regularly exhibited from its inception in 1898.

Wilfrid De Glehn 1870-1951

De Glehn was born in London and attended Brighton College. He spent a short time at the Government Art Training School before going to Paris in 1890, where he trained at the Ecole des Beaux-Arts under Gustave Moreau. He was based in Paris for six years, during which time he absorbed the lessons of Impressionism. During this period he gave assistance to his friend Sargent and to Edwin Austin Abbey with their murals for the Boston Public Library. From 1891 De Glehn exhibited at the Salon and at the Galérie Durand-Ruel. In London he was a member of the New English Art Club from 1900 and he had a particular friendship with Steer and Tonks. He also showed at the Royal Academy from 1896 until his death. His subject matter was wide ranging, and included plein-air landscapes, nudes and portraits. Often Sargent's influence was revealed in

these works with their loose handling, vibrant colour and fascination for the effects of light on surfaces. In 1904 De Glehn married the American Jane Emmet, a friend of Henry James, and she became a frequent model for his informal outside studies, either lying or wandering by a river bank on a sunny afternoon and dressed, invariably, in white. His first solo exhibition was held at the Carfax Gallery in 1908. In 1923 he was elected an ARA and an RA in 1932. A later nomination for presidency of the Academy was turned down.

T. Martin Wood, 'The paintings of Wilfred G. Von Glehn', *The Studio*, vol.56, 1912, pp.3-10.
Laura Wortley, *Wilfred de Glehn, A Painter's Journey*, 1989.

85 GWENDREATH BLOSSOM – JANE SITTING IN THE SHADE
c.1905
oil on canvas, 20 x 25 in 50.8 x 63.5 cm
PRIVATE COLLECTION

Reference
Kenneth McConkey, *British Impressionism*, 1989, p.131 (illus.).

86 JANE EMMET DE GLEHN BY A STREAM, VAL D'AOSTA
(ill. above)
c.1907
oil on canvas, 23 x 30 in / 58.4 x 75.2 cm
THE DAVID MESSUM GALLERY, LONDON

Reference
Laura Wortley, *British Impressionism, A Garden of Bright Images*, 1989, p.30 (illus.).

Before he accompanied Sargent on his visit to the Val d'Aosta in 1907, De Glehn had already developed methods of swift sketching from nature. His major efforts were, however, directed to large semi-classical multi-figure nude compositions which were not entirely successful. It is likely therefore that the trip to Purtud with his friend and mentor was as much a liberation for him as it was for Sargent. Recently married to Jane Emmet, a friend of Henry James, he found that he had a willing model who posed for two canvases by a stream dressed in white (see K. McConkey, 1989, p.130). The clear air and shrill colour of these scenes drew both Sargent and De Glehn back to the essential values of 1880s Impressionism, prior to the advent of Divisionism.

87 FISHING (ill. right)
1931-32
oil on canvas, 22 x 27½ in / 55.9 x 69.9 cm
inscribed bottom left, De Glehn
ROYAL ACADEMY OF ARTS, LONDON

Exhibition

1988 London, Royal Academy of Arts, *The Edwardians
 and After, The Royal Academy, 1900-1950* (15).

Although De Glehn occasionally painted misty pictures
of the London river, the primary experience provided by
his work was of midday summer sunlight. This had
gained him a reputation as a 'light-hearted' painter who
converted modern conditions into an eighteenth-century
idyll which made him the envy of other artists. T.M.
Wood, writing in 1912, described this as 'a delightful
sort of pantheism ... people among the trees
besmattered with splashes of sunlight, moving there
even in all their modern costume as if they belonged to
the scenes, dryads and children of Nature in the spirit of
their love for her and their pleasure in the sun' (p.9).

Thomas Frederick Goodall 1857-1944

A naturalist as well as an artist, Goodall studied under
John Sparkes at Lambeth School of Art. He developed as
a painter of landscape and rustic genre scenes, influen-
ced by his friendship with Stanhope Forbes and La
Thangue. From 1878 Goodall began to exhibit at the
Royal Academy, although he was a more regular
exhibitor at Suffolk Street and was a founder-member of
the New English Art Club in 1886. His painting *The Bow
Net,* of that same year, was purchased by the Walker Art
Gallery, Liverpool, in 1887. Much of Goodall's subject
matter derived from his close working relationship with
the photographer P.H. Emerson, and he provided the text
to several of Emerson's publications, including *Life and
Landscape on the Norfolk Broads* in 1886.

88 ROCKLAND BROAD, NORFOLK (ill. below)
1883
oil on canvas, 36 x 60¼ in / 91.4 x 153 cm
inscribed lower left, T.F. Goodall 1883,
Rockland Broad, Norfolk
NORFOLK MUSEUMS SERVICE, NORWICH CASTLE
MUSEUM

Exhibition

1986 Norwich, Sainsbury Centre, University of East
 Anglia, *Life and Landscape, P.H. Emerson Art and
 Photography in East Anglia, 1885-1900* (42) .

89 THE BOW NET (ill. p.29)
1886
oil on canvas, 33 x 50 in / 83.8 x 127 cm
inscribed
BOARD OF TRUSTEES OF THE NATIONAL MUSEUMS AND
GALLERIES ON MERSEYSIDE: WALKER ART GALLERY,
LIVERPOOL

Exhibitions

1887 London, New English Art Club (40).
1986 Norwich, Sainsbury Centre, University of East

Anglia, Life and Landscape, *P.H. Emerson, Art and
Photography in East Anglia, 1885-1900* (43).

Few examples of Goodall's work survive. *Rockland
Broad,* however, reveals a painter who, like O'Meara, was
extraordinarily sensitive to tonal effects. Prior to his
association with Emerson, Goodall's work possesses the
'depth of field' of photography. This is evident in *The
Bow Net,* a picture which appears to be the most
complete photographic transcription to date. Before and
after its completion it was common for artists to employ
photography in a number of ways, most frequently to
inform parts of compositions, much in the same way as
study drawings. A multi-figure subject might thus
actually be an assemblage drawn from quite different
sources. Photographs might also be used to define the
setting and inform the painter about what he was
actually seeing – as in the case of blurred figures in
classic Impressionist paintings. By 1886 the technical
possibility of transcribing a photograph in its entirety
had not been explored. It seems likely, although we

87 **Wilfrid de Glehn**
Fishing 1931-2

88 **Thomas Frederick Goodall**
Rockland Broad, Norfolk 1883

90 **Spencer Frederick Gore**
The Garden, Garth House
1908

Frederick Gore, *Spencer Frederick Gore, 1878-1914*, catalogue of an exhibition, Anthony D'Offay Gallery, London, 1974.
Wendy Baron, *The Camden Town Group*, 1979.

90 **THE GARDEN, GARTH HOUSE** (ill. left)
1908
oil on canvas, 20¹⁄₄ x 24 in / 51.4 x 61 cm
inscribed F. Gore
BOARD OF TRUSTEES OF THE NATIONAL MUSEUMS AND GALLERIES ON MERSEYSIDE: WALKER ART GALLERY, LIVERPOOL

Exhibitions
1955 Arts Council, *Spencer Frederick Gore, 1878-1914* (12).
1970 Sheffield, Graves Art Gallery, *Spencer Gore* (15).
1974 London, Royal Academy of Arts, *Impressionism* (120).

From 1904 Gore's mother lived at Garth House, Hertingfordbury, to which he repaired for extended visits between 1907 and 1910. On these occasions he worked mostly in the garden, depicting its rich foliage, the tennis games played by members of his family and, on this occasion, their quiet conversations. Away from the din of aesthetic debate in London he was able to absorb new ideas at a gentler pace. Prior to 1908 he had joined the Fitzroy Street Group and was particularly friendly with Sickert and Lucien Pissarro. His style was deeply affected by Lucien's work and the works owned by his father Camille Pissarro. It is not inconceivable, for instance, that he would have seen and admired the Bath Road canvases of 1897 which Camille had left with Lucien. The effect of these was to produce a modified Divisionism which, applied to an English garden, achieves a quiet serenity. Jack Wood Palmer, writing in 1955, regarded pictures of this type as the quintessence of the Edwardian era. 'In this garden', he wrote, 'with its ilex and poplars in a stilled radiance of light, the gravel paths along which frilled white muslin skirts have lightly swept, the roses heavy in their Chinese moment of perfection, it is always afternoon, and Gore's paintings of it are among the most exquisite evocations of the Edwardian era'.

cannot be certain, that this was the case with *The Bow Net*. The differences between the two visual statements are significant. Goodall takes a higher viewpoint in the painting than in the photograph in order to portray the space around the figures.

Spencer Frederick Gore 1878-1914

Gore's early years were spent in Epsom, Surrey. Schooling was at Harrow, where he won a drawing prize, and this doubtless encouraged him to attend the Slade School between 1896 and 1899. It was then that a friendship was established with Harold Gilman, another later member of the Camden Town Group. Reflecting the Slade's current obsession with the art of Goya and Velázquez Gore, together with Wyndham Lewis, visited Spain in 1902. More important for his subsequent development, however, was his trip to Dieppe to meet Sickert two years later. From Sickert he learned of more recent developments in French painting, of Degas in particular, and his knowledge was extended in 1907 when Lucien Pissarro introduced him to the methods of neo-Impressionism. That same year Gore was a founder member of the Fitzroy Street Group. From this point, the influence of Steer on landscapes gave way and Gore's work displayed a greater intensity of colour and a concern for decorative effect. The influence of neo-Impressionism revealed itself in scenes of music-halls and mad ballets, as well as in landscapes. In 1908 Gore was a founder member of the Allied Artists Association and increasingly his work was drawn to the influence of Matisse and, more especially, Gauguin. These influences were revealed in his design scheme for Madame Strindberg's *Cave of The Golden Calf* in 1912, and so by the time the Camden Town Group was established in 1911 his style had evolved considerably from that of Sickert who, partly from age, was unable to respond to the French Post-Impressionists with enthusiasm. Gore died of pneumonia in 1914.

James Guthrie 1859-1930

The son of a clergyman, Guthrie's childhood was spent in Greenock. He abandoned his original intention to study law and in 1877 took up painting. He was essentially self-taught, although he received encouragement in his new career from a number of successful Scottish painters based in London. In 1879 he worked at Rosneath in southern Scotland with two later luminaries of the Glasgow School, E.A. Walton and Joseph Crawhall. During the following years, Guthrie was influenced in turn by British social realist painters and by the leaders of the Hague School, before he succumbed to the plein-air naturalism associated with Bastien-Lepage. In works like *To Pastures New*, 1882 and *A Hind's Daughter*, 1883, he applied the square brush method more rigorously than most of his comrades. After completing *Schoolmates*,

1884, Guthrie began to experience difficulties in scaling up his imagery for the large monumental canvases of field work which he hoped to produce. At this point he turned to portraiture and instantly achieved considerable success with *Rev. Andrew Gardiner D.D.*, 1886. Thereafter Guthrie became one of the most prominent Scottish portraitists, eventually securing election to the Presidency of the Royal Scottish Academy. Around 1890 his experiments with the medium of pastel produced some startling results. The new emphasis upon colour rejuvenated his painting and in works like *Midsummer* he demonstrated a sympathetic awareness of Impressionism. Guthrie's later career was plagued by ill health, although shortly after his resignation from the presidency of the Scottish Academy he was given his last major project, a large celebratory canvas portraying *Some Statesmen of the Great War*.

James L. Caw, *Sir James Guthrie, PRSA, HRA, LLD*, 1932.

91 **FIRE LIGHT REFLECTIONS** (ill. above)
1889
pastel, 24¹/₂ x 29¹/₄ in / 62 x 74 cm
inscribed lower right, J. Guthrie, 1889
PAISLEY MUSEUM AND ART GALLERIES, RENFREW DISTRICT COUNCIL

References
Roger Billcliffe, *The Glasgow Boys*, 1985, pp.273-76.

For a short period in 1890 Guthrie turned from portraiture and began to work once more in pastel. Influenced by E.A. Walton, he drew his subjects from the everyday middle class lives of those who lived around Helensburgh on the Firth of Clyde. Following Walton's example also he became particularly absorbed in studies of the social activities of the ladies of that area. In interior subjects like this one and in *Candlelight*, 1890, he depicted these women in fire or candle-lit rooms where they read or play music. At the same time, he made contrasting sunny exterior studies such as *Tennis* and *The Morning* Walk. Several of these were exhibited at the Glasgow Institute exhibition in early 1890.

92 **MIDSUMMER** (ill. p.68)
1892
oil on canvas, 40 x 49¹/₄ in / 101.8 x 126.6 cm
inscribed bottom left, James Guthrie
ROYAL SCOTTISH ACADEMY, DIPLOMA COLLECTION, EDINBURGH

References
George Moore, *Modern Painting*, 1893, p.206.
Roger Billcliffe, *The Glasgow Boys*, 1985, pp.280-84.
Kenneth McConkey, *British Impressionism*, 1989, p.99 (illus.).

Midsummer represents the high point of Guthrie's Impressionist period which, in many respects, developed

inscribed bottom left, J. Guthrie '93
NATIONAL GALLERY OF SCOTLAND, EDINBURGH

Guthrie's free Impressionist manner continued to develop in canvases produced in Oban in 1893. Painting the sort of subject familiar to the Newlyn artists, he was careful to avoid becoming embroiled in detail. What faced him in the present work was clearly a nocturne, but one which demanded a subtle range of tones. The colour is not so strident as Monet's earlier harbour scenes, but the overall effect is equally spontaneous.

Arthur Hacker 1858-1919

Arthur Hacker attended the Royal Academy Schools in 1876. In 1880 he studied for a year in Paris at Léon Bonnat's atelier together with Stanhope Forbes. At that time his painting was much influenced by French Realism, as *Her Daughter's Legacy* demonstrated when shown at the Academy in 1881. In 1886 he joined the newly formed New English Art Club, but his style soon developed away from that typical of the Club, towards a more dramatic and academic treatment with biblical subject pictures like *By the Waters of Babylon*, 1888. In 1892 his painting *The Annunciation* was purchased by the Chantrey Bequest. But pictures of this type were gradually losing favour even in the more conservative quarters and they were especially despised by New English critics like George Moore. As a result, perhaps, Hacker began to further his practice as a portrait painter and also to produce his atmospheric London street scenes. Throughout the 1890s he taught at the Royal Academy Schools. He was elected an ARA in 1894 and *A Wet Night at Piccadilly Circus* was his RA diploma work in 1910.

out of his experience of working with pastel. The scene depicts an afternoon tea party in Thornton Lodge garden in Helensburgh. Hannah Walton, the sister of Guthrie's friend, is one of the three women sitting in the dappled shade of a spreading tree. One of the most enthusiastic commentaries for this painting came from George Moore, who described it as, 'Summer's very moment of complete efflorescence'. He described the dresses, one, 'like a lily drenched with green shadows, and another 'purple, beautiful as the depth of foxglove bells'. The whole work he felt was a 'delicate and yet full sensation of the beauty of modern life, from which all grossness has been omitted'.

Alfred Lys Baldry, 'The Paintings of Arthur Hacker', *The Studio*, vol. 56, 1912, pp.175-83.
John Christian, *The Last Romantics*, catalogue of an exhibition, at the Barbican Art Gallery, London, 1989.

93 **OBAN** (ill. above)
1893
oil on canvas, 22¾ x 18¼ in / 57.8 x 46.3 cm

94 **A WET NIGHT AT PICCADILLY CIRCUS** (ill. left)
1910
oil on canvas, 28 x 36 in / 71.1 x 91.4 cm
inscribed bottom left, A. Hacker 1910
ROYAL ACADEMY OF ARTS, LONDON

Exhibitions
1911 London, Royal Academy of Arts (28)
1988 London, Royal Academy of Arts, *Edwardians and After, The Royal Academy, 1900-1950* (28).

Hacker's London scenes of around 1910 marked a new departure for a painter whose portraits and mythological pictures were familar to Academy visitors. It is almost as though this establishment figure, now in his fifties, wished to reclaim some of the radicalism of his student years. The high definition of his classical pictures has dissolved into the atmosphere of a rainy night in which theatre crowds and cabs jostle under the gas street lamps. Critics were supportive of this development, recognizing Turneresque, if not Impressionist, qualities in the handling.

Fred Hall 1860-1948

Hall was born in Yorkshire, where his father had a
medical practice. In 1879 he enrolled at the art school in
Lincoln, where his family had moved two years earlier,
and in 1882 he joined Verlat's Academy in Antwerp,
accompanied by Bramley, another ex-student from
Lincoln. After four years Hall had settled in Newlyn, by
which time, as paintings such as *Home from the Fields*
reveal, he had adopted plein-air principles and the
square brush technique associated with the painters of
that group. From 1887 Hall began to exhibit at the
Academy and to produce his anecdotal, interior genre
scenes. Later he developed a considerable reputation as a
caricaturist, and his friend Norman Garstin wrote about
his talents in that area in an article for the *Art Journal* in
1891, describing his ability to express at once 'an indivi-
dual and a type'. In landscape and pastoral subjects of
the 1890s, Hall revealed an understanding of Impres-
sionism that resulted in similarities with the work of
painters like Clausen, in the use of warm, atmospheric
colour and in the relationship of figure to setting.
During the 1890s, he spent less time in Newlyn, prefer-
ring to paint at Porlock on the Somerset coast. After his
marriage in 1898 he moved quite often, finally settling
in Newbury in 1911. Hall became a member of the New
English Art Club in 1888 and showed regularly at the
Fine Art Society.

Caroline Fox and Francis Greenacre, *Painting in Newlyn
 1880-1930*, catalogue of an exhibition catalogue at the
 Barbican Art Gallery, London, 1985.
Norman Garstin, 'A New Caricaturist', *The Art Journal*,
 January 1891, pp.25-30.

95 **THE DRINKING POOL** (ill. above)
c.1898
oil on canvas, 28⁷/₈ x 63¹/₄ in / 73.5 x 160.5 cm
inscribed lower left, Fred Hall
BRADFORD ART GALLERIES AND MUSEUMS

Exhibition
1978 Bradford, Cartwright Hall and Hull, Ferens Art
 Gallery, *English Impressions* (21).

Hall's concern in this painting has been with represen-
ting the figure of the girl and the solid forms of the
cattle as the sun sinks at the end of the day. Here he
reveals his skill at depicting the shimmering, luminous
atmosphere of evening with its golden, diffuse light. The
paintings Hall produced at Porlock up to the date of
this work demonstrate the same subtle and mellow
Impressionism of such painters as La Thangue and
Clausen, and in the case of all three this was skilfully
employed to reinforce the rustic idyll.

97 **Paul-César Helleu**
Mme Helleu at Fladbury 1889

Harvey was one of the most important and prolific second generation Newlyn painters. In company with Forbes and Laura and Harold Knight he adopted a bright palette for scenes of sunlit fishing forays. By 1910 his rustics had been transformed into children on holiday, paddling and exploring the rock pools. These idyllic works typified the long Edwardian summer in the years prior to the First World War.

Paul-César Helleu 1859-1927

Helleu's father died shortly after he was born. Despite his mother's concern for him to enter a secure profession, he left his home town of Vannes and enrolled at Gérôme's atelier at the age of seventeen. In Paris in the mid 1870s he established a network of acquaintances which included Whistler, Rodin, Monet and especially Sargent, with whom he travelled to Holland in 1880. Four years later he met and soon married Alice Guérin. Having first painted her portrait as a commission, she and their subsequent children became his most frequent models. Helleu's reputation as a portraitist developed rapidly and by the later 1880s he was also etching, producing drypoints for his new patron Robert de Montesquiou. The latter, a confirmed aesthete, was drawn to what he perceived as the artist's profound good taste, describing him at one point as *'le maître des elégances'*. Such a reputation led to his presumed inclusion in Proust's *A la recherche du temps perdu*, as a basis for the painter Elstir. This refined aestheticism kept him at some distance from the ideals of the Impressionist group. In 1888 he showed alongside Toulouse-Lautrec, Signac and Whistler in Brussels and he was exhibiting pastels and drypoints in London in 1896. From the end of the 1880s he and his family had joined the yachting fraternity in France and Cowes, and from 1902 he began his visits to America where his reputation as a portrait painter had preceded him. In New York in 1912 he revealed his talents as a mural painter, with decorations of the zodiac for the ceiling of the Grand Central Station.

Ferrers Gallery, London, *Paul-César Helleu, An Exhibition of Paintings, Pastels and Drawings*, 1970.
Victoria Law, *Paul-César Helleu*, catalogue of an exhibition at Richard Green, London, 1991.

97 **Mme Helleu at Fladbury** (ill. above)
1889
oil on canvas, 21$^1/_4$ x 23$^3/_4$ in / 54 x 60.3 cm
inscribed bottom left, Helleu
RICHARD GREEN, LONDON

Harold Harvey 1874-1941

One of the few Newlyn painters who was a native Cornishman, Harvey was born in Penzance. He trained at first with Norman Garstin and in the 1890s at the Académie Julian. He returned to Newlyn and married the painter Gertrude Bodinar, a local like himself. Harvey's early work was influenced by Garstin and then by Stanhope Forbes, but gradually his palette brightened and his subjects became increasingly cheery, sharing similarities with the work of Laura Knight. Both artists developed a predilection for paintings of small children playing on sunlit beaches, or working girls going about their tasks with a sunny disposition. As a result Harvey's works are very typical of that shift away from the rustic naturalism associated with the first group of incomers to Newlyn, towards a more carefree Impressionist style that was popular at the Royal Academy from the turn of the century. After 1915 his style changed and he adopted the flattened forms and smoother surfaces of painters like Dod Proctor. He also developed a similar interest in stylish interior subjects, often including his wife and their artist friends. Harvey lived all his life in Cornwall and although he showed regularly at the Royal Academy he was never elected a member, nor was he a member of the New English Art Club. He held several shows in London, notably at the Leicester Galleries, and he exhibited consistently at the Newlyn Art Gallery.

Caroline Fox and Francis Greenacre, *Painting in Newlyn 1880-1930*, catalogue of an exhibition at the Barbican Art Gallery, London, 1985.

96 **A Quiet Paddle** (ill. p.136)
1913
oil on canvas, 20 x 18 in / 50.8 x 45.7 cm
inscribed lower left, H. Harvey '13
COLLECTION MR AND MRS MALCOLM WALKER

Exhibitions
1931 Paris, Galérie Charpentier, *Paul Helleu* (2).
1962 Dieppe, Musée de Dieppe, *Paul Helleu* (6).
1994 Osaka, Tokyo, Kitakyushu, *Women of Fashion, French and American Images of Leisure, 1880-1920* (17).

With Sargent at Fladbury in 1889, Helleu had the opportunity to experiment with Impressionism. It may be assumed that as a friend of Blanche and Sickert he was already familar with their general approach, and in

Sargent's celebrated study of *Paul Helleu sketching with his wife, Alice* he is shown at work *en plein air*. This landscape sketch appears not to have survived, and our knowledge of what Helleu produced at Fladbury is limited to the present picture. In this the painter proceeds by building up thin films of oil paint as a basis to which his deft calligraphy is applied. Helleu married Alice Louis-Guérin when she was sixteen, in 1886. She appears regularly in his work of the 1890s.

George Henry 1858-1943

A native of Ayrshire, Henry began work as a designer of posters and stained glass. He studied at Glasgow School of Art briefly in 1882 and also attended W.Y. Macgregor's classes in Bath Street. By this time he was already painting with Guthrie and Walton at Brig O'Turk, and with Guthrie again at Cockburnspath in 1883. Influenced by the square brush technique and rustic subjects, he shared Guthrie's admiration for Bastien-Lepage until around 1885. In that year Henry met E.A. Hornel and painted with him, first in Galloway and later in Kirkcudbright, working in oils but also increasingly in watercolour. From this point his painting developed away from rustic naturalism and displayed his new concern for brighter colour and a more decorative design. These tendencies were most clearly revealed in *A Galloway Landscape* of 1889, which bears interesting similarities with paintings by the Pont-Aven group. By

1890 Henry and Hornel were drawing their inspiration from Celtic mythology, and in large symbolist works such as *The Druids* of that year gesso and gold overlays produced a rich patterning far removed from their earlier realist subjects. In 1893 the two travelled to Japan, funded by Alexander Reid. The visit lasted for eighteen months, resulting in highly decorative images of Japanese gardens, but many of Henry's oil paintings were ruined on the return voyage. After 1900 he settled in London and began to concentrate mainly on portraits, which were shown at the Royal Academy from 1904.

James L. Caw, *Scottish Painting Past and Present 1620-1908*, 1908, (Kingsmead reprint, 1975).
Roger Billcliffe, *The Glasgow Boys*, 1985.

> 98 **Noon** (ill. above)
> 1885
> oil on canvas, 20 x 24 in / 50.8 x 61 cm
> inscribed bottom right, George Henry 1885
> Lord and Lady Macfarlane of Bearsden

References
Billcliffe, 1985, pp.156-57, 192-93.
Percy Bate, 'The Work of George Henry, RSA: A review and an Appreciation', *The Studio*, vol. 31, 1904, pp.4-5 (illus.).

Writing in *The Studio*, Percy Bate described how in this work and in *A Hedge Cutter* Henry's main concern was to render direct sunlight through the means of strong

contrasts. This he achieved through the use of dark purplish foreground shadows which accentuate the yellow sunlight flooding the rest of the picture. For this critic, Henry achieved a balance between truth to the landscape and 'the artistic value of rustic character'. *Noon* was painted either at Kirkcudbright or Cockburnspath and indicates the strong influence of Guthrie on Henry's work at that time. Billcliffe suggests that the model used for the picture may have been Hornel's sister, who appeared also in Hornel's own *Resting*, 1885.

Charles Edward Holloway 1838-97

Holloway came from Christchurch in Hampshire and trained at Leigh's studio in Newman Street, alongside Fred Walker. Until 1866 he designed stained glass with William Morris, after which time he painted topographical landscapes and seascapes, mostly of areas around the Thames, Essex and in Suffolk. These were exhibited until 1894 at the Royal Academy, where he developed a particular reputation as a painter of churches. In the preceding year Holloway had been wooed into the New English art Club where he showed scenes of the London river, East Anglia and Venice. He was a noted watercolourist and exhibited at the Royal Watercolour Society works which displayed his understanding of Whistler, and of Impressionism, in their handling and subtle use of colour.

The Art Journal, 1897, p.127.
Martin Hardie, '*Watercolour Painting in Britain*', 1967-69, vol. 3, pp.82, 84.
'British Marine Painting' *The Studio*, (Special no.), 1919, pp.28, 68.

> 99 **TILBURY FORT** (ill. below)
> c 1895
> oil on canvas, 21 x 34¹/₂ in / 53 3 x 87.6 cm
> inscribed bottom right, C.E. Holloway
> HUGH LANE MUNICIPAL GALLERY OF MODERN ART,
> DUBLIN

Holloway emerged belatedly as one of Whistler's most interesting associates. In the last few months before his premature death Holloway was the subject of a small full-length portrait by Whistler, *Rose and Brown: the Philosopher*. This was shown at Holloway's posthumous exhibition at the Goupil Gallery in March 1897. *Tilbury Fort* perfectly represents the sensibility of a painter of wide estuaries and lagoons, which in their essential characteristics have much in common with the late photographs of Emerson.

Edward Atkinson Hornel 1864-1933

Hornel was born in New South Wales, Australia, but his family moved to Kirkcudbright in 1866. He studied briefly in Edinburgh before enrolling at Verlat's Academy in Antwerp in 1883. On his return to Scotland his work was initially influenced by Bastien-Lepage, having been encouraged in that direction by his meeting with James Guthrie in 1885. Friendship with Henry, however, soon resulted in his development away from rustic naturalism towards a greater impasto and more intensely decorative works. In this they were influenced at first by the paintings of Monticelli, to be seen at the Edinburgh International Exhibition in 1886. Hornel's collaboration with Henry reached its peak with *The Druids* in 1890, and was consolidated by their joint trip to Japan in 1893-94. After this the richly patterned style which the two had evolved continued, in Hornel's case with a whole series of paintings of young girls in flower gardens and woodland scenes. In these images figures and foliage are all absorbed into one dense mosaic of coloured dabs of paint, and any narrative interest is virtually abandoned. These were, financially at least, very successful works and in the 1890s and early 1900s Hornel exhibited widely in America, Venice, Vienna and St Petersburg.

James L. Caw, *Scottish Painting Past and Present, 1620-1908*, 1908, (Kingsmead reprint, 1975).
Roger Billcliffe, *The Glasgow Boys*, 1985.

> 100 **PIGS IN A WOOD** (ill. above)
> 1887
> oil on canvas, 15¹/₂ x 11¹/₂ in / 39.4 x 29.2 cm
> inscribed lower left, E.A. Hornel 1887
> ANDREW McINTOSH PATRICK

Reference
Billcliffe, 1985, p.195 (illus.).

The work of the nascent Glasgow school, from its earliest phase, was characterized by colourful impasto. In this case the broken brushwork suggests foreground grasses, which balance dabs of colour used in the upper portion of the canvas to suggest daylight breaking through the foliage. Through the Glasgow Institute of Fine Art and through the activities of Alexander Reid, Hornel had access to the work of Barbizon and other pre-Impressionist painters as this *sous-bois* was being painted.

Fred Jackson 1859-1918

Fred Jackson came originally from Middleton, near Manchester. He trained first at Oldham School of Art and by 1880 was painting with J. Anderson Hague at the Manchester School. Members of this school, who painted in a style similar to that of the Barbizon painters, worked at sites in North Wales and Jackson accompanied them on one visit that year. Shortly afterwards he went to Paris and enrolled at the Ecole des Beaux-Arts under Lefebvre and Boulanger. Before returning to England in about 1885 he travelled widely around Italy and to Morocco. The following year Jackson joined the newly formed New English Art Club, showing with them regularly until 1891 and for a while between 1907 and 1910. He was also a member of the Staithes Group. Practising mostly as a landscape painter, his works have been compared to those of James Charles, also from Lancashire, for their gentle and rather sentimental character. Watercolour sketches were an important part of his production, these were atmospheric and loosely handled, and he was noted too for his decorative design work.

Michael Cross, *F.W. Jackson, 1859-1918*, catalogue of an exhibition at Rochdale Art Gallery, 1978.
Peter Phillips, *The Staithes Group*, catalogue of an exhibition at Nottingham, Castle Museum, 1993.

101 **FOUNTAIN, MONTREUIL-SUR-MER** (ill. above)
c.1903
oil on panel 12½ x 16 in / 32 x 40.5 cm
inscribed bottom right, F.W. Jackson
SIR ALEXANDER GRAHAM

In the early years of the century Jackson worked at Montreuil with James Charles, using Fred Mayor's studio there as a base. *Poplars, Montreuil* (Manchester City Art Galleries) was painted at the same time as the present picture, and reveals an awareness of Impressionism which was common to members of the group who were anxious to break away from the sombre realism of their early work.

103 **Francis Edward James**
Coastal Scene c.1895

Francis Edward James 1850-1920

James entered the New English Art Club in 1888 as an associate of the Impressionist nucleus and became one of its most regular exhibitors. Described by Wedmore as a 'country gentleman', he had independent means. Throughout the 1890s he lived in Hastings as a neighbour and close associate of Hercules Brabazon Brabazon. Generally his watercolours are more tightly topographical than Brabazon's, although flowerpieces shown at the New English were at times regarded as both delicate and free. These were likened to the work of the Japanese. Elsewhere he produced finely detailed shop exteriors in villages on the south coast, and continental church interiors. James spent his winters travelling in France, southern Germany and Italy for health reasons, and in about 1902 he moved to Devon, where he spent the rest of his life.

Frederick Wedmore, 'Mr Francis E. James's
 Watercolours', *The Studio*, vol. 12, 1898, pp.259-26.

104 **Alexander Jamieson**
*The Construction of the South
Kensington Museum* 1903

102 **ITALIAN SCENE**
c.1895
watercolour on paper, 9¹/₂ x 13¹/₄ in / 24 x 34 cm
PRIVATE COLLECTION

103 **COASTAL SCENE** (ill. above)
c.1895
waterclour on paper, 9¹/₄ x 12¹/₂ in / 24.7 x 31.7 cm
inscribed bottom left, Francis E. James
CHRIS BEETLES LTD., ST JAMES'S, LONDON

These two watercolours illustrate the diversity of James' style. Working in the environs of Asolo in the mid 1890s, he produced many rapid notes of landscape which are characterized by vivid coloration. In *Coastal Scene* the influence of Brabazon Brabazon is more clearly evident. With complete economy of means he notes the lone ship against a coastline of trees at sunset.

Alexander Jamieson 1873-1937

Jamieson came from Glasgow and studied there at the Haldane Academy. In 1898 he received a scholarship to travel to Paris. As a result he developed a broad Impressionist style, as shown in the paintings of French towns and scenery on which he built his reputation. On leaving France he decided to settle in London and took a studio in South Kensington, although he continued to travel abroad, visiting France, where he painted in the gardens of Versailles and Fontainebleau, and also Spain in 1911. In 1904 Jamieson had become a member of the International Society of Sculptors, Painters and Gravers and he later showed widely, with a notable solo exhibition at the Carfax Gallery in 1912. From this period his style was felt to have evolved closer to the Post-Impressionist landscape studies of artists like Gaston La Touche. During the First World War he served in France as a quartermaster, and he later lived at Weston-Turville in Buckinghamshire with his wife, the painter Gertrude (Biddy) Macdonald.

James Bolivar Manson, 'The Paintings of Alexander
 Jamieson', *The Studio*, vol. 49, 1910, pp.274-82.

104 **THE CONSTRUCTION OF THE SOUTH KENSINGTON
MUSEUM** (ill. left)
1903
oil on canvas, 24 x 20 in / 61 x 50.8 cm
inscribed lower left, A. Jamieson/1903
PRIVATE COLLECTION

Exhibition
1903 (?)London, New English Art Club, winter, as *The Oratory, London* (123).

Reference
Kenneth McConkey, *British Impressionism*, 1989, p.87 (illus.).

Jamieson's aerial view of Cromwell Road, London on a bleak winter's day, for all its dullness, presents an extraordinary image. The idea of labour in the construction of a great museum is combined with the smudgey happenings of the street. These are conveyed in a vivid visual shorthand which logs the shape of the loaded omnibus and the passers-by. Jamieson's London is strikingly similar to Johnston's Liverpool. Both painter and photographer were preoccupied with contrasting high buildings and street life for almost symbolic purposes.

John Dudley Johnston 1868-1955

Dudley Johnston's interest in photography as a pastime emerged quite early in his life, and by 1904 he was a member of the Liverpool Photographic Society. Three years later he was elected to the Linked Ring. Having moved to London, he began to devote more of his time to pictorial photography and by 1911 he had abandoned his career in business. Throughout these years his work covered a wide range of subjects, from wintry landscapes to portrait and figure studies, and he was a respected practitioner of the gum platinum printing process. Dudley Johnston earned much praise also for his curatorship of the Royal Photographic Society from 1923. He was responsible for building up the Society's collection virtually from scratch and for securing examples of the work of the most important past and contemporary practitioners. As a result he became one of the first leading photographic historians.

Margaret F. Harker, *The Linked Ring, The Secession in Photography, 1892-1910*, 1979.

105 LIVERPOOL – AN IMPRESSION (ill. below)
1906
gum bichromate print, 14^1/$_4$ x 8^3/$_4$ in / 36.2 x 22.2 cm
THE ROYAL PHOTOGRAPHIC SOCIETY, BATH, GIFT OF JOHN DUDLEY JOHNSTON

The obvious references for this photograph of a lone cab driver on a street at dusk are the nocturnes of Whistler, and this is a particularly good example from Johnston's most successful period between 1905 and 1912. During that time he used the gum platinum printing process, with which he could produce the desired atmospheric and impressionistic effects.

William Kennedy 1859-1918

Kennedy was born in Glasgow and studied at the Paisley School of Art before joining the Académie Julian in the early 1880s, where he trained under Bouguereau and Robert Fleury. He remained in Paris until 1885 during which time he, like Lavery, was influenced by the naturalistic techniques of Bastien-Lepage. On his return to Scotland Kennedy took a studio in Stirling and was closely involved with the Glasgow Boys, becoming President when the group formed a society in 1887. Around this date he was engaged in painting scenes of army life taken from a nearby military camp in Stirling. These works were generally much bolder in colour and design than more delicately handled paintings such as *Stirling Station*, which bore more of a relation to Whistler's nocturnes. After 1900 Kennedy spent much time painting pastoral subjects in Berkshire, but then in 1912 ill health encouraged his move to Tangier, where he occupied Lavery's house. He continued to work, producing scenes of everyday life there.

David Martin, *The Glasgow School of Painting*, 1898, (1976 reprint).
Roger Billcliffe, *The Glasgow Boys*, 1985.

106 STIRLING STATION (ill. p.49)
1888
oil on canvas, 20^1/$_2$ x 31^1/$_2$ in / 52.1 x 80 cm
inscribed bottom right, William Kennedy
ANDREW MCINTOSH PATRICK

Reference
Billcliffe, 1985, p.191 (illus.).
Kenneth McConkey, *British Impressionism*, 1989, p.42 (illus.).

In the late 1880s Kennedy moved away from the depiction of peasant subjects in favour of more urban,

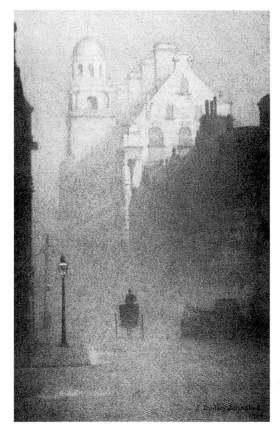

105 **John Dudley Johnston**
Liverpool – An Impression
1906

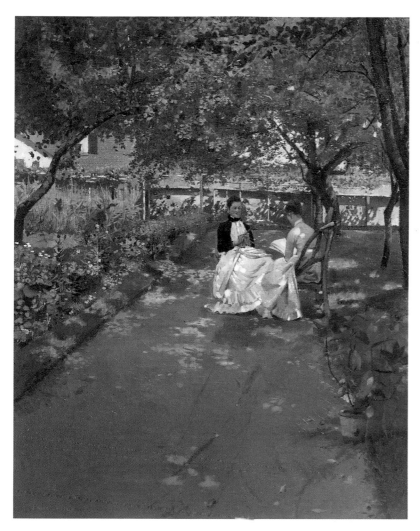

paintings were exhibited in London from 1890 at Suffolk St and at the Royal Society of Portrait Painters. An interest in mural painting resulted in several decorative architectural schemes, and in 1900 Kerr-Lawson was a founder-member of the Society of Painters in Tempera. He lived most of his life in Glasgow, where he was actively involved in the Glasgow Art Club. The Dowdeswell Gallery staged the first solo exhibition of his work in 1903.

Art Gallery of Windsor, Ontario, *James Kerr-Lawson*, catalogue of an exhibition, 1983.

107 **SUMMER AFTERNOON, THE ARTIST'S WIFE SEWING IN THE GARDEN** (ill. left)
1885
oil on canvas, 20 x 16 in / 50.8 x 40.6 cm
inscribed, bottom left J. Kerr-Lawson 1885
THE FINE ART SOCIETY, LONDON

Summer Afternoon, the Artist's Wife sewing in the Garden demonstrates Kerr-Lawson's proximity to Lavery, a painter whom he admired throughout his life and whose portrait he painted (Ferens Art Gallery, Hull). In this picture he takes the motif of Lavery's *Sewing in the Shade* and combines it with elements of other works such as the garden picture known as *A Grey Summer's Day, Grez* (Andrew McIntosh Patrick). Here sunlight drops through the trees upon the figures and upon the path, picking out the brightly coloured flowers in the border of the vegetable patch.

Harold Knight 1874-1961

The son of an architect, Harold Knight came from Nottingham. In about 1893 he attended Nottingham School of Art, where he met his future wife, Laura Johnson. Harold was a very successful student, receiving a small British Institute Travelling Scholarship in 1893. Soon afterwards he travelled to Paris, to the Académie Julian where he studied under Constant and J.P. Laurens, but this was a fairly short experience for, having run out of funds, he returned to Nottingham in less than a year. A visit to Staithes with Laura Knight's aunt resulted in Harold's decision to settle there and paint alongside artists such as Arthur Friedenson and Fred Mayor. The daily life of the Yorkshire fisher folk became his subject and, like his wife, he was greatly influenced by the Dutch painters they studied on trips to Holland. Rembrandt and Vermeer were of enormous significance to him at this point. Gradually his work was finding a wider market and particular success came in 1905, when his painting of an impoverished family grouped round a table, *A Cup of Tea*, was purchased for the Queensland Art Gallery in Australia. In 1907 Harold and Laura moved to Newlyn, where Harold's painting was similarly brightened in appearance by the changed surroundings. His subject matter began to change, with a number of pictures of women in interiors, revealing his particular debt to Vermeer. Throughout the First World War he was a conscientious objector and worked on the land. Soon afterwards the couple moved to London, where he established a name as a portrait painter. In 1928 Harold was elected an ARA and he became an RA in 1937.

107 **James Kerr-Lawson**
Summer Afternoon, the Artist's Wife sewing in the Garden 1885

modern themes. In 1887 he painted the activity of passengers disembarking at the local railway station in Stirling. One obvious source for this work appears to be Sidney Starr's *Paddington Station* of the previous year, and this is a more likely precedent than Monet's railway station pictures. Like Starr, Kennedy has been concerned with scale and perspective here, and although the subtle tonalities of the work bear witness to Whistler's influence, his observation of the scene owes something also to Tissot.

James Kerr-Lawson 1865-1939

Kerr-Lawson came originally from Anstruther in Fife, but most of his childhood was spent in Canada. He first studied painting in Rome, under Luigi Galli, and then in Paris, under Lefebvre and Boulanger. He continued to travel, to Italy, Spain and Canada, but also returned to London and to Scotland where he had friendships with Whistler and Lavery. Kerr-Lawson developed a reputation as a landscapist and painted several scenes of rural workers in Kirkcudbright, which reflected his concern for naturalism. He also practised as a portrait painter, where Whistler's influence was more in evidence. His

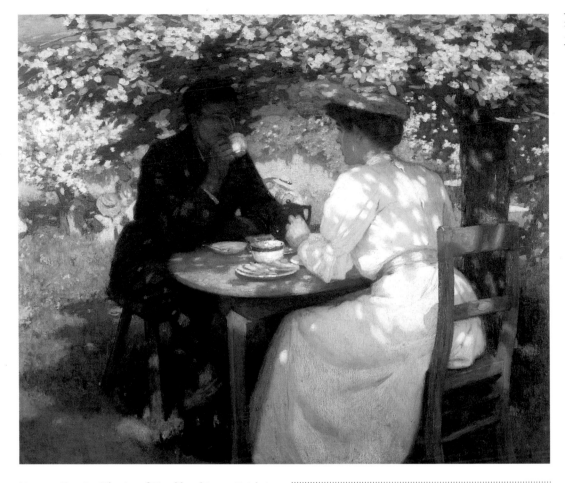

Norman Garstin, 'The Art of Harold and Laura Knight',
 The Studio, vol. 57, p.183.
Caroline Fox and Francis Greenacre, *Painting in Newlyn
 1880-1930*, catalogue of an exhibition at the Barbican
 Art Gallery, London, 1985.

108 **IN THE SPRING** (ill. above)
1908-09
oil on canvas, 52¹/₄ x 62¹/₄ in / 132.3 x 158.2 cm
inscribed bottom left, Harold Knight
LAING ART GALLERY, NEWCASTLE UPON TYNE (TYNE
AND WEAR MUSEUMS)

Exhibition
1985 London, Barbican Art Gallery, *Painting in
 Newlyn, 1880-1930*, (150).

Reference
Kenneth McConkey, *British Impressionism*, 1989, p.7
 (illus.).

In the Spring, a study of tea-time under a shady tree,
raises immediate comparisons with the same subject in
Midsummer, painted by James Guthrie in 1892. Although
the move to Newlyn had caused a considerable lightening
in Knight's style, this work nevertheless reveals a more
cautious realism, with a greater emphasis on drawing
and tone than the brighter Impressionist approach of
Guthrie. Knight has been more concerned with detail
and design than with the overall creation of atmosphere.

Laura Knight 1877-1970

Laura Knight (née Johnson), was born at Long Eaton,
Derbyshire. She grew up with members of her mother's
family in Nottingham, since her father had left home by
the time of her birth. Her mother, a drawing mistress,
encouraged her ambitions to become an artist and from
1890 Laura attended Nottingham Art School. It was
there that she met her future husband, Harold Knight.
In 1894, they went to Staithes together, on the advice of
one of her teachers, and began to paint scenes of village
life. While in Staithes they may even have made contact
with the Newlyn refugee Blandford Fletcher, who
worked there during the 1890s. Knight later recalled
seeing the 1894 exhibition of Cornish paintings at the
Nottingham Castle Museum and being moved to tears
by Bramley's *Hopeless Dawn*. However, during that
period, like many of their contemporaries, the Knights
were most influenced by Dutch art. After their marriage
in 1903, Harold and Laura Knight visited Holland and
greatly admired the work of the Hague School. Their
final Staithes compositions of 1906 have some of the
sombre tonalities associated with Israels. In 1907 they
decided to move to Newlyn, where they were imme-
diately absorbed into the art student community around
Stanhope Forbes. Moving from north to south brought
with it a kind of liberation and a *joie de vivre* that neither
had known before. Remarkable impressionist land-
scapes such as *The Beach* followed. Bright, sunny

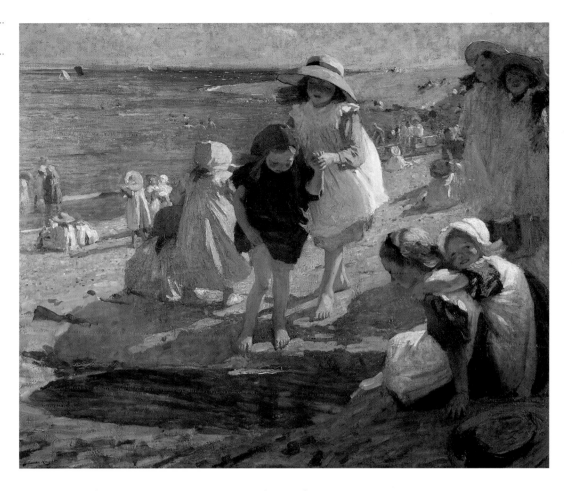

landscapes with figures set against panoramic views of sea and sky came to typify Laura Knight's best work of this period. But this Edwardian summer came to an end with the First World War, when artists were restricted and the painting of coastal landmarks was strictly forbidden. In 1918 the Knights moved to London and in the inter-war period Laura Knight developed a new subject matter in the depiction of theatre and circus performers. In 1929 she was created Dame of the British Empire and she became a Royal Academician in 1936.

Dame Laura Knight, *Oil Paint and Grease Paint*, 1936.
Janet Dunbar, *Laura Knight*, 1975.
Caroline Fox and Francis Greenacre, *Painting in Newlyn 1880-1930*, catalogue of an exhibition at the Barbican Art Gallery, London, 1985.
Caroline Fox, *Dame Laura Knight*, 1988.

109 **THE BEACH** (ill. above)
1909
oil on canvas, 50¼ x 60¼ in / 127.6 x 153.2 cm
inscribed bottom left, Laura Knight
LAING ART GALLERY, NEWCASTLE UPON TYNE (TYNE AND WEAR MUSEUMS)

Exhibitions
1909 London, The Royal Academy of Arts, (439).
1985 London, Barbican Art Gallery, *Painting in Newlyn, 1880-1930* (128).

References
Knight, 1936, pp.167, 172.
Dunbar, 1975, p.78.
Fox, 1988, p.27 (illus.).

Painted shortly after Laura Knight's move to Newlyn, *The Beach* represents a marked transition in style away from the more sombre mood of her Staithes period. Norman Garstin summed up what he described as the utter change in the Knights's outlook and method as a plunge 'into a riot of brilliant sunshine, of opulent colour, and of sensuous gaiety' (*The Studio*, vol. 57, 1912, p.195). This corresponds with the more general shift among Newlyn painters from rustic naturalism towards Impressionism during the early years of this century. In works like this one a remote fishing community is transformed into a holiday resort and is seen here almost as an Impressionist idyll.

John William Buxton Knight 1943-1908

Buxton Knight came from Sevenoaks in Kent, where his father William Knight was an artist and art teacher. As a youth Buxton Knight painted out of doors in nearby woods and parkland, and he first exhibited at the Royal Academy at the age of eighteen, only attending classes at the Academy schools four years later in about 1865. On leaving he continued his plein-air practices, and for forty

years he devoted himself for the most part to landscapes and coastal subjects. He made several trips to Devon and Cornwall, but travelled abroad infrequently and lived in London. His primary concern was with the study of nature in varying conditions, and he was little affected by changing fashionable trends in painting. With works such as *Portsmouth Harbour*, 1907, he was regarded as something of a successor to Constable and to painters of the Barbizon school. In his sympathetic review of Buxton Knight's exhibition at the Goupil Gallery, A.L. Baldry described his sensitive Impressionism which was 'obtained by long and intimate contact with nature'. He continued to exhibit at the Academy until 1907, but more consistently at Suffolk Street and the New English Art Club. *December Landscape*, one of his best works, was bought by the Tate Gallery in 1908.

Alfred Lys Baldry, 'John Buxton Knight: An Appreciation', *The Studio*, vol. 43, 1908, pp.278-92.
A. Lingfield, 'The Work of J. Buxton Knight', *The Magazine of Fine Art*, vol. 2, 1906, pp.159-68.

110 **PORTSMOUTH HARBOUR** (ill. right)
1907
oil on canvas, 40¹/₄ x 42¹/₂ in / 104 x 108 cm
inscribed lower left, J. Buxton Knight 1907
BRADFORD ART GALLERIES AND MUSEUMS

Exhibition
1978 Bradford, Cartwright Hall and Hull, Ferens Art Gallery, *English Impressions* (25).

Like Holloway and Wyllie, Buxton Knight painted wide estuaries and industrial waterways. Scenes such as *Portsmouth Harbour*, taken with renditons of the Medway and Gravesend, may be interpreted as vague celebrations of isolation and imperial wealth.

Henry Herbert La Thangue 1859-1929

La Thangue was born in Croydon, although his parents hailed from the Bradford area. A contemporary of Clausen and Lavery, he attended Dulwich College, Lambeth School of Art and, from 1874 to 1879, the Royal Academy Schools. As a gold medallist and with the personal recommendation of Sir Frederick Leighton, he entered Gérôme's prestigious atelier at the Ecole des Beaux-Arts in Paris. Like many of his contemporaries, La Thangue was profoundly influenced by the work of Bastien-Lepage. Anxious to put Bastien's principles into action he worked during the summers of the 1880s in Brittany and the south of France. Upon his return to England he became a founder-member of the New English Art Club although, being something of a revolutionary, La Thangue caused division in the ranks by proposing that the New English should be a large national exhibition in competition with the Royal Academy. La Thangue's exhibit in the first show, *In the Dauphiné*, was also controversial. A scene showing two haymakers progressing to the fields, it was striking for its broad handling and bright colour. In the years which followed, La Thangue accentuated this 'square brush' aspect of his work, with a sketchy style in which the figures almost disintegrate. At the same time,

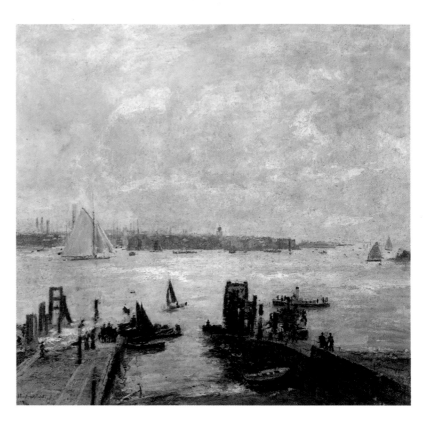

conscious of public demands, he produced a number of large exhibition pieces addressing social issues. These began with *Leaving Home*, 1889, and continued after his return to regular Royal Academy exhibiting with *The Last Furrow*, 1895, and *The Man with the Scythe*, 1896. Around the turn of the century La Thangue went on regular painting trips to Provence and Liguria. There he discovered the relaxed rural way of life which was fast disappearing in England. He also discovered pure landscape on these occasions, and such pictures made up the core of his solo exhibition at the Leicester Galleries, London in 1914. The work in this show was enthusiastically supported by Walter Sickert. In the years up to his death La Thangue concentrated exclusively on scenes of village life in northern Italy.

Kenneth McConkey, *A Painter's Harvest, H.H. La Thangue RA, 1859-1929*, catalogue of an exhibition at Oldham Art Gallery, 1978.

111 **THE HEDGER**
1888
oil on canvas, 24 x 15¹/₂ in / 61 x 39.4 cm
inscribed bottom left, H.H. La Thangue
PRIVATE COLLECTION, COURTESY OF THE FINE ART SOCIETY, LONDON

Reference
Kenneth McConkey, *British Impressionism*, 1989, p.44 (illus.).

In the late 1880s, La Thangue produced numerous paintings and sketches of the local inhabitants of the Norfolk Broads, where he himself had recently retired. In works such as *The Hedger* he presents a striking

110 **John William Buxton Knight**
Portsmouth Harbour 1907

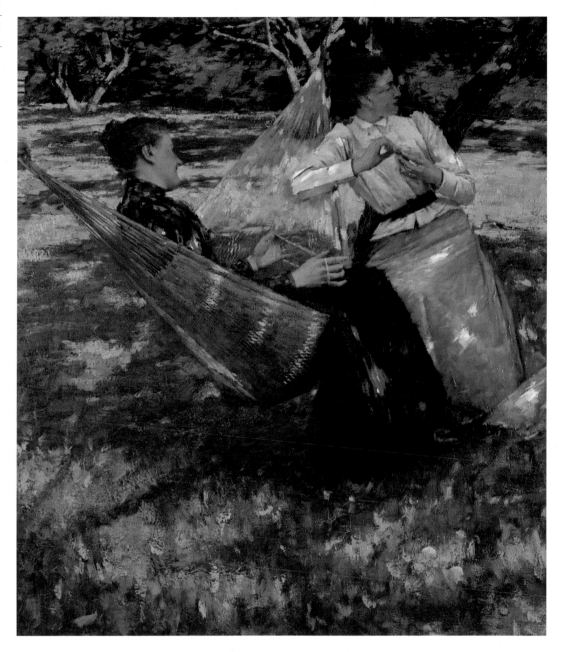

composition in which his primary concern has been with the movement of the single figure. The paint here is rapidly and loosely applied, and the picture's immediacy and spontaneity strike similarities with photographs by Peter Henry Emerson, with whom both La Thangue and Clausen were acquainted. In the case of all three a careful balance was struck between considered staging and an apparent naturalism.

112 **IN THE ORCHARD** (ill. above)
c.1893
oil on canvas, 32¾ x 28½ in / 83 x 72.5 cm
inscribed bottom left, H.H. La Thangue
BRADFORD ART GALLERIES AND MUSEUMS

Exhibitions
1893 London, The New Gallery (52).

1933 London, Royal Academy of Arts, *Late Members* (29).
1978 Bradford, Cartwright Hall and Hull, Ferens Art Gallery, *English Impressions* (29).
1978 Oldham Art Gallery, *A Painter's Harvest, H.H. La Thangue, 1859-1929* (11).

This picture was described by *The Times* critic in the following way: 'we must be content to admire the scene of the two girls under the trees, with the sunshine flecking the grass and the branches and shining through the shadows cast by the leaves' (1 May 1893, p.10). The woman on the left was undoubtedly posed for by Mrs La Thangue, and the swinging hammock on which she sits, the fresh greens of her surroundings, which *The Athenaeum* found 'heavy and crude', recall earlier treatments of a similar theme by Lavery.

113 A LIGURIAN VALLEY
c.1910
oil on canvas, 27 x 30¹/₄ in / 68.6 x 76.8 cm
inscribed bottom left, H.H. La Thangue
FERENS ART GALLERY, HULL CITY MUSEUMS, ART
GALLERIES AND ARCHIVES

Exhibitions
1914 London, Leicester Galleries (19).
1978 Bradford, Cartwright Hall and Hull, Ferens Art
 Gallery, *English Impressions* (32).
1978 Oldham Art Gallery, *A Painter's Harvest, H.H.
 La Thangue, 1859-1929* (28).

This picture was shown at La Thangue's one-man
exhibition at the Leicester Galleries in 1914 and may,
to some extent, be taken as evidence of the artist's desire
to renovate his style. Along with *A Mountain Frontier*,
and *A Provençal Morning*, it marks a new and, for La
Thangue, radical departure in that it abandons the
familiar mosaic of flat touches for a more grainy texture
suited to conveying a sense of humid atmosphere. In
addition it presents us with the first wide vista to be
seen in his work, and its conventional landscape format
in some respects recalls Corot and Constable. Beyond
this there may with particular work be a faint recollec-
tion of Cézanne's *Le grand pin*, which had been shown
in Roger Fry's '*Manet and the Post Impressionist*'
exhibition in 1910.

114 A MOUNTAIN FRONTIER (ill. right)
c.1910
oil on canvas, 36 x 39¹/₂ in / 91.4 x 100.3 cm
inscribed H.H. La Thangue
BLACKBURN MUSEUM AND ART GALLERY

Exhibitions
1914 London, Leicester Galleries (25).
1930 Brighton Art Gallery (70).
1931 London, The Fine Art Society (16).

1978 Oldham Art Gallery *A Painter's Harvest, H. H.
 La Thangue, 1859-1929* (29).

Walter Sickert admired La Thangue's landscapes around
this date for their originality and for the artist's ability
to express space and atmosphere. 'What renders La
Thangue's work particularly interesting', he wrote in his
review in 1914, 'is that, while using the language of the
day in painting, that is to say an opaque mosaic for
recording objective sensations about visible nature, he
is using it in a personal manner'. Through his talent at
developing relations of colour with a warm colour at
their base, La Thangue had, in Sickert's view, 'been able
to build on it a series of beautiful and interesting
sensations of nature which is what he, and not someone
else, has to say'.

115 VIOLETS FOR PERFUME (ill. left)
1913
oil on canvas, 51 x 57 in / 129 x 144.8 cm
inscribed bottom left, H.H. La Thangue
ROYAL ACADEMY OF ARTS, LONDON

Exhibitions
1914 London, Royal Academy of Arts, (100).
1933 London, Royal Academy of Arts, (190).
1978 Oldham Art Gallery, *A Painter's Harvest, H.H.
 La Thangue, 1859-1929*, (31).
1988 London, Royal Academy of Arts, *The Edwardians
 and After, The Royal Academy 1900-1950* (37).

La Thangue's later abandonment of the English country-
side in favour of Provence and Liguria may be taken as
the ultimate proof of his commitment to painting in the
open air on full-size canvases. Almost no studies or
small variants of his later works exist, because in these
more stable climes he had the opportunity to revel in the

114 **Henry Herbert La Thangue**
A Mountain Frontier c.1910

115 **Henry Herbert La Thangue**
Violets for Perfume c.1913

atmospheric effects he most enjoyed. A number of pictures were painted under the pergola seen in *Violets for Perfume*. These invariably contain single figures in dappled sunlight, exemplifying Clausen's belief that it was 'the beauty of things in sunlight that excited him'.

...

John Lavery 1856-1941

...

The son of an unsuccesful publican, Lavery was born in Belfast. The early deaths of both his parents left him orphaned and he was brought up on his uncle's farm near Moira. At the age of ten he was transferred to another relative in Ayrshire, and he eventually ended up as an apprentice retoucher to a Glasgow photographer. He attended the Haldane Academy in the late 1870s, before gravitating to Paris where he studied at the Académie Julian. At this early stage in his career he was influenced by Bastien-Lepage and he painted in a plein-air naturalist style with the little community of British, Irish and American artists working at the village of Grez-sur-Loing. Upon his return to his adopted city, Lavery became one of the leaders of the Glasgow School, creating such important pictures as *The Tennis Party*. Of all the young Glasgow painters, he was selected to represent Queen Victoria's visit to the Internatonal Exhibition in 1888. After he had secured a sitting from the Queen, Lavery's position as the premier young portraitist of his period was assured. Eventually he moved to London and became Vice-President of the International Society of Sculptors, Painters and Gravers under Whistler and Rodin. Although resident in London he was more favoured in Paris, Rome and Berlin, and only after his great success at the Venice Biennale in 1910 was he elected an ARA. By that stage, Lavery's subject matter had broadened considerably. He had painted in Spain and Morocco. Two of his pictures had been purchased for the Musée du Luxembourg. By 1911 Lavery had also met and married Hazel Trudeau, the daughter of a Chicago industrialist, and in the years that followed they became central figures in London society. In 1912, he was commissioned to paint the Royal Family for donation to the National Portrait Gallery. He was appointed Official War Artist to the Royal Navy in 1917 and painted naval bases and munitions factories for the remainder of the First World War. He was knighted in 1918 and he and his wife acted as go-betweens in arranging the Irish Treaty in 1921. During the 1920s the Laverys travelled widely and the artist executed many 'portrait interiors' of the rich and famous. He staged numerous exhibitions and, under Duveen's management, attained a formidable reputation in the United States. After Hazel's death he took off for Hollywood with the idea of painting the stars. But with the outbreak of war he was obliged to retreat to his step-daughter's house at Kilkenny, where he died at the beginning of 1941.

Walter Shaw Sparrow, *John Lavery and his Work*, 1911.
Sir John Lavery, *The Life of a Painter*, 1940.
Kenneth McConkey, *Sir John Lavery R.A. 1856-1941*, catalogue of an exhibition at Ulster Museum, Belfast and The Fine Art Society, London, 1984.
Kenneth McConkey, *Sir John Lavery*, 1993.

116 **The Bridge at Grez** (ill. p.23)
1883
oil on canvas, 30 x 72 in / 76.2 x 182.9 cm
inscribed bottom right, J. Lavery 1883
PRIVATE COLLECTION, COURTESY OF THE FINE ART SOCIETY, LONDON

Exhibitions
1883 Paisley Art Institute, as *The Passing Salute* (342).
1884 Edinburgh, Royal Scottish Academy (766).
1889 Paris, Exposition Universelle.
1890 London, Royal Academy (679).
1891 Glasgow, Royal Glasgow Institute of Fine Arts (393).

Reference
McConkey, 1993, pp.29-30 (illus.).

The result of the artist's first two-week visit to Grez in 1883, years later he recalled this work as 'a river picture with a man in a skiff kissing his hand to a pair of happy girls in a distant boat'. *The Bridge at Grez* is a perfect example of Lavery's skills at this stage in the manipulation of space, the disposition of figures and the rendering of a scene's atmosphere. The obvious success of the work led to its inclusion in several important exhibitions over the following few years. At its final showing at the Glasgow Institute of Fine Arts one critic gave it enthusiastic praise, remarking that it 'might easily pass for a French Salon picture'. Another later recorded that 'few more delightful impressions of summer in the open air have ever hung on the Academy walls'.

117 **Sewing in the Shade** (ill. p.24)
1884
oil on canvas, 22 x 18¼ in / 55.9 x 46.3 cm
inscribed lower left, John Lavery 1884
PRIVATE COLLECTION, COURTESY OF PYMS GALLERY, LONDON

Reference
McConkey, 1993, p.36 (illus.).

Painted on the banks of the Loing at Grez, this work, which may have been shown first as *The Two Friends*, reveals Lavery's concern at the time for simple and striking compositions. The rather taut organization of forms within the foreground is juxtaposed by subtle gradations of colour in the background. As in related works of the period, such as *On the Loing: An Afternoon Chat*, Lavery presents the river as a focus for social interaction. He accentuates this here by providing a framing device of tree and foliage, and so creates a more intimate mood for the exchange of confidences between the two girls. The relaxed atmosphere of this and several other images of peasant women at Grez contrast markedly with the exhausted field workers in paintings by Bastien-Lepage.

118 **The Blue Hungarians** (ill. p.150)
1888
oil on canvas, 12 x 14 in / 30.5 x 36.6 cm
inscribed bottom right, J. Lavery '88
ANDREW McINTOSH PATRICK

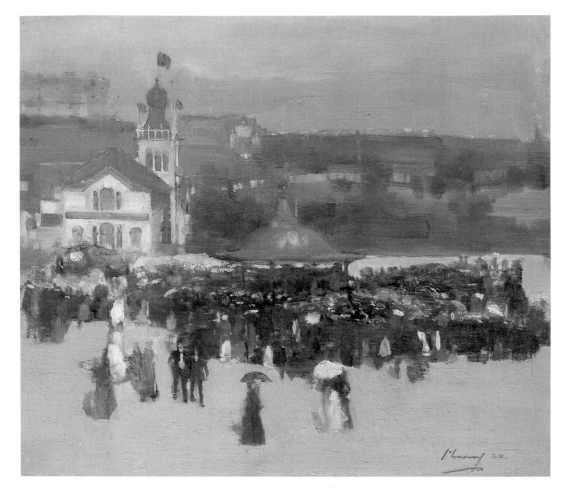

Exhibitions

1888 Glasgow, Craibe Angus Gallery.

1977 Edinburgh, Fine Art Society, *Scottish Painting, 1777-1927*, 1977 (76).

1984 Belfast, Ulster Museum and The Fine Art Society, London (29).

References

The Scottish Art Review, vol. 1, 1888, p.181.
McConkey, 1993, pp.54, 56.

In 1888 Lavery was engaged with a series of paintings associated with the International Exhibition held in Glasgow that year. In these he adopted a spontaneous Whistlerian aesthetic, working outwards from the main focus of interest in the composition, and his handling was similar in many respects to several of Whistler's nocturnes, in particular *Nocturne in Blue and Gold, Valparaiso*, which he had seen at the exhibition of the Society of British Artists the previous year. Two works which bear Whistler's influence, *The Indian Pavilion* and this one, were reproduced in *The Scottish Art Review*, alongside a slightly satirical, mock medieval verse describing the commercial motives of the exhibition and its desire to 'elevate other brother man, With music (Blue Hungarian)', which accounts for the title of Lavery's picture.

119 **A GARDEN IN FRANCE** (ill. p.69)
1898
oil on canvas, 39³/₄ x 50 in / 101 x 127 cm
inscribed bottom left, J. Lavery
PRIVATE COLLECTION

Exhibitions

1898 London, International Society of Sculptors, Painters and Gravers (242).

1898 Pittsburgh, Carnegie Institute (50).

Reference

McConkey, 1993, pp.87, 88, 89.

Painted at Marlotte in northern France, where Lavery was visiting his friend Arthur Heseltine, *A Garden in France* is one of his most Impressionist works from this period. The three models for the picture, including Heseltine's wife, are gathered under the dappled shade of a tree in the afternoon sunlight. Lavery clearly deliberated over the exact composition for the finished work. In a sketch of the same subject one woman occupies the here empty bench. In this work she has been moved to the right of the table and is virtually obscured by tall flowers. The picture is essentially a conversation piece, an idyllic, nostalgic view of the rural bourgeoisie in France, but it bears comparison to several works by other painters of the period, notably James Guthrie's *Midsummer*.

120 THE BRIDGE AT GREZ

c.1900
oil on canvas, 35¹/₄ x 58¹/₂ in / 89.5 x 148.6 cm
inscribed bottom left, J. Lavery
ULSTER MUSEUM, BELFAST

Principal Exhibitions

1901 Glasgow, Royal Glasgow Institute of Fine Arts
 (488).
1905 Liverpool, Autumn Exhibition (1019).
1912 Pittsburgh, Carnegie Institute, Sixteenth Annual
 Exhibition (199).
1984 Belfast, Ulster Museum and The Fine Art
 Society, London, *Sir John Lavery, RA 1856-1941*
 (52).

References

The Art Journal, 1904, p.9, (illus.).
The Magazine of Art, 1904, p.309.
Shaw Sparrow, 1911, pp.180, 182.
Lavery, 1940, p.255.
McConkey, 1993, p.89 (illus.).

Lavery painted the bridge at Grez on several occasions.
This version is closest in composition to the painting of
1883, known also as *The Passing Salute,* though by elimi-
nating the oarsman in the single scull Lavery here reduces
the narrative content and concentrates to a greater extent
on impressionistic effect. This raises questions of his
understanding of Monet's art in the late 1890s. His skilful
manipulation of sunlight and shadow, and in particular
their effect on the reclining figure with the parasol, were
noted with delight by a critic in *The Magazine of Art* who
described the 'free rendering of limpid water' and 'the
beautiful placing on the canvas of the brilliant white of the
parasol carried by the lady in the boat'.

William John Leech 1881-1968

122 **William John Leech**
Interior of a Barber's Shop
c.1910

Leech's early years were spent in Dublin where his
father, Henry Boughton Leech, was Regius Professor of
Law at Trinity College. He attended the Metropolitan
School of Art, Dublin and the Royal Hibernian Academy
Schools, before joining the Académie Julian in Paris,
where he studied under Laurens and Bouguereau. In

company with two students from Julian's, one Russian
and one New Zealander, Leech made his first trip to
Brittany in 1903. His early work betrays the influence of
Whistler in low-toned shop and café interiors. Strikingly,
the rich colour and bright light of Brittany, the home of
Gauguin and the Synthetistes, did not immediately
impress Leech. Around 1910, however, there was a
significant change of direction and Leech began to adopt
a bright, Post-Impressionist palette. Throughout these
years he exhibited regularly at the Royal Hibernian
Academy, and in 1914 he was awarded a bronze medal
at the Paris Salon for *Le Café des Artistes, Concarneau.* He
returned to London in 1916 and moved to Guildford. He
showed at the Royal Academy and at the New English
Art Club, and was also represented at the important
international exhibitions of Irish art. During the 1920s,
the decorative possibilities of his work were explored in
the *Aloes* series, a group of large pictures which
attempted to synthesize rhythm and colour. Thereafter
Leech continued to produce landscapes, portraits and
still-lives. He was represented in all the major
exhibitions of Irish art and staged regular solo
exhibitions at the Dawson Gallery, Dublin. He
died in Guildford in 1968.

Alan Denson, *William John Leech RHA, His Life and
 Work,* 1969.

121 GLION

c.1910
oil on canvas, 23¹/₄ x 19¹/₄ in / 57.8 x 50.2 cm
inscribed lower left, Leech
PRIVATE COLLECTION, COURTESY PYMS GALLERY,
LONDON

Exhibition

1913 Dublin, Royal Hibernian Academy as *Blue and
 White, Glion* (368).

The fluid handling and tonal restraint of Leech's land-
scapes of Glion immediately confirm the strong influence
of Whistlerian aesthetics upon his early career. The picture
is composed from a simple series of rectangles and sweep-
ing curves, taking the eye into the space of the picture.
Although in the years up to 1910 he experimented freely
with a Post-Impressionist palette, he reserved the right, on
occasions such as this, to revert to gentler harmonies.

122 INTERIOR OF A BARBER'S SHOP (ill. left)

c.1910
oil on canvas, 12 x 20¹/₈ in / 30.5 x 51 cm
inscribed bottom left, Leech
CRAWFORD MUNICIPAL ART GALLERY, CORK

Exhibition

1984 Dublin, National Gallery of Ireland, *The Irish
 Impressionists* (116).

In Concarneau Leech produced several small shop
interiors which, although dark and cavernous, have all
the spontaneity which characterizes his landscapes.
These are at once a social record as well as an opportu-
nity to work in challenging circumstances. As with
Whistler's pictures of shop-fronts, informality belies
conscious contrivance. Once again Leech is preoccupied
with geometric divisions and balancing rectangles.

123 **GOLDEN CAVES, CONCARNEAU** (ill. right)
c.1912
oil on canvas, 21¹/₂ x 25¹/₂ in / 54.6 x 64.8 cm
inscribed lower right, Leech
PRIVATE COLLECTION, COURTESY PYMS GALLERY,
LONDON

Golden Caves, Concarneau carries the full force of Leech's
conversion to an Impressionist manner. It is clear that
he has espoused abstract principles and advanced
notions of colour harmony for what could almost be
described as a lunar landscape. The strident colour and
flowing application recall Monet's canvases painted in
the valley of the Creuse in 1889, although there is an
unmistakable similarity to Sargent's more recent Alpine
landscapes here.

William Lee-Hankey 1869-1952

Lee-Hankey began his working life as a designer of
textiles and furniture. Having decided to become a
painter, he enrolled at Chester School of Art under
Walter Schroeder. As a talented student he then received
a scholarship to the South Kensington Schools but,
finding the curriculum unbearably stifling, he forfeited
his scholarship and went instead to Paris. This began a
strong attachment to France and later he spent long
periods there, renting a house in Le Touquet and a
studio in Etaples. Commentators on Lee-Hankey's work
from the turn of the century were frequently moved by
the tender poetry and sentiment of his landscapes and
pictures of mothers with their children. A.L. Baldry
found his naturalism simple and unaffected, and
observed how strongly the artist felt both the
'picturesqueness and the pathos of the peasants struggle
for existence'. His decision to paint regularly in France
was no doubt motivated by the realization that the very
qualities he sought to represent in his rural scenes were
fast disappearing in this country. He exhibited widely,
from 1902 to 1904 he was President of the London
Sketch Club and he staged a solo exhibition at the
Leicester Galleries in 1904. During the First World
War he served in the Artist's Rifles.

A.L. Baldry, 'The Art of W. Lee-Hankey', *The Studio*, vol.
36, 1905, pp.291-300.
Irving Grose, *William Lee-Hankey 1869-1952*, catalogue of
an exhibition at the Belgrave Gallery, London, 1981.

124 **ON THE DYKES** (ill. right)
c.1910
oil on canvas, 60¹/₂ x 69 in / 153.5 x 175 cm
BRADFORD ART GALLERIES AND MUSEUMS

Exhibition
1978 Bradford, Cartwright Hall and Hull, Ferens Art
Gallery, *English Impressions* (36).

As a painter of rural life, Lee-Hankey drew his inspira-
tion from the villages of Normandy and Brittany which
he visited in the early years of the century. Like Clausen
around 1910, he wished to translate this subject matter
on to a monumental scale, and this is evident as much
from his graphic work as from his paintings. The

figures walking along the dykes at evening therefore
fuse the separate idioms of Breton, Lhermitte and
Bastien-Lepage with a solid facture suggestive of a
sculptural frieze.

Leon Augustin Lhermitte 1844-1925

Lhermitte was born in Mont-St-Père, Château Thierry,
the son of a school master. In 1863 he enrolled in the
Ecole Imperiale du Dessin under Horace Lecoq de
Boisbaudran, a contemporary of Cazin. His first exhibit
at the Salon in 1864 was a charcoal drawing, *The Banks
of the Marne near Alfort*. In these years Lhermitte
worked primarily as a graphic artist. His first important
etching was produced in 1866 for a book entitled
Paysagiste aux Champs, by his friend and future biogra-
pher Frederic Henriet. The following year Lhermitte
helped to demonstrate Lecoq's controversial memory

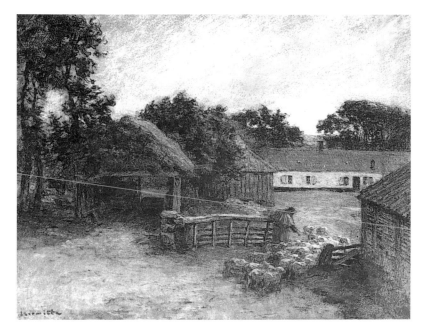

125 **Leon Augustin Lhermitte**
Entering the Fold c.1900

Rustique, an eloquent and detailed account of all aspects of rustic life. Lhermitte's Salon pieces of the 1890s reveal his search for rustic symbolism, in pictures such as *The Friend of the Humble* and *Death and the Wood-cutter*. At the same time he developed as a pastellist, and in the years after 1912 this became his preferred medium. In 1924, the year before his death, he was honoured by an exhibition of ninety pastels and twelve drawings at the Salon.

Robert Walker, 'Leon A. Lhermitte', *The Art Journal*, 1886, pp.266-268.
Frederic Henriet, 'Leon Lhermitte, Painter of French Peasant Life', *The Studio*, vol. 48, June 1909, pp.3-14.
Mary Michele Hamel, 'A French Artist : Leon Lhermitte 1844-1925', Unpublished Ph.D Thesis, Washington University, St Louis, 1974.
Monique Le Pelley Fontenay, *Léon Augustin Lhermitte* 1991.

125 **ENTERING THE FOLD** (ill. left)
c.1900
pastel on paper, 13½ x 17 in / 34.5 x 43 cm
inscribed bottom left, L. Lhermitte
PAISLEY MUSEUM AND ART GALLERIES, RENFREW DISTRICT COUNCIL

Exhibition

1981 Newcastle upon Tyne Polytechnic, *Peasantries* (38).

As a major French rustic naturalist painter Lhermitte enjoyed a high profile in the annual Salons, especially after the death of Bastien-Lepage in 1884. However, in common with other erstwhile naturalists, his style began to broaden around the turn of the century and this was in part as a result of the experience of working in pastel. Colouration became more vivid and compositions more daring. Pastels also supplanted small oils in the affection of private collectors, and it was these which were particularly popular in Britain.

method of drawing before the Education Committee of the Exposition Universelle. In 1869 he visited London, probably to make contact with Legros, through whose good offices he obtained a commission to illustrate a book on British art collections. He spent five months in England in 1871 and during the 1870s made regular visits to London. His reputation as a painter grew with the showing of *Oxen Ploughing* at the Royal Academy in 1872 and the award of a third class medal at the Salon of 1874 for *The Harvest*. This picture of elegant female reapers recalls the work of Jules Breton. Yet Lhermitte's most important mentor was Legros. The many paintings and fusains of the 1870s depicting praying Breton women vie with Legros' works in their precision and sobriety, though they are more naturalistic. Through Legros, Lhermitte was introduced to Durand-Ruel who showed his work in his New Bond St gallery. In the 1880s his painting style developed dramatically. *Paying the Harvesters* was purchased for the Musée du Luxembourg in 1882. In this, and subsequent pieces of almost sculptural naturalism, Lhermitte temporarily abandoned sombre tonalities for high-key open air effects. Many of his major Salon pieces were shown in London and found their way into British private collections. In 1888 he illustrated André Theuriet's *La Vie*

Leon Little exh. 1884-1926

Little was born in London and went first to St Martin's Lane School, then to the South Kensington Schools. He painted several portraits, most notably one of Sir Henry Rider Haggard which was presented to the National Portrait Gallery. His landscapes were evocative and atmospheric, and often of moonlit scenes. A contemporary reviewer described him as 'a modern nature lover', whose art was characterized by a restrained fidelity to the natural scene, and stated that the artist was not one 'to parade his art for its own sake'. Two of his landscapes were exhibited at the Royal Academy in 1900 and 1902 and he also showed at Suffolk Street Little lived at Horsham in Sussex, and then at Reigate where he died in 1941.

The Studio, vol. 37, 1906, p.157.
The Art Journal, 1894, p.171.

126 **AN IMPRESSION OF EAST ANGLIA** (ill. left)
1887

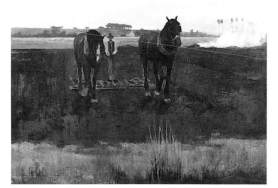

126 **Leon Little**
An Impression of East Anglia
1887

oil on canvas, 36 x 48 in / 91.5 x 122 cm
inscribed bottom left, Leon Little
HUGH LANE MUNICIPAL GALLERY OF MODERN ART,
DUBLIN

Little's work conforms to the tonalism of O'Meara and
T.F. Goodall. It is evident from *An Impression of East
Anglia* that he was prepared to generalize form in order
to enhance the effect of the evening light in which the
lone fieldworker guides his harrow over the fenland
landscape. It may even be that this relatively large canvas
was executed in the open air on successive evenings,
since it is informed by a restrained fidelity to nature.

Albert Ludovici Jun. 1852-1932

Ludovici first studied under his father. In the late 1860s
the family moved to London from Prague and between
1880 and 1897, Ludovici exhibited interior scenes of
bourgeois life at the Royal Academy, to considerable
success. During these years his interests in French
naturalism declined, and he became closely involved
with Whistler's circle of admirers around the time of
the latter's presidency of the International Society.
Ludovici's paintings of London were particularly
indebted to Whistler in terms of his handling of tone
and colour, but as one critic noted, on to these he
grafts 'a lighter, gayer stem, that of his own artistic
individuality'. He became a consistent observer of parks
and streets at the height of the Season, attempting to
represent all the subtle colour combinations, the
vibrations of light and the relations of tone that he
found there. Ludovici lived a greater part of his time in
Paris, but he exhibited at the Royal Academy from 1880,
the Royal Society of British Artists from the following
year, and at the New English Art Club from 1891.

A. Ludovici Jun., *An Artist's Life in London and Paris*,
　1926.
The Studio, vol. 35, 1905, p.238.

　127 **A BUSY STREET** (ill. right)
　c.1895
　oil on panel, 11 x 4½ in / 27.9 x 11.4 cm
　inscribed lower left, A. Ludovici
　PRIVATE COLLECTION

Ludovici produced many small panel studies of London
streets which present a microcosm of London life. A
confirmed Whistlerian, he evolved his own visual
shorthand to enable these notes to be recorded and his
first exhibition of works of this type, *Dots, Notes, Spots,*
was held at Dowdeswells Galleries, London, in 1888.

Paul Fordyce Maitland 1863-1909

Maitland was born in Chelsea. He studied at the
Government Art Training School and later was a pupil
of Theodore Roussel, moving in the circle of Whistler's
followers. In 1888 he became a member of the New
English Art Club and the following year he exhibited
with the London Impressionists. Typically, his painting

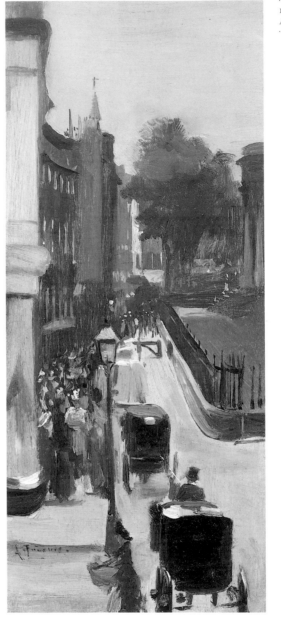

127 **Albert Ludovici Jun.**
A Busy Street c.1895

reflected the influence of Whistler in both composition
and handling, and his subjects were drawn mostly from
locales such as Kensington Gardens and the Chelsea
Embankment. These largely corresponded to Sickert's
desire in his introduction to the London Impressionists
show that artists should express the 'magic and poetry'
of city life. Maitland was a member of the Society of
British Artists, although he resigned in solidarity with
Whistler. He also resigned his membership of the New
English Art Club alongside Roussel, over a dispute with
Sickert in 1893. Sickert retained his affection for him,
however, and described his work favourably in later
years. From 1893 to 1908 he was art examiner to the
Board of Education, and he also taught drawing for a
time at the RCA. He suffered from curvature of the
spine, which accounted for his inability to travel and for
his relatively short life.

The Studio, vol. 96, 1928, p.134.
Walter Sickert, *A Free House*, 1947, pp.273-4.
Tessa Sidey, 'The Small Oils by Paul Maitland', *York City Art Gallery Bulletin*, October 1980, vol. 32, pp.26-35.

128 CHEYNE WALK, SUNSHINE (ill. below)
c.1887-88
oil on canvas, 14 x 12 in / 35.6 x 30.5 cm
inscribed
YORK CITY ART GALLERY, PRESENTED BY THE VERY REVEREND ERIC MILNER-WHITE, DEAN OF YORK

The similarity of approach between Maitland and his mentors, Roussel and Whistler, in the portrayal of the riverside rows and walks in Chelsea has often been noted. However, while Whistler, following Vermeer, tended to face the buildings he wished to paint, Maitland often looked down a row of houses, involving himself in problems of recession and light and shade. Only gradually did Maitland succumb to the subtler colours of grey days.

129 KENSINGTON GARDENS (ill. p.89)
c.1890
oil on canvas, 10¼ x 18 in / 26 x 46 cm
inscribed lower left, P. Maitland
VISITORS OF THE ASHMOLEAN MUSEUM, OXFORD

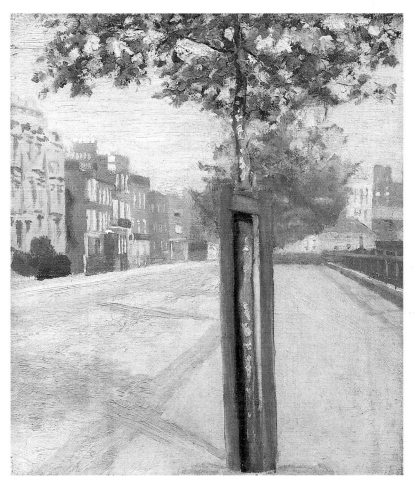

128 **Paul Fordyce Maitland**
Cheyne Walk, Sunshine
c.1887-88

130 THE FLOWER WALK, KENSINGTON GARDENS
c.1897
oil on canvas, 5 x 7 in 12.7 x 17.8 cm
inscribed bottom right, P.M.
TATE GALLERY, LONDON, PRESENTED ANONYMOUSLY IN THE MEMORY OF SIR TERENCE RATTIGAN, 1983

Reference
Anna Gruetzner Robins in Norma Brooude ed., *World Impressionism*, 1990, p.81 (illus.).

Kensington Gardens provided Maitland with one of his essential motifs. As in the present pictures, he would often position himself in the shade and look into the light, observing the unoccupied seats and the tiny figures beyond them, almost out of hailing distance. Such works led the critic of *The Art Journal* to observe two years before his death that Maitland's perceptive talent had 'found itself in delicate response to the pensive London of empty parks, in damp weather, or when the wintry grey yields to a day that foretells the return of colour' (1907, p.282).

Edouard Manet 1832-83

Manet grew up in Paris and lived there for most of his life. Between 1850 and 1856 he attended the atelier of Thomas Couture, afterwards spending time in Italy. By the end of that decade he had rebelled against Couture's academic training and begun his treatment of modern life themes, with his starkly handled *Le Buveur d'absinthe*. His fascination for Spanish painting persisted throughout the 1860s, resulting in overtly Spanish subjects such as *Lola de Valence* of 1862, and in the technique employed in the controversial *Olympia* of 1865, with its restrained use of colour and contrasts of light and dark. Manet persisted in submitting to the Salon despite the outcry much of his work provoked and he was regularly rejected. From 1863 he was active in the establishment of the Salon des Réfusés and after the death of Baudelaire Zola emerged as the main supporter of his work. By 1870 he had established his friendship with Monet, as a result of which his palette lightened, he abandoned the use of black and he began to make plein-air studies in Impressionist locales such as Argenteuil. There his handling loosened considerably and the sober themes of his earlier work disappeared. His involvement with the Impressionist circle did not however, extend to a willingness to show at the Impressionists' group exhibitions. Manet's influence in this country was chiefly absorbed through similarities between his and Whistler's techniques in portraiture, as for example in the model they both depicted, Théodore Duret. Those pictures by Manet which bore particular signs of the influence of Velázquez were, by the 1890s, regarded as inspirations by staff and students at the Slade School and by sympathetic critics such as D.S. MacColl, who continued to regard the artist as essentially a Realist rather than an Impressionist.

D. Rouart and D. Wildenstein, *Edouard Manet*, (catalogue raisonné), Lausanne and Paris, 1975.

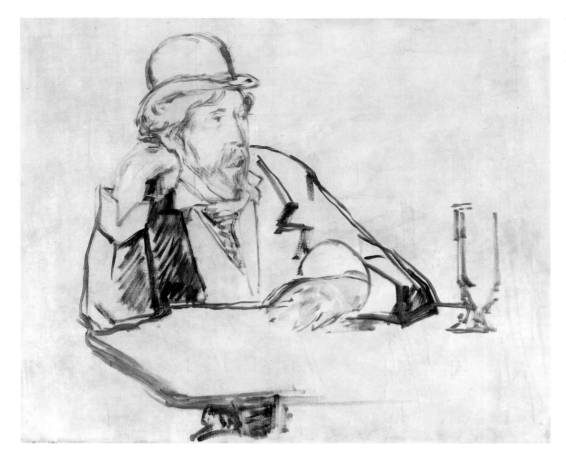

Françoise Cachin and Charles S. Moffett, *Manet 1832-1883*, catalogue of an exhibition at the Grand Palais, Paris and the Metropolitan Museum of Art, New York, 1983.

131 **GEORGE MOORE AT THE CAFÉ** (ill. above)
c.1879
oil on canvas, 25¼ x 32 in / 65.4 x 81.2 cm
THE METROPOLITAN MUSEUM OF ART, NEW YORK, GIFT OF MRS RALPH J. HINES, 1955

Exhibition
1983 Paris, Grand Palais and Metropolitan Museum of Art, New York, *Manet 1832-1883* (176).

Reference
Anne Coffin Hanson, *Manet and the Modern Tradition*, 1979, p.170.

Manet produced three portraits of George Moore in the winter of 1878-79. In one of these (Paul Mellon Collection) he is posed, seated in a garden. The second (Metropolitan Museum of Art) is simply a head and shoulders study, while the third, the present picture, shows Moore in his preferred ambience, that of the café-bar. This is, as Hanson and Moffett point out, a swift and freehand indication of an unrealized portrait. Up to this point Manet had produced a number of bar-room 'portraits', the most salient of which is *The Plum* (National Gallery of Art, Washington), in which the female drinker adopts a pose similar to that of Moore in the present work. It

may well be that Manet intended to insert a cigarette between the fingers of Moore's left hand. However, the closest parallel to the present picture is the portrait of an unidentified journalist, known as *Chez Tortoni* (Isabella Stewart Gardener Museum, Boston). This shows a similar intention to juxtapose the figure with the half-consumed glass of beer.

Alexander Mann 1853-1908

Alexander Mann's father was a successful Glasgow businessman. After leaving school, Mann spent seven years working in the family business and attending part-time classes at the Glasgow School of Art, before deciding to take up painting full time. He travelled to Paris in 1877, firstly to the Académie Julian and then to Carolus-Duran's where, as Garstin wrote, the tradition of Velázquez was handed down to students gathered from 'half the nations of the earth'. Initially he was most attracted to figure painting, but landscape emerged as his particular interest after 1886, and he was especially concerned to capture the tranquil effects of light and atmosphere, often in scenes set at twilight. Several landscapes of that ilk were painted around Findhorn in the late 1880s. Following this Mann spent two years in Morocco and by the mid 1890s he had settled in London where the English landscape, which he observed on family holidays to sites such as Walberswick, became his subject.

132 Alexander Mann
Picking up Silver and Gold
1906

Norman Garstin, 'Alexander Mann: An Appreciation', *The Studio*, vol. 46, 1909, pp.300-05.
James L. Caw, *Scottish Painting: Past and Present, 1620-1908*, 1908, (Kingsmead reprint, 1975).
Christopher Newall, *Alexander Mann 1853-1908*, catalogue of an exhibition at The Fine Art Society, London, 1983.

132 PICKING UP SILVER AND GOLD (ill. above)
1906
oil on canvas, 17 x 22 in / 43.2 x 55.9 cm
inscribed bottom left, Alex Mann
PRIVATE COLLECTION, COURTESY OF THE FINE ART SOCIETY, LONDON

Exhibitions

1906　Glasgow, Royal Glasgow Institute of Fine Arts (312).
1991　London, The Fine Art Society, London, *Alexander Mann 1853-1908* (28).

By the early years of this century the association between blossoming meadows and childhood innocence was commonplace in painting and photography. Mann

had moved away from the prosaic naturalism of his youth to a lighter palette. His handling, however, continued to be restrained and, for all the brilliance of his colour, a respect for Corot-esque tonalities was retained, even in his many studies of haystacks.

Mary McCrossan c.1865-1934

Mary McCrossan came from Liverpool and studied first at Liverpool School of Art and then in Paris at the Académie Delecluse. On her return to England she began to show at the Royal Academy from 1898, and also at the New English Art Club. She was elected to the Royal Society of British Artists in 1926. She lived in London and later at St Ives, having been encouraged by the presence there of Julius Olsson. Ultimately McCrossan herself gave painting lessons at St Ives. She became particularly known for her landscapes and coastal scenes, and her most significant paintings include *Southwold Harbour*, *White Herring Boats* and *St Ives*. After the impact of Fry's Post-Impressionist

exhibitions, she experimented in some of her paintings with the use of the *cloisonné* outline as an attempt to impose a more striking and rhythmic quality on her paintings of the sea. There are several works by her in public collections.

133 **White Herring Boats** (ill. right)
1899
oil on canvas, 25 x 29¼ in / 63.5 x 75.6 cm
inscribed lower left, M. McCrossan '99
Private Collection

A number of pictures very similar to *White Herring Boats* were shown at McCrossan's studio exhibition in Liverpool in 1900. Reporting on the exhibition, *The Studio* (vol. 21, 1900, pp.59-61) reproduced a study of *Herring Boats* in the same configuration as those in the present picture. Its critic praised her efforts 'at recording effects of brilliant sunshine lighting up the sea'. McCrossan's work on these occasions provides a vivid recollection of Monet's studies of moored rowing boats at Argenteuil.

133 **Mary McCrossan**
White Herring Boats 1899

William McTaggart 1835-1910

William McTaggart was born at the Laggan of Kintyre, the son of a labourer. Despite his humble origins he went to Edinburgh in 1852 to join the Trustees Academy as a pupil of Robert Scott Lauder. He made his début at the Royal Scottish Academy in 1855, and during the next two years won several student prizes. A visit to the Manchester Art Treasures Exhibition in 1857 widened his horizons and made him aware of Pre-Raphaelite painting in England, the effect of which was seen mostly in his genre pictures of the following ten years. Many of these, such as *Going to Sea*, 1858, are extraordinarily naturalistic, and they pose the question of McTaggart's knowledge of the writings of Ruskin. At the same time, in dramatic works like *The Wreck of the Hesparus*, 1861, McTaggart hoped to display his ability as a painter of literary themes. In about 1870, however, he abandoned these ambitions for coastal genre works which aimed for a high degree of naturalistic truth. In this his work bears comparison with that of the Hague School, a group of painters whose work was avidly collected in Scotland at that time. Examples such as *Fisher Children*, 1876, begin to reveal new technical developments. McTaggart looked for broad effects and broken brushwork in expressing the moods of the sea. The concern for visual drama led to a number of powerful coastal scenes in which clifftop spectators look expectantly out to sea. *The Storm*, 1883, has led to the supposition that McTaggart must have been aware of contemporary painting on the continent. When he came to the second version of *The Storm*, 1890, even the tight definition of figures is lost, in favour of a stirring evocation of atmosphere. In his final

134 **William McTaggart**
Machrihanish, Bay voyach
1894

works, painted at Machrihanish, such concerns were of paramount importance to him in large, unfinished canvases which seem almost abstract.

Lindsay Errington, *William McTaggart, 1835-1910,* catalogue of an exhibition at the National Gallery of Scotland, 1989.

134 **MACHRIHANISH, BAY VOYACH** (ill. p.158)
1894
oil on canvas, 36¹/₂ x 64¹/₂ in / 92.7 x 163.8 cm
inscribed W. McTaggart 1894
ROBERT FLEMING HOLDINGS LIMITED

Exhibition
1989 Edinburgh, National Gallery of Scotland,
 William McTaggart, 1835-1910 (95).

Machrihanish, Bay Voyach comes from an extraordinary sequence of large landscapes painted at the end of McTaggart's career which challenge accepted notions of finish. The paint is scumbled and smeared across the surface and figures are sketched with such brevity that they dissolve into the background – as sometimes occured in Steer's beach scenes. Although the figures appear to have been added as afterthoughts, they were essential to McTaggart's pictorial concept. Rather than reposition them in the present work, the artist preferred to extend the righthand portion of the composition by extending the canvas.

Arthur Melville 1855-1904

Melville's early years were spent in Angus. By the age of fifteen, his family had moved to East Linton, near Edinburgh, where Melville was first apprenticed to a grocer. After attending part-time evening classes he enrolled at the Royal Scottish Academy in Edinburgh, where he initially came under the influence of his teacher, R.S. Noble, and produced what Caw described as pictures of 'homely incident in cottage or garden'. One of these, *The Cabbage Garden,* was hung at the Royal Academy in London in 1878. Encouraged by that

success, Melville went to Paris the same year and spent the following two years at the atelier Julian, supplementing the teaching he received there with valuable sketching and watercolour studies in sites such as Fontainebleau and Mont St Michel. Prior to his return to Scotland in 1882 he travelled to Persia, India and Egypt, where he continued to develop his specific Impressionist technique of watercolour painting, of blotting fluid dabs of paint on to an already damp background, and expressing the heightened colour and atmosphere of his surroundings. These watercolours were particularly influential to the members of the Glasgow School. Melville continued to paint oils, including portraits, which attracted attention at the RSA and were characterized by concern for overall decorative effect, rather than any revelation of individual personality. In 1883-84 he painted with Walton, Crawhall and Guthrie at Cockburnspath and in 1886 he went with Guthrie to France. By 1889 Melville had settled in London and, along with the other members of the Glasgow School, he then joined the New English Art Club. Three years later he travelled to Spain with Frank Brangwyn, who was much influenced by the bright colour of his companion's watercolours and from that point intensified the colour in his own oil paintings. On a subsequent visit to Spain Melville contracted typhoid, which claimed his life in 1904.

Gerald Deslandes, *Arthur Melville, 1855-1904,* catalogue of an exhibition at Dundee Art Gallery, 1977.
James L. Caw, *Scottish Painting 1620-1908,* 1908, (1975 reprint).

135 **HOMEWARD** (ill. left)
1880
oil on canvas, 25¹/₂ x 38 in / 64.8 x 96.5 cm
inscribed lower left, Arthur Melville, 1880
CITY ART CENTRE, EDINBURGH

Exhibition
1981 Newcastle upon Tyne, Polytechnic Art Gallery,
 Peasantries (50).

Melville was one of the earliest Scottish painters to escape from the Paris ateliers and take refuge at Grez-sur-Loing. *Paysanne au Grez* painted at this time is a typical plein-air study of a village woman in strong sunlight. *Homeward* is a more complex picture, based upon a theme from Jean-François Millet, in which the painter was preoccupied with tonal notation at the expense of form. He refuses to engage with detail, concentrating rather upon a mosaic of blocks of colour which almost work against the deep perspective.

Mortimer Menpes 1860-1938

Menpes came originally from Adelaide in Australia and, after some preliminary study in his native city, he arrived in London in 1879 to enrol in the South Kensington Schools. He apparently spent some of his first two summers in Europe, painting and etching at Pont-Aven in Brittany, before meeting Whistler in the winter of 1880-81. Like Sickert, Menpes was induced to abandon his studies and became Whistler's disciple and studio

assistant. In 1883 he and Sickert accompanied the master on a sketching trip to St Ives and later, with Sydney Starr, Theodore Roussel and Fred Brown, Menpes set up a studio in Baker St where discussions on Impressionism took place. This group, possibly on Sickert's instigation, particularly admired Degas – or 'Digars' as Menpes called him. Menpes was one of the faithful who joined the Society of British Artists under Whistler in 1886, but their friendship cooled in the following year when he took the initiative to visit Japan. The final break came in May 1888 when, after his return, Menpes staged an exhibition of his work and refused to sign himself 'pupil of Whistler'. The work from this voyage was extensively publicized and the artist himself wrote an account of his reactions to Japanese art in an article in *The Magazine of Art*. This furnished the precedent for further travels. He returned to Japan in 1896 and again recorded his adventures. The products of a visit to the Boer War were exhibited at the Fine Art Society in 1901, and in later years he showed watercolours and prints of Venice, the Holy Land and the Far East. These were often accompanied by the publication of illustrated books, which were on occasions written by himself or his sister, Dorothy. Unfairly excluded by Whistler from the International Society, Menpes later turned to the Royal Academy. The final years of his life remain obscure.

Mortimer L. Menpes, 'A Personal View of Japanese Art',
 The Magazine of Art, Vol. 11, 1888, pp.192-99, 255-61.
Mortimer L. Menpes, '*Whistler as I Knew Him*', 1904.

136 A JAPANESE BOY
c.1887
oil on panel, 4 x 4 in / 10.2 x 10.2 cm
inscribed bottom left with monogram
PRIVATE COLLECTION, COURTESY OF THE FINE ART
SOCIETY, LONDON

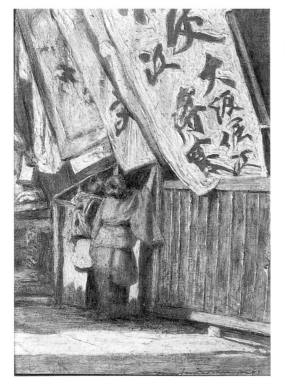

Menpes carried with him to Japan Whistlerian methods of composing. Whistler stressed compositional balance in the arrangements of rectangles in the facade of a shop. Menpes claimed that in Japan these harmonies occurred naturally. They extended to the graphic simplicity of local colour which Menpes found particularly appealing in his tiny pictures.

137 FLAGS (ill. below)
c.1887
oil on board, 6 x 4¹/₄ in / 15.2 x 10.8 cm
inscribed bottom right, Mortimer Menpes
ANDREW McINTOSH PATRICK

Claude-Oscar Monet 1840-1926

Monet was born in Paris, although his childhood was spent at Le Havre on the channel coast. Under Boudin's influence Monet began to paint landscapes in 1856. By the end of that decade he had met Pissarro and at Gleyre's studio in Paris in 1862 his contemporaries were the remaining nucleus of the Impressionist group, Renoir, Sisley and Bazille. Monet's military service was spent in Algeria where the strong light, combined with his interest in the techniques of the Dutch watercolourist Jongkind, resulted in luminous studies painted with free and rapid brushstrokes. Some works from this period were exhibited at the Salon in the 1860s, although thereafter the informal nature of his work meant he showed more frequently with dealers and in group exhibitions. During the Franco-Prussian War Monet and Pissarro were in London, where they admired the work of Turner, Constable and Crome. This fact was made much of by writers such as Dewhurst at the turn of the century, when seeking to emphasize the apparently important English antecedents of the Impressionist movement. From the late 1860s to the first Impressionist group exhibition in 1874 Monet developed his practice of painting *en plein air*, in the semi-rural areas around Paris like Chatou, Bougival and Argenteuil. He had also evolved his technique of working with modified local colours and with flexible, comma-like brushstrokes which, knitted together across forms, tended to flatten the picture plane and keep a surface uniformity. In 1883 he settled at Giverny and by the end of the decade was being visited by increasing numbers of eager students. One such was Sargent, who painted his *Claude Monet painting at the Edge of a Wood* (cat 191) in emulation of the master's style in 1887. This was exhibited at the New Gallery the following year, where it had a considerable effect in increasing discussion of Monet's painting, even though his works had been exhibited at Durand-Ruel's New Bond Street exhibitions in the early 1870s. That same year Monet's canvases filled the winter exhibition of the Royal Society of British Artists, and a year later Whistler was ousted as the Society's President. Contemporary reaction tended, on the whole, to be hostile to Monet's work, which was regarded as unfinished, crude and ugly. Nevertheless a growing number of supporters for the artist was emerging from within the ranks of the New English Art Club, including in particular Steer, Sickert and Fred Brown, the mainstay of the London Impressionist group set up in 1889. At the same time, 'Twenty Impressions by Claude Monet' were to be seen

137 **Mortimer Menpes**
Flags c.1887

at the Goupil Gallery. Throughout this period Monet himself painted at a number of sites, but by the turn of 1890s he had begun to concentrate on his series pictures, studying the same motif in varying conditions. It was from the later 1890s in this country that Impressionism came to be regarded by several important critics as something other than a direct response to the works of the French painters and, rather as MacColl put it, as simply a 'refined vision of the object', a process of selective perception that could be identified with a long tradition in art history.

Daniel Wildenstein, *Claude Monet, biographie et catalogue raisonné*, 5 vol., 1978-85.
Robert Gordon and Andrew Forge, *Monet*, 1983.
John House, *Monet: Nature into Art*, 1986.
Paul Hayes Tucker, *Monet in the 90s: the Series Paintings*, catalogue of an exhibition at Boston, Chicago and London, 1989.

138 HYDE PARK, LONDON (ill. p.15)
c.1871
oil on canvas, 15¹⁵/₁₆ x 29¹/₈ in / 34 x 72.5 cm
inscribed lower left, Claude Monet
MUSEUM OF ART, RHODE ISLAND SCHOOL OF DESIGN, GIFT OF MRS MURRAY S. DANFORTH, 42-218

Principal Exhibitions
1895 New York, Durand-Ruel, *Monet* (28).
1895 Boston, St Botolph Club, *Monet* (2).
1935 Paris, Galérie Durand-Ruel, *Monet de 1865 à 1888* (7).
1974 London, Hayward Gallery, *The Impressionists in London* (2).

Principal References
John Rewald, *The History of Impressionism*, New York, 1961 ed., pp.254-56 (illus.).
Wildenstein, 1979-85, vol. 1, p.192, no. 164.

Monet appears to have produced only five canvases on his first visit to London during the winter of 1870-71. Three of these are views of the Thames and the Pool of London, the other two represent London parks. Of these the view of Hyde Park looking north-west towards the houses of Bayswater has been frequently compared with Manet's panoramic view of Paris painted during the Exposition Universelle of 1867. It is clear that the London atmosphere enabled Monet to manage spatial transitions more clearly than he had in his first cityscapes of Paris, painted three years earlier. The subtler appreciation of tones in the first London pictures was consolidated in the ensuing sojourn in Holland and may be taken as a preparation for the harbour scenes of Le Havre, the most significant of which was *Impression, Sunrise* (Musée Marmottan, Paris).

139 GREEN PARK, LONDON (ill. p.93)
1871
oil on canvas, 13¹/₂ x 28⁵/₈ in / 34.3 x 72.4 cm
inscribed lower left, Claude Monet
PHILADELPHIA MUSEUM OF ART, W.P. WILSTACH COLLECTION

Principal Exhibitions
1872 London, Durand-Ruel, *5th Annual Exhibition of the Society of French Artists* (131).

1957 Edinburgh, Royal Scottish Academy and London, Tate Gallery, *Claude Monet* (24).
1973 London, Hayward Gallery, *The Impressionists in London* (3).

Principal References
John Rewald, *The History of Impressionism*, 1961 ed., p.257 (illus.).
Wildenstein, 1979-85, vol. 1, p.192, no. 165.

The present canvas, showing Green Park looking west, has been regarded as a companion-piece to *Hyde Park* (cat 138). Monet must have found the royal parks an extraordinary incursion of landscape into the heart of the city. Unlike the gardens of Paris, these were rambling, hilly and apparently unplanned. Visitors, wandering freely, communed with nature and disregarded the paths. The absence of these from the foreground of *Green Park* permits closer analysis of Monet's methods of rendering space. Parallel horizontal strokes of paint give way to a more modulated middle distance punctuated by random figures. These alterations in handling, as well as tone and colour, substitute for more conventional perspectives.

140 LAVACOURT UNDER SNOW (VÉTHEUIL: SUNSHINE AND SNOW) (ill. p.81)
1881
oil on canvas, 23¹/₂ x 31¹/₄ in / 59.7 x 80 6 cm
inscribed, bottom right, Claude Monet 1881
THE TRUSTEES OF THE NATIONAL GALLERY, LONDON

Principal Exhibitions
1900 London, New English Art Club (114).
1903 Berlin, Grosse Berliner Kunst-Ausstellung (621).
1905 London, Grafton Galleries, *Pictures by Boudin, Monet* (119).
1905 Dublin, National Museum of Ireland (10).
1906 Belfast, Municipal Art Gallery (77).
1908 Dublin, Municipal Gallery of Modern Art (109).
1957 Edinburgh, Royal Scottish Academy and London, Tate Gallery, *Claude Monet* (61).
1991 London, National Gallery, *Art in the Making, Impressionism* (13).

Principal References
Thomas Bodkin, *Hugh Lane and his Pictures*, 1932, (1956 ed.), n.p., plate XLIV.
Lionello Venturi, *Les Archives de l'Impressionisme*, 1939, vol. 2, pp.267-68.
Wildenstein, 1979-85, vol. 1, p.336, no. 511.
David Bomford, Jo Kirby, John Leighton and Ashok Roy, *Art in the Making, Impressionism*, 1991, pp.182-87.

Lavacourt under Snow was acquired by Hugh Lane under its original erroneous title, *Vétheuil: Sunshine and Snow*. Discomfort with this title was expressed by Bodkin in 1932 and subsequent writers have confirmed that the picture actually represents buildings in the tiny hamlet of Lavacourt, facing Vétheuil on the opposite bank of the Seine, where Monet lived between 1878 and 1881. An earlier canvas, *The Seine at Lavacourt*, c.1879 (Portland Art Museum, Oregon), shows a similar but not identical group of houses screened by trees which have not been pollarded like those in the present picture. The existence of this work and others showing presumably the same buildings has prompted Wildenstein to disregard the

artist's dating in favour of 1879. The great importance of *Lavacourt under Snow* for the study of Impressionism in Britain and Ireland lies in the fact that when it was shown in London in 1905 Frank Rutter expressed interest in the painting on behalf of the National Art Collections Fund. He reckoned that this would be a suitable candidate for donation by the Fund as the first Impressionist picture to enter the National Gallery, London – until he realized that its Trustees would not accept a work by a living painter.

141 **POPLARS ON THE BANKS OF THE EPTE, EVENING EFFECT** (ill. right)
1891
oil on canvas, 39¹/₂ x 25¹/₂ in / 100.3 x 64.8 cm
inscribed lower right, Claude Monet, '91
PRIVATE COLLECTION, COURTESY PYMS GALLERY,
LONDON

Principal Exhibitions

1892	Paris, Galérie Durand-Ruel, *Monet* (?12).
1895	Paris, Galérie Durand-Ruel, *Monet* (48).
1904	Brussels, La Libre Esthetique, *Peintres Impressionistes* (105).
1905	London, Grafton Galleries, *Pictures by Boudin, Monet* (115).
1928	Cairo, *Exposition de Caire* (233).
1952	Zurich, Kunsthaus, *Monet* (81).
1952	The Hague, Gemeentemuseum, *Monet* (64).

Principal References

Wynford Dewhurst, *Impressionist Painting, Its Genesis and Development*, 1904, p.43.
George Grappe, *Claude Monet*, 1909, p.31 (illus.).
Arsène Alexandre, *Claude Monet*, 1921, p.97 (illus.).
Gustave Geffroy, *Claude Monet, sa vie, son temps, son oeuvre*, 1922, pp.209, 236.
Wildenstein, 1979-85, vol. 3, p.146, no. 1292.

Monet painted a series of twenty-three *Poplars* canvases, beginning in the spring of 1891 and continuing over a ten month period. The story of his negotiation with the owner of the local saw-mill to retain the trees until the series was finished is well-known. Monet was unusually happy with the progress of the series, which expresses a sense of exuberance less immediately perceived in the earlier *Grainstacks*. Within the group there are three sub-groups: those painted in the format of the present picture, those in which the lines of trees are extended to a wider, square format, and those in which the tops of the foreground trees are not shown. The present example, which was shown at Durand-Ruel's great Impressionist exihibition in London in 1905, is one of the best of the first sub-group. Here more than else-where the full richness of Monet's technique is evident, with the strong diagonal thrust of the treetops being echoed in the bands of pink cirrus cloud in the sky.

In general terms the *Poplars* series was as influential among British Impressionists as the *Grainstacks*. By an extraordinary coincidence, Steer had painted a riverbank row of poplars two years earlier in 1889 at Montreuil, and in later years many British artists who visited the val de Seine painted upright compositions including poplar trees. Monet's pictures were particularly admired by

Wynford Dewhurst who described them in eulogistic prose: 'the subject is of the simplest. Seven great Normandy poplars are reflected in the sluggish waters of a rivulet slowly running through marshy ground. The continuation of the long column of these trees, ever diminishing, is lost in the distance, marking the sinuous course of the stream. The gracefulness of the subject gives it a nobility of effect. The landscapes are poems'.

142 **WATERLOO BRIDGE** (ill. p.163)
1900
oil on canvas, 25 x 36¹/₂ in / 63.5 x 92.7 cm
inscribed lower right, Claude Monet, 1900
HUGH LANE MUNICIPAL GALLERY OF MODERN ART,
DUBLIN

141 **Claude Monet**
Poplars on the Banks of the Epte, Evening Effect 1891

Principal Exhibitions

1904 Paris, Galérie Durand-Ruel, *Série des Vues de la Tamise à Londres* (10).
1904 Dublin, Royal Hibernian Academy (132).
1905 Dublin, National Museum of Ireland (37).
1906 Belfast, Municipal Art Gallery (78).
1908 Dublin, Municipal Gallery of Modern Art (108).
1973 London, Hayward Gallery, *The Impressionists in London* (13).
1987 London, Barbican Art Gallery, *The Image of London* (252).
1990 Liège, Musée d'Art Moderne, *Claude Monet* (30).
1993 Dublin, Hugh Lane Municipal Gallery of Modern Art, *Images and Insights*.

Principal References

Thomas Bodkin, 'The Impressionist Room in the Dublin Municipal Gallery ...', *The New Ireland Review*, February 1908.
Lionello Venturi, 1939, vol. 1, p.393.
John House, 'The Impressionists in London', *Burlington Magazine*, vol. 115, March 1973, pp.194-97.
Grace Sieberling, *Monet's Series*, 1981, p.372, no. 18.
Wildenstein, 1979-85, vol. 4, pp.170-71, no. 1556.

It seems likely that *Waterloo Bridge*, clearly dated 1900, was one of the pictures which Monet actually painted on the motif. Geffroy and Clemenceau, who visited Monet in London in 1900, recalled the set up on his balcony, with canvases facing in either direction in order to respond quickly to the changing effects. 'The bridges were barely discernible ... buses streaming across Waterloo Bridge, wafts of smoke that soon disappeared into the thick livid vastness. It was an awe-inspiring, solemn and gloomy spectacle'. The majority of the London pictures were, however, produced in the studio from memory, in preparation for Monet's exhibition at Durand-Ruel's gallery in Paris in May 1904.

Although he had gone to London ostensibly to visit his son in 1889, there was from the first of his three visits a sense of mission. The recollection of his exile in London thirty years earlier, and the knowledge that in tackling these scenes he was paying homage to the local household gods, Whistler and Turner, impelled him. From his vantage points in the Savoy Hotel and St Thomas' Hospital he painted three views: looking down river to Waterloo Bridge in the mornings and in the afternoons looking westward to Charing Cross Bridge and to the Houses of Parliament. In each instance he was seeing the motif in *contre jour*. He was nevertheless aware that his manner of working over the whole surface of the canvas at once enabled an 'envelope' to be created in which the motif was suspended. Unlike Whistler's 'veil' which was an unbroken 'skin', Monet's touches of paint were intended to describe atmospheric depth. Hugh Lane, when he acquired *Waterloo Bridge* in 1905, may have admired it's relative lack of those romantic evocative qualities which particularly characterized the Houses of Parliament works in the series.

143 **HOUSES OF PARLIAMENT, EFFECT OF FOG** (ill. p.79)
1904
oil on canvas, 32½ x 36½ in / 82.5 x 92.7 cm
inscribed bottom right, Claude Monet, 1904
MUSEUM OF FINE ARTS, ST PETERSBURG, GIFT OF CHARLES AND MARGARET STEVENSON HENDERSON AND FRIENDS OF ART

Principal Exhibitions

1904 Paris, Galérie Durand-Ruel, *Monet, Vues de la Tamise* (37).
1904 Berlin, Paul Cassirer, *Monet, Vues de la Tamise* (11).
1905 Boston, Copley Hall, *Monet et Rodin* (57).
1987 London, Barbican Art Gallery, *The Image of London* (256).

CATALOGUE

Reference
Wildenstein, 1979-85, vol. 4, p.188, no. 1611.

Houses of Parliament, Effect of Fog is one of the final and most ethereal of the Parliament pictures. In a number of instances tiny Thames barges have been added to the foreground in order to balance the towers of Westminster looming above the fog. Monet was particularly enamoured with this effect and declared that London 'would not be beautiful without the fog, which gives it its marvellous breadth. Its regular massive blocks become grandiose in that mysterious cloak'. It was just such effects which drew the most eulogistic prose from reviewers of Monet's exhibition in 1904. Gustave Kahn, for instance, writing in the *Gazette des Beaux-Arts,* felt that Parliament seemed to have different densities from one picture to the next, depending upon the opacity of the haze rolling 'across calm waters that reflect both the building and the sky in a convent-like peace and solitude'.

Berthe Morisot 1841-1895

Morisot was born in Bourges, the daughter of a high-ranking civil servant. The family finally settled in the Passy district of Paris in 1852. Morisot received her first instruction in art from Corot in 1861 and her early works of the 1860s reflect his influence. She made her Salon début in 1864. In 1867, however, while copying a Rubens in the Louvre, she was introduced to Manet by Fantin-Latour. Within a short time she was posing in his studio for *Le Balcon* and other works. Through Manet, Morisot's circle widened to include Degas and the other nascent Impressionists, and her work began to develop in the range of subject matter and technique. Two important works of 1873, *Hide and Seek* (Mrs John Hay Whitney) and *Reading* (Cleveland Museum of Art, Ohio) bring the contemporary female into the forefront of her painting. Thereafter cool Corotesque effects disappear. In 1874 she married Manet's brother, Eugène, and the alliance was sealed. Nevertheless Morisot retained her independence, exhibiting at seven of the eight Impressionist exhibitions. Her style broadened and her sense of colour became more individual, particularly after experiments with watercolour and pastel, both of which she used at different stages in the 1870s and 1880s. As this occured she moved closer to Renoir, particularly admiring the delicacy of his handling of paint. She was also a close friend of Mallarmé. In her later work she confined herself almost entirely to her family circle, painting numerous portrait-interiors of her daughter, Julie. These diaphanous sketches are similar in character to those of Helleu.

Charles F. Stuckey and William P. Scott, *Berthe Morisot, Impressionist,* 1987.

144 HARBOUR SCENE, ISLE OF WIGHT (ill. p.18)
1875
oil on canvas, 16⁷/₈ x 25¹/₄ in / 43.1 x 64.1 cm
inscribed bottom left, Berthe Morisot
THE NEWARK MUSEUM, NEW JERSEY

Berthe Morisot and her husband Eugène Manet visited the Isle of Wight in the summer of 1875, staying at a boarding house overlooking the Solent. Several harbour scenes were painted from this location, some of which have been misascribed as pictures of the Thames estuary, since Morisot moved on to London immediately after this visit. The present picture is almost a *grisaille* version of a more colourful canvas, formerly in the collection of Denis Rouart. There have been, however, a number of important changes which indicate that the Newark picture is an independent, rather than a preparatory work. From the Newark picture we have a vivid sense of an artist confronting nature and responding to a rapidly changing scene. Figures are blocked in and then removed; boats sail away and others come into view. What appears unfinished is in fact a fascinating sequence of thoughts and sensations.

Alfred Munnings 1878-1959

Munnings' family lived at Mendham in Suffolk. On leaving school, Munnings was apprenticed as a lithographer in Norwich. His spare time was spent on bicycle tours of Norfolk, and on producing watercolours, which sold at the Norfolk Art Circle. From 1893 to 1898, he studied at evening classes at Norwich School of Art under Walter Scott, who had been a contemporary of Clausen, and he had a first showing at the Royal Academy with three pictures, including *Stranded*. Before going to France in 1903, he had already developed his particular interest in paintings of horses and gypsies, with works such as *Vagabonds*, 1902. The following year Munnings was in Paris at the Académie Julian, but his later memories yield little of his experiences there and more of poplars and French landscape. He continued to travel, to Switzerland and Germany and to Paris again, before returning to Mendham, having been impressed by the work of Lucien Simon and Bastien-Lepage. The subjects of his paintings were continually drawn from his passion for hunting, horse fairs and local country life. These were extended to include scenes from a painting expedition to Cornwall and his experiences

145 **Alfred Munnings**
Daniel Tomkins and his dog
1898

among gypsy hop pickers in Hampshire. From 1899 Munnings exhibited consistently at the Royal Academy, becoming an RA in 1925. During the First World War he was a War Artist for the Canadian Government. His numerous commissioned paintings of racehorses reflected his great enthusiasm for the work of Stubbs and this, coupled with a taste for impressionistic effects, formed the basis of his style for years to follow. In later years he was a vociferous opponent of Modernism. Munnings was knighted in 1944 and was elected President of the Royal Academy in 1944, retiring in 1949.

Sir Alfred Munnings, *An Artist's Life*, 1950.
Nicholas Unsherwood, *Alfred Munnings, 1878-1959*, catalogue of an exhibition at Manchester City Art Galleries 1986.

145 DANIEL TOMKINS AND HIS DOG (ill. p.164)
1898
oil on canvas, 22 x 26 in / 55.9 x 66 cm
THE SIR ALFRED MUNNINGS ART MUSEUM, DEDHAM

Exhibitions
1928 Norwich, Castle Museum (17).
1977 Norwich, Castle Museum (3).

Daniel Tomkins' portrait was commisioned by his son, John Shaw Tomkins, Director of Caley's Chocolate in Norwich. In comparison with orthodox Academy portraiture of the period, the work is a naturalistic *tour de force*. Its spontaneity and quick observation became Munnings' hallmark. Just comparison might be made between this portrait and Walter Osborne's *J.B.S. MacIlwaine* (cat 163).

146 VIOLETS (FLOWER GIRL)
c.1904
oil on canvas, 14 x 17 in / 35.6 x 43.2 cm
inscribed bottom left, A.J. Munnings
THE SIR ALFRED MUNNINGS ART MUSEUM, DEDHAM

Violets (Flower Girl) stands out in Munnings' oeuvre as an urban subject, although even here he has not avoided the opportunity to include a horse-drawn omnibus and hansom cab. The picture nevertheless remains an unusual foray into the world of Orpen, Nicholson and Rothenstein.

147 THE POPPY FIELD (ill. above)
1905-06
oil on canvas, 30 x 50 in / 76.2 x 127 cm
inscribed bottom right, A.J. Munnings
DUNDEE ART GALLERIES AND MUSEUMS

Munnings first tackled the subject of *The Poppy Field* in about 1901. Further variants were produced up to 1910. This version is unique in a number of ways. The vivid vermilion of the poppies was repeated in later years, but seldom with the intensity of the present picture. The artist claimed, in a letter to J. Torrington Bell (14 July 1956, Dundee Art Gallery) that this was 'the first real go I had at a large outside painting'. The picture was painted at Mendham over two or three afternoons, using Charlotte Grey as the model.

148 ON THE ROAD
1907
oil on canvas, 14 x 18 in / 35.6 x 45.7 cm
inscribed lower right, A.J. Munnings 1907
PRIVATE COLLECTION, COURTESY PYMS GALLERY, LONDON

In about 1904 Munnings began to consort with Romany horse dealers who were camped on Alby Common near Norwich. There he met his favourite model, 'an undersized, tough, artful young brigand' who went by the name of Shrimp (*An Artist's Life*, p.207). In the years up to the First World War this young man and his herd of horses were painted again and again, sometimes in large academy-pieces on other occasions in more informal and impressionistic works such as *On the Road*.

David Murray 1849-1933

Born in Glasgow, Murray worked in business for eleven years before enrolling at Glasgow School of Art, where he studied under the watercolourist Robert Greenlees. From Greenlees he developed a detailed realism which, though greatly modified in later years, led to his reputation for pictures of nature 'naked and unadorned'. He travelled to France on several occasions, furthering his taste for plein-air painting and subsequently tackling six-foot canvases in the open air. In 1886 Murray moved to England and from this point his realistic studies declined and his work became increasingly formulaic, as he began to produce highly keyed and majestic visions of the countryside. His concerns were described as being to express the grandeur and the 'splendid impassiveness of nature'. These culminated in his *In the Country of Constable*, purchased by the Chantrey Bequest in 1903, painted in a style then popular at the Academy and similar to works by Alfred East and Arnesby Brown. Murray became an RA in 1905 and President of the Royal Institute of Painters in Watercolour in 1917.

Marion Hepworth Dixon, 'David Murray', *The Art Journal*, 1892, pp.144-48.

149 HOMEWARD, SUNSET
1890
oil on canvas, 9½ x 13⅓ in / 24.1 x 33.6 cm
SHEFFIELD CITY ART GALLERIES

Exhibition
1981 Newcastle upon Tyne, Polytechnic Art Gallery, *Peasantries* (45).

This dramatic sketch shows Murray at his most experimental. The speedy, palette knife handling of the rickyard through which the lone farm worker returns

homeward contrasts with the conventional landscapes which were the cornerstone of Murray's reputation at the Royal Academy.

150 SWEDES (ill. above)
1905
oil on canvas, 47 x 72 in / 119.4 x 182.9 cm
inscribed bottom right, David Murray 1905
ROYAL ACADEMY OF ARTS, LONDON

Exhibition
1988 London, Royal Academy of Arts, *The Edwardians and after, the Royal Academy 1900-1950* (43).

From the 1890s onwards Murray's landscapes of East Anglia seldom avoid reference to those of Constable,

150 **David Murray**
Swedes 1905

151 **James McLaughlan Nairn**
Auchenhew, Arran 1886

with whom he was frequently compared. He was nevertheless aware of more recent developments, as occasional moments of daring in his handling demonstrate. In his hands, however, Constable's radicalism did not develop into Monet, and he remained rooted in Victorian concepts of narrative which led to the inclusion of diverting details, such as the galloping horses in the present work.

In his management of foreground detail, middle distance farm buildings and pale glowing landscape backdrop, Nairn demonstrates a thorough familiarity with the spatial strategies of the naturalist painter. His palette is similar to that of Frank O'Meara, whose *Towards the Night and Winter* is recalled in the female figure laying out the sheets on an unusually calm evening on Arran.

James McLaughlan Nairn 1859-1904

Nairn was brought up in Glasgow and studied at the Glasgow School of Art under Greenlees and MacGregor. Early on he, like Lavery and Pringle, produced several overhead views of bustling city scenes which have echoes in works such as Monet's *Boulevard des Capucines*. In 1889 he moved to New Zealand, apparently for health reasons, and there he painted landscapes with titles such as *Twixt Sun and Moon*, and *A Summer Idyll*. These were loosely handled, atmospheric studies of light and air which proved less popular with the New Zealand public than his more highly finished portraits. A retrospective exhibition of Nairn's work was held in Auckland in 1964.

James L. Caw, '*Scottish Painting, 1620-1908*', 1908 (Kingsmead reprint, 1975).
'The Art of the British Overseas', *The Studio*, Winter no., 1916-17.

> 151 **Auchenhew, Arran** (ill. p.166)
> 1886
> oil on canvas, 24 x 36 in / 61 x 91.4 cm
> inscribed lower left James M. Nairn
> lower right, Auchenhew, '86
> Andrew McIntosh Patrick

Reference
Roger Billcliffe, *The Glasgow Boys*, 1985, p.210 (illus.).

Dermod O'Brien 1865-1945

O'Brien's family were wealthy landowners from Cahirmoyle, County Limerick. His grandfather was William Smith O'Brien, of the Irish Republican Brotherhood. Despite this nationalist background, he was educated at Harrow and Trinity College, Cambridge. In 1886 he travelled to Paris and Rome, studying works of art, before deciding to become a painter. He joined the Antwerp Academy under Verlat and worked for four years acquiring the solid academic style evident in such works as, *The Fine Art Academy, Antwerp*. In 1891 he embarked upon a further two years study at the Académie Julian in Paris. There he met Conder and Rothenstein and, possibly as a result of their influence, he eventually returned to London to join the Slade. He made his début at the Royal Hibernian Academy in 1894, while still based in London. He shared a studio with Henry Tonks and he was readily accepted in London literary circles, numbering Leslie Stephens, Ricketts, Shannon, Sargent and Lavery among his friends. In 1901 he returned to Ireland, with ambitions to execute large allegorical works. These revivals of the 'pompier' style of Bouguereau and the eighteenth-century *fête galante* were not wholly successful. Conversely, landscape sketches painted in and around Cahirmoyle are more revealing of a nascent Impressionism. He was elected as a Royal Hibernian Academician in 1907 and became the Academy's President in 1910. When his farm at Cahirmoyle was sold in 1920, O'Brien settled in Fitzwilliam Square, Dublin. He made regular forays to the south of France, where some of his most innovative landscapes were painted. In later years these often maintained the dry granular texture of the work of his friend, Sir George Clausen.

Lennox Robinson, *Palette and Plough*, 1948.

> 152 **The Sand Pit** (ill. left)
> c.1910
> oil on canvas, 24 x 32 in / 61 x 81.3 cm
> Private Collection, courtesy Pyms Gallery, London

Reference
Kenneth McConkey, *A Free Spirit, Irish Art 1860-1960*, 1990, p.107 (illus.).

Painted at the farm at Cahirmoyle where O'Brien lived from 1907, *The Sand Pit* is one of a series of landscapes and pastoral subjects produced over the following thirteen years. Their informality stands as a contrast to his large classical nude compositions like *The Youth of Bacchus*, painted around the turn of the century. This record of his young family playing in the sand demon-

152 **Dermod O'Brien**
The Sand Pit c.1910

strates the influence of French Impressionism on O'Brien. However, it is one mediated and restrained through the example of Constable, then regarded as the important predecessor of Monet and Pissarro.

Roderic O'Conor 1860-1940

O'Conor was the son of the High Sheriff of County Roscommon. He was educated at Ampleforth College, Yorkshire. When he returned to Ireland he initially joined the Metropolitan School of Art, Dublin before moving to the Royal Hibernian Academy Schools. Following in the footsteps of Osborne and Kavanagh he attended the Antwerp Academy, before travelling to Brittany on a painting expedition. Unlike many others of his generation, O'Conor showed no inclination to return to Ireland. He lived in Paris, taking further instruction from Carolus-Duran and, in 1889, he painted at Grez-sur-Loing. During the 1890s, O'Conor worked mostly in Brittany, under the twin influences of Van Gogh and the Pont-Aven group. In 1894, when Gauguin returned from the South Seas, O'Conor became a close friend, although he resisted the temptation to accompany his mentor back to Tahiti. For much of the remainder of his life O'Conor lived in Paris, making occasional sorties into the French countryside to paint landscapes and, in the early years of the century, returning regularly to Brittany, staying at Pont-Aven and Rochefort-en-Terre. Much of his production at this time was given over to *intimiste* interiors, which echo the work of Bonnard. In order to demonstrate his centrality to the modern movement, he exhibited at the Salon d'Automne in Paris, La Libre Esthetique in Brussels and the Allied Artists' Association in London. Visits to the South of France, particularly to Cassis in 1913, took him to the cradle of Fauvism. During the 1920s, he acted as host to a number of British painters associated with the Bloomsbury Group, such as Matthew Smith. In 1933 he married his mistress, Renée Honta, also a painter, and they moved from Paris to Neuil-sur-Layon. During 1935 and 1936 he worked in Spain and in the following year he staged his only one-man exhibition, at the Galérie Bonaparte, Paris.

Roy Johnston, *Roderic O'Conor*, catalogue of an exhibition at the Musée de Pont-Aven, 1984.
Roy Johnston, *Roderic O'Conor*, catalogue of an exhibition at the Barbican Art Gallery, London, 1985-86.
Jonathon Benington, *Roderic O'Conor*, 1992.

153 LANDSCAPE WITH ROAD AND FARM BUILDINGS (ill. right)
1887
oil on canvas, 21¼ x 26 in / 55.2 x 66 cm
inscribed bottom right, R. O'Conor
PRIVATE COLLECTION

Reference
Benington, 1992, p.35 (illus.).

O'Conor absorbed Impressionism with amazing speed while studying under Carolus-Duran in 1887. *Landscape*

with Farm Buildings may be the by-product of a first trip to Pont-Aven, which is thought to have taken place at this time. The stylistic derivation of the picture is clear. Benington suggests that O'Conor must have been familiar with the work of the Impressionists at this time and stresses Sisley's influence above that of the others. Like Monet and Sisley, O'Conor uses the colour of the ground to give a warm neutral light tone. He employs contrasting reds and blues in the shadows formed by the cart-tracks.

Julius Olsson 1864-1942

Olsson had no formal training in art, but began to paint in London and on various journeys abroad. He moved to St Ives in 1896, where he stayed until about 1915 and where he developed his reputation as a painter of landscapes and of often stormy or moonlit seascapes, handled in an Impressionist manner. Eventually Olsson became a member of the St Ives Art Club, where he gave instruction to younger artists such as John Park and Borlase Smart. Retaining diverse interests outside painting, he became Captain of the West Cornwall Golf Club as well as a J.P. After 1890 he exhibited regularly at the Royal Academy and he became an RA in 1920. He also showed widely in other London galleries and art societies and abroad. One of his works, *Moonlit Bay*, a picture of St Ives bay, was bought by the Chantrey Bequest in 1911, and shortly afterwards Olsson moved to London. In 1919 he became President of the Royal Institute of Oil Painters and served twice on the international jury of the Carnegie Institute, Pittsburgh. He married in 1925 Edith Mary Ellison, whose father was a respected horse breeder in Ireland. Olsson's last years were spent in Ireland, and he died in County Dublin in 1942.

153 **Roderic O'Conor**
Landscape with Road and Farm Buildings 1887

A.G. Folliott Stokes, 'Painter of Seascapes' *The Studio*, vol. 48, 1910, pp.274-83.

154 **SILVER MOONLIGHT, ST IVES BAY** (ill. above)
c.1910
oil on canvas, 24 x 30¹/₄ in / 61.1 x 76.5 cm
inscribed bottom right, Julius Olsson
SOUTHAMPTON CITY ART GALLERY

Olsson, like other Edwardian painters of his day, found himself poised between conflicting interests. At times his small oil studies of the sea are astonishingly Impressionistic. They might be compared with the Belle-Isle works of Monet in their luminosity. For the most part, however, these dramatic aspects of handling were subdued in the more finished exhibitable pictures which came from his studio. These latter works are more comparable to the moonlight marines of Alexander Harrison. Olsson made evening scenes 'peculiarly his own'. In the words of Folliott Stokes, 'it is a moment of intense beauty ... everything is enveloped in a tender afterglow: there are no strong contrasts of tone. The mystery and charm is one of colour only: hence its attraction for the artist'.

Joseph Oppenheimer 1876-1966

A German artist, Oppenheimer was born in Wurzburg, Bavaria. He trained in Munich and before moving to London in 1896 he travelled to the Middle East and to Rome. He first began to show at the Royal Academy in 1904, continuing until 1953. His subjects were wide ranging, including city scenes, landscapes and portraits, and he worked at first in a brightly coloured, Impressionist style. As the years passed this style intensified, becoming increasingly Expressionist. In 1910 he was awarded a gold medal at the Munich International Exhibition and another was won at Barcelona. After the First World War Oppenheimer lived in Berlin, where he became involved in the Berlin, and Munich Secession. Following the Second World War he lived in both London and Montreal, and finally he settled at Totteridge in Hertfordshire.

155 **BEXHILL BEACH** (ill. p.170)
1900
oil on canvas, 22 x 27 in / 55.9 x 68.6 cm

inscribed lower right, J. Oppenheimer/1900
PRIVATE COLLECTION, COURTESY PYMS GALLERY,
LONDON

In his sketches of beach scenes on the south coast
Oppenheimer added a new dimension to British Impressionism around 1900. Their staccato technique probably owes more to his Germanic roots, to painters like Liebermann and von Uhde, than to any French source.

156 PICCADILLY CIRCUS (ill. above)
1903
oil on canvas, 27 x 22 in / 68.6 x 55.9 cm
inscribed bottom right, Joseph Oppenheimer, 1903
PRIVATE COLLECTION

Oppenheimer's London of 1903 might be compared with Pissarro's Paris of a few years earlier. London appears more crowded in these years prior to the arrival of the motor car. Its activity takes place under a cement sky. The painter worked from the balcony of the London Pavilion looking towards Lower Regent Street to obtain the viewpoint for the present picture.

William Orpen 1878-1931

Orpen was born at Stillorgan, County Dublin, the son of a lawyer. He studied at the Metropolitan School of Art, Dublin from 1890 to 1897, before going to the Slade where he was one of the generation which included Augustus and Gwen John, Ambrose McEvoy and Spencer Gore. Orpen's talent emerged quickly at the Slade, where he won the 'summer composition' in 1899 with *The Play Scene from Hamlet*, an early example of his taste for allegorical works. From 1900 he exhibited regularly at the New English Art Club, with paintings that expressed his understanding of both Whistler and of seventeenth-century Dutch art. In 1902 Orpen and John opened a

teaching atelier in Chelsea. At this time, he began regular annual teaching periods at the Metropolitan School of Art, and in 1904 he was elected Associate of the Royal Hibernian Academy. Throughout these years Orpen's style broadened and became more flexible, his application of paint became more rapid and his seizure of a telling abstract arrangement more confident. This is evident in portraits and also in allegorical works such as *The Holy Well*. In the latter, Orpen expressed his serious concern for Irish culture. For him, the Irish gypsy and the Aran Islander embodied a freedom of spirit far removed from his own existence as a fashionable London portrait painter. Orpen was one of the first artists to be selected under the War Artist's scheme and was despatched to the Western Front in 1917. From the outset he was deeply affected by this experience, which reverberated in his work until the 1920s and was reflected in paintings such as *To the Unknown British Soldier in France*, which was accepted by the Imperial War Museum in 1928, but only after considerable reworking.

Sir William Orpen, RA, *An Onlooker in France, 1917-1919*, 1921.
R. Pickle, *Sir William Orpen*, 1923.
Sir William Orpen, RA, *Stories of Old Ireland and Myself*, 1924.
Sidney Dark and Paul G. Konody, *Sir William Orpen, Artist and Man*, 1932.
Bruce Arnold, *Orpen, Mirror to an Age*, 1981.
Kenneth McConkey, *A Free Spirit, Irish Art 1860-1960*, 1990.

157 HOMAGE TO MANET (ill. p.10)
1909
oil on canvas, 64¹/₂ x 51³/₁₆ in / 163.8 x 130.2 cm
inscribed bottom left, Orpen, 1909
MANCHESTER CITY ART GALLERIES

Exhibition

1909 London, New English Art Club (13).

156 **Joseph Oppenheimer**
Piccadilly Circus 1903

155 **Joseph Oppenheimer**
Bexhill Beach 1900

Reference
Arnold, 1981, pp.227-36.

Homage to Manet is one of several paintings in which Orpen was concerned to make a statement about personal or collective experience. In this case, the result was a memorial to the individuals who had done much to create a climate of acceptance for French Impression-ism in the 1880s and 1890s but who, by 1909, had been largely surpassed by artists and writers with new allegiances. Under Manet's portrait of *Eva Gonzales*, recently acquired by Hugh Lane for Dublin, George Moore regales the assembled afternoon guests with readings from his reminiscences of the Impressionists. Lane himself, MacColl, Steer, Sickert and Henry Tonks are 'the eager listeners'. The slight irony that was a feature of much of Orpen's art would not have been lost on those assembled. Sickert himself was known to cherish Moore's statements on art as 'so much sublime nonsense'. More importantly, the picture also restated the importance of Spanish art to Manet and was a strong sign of Orpen's own commitment, taking two and a half years to complete.

158 **ON THE BEACH, HOWTH** (ill. above)
1910
oil on canvas 34¹/₂ x 46¹/₂ in / 87.6 x 118.1 cm
PRIVATE COLLECTION

Exhibitions
1910 London, New English Art Club, Winter (16).
1971 Cork, R.O.S.C., *Irish Art in the 19th Century* (109).
1978 Dublin, National Gallery of Ireland, *William Orpen 1878-1931 – A centenary exhibition* (72).

Reference
Konody and Dark, 1932 pp.187-88.
Anne Crookkshank and the Knight of Glyn, *The Painters of Ireland, 1660-1920*, 1978, p.277 (illus.).
Arnold, 1981 p.224 (illus.).

Every summer from 1909 Orpen and his family spent two months at Howth Head, to the north of Dublin Bay. A series of works featuring his wife Grace and his daughters Mary and Kit capture the holiday mood. The present work has been compared with Degas's *Sur la plage*, currently in the collection of Hugh Lane and a picture which Orpen may have been instrumental in selecting. Although it contains some of the same elements as the Degas – basket, umbrella and reclining figure – Orpen's version has none of the planar simplicity of Degas. His delight in the complexity of shingle, rocks and sand which the high viewpoint gave him might be compared to that of Steer in *Knucklebones*. Here, as in few other works, the richness of colour in the shadows, which at times become mauve and at others become cerulean, contrasts with the rich ochres and creams of the costumes of Grace and Mary.

159 **SUNLIGHT** (ill. p.171)
c.1925
oil on panel, 20 x 24 in / 50.8 x 61 cm
inscribed bottom right, Orpen
NATIONAL GALLERY OF IRELAND, DUBLIN

Exhibitions

1951 Amsterdam, Irish Exhibition State Museum (20).
1978 Dublin, National Gallery of Ireland, *William Orpen 1878-1931* (88).

References
Dark and Konody, 1932, p.49.
Arnold, 1981, p.384.

In works such as *Sunlight* and *Looking Towards the Sea* Orpen was engaged in studies on board using varying techniques in order to exploit Impressionist effects. Here his subject is simply the effect of strong sunlight flooding through the window and striking the nude figure on the sofa. The freedom and energy of this work was noted by P.G. Konody, who described Orpen's technique as 'free from all restraint, displaying all his virtuosity and an almost feverish vivacity. So startling is the effect of the streaks and splashes of light cutting into the solid forms, that at first glance the spectator is almost turned giddy'.

Walter Osborne 1859-1903

The son of the animal painter William Osborne, Walter Osborne was educated at Rathmines School before attending the Royal Hibernian Academy Schools in Dublin. In 1881 he won the Taylor Scholarship and registered as a pupil at Verlat's Académie in Antwerp. Two years later he travelled to Brittany where he worked in company with Blandford Fletcher at Quimperlé. His *Apple Gathering, Quimperlé* demonstrates his interest in the plein-air painting associated with Bastien-Lepage. In 1884, he returned to England where he worked at Evesham with Edward Stott and Nathaniel Hill, developing a more lucid naturalism. Osborne remained in England until 1892 and associated himself with the painters of the New English Art Club, notably Stott,

Fletcher, Brown and Steer. Pictures such as *October by the Sea*, shown at the second New English exhibition, influenced the work of Steer in its stippled effect of foreground stones. During these years, Osborne wavered between precise naturalism and the looser sketch-like handling of Whistler. His subject matter also varied between scenes of rural life and coastal genre. He remained in contact with the Dublin Art Club, of which he was a founder-member, and the Royal Hibernian Academy, to which he had been elected in 1886. His profound attachment to Dublin life was only fully explored after his return to Ireland in 1892. Such works as *In a Dublin Park, Light and Shade*, c.1895, confirmed Osborne as an urban painter. At the same time, he began to develop a portrait practice. In this lucrative profession he combined a Whistlerian aesthetic with an admiration for the work of Hals, Rembrandt and Velázquez. He nevertheless continued to paint garden scenes and interiors with children. Renewed interest in watercolour extended the stylistic possibilities of these works, and with them he returned to exhibiting at the New English Art Club. He died prematurely in 1903.

Jeanne Sheehy, *Walter Osborne*, 1974.
Jeanne Sheehy, *Walter Osborne*, catalogue of an exhibition at the National Gallery of Ireland, 1983.

160 **AN OCTOBER MORNING** (ill. p.27)
1885
oil on canvas, 28 x 36 in / 71.1 x 91.4 cm
inscribed bottom right, Walter Osborne 1885
GUILDHALL ART GALLERY, CORPORATION OF LONDON

Exhibitions

1887 London, New English Art Club as *October by the Sea* (79).
1888 Dublin, Royal Hibernian Academy (49).
1888 Liverpool, Walker Art Gallery, *Autumn Exhibition* (986).
1904 London, Guildhall Art Gallery (161).
1979 London, Royal Academy of Arts, *Post-Impressionism* (327).
1983 Dublin, National Gallery of Ireland, *Walter Osborne* (18).

The striking feature of *An October Morning* is the stony beach, the effect of which has been created by a tapestry of individual touches of bright colour. Osborne took care to ensure that the overall effect would not swamp the figure and other objects which litter the foreground. To avoid the danger of surface recession being misread, he placed a large anchor lying flat on the shingle in perspective in the middle distance. At this time Osborne might have studied the smaller sketches of Steer, Metcalfe, Hill and Blandford Fletcher, all of whom were at Walberswick, Suffolk, in 1885. He was also a close friend of Edward Stott, who was beginning to experiment with similar textures in his work.

161 **BOY UNDER TREES**
1887
oil on panel, 11 x 17 in / 27.9 x 43.2 cm
inscribed bottom left, Walter Osborne, '87
PRIVATE COLLECTION

Exhibition

1983 Dublin, National Gallery of Ireland. *Walter Osborne* (30).

References

Sheehy, 1974, no. 158.
Sheehy, 1983, pp.66, 82.

After his experiences in Antwerp and Brittany, Osborne continued to paint rustic genre scenes throughout the 1880s. This work reveals, the strong influence on him of Bastien-Lepage, with a wholehearted adoption of the square brush technique. For the most part Osborne retained more of a commitment to the Hague School of painters than did contemporaries like Clausen, and he tended to assert the importance of drawing more than the rustic naturalists. In other works, as Sheehy points out, (1983, p.66), Osborne preferred to use the brush to model forms rather than to paint across them.

162 **Hastings Railway Station** (ill. above)
c.1889
oil on canvas, 12 x 14½ in / 30.5 x 36.8 cm
inscribed lower right [on luggage], W.O.
The Taylor Gallery Ltd

163 **J.B.S.MacIlwaine** (ill. p.71)
1892
oil on canvas, 24 x 20 in / 61 x 50.8 cm
inscribed right [on tree], W.F.O. '92
National Gallery of Ireland, Dublin

Exhibitions

1893 Dublin, Arts Club (104).
1964 Dublin, National Gallery of Ireland, *Centenary Exhibition* (182).
1983 Dublin, National Gallery of Ireland, *Walter Osborne* (82).

References

Sheehy, 1974, no. 341.
Sheehy, 1983, pp.140, 144.

Osborne's portrait of his friend the landscape painter J.B.S. MacIlwaine, is unusual simply in being a picture of a man posed out of doors. MacIlwaine and his dog are here seated in the dappled sunlight, under the tree where one would normally expect to find a woman in an inevitable white dress. The model was a frequent visitor to Osborne's house at Foxrock and this is assumed to be where the portrait was painted.

164 **Tea in the Garden** (ill. p.70)
1902
oil on canvas, 54 x 67½ in / 137.2 x 171.4 cm
Hugh Lane Municipal Gallery of Modern Art, Dublin

Exhibitions

1903 Dublin, Royal Hibernian Academy, *Memorial Exhibition* (116 as *Teatime*).
1983 Dublin, National Gallery of Ireland, *Walter Osborne* (78).

References
Jeanne Sheehy, 1974, no. 569.
Sheehy, 1983, p.135.

This picture remained unfinished on Osborne's death the following year. The models, two neighbouring girls and possibly the artist's mother, engaged in the summer afternoon tea party, are presented in a manner similar to classic French Impressionist painting of the 1870s. As such it is typical of the Impressionist influence that had appeared in Osborne's work in the early 1890s, when he produced a series of studies of figures in the outdoor sunlight. The treatment here, however, is much looser than that characteristic of Osborne's earlier work, showing less evidence of preliminary drawing.

Frank O'Meara 1853-1888

O'Meara was born in Carlow, the son of a doctor. At about the age of twenty he went to study in Paris. Shortly after his arrival he joined the newly established atelier of Carolus-Duran. O'Meara's reactions to the master's ceaseless study of Velázquez cannot be studied since his earliest surviving work dates from 1978. It may be assumed, however that O'Meara went with a small contingent of Duran pupils, including Will H. Low and R.A.M. Stevenson, to Barbizon in 1875 and then on to Grez-sur-Loing. This 'pretty and very melancholy village' as it was described, became O'Meara's base for the next ten years and none of the artists who stayed there portrayed its essential character better than he. Although he regarded himself as a realist, he was gifted with a deeply poetic sense of pitch, comparable in its blond tonalities to that of Corot, Maris and Cazin. Along with Lavery, O'Meara showed large Grez compositions at the Glasgow Institute of Fine Art in 1885 and, thereafter, important canvases found their way into leading Scottish collections. One of these, *Twilight*, 1883, demonstrates the painter's concern in his later work to evoke abstract feelings by the suggestion of mood. Paintings such as *October*, 1887, with its grey tonalities, its sense of antici-pation and elegiac qualities appealed to the notable Scot-tish collector, William Young. O'Meara lived at Grez until within a year of his death. There he exerted a forceful influence over other artists such as John Lavery and William Stott.

Julian Campbell, *The Irish Impressionists*, catalogue of an exhibition at the National Gallery of Ireland, 1984.
Kenneth McConkey, 'From Grez to Glasgow, French Naturalist Influence in Scottish Painting', *Scottish Art Review*, vol. 15, no. 4, 1982, pp.23-29.
Julian Campbell, *Frank O'Meara and his Contemporaries*, catalogue of an exhibition at the Hugh Lane Municipal Gallery of Modern Art, 1989.

165 **OCTOBER** (ill. above)
1887
oil on canvas, 39^1/$_2$ x 19 in / 100.3 x 48.3 cm
inscribed, F. O'Meara 1887
HUGH LANE MUNICIPAL GALLERY OF MODERN ART, DUBLIN

Exhibitions
1887 Glasgow Institute of Fine Arts (979).

1887 London, Grosvenor Gallery, Summer Exhibition (381).
1889 Dublin Art Club, Winter Exhibition (19).
1904 London, Guildhall Art Gallery (148).
1980 Dublin, Douglas Hyde Gallery, *The Peasant in French 19th Century Art* (80).
1984 Dublin, National Gallery of Ireland (21).
1989 Dublin, Hugh Lane Municipal Gallery of Modern Art (9).

References
Campbell, 1984, p.160 (illus.).
McConkey, 1982, p.29 (illus.).
Campbell, 1989, p.48 (illus.).

In 1878 O'Meara began his series of 'reverie' pictures at Grez with *Autumnal Sorrows*. By the early 1880s these reflected a mixture of influences from the Pre-Raphaelites to Puvis de Chavannes and Bastien-Lepage. Paintings such as *October* typify the artist's fascination with themes of age and decay, here represented by the woman burning leaves. In this and a similar work, *Twilight,* a symbolic relationship between the figures of the old peasant women and the setting sun is established. As a result O'Meara reveals a deliberate

concern to express sentiment, which sets his work slightly apart from typical rustic naturalism. Nevertheless, his work does present that contemporary view of the village of Grez as a melancholy place with an atmosphere of sadness.

James Paterson 1854-1932

The son of a Glasgow businessman, Paterson abandoned the family firm for a career in painting, having taken watercolour lessons from A.D. Robertson at the Glasgow School of Art. He showed his work at exhibitions in Edinburgh and at the Glasgow Arts Club, and then in 1877 he travelled to Paris. Initially, he studied under Jacqueson de la Chevreuse, and from 1879 he spent four years in the atelier of J.P. Laurens. Although Paterson continued to be based in Paris until 1882, he travelled widely and returned to Scotland briefly on several occasions, when he worked with MacGregor at places on the east coast. Bastien-Lepage was the crucial influence on his painting during these years, which accounts for its particular tonal quality, and he was considerably affected by the work of Puvis de Chavannes. In 1884 he settled at the village of Moniaive, near Dumfries, and the landscape around that area became his subject. From the late 1880s, Paterson was closely involved with the beginnings of the Glasgow School of Art's journal, *The Scottish Arts Review*, and in one edition he published an article based on the experiences of his own training, 'The Art Student in Paris'. Throughout the 1890s he was associated with the Glasgow Boys, showing with them at the Grosvenor Gallery and at Munich, where he received a second Class Gold Medal. In 1906 Paterson established himself in Edinburgh. He was elected RSA four years later, becoming its secretary in 1924, and was appointed President of the RSW in 1922, by which time his work had lost something of its restrained character, becoming increasingly colourful as the years passed. He spent time painting abroad, in Italy and Tenerife, after his wife's death in 1910.

The Belgrave Gallery, *The Paterson Family: One Hundred Years of Scottish Painting 1877-1977*, exhibition catalogue, 1977.
James L. Caw, *Scottish Painting: 1620-1908*, 1908 (Kingsmead reprint, 1975).

166 WINTER SUNSHINE, MONIAIVE (ill. above)
1889
oil on canvas, 23¹/₈ x 15¹/₈ in / 59.7 x 39.4 cm
Inscribed bottom left James Paterson, Moniaive 1889
ROBERT FLEMING HOLDINGS LIMITED

Paterson's landscapes of Moniaive, near Dumfries, were a consistent feature of Glasgow School exhibitions of the 1880s and 1890s. Although he painted in Tenerife and in Edinburgh, he remained loyal throughout his career to the record of the seasonal moods of this part of the Scottish lowlands. Having produced figure subjects in the early 1880s, he graduated to pure landscape by the end of the decade and his manner was perhaps influenced by the chalky tonalities of Thomes Millie Dow's *Hudson River*, 1884 (Glasgow Art Gallery).

Samuel John Peploe 1871-1935

Born and brought up in Edinburgh, Peploe first studied at the Trustees School under Charles Hodder. This was followed by attendance at the Royal Scottish Academy life classes between 1892 and 1902, and later at both the Académie Julian and the Académie Colarossi in Paris. Peploe was initially much influenced by Impressionism, as the small seascapes which he produced in the Hebrides on his return to Scotland demonstrate. He continued his firm links with France and French painting through summer visits, after 1902, to Etaples and to Paris-Plage with J.D. Fergusson. Increasingly his palette became brighter and more intense and his handling much bolder as, like Fergusson, he developed a fascination for Fauvism. That influence is clear in paintings such as the 1910 *Boats at Royan*. The same year he married Margaret Mackay and settled in Paris, where his circle included Fergusson, Middleton Murray and Katherine Mansfield. Remaining there until 1913, Peploe only returned to Scotland at the onset of war, although he was unfit for active service. His painting continued to be simplified and with a strong rhythmic organization of forms. In contrast to pictures by Fergusson, Peploe's work was often found distasteful by critics such as Caw, who admitted his freshness and vigour but felt he had a 'perverse taste for the ugly or the bizarre in figure and landscape'. Nevertheless, he was elected an ARSA in 1918 and RSA in 1927. In between he began his visits to Iona and painted views of the sea and island in all weathers and conditions. He also painted in the south of France in 1928.

James L. Caw, *Scottish Painting, Past and Present, 1620-1908*, 1908, (Kingsmead reprint, 1975).

Stanley Cursiter, *Peploe: An Intimate Memoir of an Artist and of his work*, 1947.

Guy Peploe, *S.J. Peploe 1871-1935*, catalogue of an exhibition at the Scottish National Gallery of Modern Art, 1985.

167 **SPRING, COMRIE**
c.1902
oil on canvas, 16 x 20 in / 40.6 x 50.8 cm
inscribed bottom right, Peploe
KIRKCALDY MUSEUM AND ART GALLERY

Having painted still-lives and figure pieces in the fluid *manière noire* of Manet, Peploe's style began to broaden in trips to Comrie in 1902 and 1903. Painting landscapes in and around the village, he was compelled to adopt a more flexible approach, and thus in the present picture the tracery of trees and sprouting foliage is conveyed with impressionistic dabs of colour.

168 **PLAGE SCENE** (ill. right)
1907
oil on board, 8⁷/₈ x 10⁵/₈ in / 22.8 x 26.7 cm
KIRKCALDY MUSEUM AND ART GALLERY

The long-term effects of working at Comrie and in Brittany in 1904 are seen in the large number of beach scenes painted at Paris-Plage in 1907, where Peploe was working with Fergusson. In these he returns to a calligraphy of swiftly applied brushstrokes in which sections of board are deliberately left unfilled with paint.

Arthur Douglas Peppercorn 1847-1924

Peppercorn was born in Deptford. In 1870 he was in Paris where he was a student at the Ecole des Beaux-Arts, under Gérôme. The influences on his work were the Dutch artists (he was a friend of Matthew Maris), and the Barbizon school, especially Corot, to whom he was himself later compared. The critic R.A.M. Stevenson described his subject in review as one of the greatest poets of his day. 'When', he wrote 'in future times they say Constable, Corot, Millet and Monet, they will certainly add Peppercorn'. Stevenson was less approving of the artist's earlier work, which he found often heavy and gloomy; for him, the best work revealed the artist as a 'seer of sad and remote aspects of the world', where all unessential detail was sacrificed to an ideal. Peppercorn exhibited at the Royal Academy and also at Suffolk Street and the New Gallery. He had several successes abroad, notably with *The Cornfield*, which won a gold medal at Munich. His favoured painting sites were Hampshire, Dorset and Surrey, where he lived at Ashtead. A memorial exhibition was held at the Leicester Galleries, London in 1926.

James Stanley Little, 'A.D. Peppercorn', *The Art Journal*, 1896, pp.201-05.

R.A.M. Stevenson, 'A.D. Peppercorn, An Appreciation', *The Studio*, vol. 21, November 1900, pp.77-85.

169 **LANDSCAPE WITH CATTLE, NEAR WOOL, DORSET**
(ill. below)
c.1900
oil on canvas, 18³/₈ x 32¹/₂ in / 47 x 82.5 cm
inscribed lower left, Peppercorn
BRADFORD ART GALLERIES AND MUSEUMS

Exhibition
1978 Bradford, Cartwright Hall and Hull, Ferens Art Gallery, *English Impressions* (39).

To the new critics of the 1890s, Peppercorn, like Fisher, was something of a discovery. A French-taught landscapist, he had learned his trade apparently by studying the work of Barbizon painters in the dealers' windows in Paris. Corot was, however, his real mentor, as *Landscape with Cattle* clearly indicates. A second version of this composition, entitled *The Lake*, was in the collection of J.S. Forbes.

168 **Samuel John Peploe**
Plage Scene 1907

169 **Arthur Douglas Peppercorn**
Landscape with Cattle, Near Wool, Dorset c.1900

Camille Pissarro 1830-1903

Camille Pissarro was the son of a businessman who had emigrated from Bordeaux to St Thomas in the West Indies. After schooling outside Paris, Pissarro worked for several years in the family business before returning to settle in France from the mid 1850s. In 1856 he began his training in art in the studios of the academic painters Henri Lehmann and François Picot. Four years later he first exhibited at the Salon with his *Landscape at Montmorency*. Having enrolled in life drawing classes at the Académie Suisse, he first came into contact with Monet and shortly afterwards established his friendships with Guillaumin and Cézanne. In later years he occasionally painted alongside the latter, especially in the 1870s. Throughout the 1860s, Pissarro continued to exhibit his landscapes at the Salon and he showed three works at the Salon des Réfusés in 1863, but after the turn of the decade his work was to be seen most often with private dealers such as Durand-Ruel, whom he had met in London in 1870. In 1872 he and his family returned to Pontoise. From then onwards his landscapes became less formal and, increasingly towards the early 1880s, included representations of the peasant, rendered with small, often parallel, brushstrokes. Five of his paintings appeared in the catalogue of the first Impressionist exhibition in 1874, and he showed in each of the subsequent shows. In the mid 1880s Pissarro came into contact with Seurat and Signac, largely via his son Lucien. Until the end of that decade he experimented with the *pointilliste* technique which seemed, for a while, to offer the discipline and unity of brushwork he was seeking. Paintings such as *View from My Window, Eragny*, 1888, demonstrate his assimilation of the new method which appeared also in works by him, Seurat and Signac at the 1886 Impressionist exhibition. After 1888 however, he began to express doubts and by 1890 he was increasingly abandoning neo-impressionism. From the mid 1890s he was producing cityscapes in Paris and in Rouen.

Camille Pisarro, *Letters to his Son Lucien*, 1943.
Anne Thorold ed., *The Letters of Lucien to Camille Pissarro*, 1993.
Ralph E. Shikes and Paula Harper, *Pissarro, His Life and Work*, 1980.
John Rewald et. al., *Pissarro*, catalogue of an exhibition at London, Paris and Boston, 1981.
Richard Thomson, *Camille Pissarro, Impressionism, Landscape and Rural Labour*, catalogue of an exhibition at the South Bank Centre, London, 1990.

170 **Fox Hill, Upper Norwood** (ill. p.16)
1870
canvas, 13¼ x 18 in / 34.9 x 45.7 cm
inscribed lower right, C. Pissarro, 70
THE TRUSTEES OF THE NATIONAL GALLERY, LONDON

Principal Exhibitions

1931 London, Tate Gallery (touring exhibition), *Oil Paintings by Camille Pissarro* (27).

1987 London, Barbican Art Gallery, *The Image of London* (172).

1991 London, The National Gallery, *Art in the Making, Impressionism* (4).

Principal References

David Bomford, Jo Kirby, John Leighton and Ashok Roy, *Art in the Making, Impressionism* 1991.

In later years Pissarro recalled his stay in Norwood in the winter of 1870 with considerable pleasure: it was 'a charming suburb'. He made use of bright days to record the vicinity under snow. Given the climatic conditions, the execution of *Fox Hill, Upper Norwood* is more speedy than that of the canvases painted the following spring. The main features of Pissarro's mode of conception – a centralized composition, typically a view looking down a roadway, with figures in the middle distance – are present.

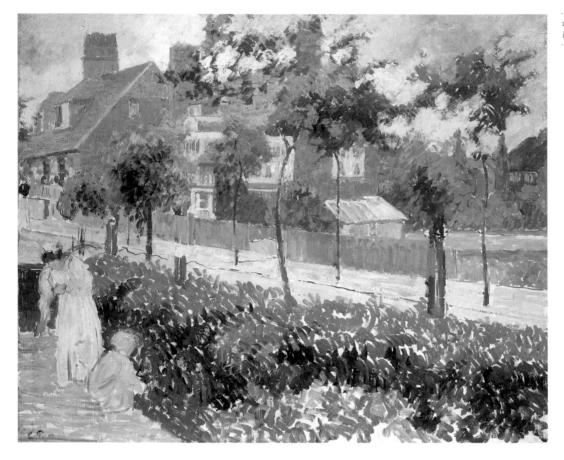

171 **Lordship Lane Station, Upper Norwood** (ill. p.177)
1871
oil on canvas, 17³/₄ x 29¹/₄ in / 45 x 74.3cm
inscribed lower right, C. Pissarro, 71
Courtauld Institute Galleries, London

Principal Exhibitions
1948 London, Tate Gallery, *Samuel Courtauld
 Memorial Exhibition* (51).
1955 Paris, Orangerie, *Impressionistes de la Collection
 Courtauld de Londres* (37).
1973 London, Hayward Gallery, *The Impressionists in
 London* (32).
1981 London, Hayward Gallery, Paris, Grand Palais
 and Boston, Museum of Fine Arts, *Pissarro* (16).

Principal Reference
Martin Reid, 'Camille Pissarro: three paintings of
London. What do they represent?', *Burlington
Magazine*, vol. 109, 1977, pp.251-61.

Lordship Lane Station, Upper Norwood has prompted a
great deal of speculation on account of its subject matter. It
predates Monet's sequence of St Lazare canvases of 1877
and, given the sometimes conflicting statements made by
its author on the importance of Turner, has fed speculative
comparisons with *Rain, Steam and Speed*. If Pissarro
thought in these terms, it is clear from the present picture
that he wished to dispel all romantic overtones which
might be associated with a celebrated Turner. The
measured tonalities of this picture on an early spring day

are recorded with patient accuracy. The site, long thought
to be Penge Station, was identified by Reid in 1977.

172 **Bath Road, London** (ill. above)
1897
oil on canvas, 21¹/₄ x 25¹/₂ in / 54 x 65 cm
Visitors of the Ashmolean Museum, Oxford

In May 1897 Camille Pissarro came to London to see his
son Lucien, who was recovering from a stroke. Lucien
had just moved back to the city and was living at 62
Bath Road, Bedford Park. The present picture was
painted from a front window in the house. At this time
Pissarro had returned to a more orthodox Impression-
ism, building up the image from separate paint-marks.
This distinguishes the London works of 1897 from those
of 1892, which are more neo-Impressionist in character.
Other paintings from this visit such as *The Train at
Bedford Park* are more densely worked; as a sequence
they exerted a strong influence upon Lucien when he
returned to painting around 1902.

Lucien Pissarro 1863-1944

The son of Camille Pissarro, Lucien was born in Paris and
was taught to paint from an early age by his father,
exhibiting with him in the final Impressionist exhibition
of 1886. By this date he had become increasingly interes-
ted in the *pointilliste* techniques of Seurat, and along with

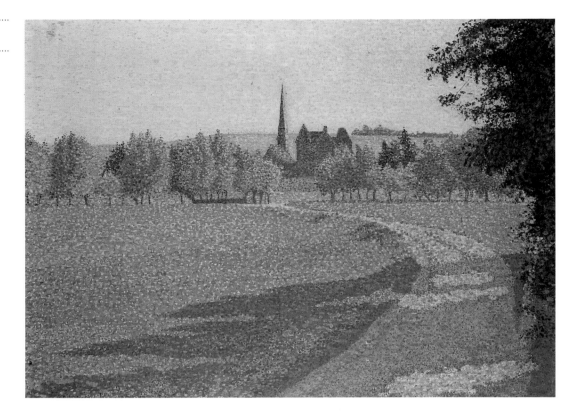

Camille he began to experiment with colour divisionism. In Lucien's case this resulted in works such as the portrait of his sister *Jeanne*, which was shown at the Salon des Indépendants in 1889 and was typified by contrasts of luminous red and green dashes and flecks of paint. The following year he settled in London, where he at first associated with the Arts and Crafts circle and planned a career as an illustrator. But his avant-garde background meant he was of considerable importance to the more radical members of the New English Art Club, in particular to Steer, who had shown interest in neo-Impressionist methods as early as 1889. Lucien himself exhibited with the Club from 1904, becoming a member two years later, although he continued his arts and crafts concerns, having founded the Eragny Press in Epping in 1893. The first book to be published by the Press was *The Queen of the Fishes*, for which Lucien produced woodcuts somewhat indebted to the style of Charles Ricketts. This work revealed an influence from Pre-Raphaelitism which was to disturb his father. Lucien's status, derived from Camille, meant that like Sickert he continued to have significance for ever younger generations of painters, and in 1906 he became involved with Sickert's Saturday afternoon gatherings at Fitzroy Street. As a result he was a crucial influence on the development of artists such as Spencer Gore. A strong friendship between these two developed, and in 1911 Lucien presented his *The Thierceville Road*, 1885, to Gore as a wedding present. That same year he became a founder-member of the Camden Town Group. His first solo exhibition was held at the Carfax Gallery in 1913, and in 1919 he established the Monarro Group with J.B.Manson. After 1934 he began to show at the Academy. For many years after 1902 he lived in Hammersmith, although he died in Somerset in 1944.

Camille Pissarro, *Letters to his Son Lucien*, 1943.
W.S. Meadmore, *Lucien Pissarro, Un Coeur Simple*, 1962.
Anne Thorold, *A Catalogue of the Oil Paintings of Lucien Pissarro*, 1983.
Anne Thorold ed , *The Letters of Lucien to Camille Pissarro*, 1993.

173 **L'Eglise d'Eragny** (ill. above)
1886
oil on canvas, 20 x 27^1/$_2$ in / 51 x 70 cm
VISITORS OF THE ASHMOLEAN MUSEUM, OXFORD

Exhibitions
1963 London, Arts Council Gallery and other venues, *Lucien Pissarro, 1863-1944* (2).
1974 London, Royal Academy of Arts, *Impressionism* (122).

Reference
Thorold, 1983, no. 10.

By the beginning of 1886 both Lucien and Camille Pissarro had been converted to *pointillisme*. The thoroughness of Lucien's understanding of this technique is demonstrated by *L'Eglise d'Eragny*. The work might also be compared with that of Signac, with whom Lucien spent part of the summer, working at Le Petit Andely on the Seine. Both father and son recognized the difficulty in selling works in the new manner, and for most of the year Lucien produced wood engravings for *La Revue Illustrée*. A watercolour in the *pointilliste* manner, showing the central portion of the present composition, is clearly dated '87, in some respects a more logical date for the present picture.

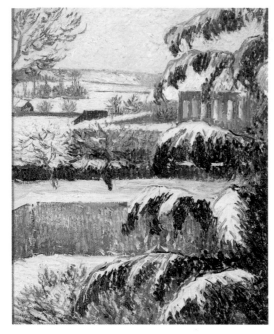

174 **Effet de Neige, Eragny** (ill. above)
1892
oil on canvas, 22 x 18 in / 55.8 x 45.7 cm
inscribed bottom right, 1892, Lucien Pissarro
AGNEW'S

Exhibition

1893 Paris, Société des Artistes Indépendants (1037).

References
Thorold, 1983, no. 45.
Kenneth McConkey, *British Impressionism*, 1989, p.147
 (illus.).

After his marriage in August 1892 Lucien Pissarro and
his new wife spent eight months at Eragny. Having
painted intermittently in the preceding years, he was
again experimenting. The more decorative effects
contained in his woodcuts were not completely rejected
when he returned seriously to the use of oil paint.
Although faced with a scene not dissimilar to the
miserable backgarden painted by Gauguin in the Rue
Carcel ten years earlier, Pissarro exploits the rhythmic
possibilities of the snow-laden branches of a fir tree,
beyond which the fields and hedgerows stretch into
the distance.

175 **Route de Thierceville**
1893
oil on canvas, 23¹/₂ x 28¹/₄ in / 60 x 73 cm
inscribed, lower left, Lucien Pissarro, 1893
VISITORS OF THE ASHMOLEAN MUSEUM, OXFORD

Exhibitions

1963 London, Arts Council Gallery and other venues,
 Lucien Pissarro 1863-1944 (9).
1974 London, Royal Academy of Arts, *Impressionism*
 (123).

Reference
Thorold, 1983, no. 61.

As in *Effet de Neige, Eragny*, Lucien Pissarro wished to
achieve an overall effect without the fragmentation
which characterized the majority of his *pointilliste*
works. The broad sweep of the countryside recalls
the landcapes of the American Impressionists, whose
work Pissarro had seen on his visit to Giverny in the
preceding year.

176 **Portrait of Esther**
(ill. below)
1893
oil on canvas, 16 x 15 in / 40.6 x 38.1 cm
FERENS ART GALLERY, HULL CITY MUSEUM, ART
GALLERIES AND ARCHIVES

Exhibition

1963 London, Arts Council Gallery, and other venues,
 Lucien Pissarro, 1863-1944 (12).

Reference
Thorold, 1983, no. 71.

Lucien Pissarro married Esther Levi Bensusan on 10
August 1892. Perhaps because of persistent objections
to the marriage by members of Esther's family, they
spent until May the following year at Eragny, where she
became pregnant. Shortly after their return to England
they leased a cottage at Epping, where their daughter,
Orovida, was born. The present profile portrait shows
Esther seated in front of a William Morris tapestry.

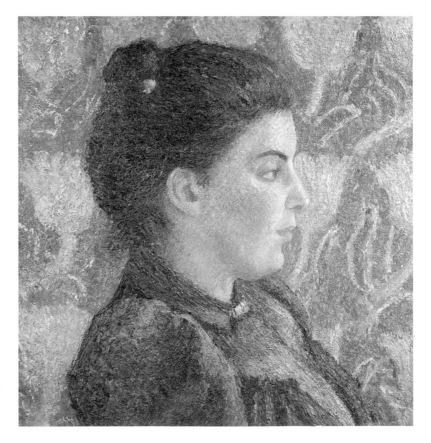

177 **GREY WEATHER, FINCHINGFIELD** (ill. p.84)
1905
oil on canvas, 21 x 25¹/₂ in / 53.5 x 64.8 cm
inscribed bottom right with monogram, 1905
SOUTHAMPTON CITY ART GALLERY

Exhibitions
1905 London, New English Art Club, winter (27).
1963 London, Arts Council Gallery and other venues,
 Lucien Pissarro, 1863-1944 (19).

Reference
Thorold, 1983, no. 101.

178 **SUNSET, FINCHINGFIELD, JUNE**
1905
oil on canvas, 21 x 25¹/₂ in / 53.3 x 64.8 cm
inscribed bottom right, with monogram, 1905
PRIVATE COLLECTION

Exhibition
1905 London, New English Art Club, winter (24).

Reference
Thorold, 1983, no. 104.

In the winter of 1904 Lucien Pissarro began to exhibit at
the New English Art Club. Although in letters to his
father in the early 1890s he had been disparaging about
the Club, he now saw that its leading proponents
remained in sympathy with the ideals of Impressionism.
There was a new generation who were curious for the
kind of inside knowledge he possessed, and he found
himself fêted by Sickert. In June 1905 he returned to
Finchingfield in Essex, where he had spent an unsatis-
factory five week period the previous year. Although the
weather was poor, he produced six oil paintings and a
number of watercolours. Working in the countryside of
Clausen and Mark Fisher, Pissarro was more responsive
than he had been to climatic change and to fluctuations
of colour at different times of day. In *Sunset, Finching-
field, June* light filters through the tall trees and casts
emerald shadows across the field. Such colours, such
intensity of effect, particularly appealed to the young
Spencer Gore, whose early work took on a similar
palette.

Bertram Priestman 1868-1951

Born in Bradford, Priestman travelled to Egypt, Palestine
and Italy before attending the Slade School, and later
spent time working in the studio of William Llewellyn.
From 1889 he showed consistently at the Royal
Academy and was represented in the first International
Society Exhibition in 1898. In 1900 his atmospheric
study of cattle beside the water, *Homewards*, was
purchased for the New South Wales Gallery, and *The
Studio* magazine was hailing Priestman, along with
Lavery and T.C. Gotch, as leaders of the modern school
in this country. His loosely handled studies of light and
reflections on water displayed an influence from Monet
and from Constable. These peaceful rural idylls proved
to be equally successful both here and abroad. He
received an honourable mention at the Paris Salon in
1900 and the following year was awarded a gold medal
at Munich. At home, Priestman was a member of the
Society of 25 Artists and showed widely in the London
galleries. He lived both in London and in Suffolk.

Alfred Lys Baldry, 'The Work of Bertram Priestman',
 The Studio, vol. 14. 1898, pp.77-98.
Frederick Wedmore, 'Bertram Priestman', *The Art
 Journal*, 1907, pp.179-84.

179 **A HAZY DAY ON THE ROCHESTER RIVER** (ill. left)
1890
oil on canvas, 66¹/₄ x 60 in / 168 x 152.5 cm
inscribed lower right, B Priestman '90
BRADFORD ART GALLERIES AND MUSEUMS

Exhibitions
1893 Bradford, Arcadian Art Club.
1978 Bradford, Cartwright Hall and Hull, Ferens Art
 Gallery, *English Impressions* (40).
1981 Bradford, Cartwright Hall and Hull, Ferens Art
 Gallery, *Bertram Priestman RA* (9).

Reference
Baldry, 1898, p.81 (illus.).

In the early 1890s, before his visit to Holland in 1895,
Priestman shared C.E.Holloway's interest in painting
industrial river scenes. At this time he produced a large
number of pictures of tug-boats manoeuvring at the
mouth of the Medway and in the Thames estuary.
Recollections of Turner as well as the earlier phases of
Impressionism inform this work although, as Wedmore
pointed out, it marked a youthful phase which bore little
resemblance to the later Dutch-inspired period in
Priestman's work.

Mabel Pryde 1871-1918

Born in Edinburgh, Pryde was the daughter of the Headmaster of Edinburgh Ladies' College. She studied at Hubert von Herkomer's art school at Bushey where, although she was chaperoned by her brother, James Pryde, she met and later married William Nicholson. Although a gifted painter, her work was overshadowed by that of her husband and brother, who formed the highly successful partnership known as the Beggarstaff Brothers. It is as a shadowy background figure that she appears in Orpen's *A Bloomsbury Family* 1907 (Scottish National Gallery of Modern Art). After the birth of their children she refused to accept invitations to social engagements at which her husband's presence was necessary and she ceased to paint. In 1918 she died of influenza following a rash decision to see her son Tony depart for his final tour of duty on the Western Front.

Marguerite Steen, *William Nicholson*, 1943.

> 180 **The Artist's Daughter, Nancy, as Pierrot** (ill. p.6)
> c.1909
> oil on canvas, 39¹/₄ x 24⁵/₈ in / 101 x 82.5 cm
> Robert Fleming Holdings Limited

Despite the fact that her oeuvre is small, Mabel Pryde was an extraordinarily gifted painter. The present work shows her complete mastery of the *hispagnoliste* idiom, derived from Manet and practised to effect by painters such as Orpen and Nicholson. In this instance one may cite Manet's *The Fifer* as a possible inspiration, although the management of tone and the cool, detached use of visual shorthand recall the work of followers of Whistler. As a mother's contemplation of her daughter the picture is measured, meditative and restrained. It is tempting to see it as a reflection of the overheard aesthetic debates of Nicholson's contemporaries, but it is too reductive, too direct, to be taken as a mere by-product of superficial understanding.

Alexander Ignatius Roche 1861-1921

Roche came from Glasgow, although his father was of French origin. He began his career with several years in an architect's office but then, having decided upon painting, he spent some time at the Glasgow School of Art. It was there that he first developed his friendship with John Lavery. Around 1880 Roche travelled to Paris, where he attended the atelier Julian under Boulanger and Lefebvre, and later the Ecole des Beaux-Arts under Gérôme. His training there was not to have a marked effect on the style of the work he produced on his return to Scotland in the early 1880s although, in later years, he remembered that the talk in the cafés among the Scottish ex-patriot students consisted of admiration for seemingly disparate artists like Puvis de Chavannes and Bastien-Lepage. While still in France Roche worked at Grez-sur-Loing alongside Lavery and Kennedy. His return to Scotland, where he settled first in Glasgow and later near Edinburgh, saw him continuing with Bastien-Lepage's practice of painting the figure out of doors.

This resulted in works such as *The Shepherdess*, which was shown at the Royal Academy in 1887. Increasingly, the impact of Barbizon and modern Dutch painting gave way in Roche's work as Whistler's influence, assimilated through time spent in MacGregor's life-classes, began to appear alongside a growing ability as a colourist. These concerns revealed themselves especially in paintings of the sea, inspired by a yachting cruise along the west coast of Scotland. One example of these, *The Squall on the Clyde*, was exhibited at the Paris Salon in the early 1890s and was purchased by Gaston La Touche. The intensity of his use of colour increased after a subsequent visit to Italy, and he continued this with the landscapes he produced afterwards in Scotland, particularly *The Idyll* of 1892, which was purchased for New South Wales. The following year Roche was in Madrid studying Velázquez, and thereafter he turned increasingly to portraiture. Around the turn of the century he was commissioned, with Lavery, Walton and Henry, to execute a mural in the Banqueting Hall in Glasgow. Although now dominated by portraiture, he occasionally produced small impressionistic genre pieces.

Haldane MacFall, 'The Art of Alexander Roche, RSA', *The Studio*, vol. 37, 1906, pp.203-13.
Roger Billcliffe, *The Glasgow Boys*, 1985.

> 181 **The Building of the Ship** (ill. below)
> c.1883
> oil on canvas, 18 x 16¹/₂ in / 46 x 67.8 cm
> inscribed
> Hugh Lane Municipal Gallery of Modern Art, Dublin

Roche's vivid study of boat-builders may owe its inspiration to Henry Herbert La Thangue's *The Boat-building Yard* (National Maritime Museum, Greenwich), which was shown at the Grosvenor Gallery in 1882. There were other recent treatments of this theme by Cazin and P.R. Morris. However, Roche's fascination with the subject clearly lies in the architectural presence of the boat's skeleton, rather than the incidental details of its construction.

181 **Alexander Ignatius Roche**
The Building of the Ship c.1883

William Rothenstein 1872-1945

Rothenstein was from a German Jewish family involved in the textile trade in Bradford. From 1888 to 1889, he attended the Slade School in London. In later years he recounted his experiences there and the system of training established under Legros' professorship which, although it involved the traditional periods spent toiling over antique casts, nevertheless placed stress on the importance of observational drawing. This was the practice which made the Slade unique among British art schools at the time. The appeal of that method of training, then regarded as French, doubtless encouraged Rothenstein's decision to enrol at the Académie Julian for the years 1889-93. By this time he had also established a strong enthusiasm for French painting, in particular for Millet and painters of the Barbizon School. While in Paris he was exposed to a wide range of differing influences, and his work at times reflected signs of his admiration for Puvis de Chavannes, Degas and Toulouse-Lautrec, with whom he established a particular friendship. By 1893 the contemporary fascination with seventeenth-century Spanish painting began to surface in Rothenstein's painting. This culminated in a trip to Spain and Morocco, and in a book on Goya in 1899. Goya's work, he felt, had rekindled a concern for an architectural sense of design and proportion in art. The influence of Spanish art resulted in his own painting *Zuloaga as a Torero* in 1895. By 1900 Rothenstein, like Orpen, had begun to concentrate on realistic interior subjects, either of a domestic kind such as *The Browning Readers* or with a dramatic air of unease as in *The Doll's House*, 1899. From this date he had assumed artistic management of the Carfax Gallery, and thus began his long involvement with art world politics which took up much of his energy, particularly in the 1900s. Throughout this period portraiture came to form a significant part of his practice; he had been publishing a series of lithographic portrait studies since 1893 His landscape painting was to be stimulated in particular by his decision to settle at Far Oakridge, Gloucestershire, in 1912. Rothenstein was highly instrumental in the development of the Official War Artists Scheme during the First World War, and he participated in the scheme himself in France, between 1917 and 1919. In 1926 he executed a mural in the Palace of Westminster, from 1920 to 1935 he was Principal of the RCA, and he was knighted in 1931.

William Rothenstein, *Men and Memories*, 3 vol. 1931, 1932, 1938.
Robert Speaight, *William Rothenstein*, 1962.
John Thompson, *Sir William Rothenstein 1872-1945*, catalogue of an exhibition at Bradford City Art Gallery & Museums, 1972.

182 **THE COSTER GIRLS** (ill. p.60)
1894
oil on canvas, 39 x 30 in / 100.3 x 76.2 cm
inscribed lower left with initials, '94
SHEFFIELD CITY ART GALLERIES

Exhibitions
1894 London, New English Art Club, winter (84).
1950 London, Tate Gallery, *William Rothenstein Memorial Exhibition*, (6).

1972 Bradford, City Art Gallery and Museums, *Sir William Rothenstein, 1872-1945* (3).
1986 London, Christie's, *New English Art Club Centenary Exhibition* (84).

The Coster Girls amply illustrates Rothenstein's precocity. Having imbibed the gospel of modern life in Paris, he returned to England with a mission to discover Degas-ist subject matter. Faint echoes of Hogarth's *Shrimp Girl* could, however, not be excluded. He clearly wished to give the impression that this sort of character might be encountered in a riverside tavern at the close of day. Frederick Wedmore, writing in December 1894 in *The Studio* (vol. 4, p.72), was not overly impressed by the picture and described the leading figure as a 'pretty little doll, comparatively inexperienced', while her companion clearly had 'a Past'.

183 **HABLANT ESPAGNOL** (ill. above)
1895
oil on canvas, 32 x 18 in / 81.3 x 45.7 cm
inscribed lower left, Will Rothenstein '95
PRIVATE COLLECTION, COURTESY PYMS GALLERY, LONDON

Exhibitions
1895 London, New English Art Club, spring (28).
1950 London, Tate Gallery, *William Rothenstein, Memorial Exhibition* (11).

In 1894 Rothenstein visited Morocco. Returning via Seville he visited taverns where he witnessed a truer form of Spanish dancing than that portrayed in Sargent's *La Carmentcita*, 1890 (Musée d'Orsay, Paris). These dancers wore 'shabby old gowns, ill made and ill fitting', they sat around in a state of boredom untill their turn came, and then they were transformed: 'never had I seen such dancing' (*Men and Memories*, vol. 1, p.223). Rothenstein's *hispagnolisme* around 1895 was crucially formative. Through Whistler and in his contacts with the Spanish painter Ignacio Zuloaga, a deep respect for the work of Velázquez and Goya developed.

Theodore Roussel 1847-1926

Roussel was from Lorient in Brittany. Although his background remains obscure, it appears that he had settled in London by 1874. Before he entered Whistler's entourage in the mid 1880s he was largely self-taught. Within a few years he acquired a strong reputation, particularly with works such as *The Reading Girl*, which was shown at the New English Art Club in 1887. At the same time Roussel was one of the radical band of Whistler followers at the Society of British Artists. When the conservative members of the Society staged a coup in 1888, Roussel was ousted along with his master. His closeness to Sickert led to his selection for the London Impressionists exhibition in 1889, at which the resplendant *Blue Thames, End of a Summer Afternoon, Chelsea* was a centrepiece. With this Roussel began to emerge from the shadow of his mentor and arrive at a technique which was individual. By this stage he had his own pupil, Paul Maitland. He was also well-established as a portraitist and etcher of the London scene. Most of the rest of his career was spent working in and around Chelsea.

Frank Rutter, *Theodore Roussel*, 1926.
Margaret Dunwoody Hausberg, *The Prints of Theodore Roussel, A Catalogue Raisonné*, 1991.

184 THE READING GIRL (ill. p.40)
1886-87
oil on canvas, 60⅛ x 64⅝ in / 152.4 x 163.8 cm
inscribed bottom left, Theodore Roussel
TRUSTEES OF THE TATE GALLERY, LONDON, PRESENTED BY MRS WALTER HERRIOT AND MISS R. HERRIOT IN MEMORY OF THE ARTIST, 1927

Exhibitions
1887 London, New English Art Club (3).
1986 London, Christie's, *New English Art Club Centenary Exhibition* (86).

Reference
Kenneth McConkey, *British Impressionism*, 1989, p.50 (illus.).

The Reading Girl became one of the most important reference points for members of the Impressionist circle in London in the late 1880s. At the time of its first exhibition, it excited controversy on account of its evident modernity. Although it stemmed from the Whistler/ Manet tradition of the 1860s, it lacked the aesthetic distancing of their nudes, being devoid of classical or Old Master references. At one level it could

be taken as a life painting in the modern sense, portraying a model, Hettie Pettigrew, who would pose for payment in the corner of a studio which lacks the opulence which the general public was accustomed to see in the establishments of Academicians. Aesthetic aspirations are confined to the kimono, thrown over the back of the chair.

185 BLUE THAMES, END OF A SUMMER AFTERNOON, CHELSEA (ill. p.94)
1889
oil on canvas, 33 x 47½ in / 83.8 x 120.6 cm
inscribed bottom right, Theodore Roussel
PRIVATE COLLECTION

Exhibition
1889 London, Goupil Gallery, *London Impressionists* (53).

References
Kenneth McConkey, *British Impressionism*, p.62 (illus.).
Anna Gruetzner Robins in Norma Broude ed., *World Impressionism*, 1989, p.76 (illus.).

A group of Battersea warehouses and barges provided the inspiration for one of Roussel's most important pictures. In this the pervasive influence of Whistler has begun to be modified. The important decisions in such a picture remain abstract ones – the level of the horizon, the position of the main chimneys – but where Whistler would paint this scene as a nocturne and lose much of the detail, Roussel portrays it at the end of a summer afternoon. Timing is important: the London Impressionists were preoccupied with the possibility of conveying a specific time of day and time of year in their works. Although climatic conditions are calm and sunny on the river, Roussel began to break up its surface with choppy strokes in the immediate foreground. While it would be wrong to over-react to these nuances, they are evidence of the distance between Whistler and Roussel in 1889. Roussel painted the Thames from the location of the present picture on a number of occasions. A small oil panel showing the same central group of buildings, but extending further to the left, exists (*New English Art Club Centenary Exhibition*, Christie's, London, 1986, no. 88).

186 THE OLD PLUMBAGO WORKS
c.1900
oil on canvas, 18 x 14 in / 45.7 x 35.6 cm
JEREMY CADDY

Roussel, his pupil Paul Maitland and their mentor James McNeill Whistler, painted this subject on many occasions. In Whistler's nocturnes it is often merely indicated as a lighted clock tower. In Whistler's eyes these same industrial buildings became *'campanili'* and 'palaces'. While their treatment by Roussel and Maitland tends to be more prosaic, it nevertheless attempts a subtler observation through river fog, rather than at night. Roussel took the opportunity afforded by the scene for the notation of a series of calm greys and blues.

187 THE 'CRÉCY' AT FOWEY (ill. p.185)
1911
oil on canvas, 20½ x 24 in / 52 x 61 cm
inscribed bottom right, Theodore Roussel
THE UNIVERSITY OF HULL ART COLLECTION

This vigorous sketch was produced on Roussel's visit to Fowey in 1911. A closely related etching, *Boats Asleep, Fowey*, adopts similar lateral divisions of the rectangle.

John Singer Sargent 1856-1925

Sargent was born in Florence in 1856, the son of an American émigré doctor. His youth was spent travelling in Europe and he enrolled, at the age of eighteen, in the newly opened teaching atelier of Carolus-Duran in Paris. He achieved success at the Salon in 1878 with *Oyster Gatherers of Cancale*. Unlike many British and American contemporaries, however, Sargent did not remain in Brittany, but for the next four years travelled extensively. In 1882 *El Jaleo* was hailed enthusiastically by critics on both sides of the channel. His glory was somewhat dulled in 1884 when *Mme X* (Mme Pierre Gautreau) created a scandal at the Salon. Sargent was obliged to take a studio in London, the city which was to become his home for the rest of his life. He did not achieve instant success in London and it was only in 1893, with the portrait of *Lady Agnew*, that he found acceptance with a London clientèle. From then until the end of 1906 Sargent was constantly engaged in portrait painting, producing some of his most celebrated images. These included the portraits of the Wertheimer family, Sir Frank Swettenham and the Marlborough family. In 1907 however, Sargent consciously decided to refuse portrait commissions and concentrate more upon landscape. Most summers up to

the First World War were spent on the Continent painting *en plein air*. He also completed a suite of murals for Boston Public Library in 1916. He was despatched to Northern France as an Official War Artist in 1918 and produced studies for his monumental war picture, *Gassed*. The last year of his life was spent painting murals for Boston Museum of Fine Arts.

William Howe Downes, *John Singer Sargent: His Life and Work*, 1926.
Hon. Evan Charteris, *John Sargent*, 1927.
Richard Ormond, *John Singer Sargent*, 1970.
James Lomax and Richard Ormond, *John Singer Sargent and the Edwardian Age*, catalogue of an exhibition at Leeds City Art Galleries, 1979.
Carter Ratcliff, *John Singer Sargent*, 1982.
Stanley Olson, Warren Adelson and Richard Ormond, *Sargent at Broadway, The Impressionist Years*, 1986.
Patricia Hills ed., *John Singer Sargent*, catalogue of an exhibition at the Whitney Museum, New York, 1987.

188 **GARDEN STUDY OF THE VICKERS' CHILDREN** (ill. p.44)
c.1884
canvas, 54³/₆ x 35⁷/₈ / 137 x 91.4 cm
FLINT INSTITUTE OF ARTS, FLINT, MICHIGAN, GIFT OF THE VIOLA E. BRAY CHARITABLE TRUST

Exhibitions
1959 San Francisco, California Palace of the Legion of Honour, *Sargent and Boldini* (4).
1979 Leeds City Art Galleries, *John Singer Sargent and*

the Edwardian Age (21).

1987 *John Singer Sargent*, Whitney Museum, New
York (unnumbered).

References

Olson, Adelson and Ormond, 1986, p.38 (illus. plate IX).
Ratcliff, 1982, p.89 (illus. p.99).
Hills ed., 1987, p.112.

This study is an obvious precedent for *Carnation, Lily,
Lily, Rose* and was produced at the beginning of summer
in 1884. The setting is the garden of Mr and Mrs Vickers
at Petworth in Sussex. The Vickers family were important
patrons of Sargent and he painted their portraits on
numerous occasions. Here the two children, Vincent and
Dorothy, stand side by side watering the tall white lilies
which surround and almost overshadow them. An
element of mystery enters into the work, engendered in
part by the symbolism of the lilies, with their suggestions
of purity and innocence. As one writer has suggested this
work, though handled with a spontaneity approaching
Impressionism, retains a decorative quality and a
sentiment which has its roots in Pre-Raphaelitism.

189 **HOME FIELDS** (ill. p.43)
1885
oil on canvas, 28 x 38 in / 73 x 96.5 cm
inscribed bottom left, to my friend, Frank Bramley
THE DETROIT INSTITUTE OF ART, CITY OF DETROIT
PURCHASE

References

Downes, 1926, p.138.
Ratcliff, 1982, p.98 (illus.).
Olson, Adelson and Ormond, 1986, p.39 (illus. plate
XIII).
Hills ed., 1987, p.117 (illus.).

Home Fields is a sketch painted late in the afternoon,
out of doors in the fields around the artist's colony at
Broadway in Worcestershire, where Sargent visited his
American friends, the painters Edwin Austin Abbey and
Frank Millet. Its loose handling, with the rapid and very
boldly applied dabs and strokes of colour describing the
line of the dilapidated fence and the old barn, would
have rendered the work Impressionist to contemporary
viewers. In the context of his oeuvre this picture has the
same strength and vivacity of the plein-air work Sargent
had produced at Nice, on visits over the previous
two years.

190 **CARNATION, LILY, LILY, ROSE** (ill. frontispiece)
1885-86
oil on canvas, 68½ x 60½ in / 174 x 153.7 cm
inscribed top left, John S. Sargent
TRUSTEES OF THE TATE GALLERY, LONDON, PRESENTED
BY THE TRUSTEES OF THE CHANTREY BEQUEST, 1922

Exhibitions

1887 London, Royal Academy of Arts (359).
1917 Glasgow, Glasgow Institute of Fine Art.
1926 London, Royal Academy of Arts, *Winter
Exhibition* (47).
1976 Liverpool, Walker Art Gallery, *American Artists
in Europe* (61).

References

Charteris, 1927, pp.72-78, 84-85, 178-79, 282-83.
Downes, 1926, pp.140-41.
Ormond, 1970, pp.33-34.
Ratcliff, 1982, pp.100 (illus.), 107-10.
Richard Ormond, 'Carnation, Lily, Lily, Rose', in Olson,
Adelson and Ormond, 1986, pp.63-75.
William H. Gerdts, 'The Arch-Apostle of the
Dab-and-Spot School: John Singer Sargent as an
Impressionist' in Patricia Hills ed., 1987, pp.112-19.

Carnation, Lily, Lily, Rose was painted over a period of a
year in the garden of Farnham House at Broadway. Two
little girls in white dresses, Dorothy and Polly Barnard,
surrounded by a cluster of Chinese lanterns in the
evening light, form the centre of this composition which
took its title from the line of a popular song of the
period. To a British audience at the time, and to
particular contemporaries like Steer and the young
Roger Fry, Sargent's work appeared at first as a prime
example of Impressionism, as a revelation in colour and
as a synthesis of realism and decoration. With hindsight,
however, the degree of contrivance in its organization
and an element of conscious aestheticism set it apart
from classic Impressionism, despite its initial resem-
blance to Monet's garden scenes from the late 1870s.

191 **CLAUDE MONET PAINTING AT THE EDGE OF
A WOOD** (ill. p.45)
c.1887
canvas, 21¼ x 25½ in / 54 x 64.8 cm
TRUSTEES OF THE TATE GALLERY, LONDON,
PRESENTED BY MISS EMILY SARGENT AND MRS
ORMOND, THROUGH THE NATIONAL ART COLLECTIONS
FUND, 1925

Exhibition

1899 Boston, Copley Hall, as 'Sketch of Claude
Monet Painting' (72).

References

Ormond, 1970, p.41.
Ratcliff, 1982, p.122 (illus. 106, 120).
Olson, Adelson, and Ormond, 1986, p.46
(illus. plate II).
Hills ed., 1987, pp.119-21.
Kenneth McConkey, *British Impressionism*, 1989,
pp.10-11, 76.

It has been generally considered that Sargent produced
this painting of Monet and an unknown female figure,
possibly Suzanne Hoschedé, at Giverny in the late
summer of 1887. However, attempts to date the picture
by studying the canvas Monet is actually engaged upon
have placed it two or three years later. In many ways it is
a painting of homage, a study in an Impressionist
manner of the master of Impressionism at work. In
emulation of Monet, the paint has been laid down at
speed and with confidence, he adopts in places the
French painter's comma-like brushstrokes, and the
result stands as a record of Sargent's spontaneous
perceptions of the event and of the natural scene. *Claude
Monet painting at the Edge of a Wood* is one of the first of
Sargent's Impressionist pictures and shows some of his
early hesitancy in the presence of blacks in the shadows,
which he was initially reluctant to abandon.

192 **John Singer Sargent**
*A Lady and a Little Boy Asleep
in a Punt under the Willows*
1887

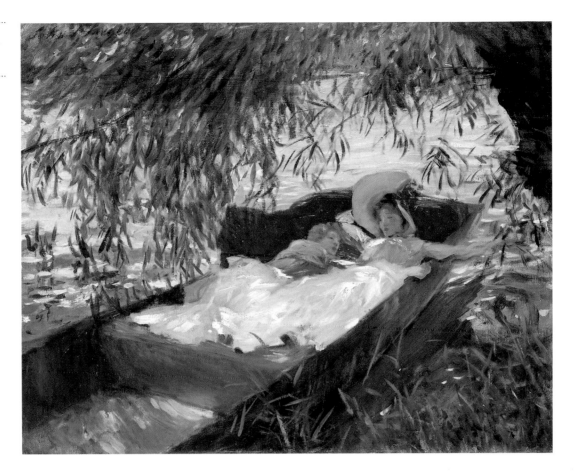

192 **A Lady and a Little Boy Asleep in a Punt under
the Willows** (ill. above)
1887
oil on canvas, 22 x 27 in / 55.9 x 68.6 cm
Calouste Gulbenkian Foundation, Lisbon

Reference
Olson, Adelson and Ormond, 1986, pp.45-46 (illus.).

This picture was painted at Henley-on-Thames during
the summer of 1887. At that time Sargent was staying
with the Harrisons of Shiplake Court whose son, Cecil,
had been painted by Sargent in 1886 (Southampton Art
Gallery). This picture shows Mrs Harrison and Cecil
dozing in the dappled sunlight under the willows. Just
comparisons have been made between this and Monet's
boating party pictures. The picture, taken with *A
Backwater at Henley* (Baltimore Museum of Art),
supports the thesis that Sargent, fresh from a visit to
Giverny, had been impressed by Monet's recent
canvases. The work has also been related to pictures
such as *St Martin's Summer*, which Sargent painted
about eighteen months later. Precedents might also be
found in the work of British contemporaries such as
E.J. Gregory, although this artist could not match
Sargent's freedom of handling.

193 **A Boating Party** (ill. p.47)
c.1889
canvas, 34⁵/₈ x 36¹/₈ in / 87.7 x 92.2 cm
Museum of Art, Rhode Island School of Design,

gift of Mrs Houghton P. Metcalf in memory of
her husband, Houghton P. Metcalf, 78-086

Exhibitions
1977 Providence, Rhode Island, *Selection VII:
 American Paintings from the Museum's
 Collection,* (83).
1979 London, Royal Academy of Arts, *Post-
 Impressionism,* 1979 (333).

References
Lomax and Ormond, 1979, pp.46-47.
Ratcliff, 1982, p.15 (illus.).
Hills ed., 1987, pp.128-29.
Olson, Adelson, and Ormond, 1986, pp.55 (illus.), 56.

A Boating Party depicts Sargent's friends Paul Helleu and
his wife Alice on the riverbank at Fladbury in Worcester-
shire, where he had taken the rectory for the summer.
Paul Helleu lolls in a canoe in the foreground, while
Sargent's sister Violet is near by and Alice carefully
threads her way carefully across the canoes at the back of
the picture. Sargent had produced several pictures of
boating previously, but with this work he most success-
fully combined expression of the atmosphere of a late
summer afternoon with strong suggestion of the
character of the three individuals.

194 **Dolce far Niente** (ill. p.75)
c.1909-10
canvas, 16⁵/₁₆ x 28⁵/₁₆ in / 41.4 x 72 cm,

Inscribed lower right, John S. Sargent
THE BROOKLYN MUSEUM, NEW YORK, BEQUEST OF
A. AUGUSTUS HEALY. 11.518

Exhibition
1909 London, New English Art Club, spring (63).

References
Downes, 1926, p.233.
Ormond, 1970, p.75.
Lomax and Ormond, 1979, p.99.
Ratcliff, 1982, p.18 (illus.).
Patricia Hills ed., 1987, p.186

Set on a tropical afternoon on a riverbank, *Dolce far Niente*
depicts an exotic, rather bizarre scene of three, apparently
Arab, veiled women, although the work was actually
painted on holiday in the Swiss Alps. Sargent's nieces,
who posed for the picture, are draped in cashmere shawls
and oriental clothing, and appear with three men either
reclining indolently on the grass or else engaged in a
game of chess. The chess game as a motif recurs once
more in a later picture, *The Chess Game*. In this work the
paint has been applied freely and the decorative colour
scheme is based on intense blues, yellows, greens and
white, which convey the effects of the intense sunlight.

Mark Senior 1862-1927

Senior came from Dewsbury and trained first at Wake-
field School of Art before moving to the Slade, where he
formed friendships with Tonks, Brown and especially
with Steer, whom he accompanied on a painting trip
to Walberswick in 1906. His own favourite site for
painting was at Runswick Bay, Yorkshire, where he spent
each summer, and it was as a painter of Yorkshire that
Senior developed his reputation. The earlier influence of
Clausen began to dissipate, and although he was still
regarded as possessing Clausen's poetic feeling for nature,
his technique increasingly reflected his interests in Steer,
Whistler and the Impressionists. Above all, Senior came
to be viewed as a colourist. A *Studio* critic in later years felt
that the broad treatment and rich impasto of works such
as *The Flemish Washhouse* meant that the artist should be
seen as 'one of the best colourists of the Flemish school'.
The same writer felt in 1917 that, unlike his friend Orpen,
Senior introduced no literary content into his pictures and
believed with Fromentin that *'la belle peinture est sans prix'*.
From 1892 to 1924 Senior showed at the Royal Academy,
but his best work was produced for particular patrons and
was to be seen only in private collections.

The Studio, vol. 69, 1917, pp.115-16.
Michael Parkin Fine Art Ltd., *Mark Senior 1862-1927, of
 Leeds and Runswick Bay and a few Friends,* 1974.
William Manwaring and Corinne Miller, *Mark Senior
 1862-1927,* catalogue of an exhibition at the Wakefield,
 Elizabethan Gallery, 1983.

195 **COMMERCIAL STREET, LEEDS** (ill. above)
c.1910
oil on canvas, 25 x 20 in / 63.5 x 50.8 cm
inscribed bottom left, M. Senior
LEEDS CITY ART GALLERIES

195 **Mark Senior**
Commercial Street, Leeds
c.1910

Exhibition
1974 London, Michael Parkin Fine Art Ltd., *Mark
 Senior 1862-1927,* (44).

Senior is more frequently cited for bright impression-
istic pictures of Staithes and Runswick Bay, favourite
haunts in which he consorted with fellow artists during
the early years of the new century. His work avoids
parochialism, however, in its technical sophistication.
At times Senior employs dense overlays of paint and
broken brushwork reminiscent of Lavery in his beach
scenes, while on other occasions, in interiors, he
appears under the sway of Clausen. *Commercial Street,
Leeds* in its spontaneity contains some of these attri-
butes. Although it represents a provincial thoroughfare,
it is comparable to the work of Edwardian London
Impressionists such as Oppenheimer and Blanche.

Walter Richard Sickert 1860-1942

Sickert spent his early childhood in Munich, the son of a
painter of Danish origin. His family moved to London in
1868. Initially he envisaged an acting career but, realiz-
ing that he could never excel on the stage, he at first
joined the Slade School of Fine Art, before becoming
Whistler's studio assistant. Whistler trusted him with the
important task of conveying *The Artist's Mother* to the
Paris Salon in 1883. There he met Degas and was shown
around Manet's studio. This was followed in the summer
of 1885 by a trip to Dieppe, in which he resumed his
Impressionist contacts. In 1888 he infiltrated the New
English Art Club and, with Steer, tried to exclude the
more conservative Newlyn painters. The following year
he emerged as one of the London Impressionists with a
series of music-hall interiors. During the 1890s Sickert
opened the first of his many art schools and recruited
Aubrey Beardsley as one of his pupils. He broke with
Whistler after his divorce and went to live in Dieppe, but

made regular visits to Venice and Paris. After his return to London in 1905 he retained his Parisian reputation, staging one-man exhibitions in the French capital in 1907 and 1909. By that stage he was acknowledged leader of the Camden Town Group, exhibiting at all three of its exhibitions between 1911 and 1913. He spent the war years in Bath, returning to his beloved Dieppe in 1919. He continued to exhibit in London at the Royal Society of British Artists and at the Royal Academy. At Orpen's instigation he was proposed as an ARA and was belatedly elected an RA in 1934, only to resign the following year in protest against the defacing of Epstein's statues on the facade of Rhodesia House. He died at Bathampton at the beginning of 1942.

Wendy Baron, *Sickert*, 1973.
Richard Shone, *Walter Sickert*, 1988.
Robert Emmons, *Life and Opinions of W.R. Sickert,* 1941.
Osbert Sitwell ed., *A Free House being the Writings of Walter Richard Sickert*, 1947.
Lilian Browse, *Sickert*, 1960.
Wendy Baron and Richard Shone, eds., *Walter Sickert, Paintings*, catalogue of an exhibition at the Royal Academy of Arts, London, 1993.

196 Queenie Lawrence on the Stage at Gatti's
c.1888
oil on canvas, 24 x 24 in / 61 x 61 cm
inscribed lower right, To Jacques Blanche/W. Sickert/ Gatti's Hungerford (The Arches)
lower centre, Queenie Lawrence/Tom Tinsley Chairman
Private Collection, courtesy of The Fine Art Society, London

References
Baron, 1973, pp.27-28.
Baron and Shone eds., 1993, p.70.

Sickert produced several versions of Katie and, here, Queenie Lawrence, on the stage at Gatti's music-hall,

near the Strand, in the late 1880s. This picture, dedicated to Jacques-Emile Blanche, was the result of numerous small, preparatory drawings made on visits to the theatre. Sickert's interest has been aroused as much by the architecture of the surrounding stage and the first few, near empty seats of the stalls, as by the performer herself, and in particular by the effects of light and shadow. As a result the work still reflects the thin, tonal qualities of Whistler's handling where the paint has been laid down in layers, wet on wet.

197 The Red Shop (ill. p.41)
c.1888
oil on board, 10½ x 14 in / 26.7 x 35.6 cm
Norfolk Museums Service, Norwich Castle Museum

Exhibitions
1889 Paris, Exposition Universelle, British Section (142).
1927 London, Royal Academy of Arts, as *St Valery-en-Caux* (544).

References
Baron, 1973, p.17.
Gruetzner, 1979, p.336.
Baron and Shone, eds., 1992, pp.72-73.

The Red Shop represents a charcuterie at St Valery-en-Caux, near Dieppe, where Sickert had begun regular visits in 1885. Sickert's pictures of shop fronts originated from his relationship with Whistler. Here the tonality of Whistler is still in evidence, but the application of the paint and the compositional organization reveal a shift in his interests from the *alla prima* method towards a more structured approach, developed from working drawings. Degas' influence is perhaps best indicated in this case by Sickert's later recollection of his advice, noted by Anna Gruetzner, that 'the art of painting was so to surround a patch of, say Venetian red, that it appeared to be a patch of vermilion' (Walter Richard Sickert, 'Degas', *Burlington Magazine*, vol. 21, November 1917, p.185).

198 Gatti's Hungerford Palace of Varieties, Second Turn of Miss Katie Lawrence (ill. p.91)
c.1903
oil on canvas, 15 x 18⅛ in / 38.1 x 26 cm
Yale University Art Gallery, New Haven, Mary Gertrude Abbey Fund

References
Baron, 1973, pp.27-28, 302.
Baron and Shone eds., 1993, pp.70-71.

The Yale *Gatti's Hungerford Palace ...* is a second, much later version of the picture painted from studies made during appearances by Katie Lawrence in 1887, and now in the Art Gallery of New South Wales. The figure on stage and those in the audience are much more clearly delineated than in the picture of Queenie Lawrence (cat 196). However, the symmetrical composition, with the artistes placed directly above the chairman, Tom Tinsley, is virtually the same. Sickert has obviously been more concerned here with a detailed arrangement of the composition, and as a result the paint has been applied more deliberately in stages and allowed to dry.

199 **Walter Richard Sickert**
The Theatre of the Young Artists, Dieppe 1890

199 **The Theatre of the Young Artists,
Dieppe** (ill. p.189)
1890
oil on board, 20¹/₂ x 25¹/₂ in / 52 x 65 cm
inscribed bottom left, Sickert-Dieppe-1890
Sefton M.B.C. Leisure Services Department, Arts
Services Section, The Atkinson Art Gallery,
Southport

References
Baron, 1973, p.39.
Anna Gruetzner Robins in Norma Broude ed., *World
Impressionism*, 1989, p.74 (illus.).

Painted in 1890 at the same time as *The Café des
Tribuneaux*, (Tate Gallery, London) this work still bears
witness to Whistler, with its thinly applied paint, its
overall lack of depth and its pervasive blue-grey tonality.
As in *Le Quatorze juillet*, the figures that throng outside
the theatre are suggested by mere strokes of the brush
and light stains of colour. Sickert maintains this treat-
ment throughout the whole picture and creates an
entirely balanced composition.

200 **Nocturne, The Dogana and Santa Maria
della Salute** (ill. right)
1895
oil on canvas, 19¹/₂ x 25⁷/₈ in / 49 x 66 cm
inscribed bottom right, Sickert
Richard Nagy, Dover Street Gallery, London

References
Baron, 1973, p.47.
Kenneth McConkey, *British Impressionism*, 1989, p.106
(illus.).

It is quite possible that on his way to Venice in 1895
Sickert may have seen Durand-Ruel's Paris exhibition
of twenty of Monet's pictures of Rouen cathedral. On
arrival in Venice, he himself demonstrated an interest in
painting in series, with several versions of the *Facade of*

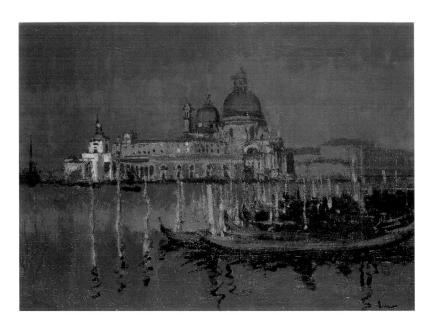

St Marks cathedral and three versions of *The Dogana and
Santa Maria della Salute*. Two of these were nocturnes.
Unlike Monet, who was concerned primarily to study
the shifting sunlight on the architectural facade, Sickert
was engaged in an attempt to see the thing all at once.
He worked freely, at speed and 'with a full brush and
full colour'.

201 **l'Hôtel Royal, Dieppe** (ill. p.53)
c.1900-01
oil on canvas, 18¹/₄ x 21³/₄ in / 46.3 x 55.2 cm
inscribed bottom right, Sickert
Ferens Art Gallery, Hull City Museums, Art
Galleries and Archives

Exhibitions
1967 Arts Council (touring exhibition), *Decade
 1890-1900* (38).
1968 Hull University, *Sickert in the North* (9).
1989 Nottingham, Castle Museum, *British
 Impressionism* (35).

References
Emmons, 1941, p.113.
Lillian Browse ed. with an essay by R. H. Wilenski,
 Sickert, 1943, p.40.
Baron, 1973, pp.80, 318, no. 110, (illus.).

In 1893-94 Sickert produced a number of pictures of the
Hotel Royal, Dieppe, in which its flat facade is seen as a
backdrop. At the end of the decade he produced a
further series of drawings and paintings which show the
same hotel prior to its demolition, viewed from the side.
These are more atmospheric than the earlier series and
they incorporate a flower bed which, Baron surmises,
must have been painted between the two series. The flag
poles which appear in one of the earlier versions have
been removed.

202 **Gaîté Rochechouart** (ill. left)
1906
oil on canvas, 24 x 19¹/₂ in / 61 x 49.5 cm

200 **Walter Richard Sickert**
*Nocturne, The Dogana and
Santa Maria della Salute* 1895

202 **Walter Richard Sickert**
Gaité Rochechouard 1906

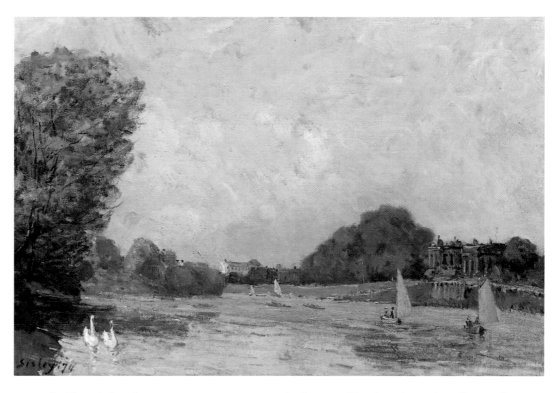

inscribed lower left, Sickert
CITY OF ABERDEEN ART GALLERY AND MUSEUMS
COLLECTIONS

References
Baron, 1973, p.96.
Baron and Shone eds., 1993, pp.188-89.

Sickert produced two views of the stage at the *Gaîté Rochechouart* in 1906. In this version the stage is reflected in a mirror behind the occupants of the box, a device possibly derived from Manet. The second version, in which a trapeze artiste is viewed from behind the spectators, creates a vertical asymmetrical arrangement which refers directly to Degas' *Mlle La La at the Cirque Fernando*. In both these works Sickert has been influenced by the French artists' method of presenting apparently incidental glimpses of a scene, which thereby create complex and tightly integrated compositions.

Alfred Sisley 1839-1899

Sisley was born in France but was of English ancestry. In 1856 he came to this country, ostensibly to begin a career in business. Having decided upon painting, however, he returned to France and attended the Ecole des Beaux-Arts in 1862, at which point he came into contact with Renoir and Monet. He was represented at the Salon des Réfusés in 1863. In 1871 the outbreak of the Franco-Prussian War prompted a stay in England and he returned again three years later, when he painted at various sites around London, including Hampton Court. That same year, Sisley was included in the first Impressionist Exhibition and he showed in several of the later ones. Of all the Impressionists, his art perhaps came closest to Monet's in that he too was primarily concerned with pure

landscape, and he adopted a similar technique of open hatchwork using a highly keyed palette. Of the French painters, Sisley was possibly one source of particular interest to Steer during his impressionist phase in the late 1880s, and Steer could have seen his work at exhibitions of the International Society.

Richard Shone, *Alfred Sisley*, 1992.
MaryAnne Stevens ed., *Alfred Sisley*, catalogue of an exhibition at the Royal Academy of Arts, 1993.

203 MOLESEY WEIR, NEAR HAMPTON COURT (ill. p.17)
1874
oil on canvas, 20¼ x 27 in / 51.5 x 68.9 cm
inscribed bottom left, Sisley 74
NATIONAL GALLERY OF SCOTLAND, EDINBURGH

References.
Shone, 1992, pp.67-70.
Stevens ed., 1992, pp.138-39.

204 HAMPTON COURT (ill. above)
1874
oil on canvas, 14¹⁵/₁₆ x 21¹³/₁₆ in / 37.9 x 55.4 cm
inscribed lower left, Sisley. 74
STERLING AND FRANCINE CLARK ART INSTITUTE,
WILLIAMSTOWN, MASSACHUSETTS

Sisley made his second visit to London shortly after the first Impressionist Exhibition closed. On this occasion he spent several months at Hampton Court and the area around East Molesey, staying possibly at the Castle Inn. He produced a number of fresh and spontaneous canvases which Kenneth Clark later described as 'a perfect moment of Impressionism' (Shone, p.34). In these works he was preoccupied with river activity – particularly at bridges and weirs. For a brief period Hampton Court and its environs became Sisley's Argenteuil.

205 **La Falaise à Penarth, le soir, marée basse** (ill. p.78)
1897
oil on canvas, 21¹/₂ x 25¹/₄ in / 54.4 x 65.7 cm
inscribed bottom right, Sisley, 97
National Museum of Wales, Cardiff

Sisley returned to England in July 1897 with the financial support of his patron, François Depeaux. He was accompanied by his common law wife of thirty years standing, Eugénie Lescouezec, whom he married in Cardiff Register Office on 5 August. Sisley and his wife lodged at a boarding house in Penarth during their stay. A number of views of the Bristol Channel painted looking east in the direction of Cardiff Bay and west, as in the present case, along the coast towards Sully Island. These works demonstrate Sisley's interest in breaking the continuity of the picture surface by using choppy strokes for the texture of grass on the dunes, smeared paint for the reaches of the channel and a drier broken brushwork for the handling of the sky.

Sidney Starr 1857-1925

Starr came from Hull. He trained at the Slade School under Poynter and then Legros, winning a Slade scholarship in 1874. In 1882 he began to exhibit at the Royal Academy. That same year he also met Whistler and became one of his circle of admirers, although his allegiances were to shift towards Degas when Sickert introduced him to the French painter's work around 1888. By 1886 Starr had deserted the Royal Academy in favour of the New English Art Club. Like several members of that group, notably Stott and his friend Clausen, he soon began to show interest in the medium of pastel, which underwent a considerable revival in the late 1880s. Out of this revival came the Grosvenor Gallery's decision to hold annual pastel exhibitions from 1888. Starr showed only at the first of these, but the following year his large *Paddington Station* was exhibited at the Exposition Universelle, where it received a bronze medal. During this period, his subject matter and technique mirrored quite closely the concerns expressed in Sickert's introduction to the London Impressionist exhibition. Some scandal in 1892 led to Starr's decision to go to America and he settled in New York, becoming a member of the New York Watercolour Club. He remained in New York until his death and carried out several commissions for murals, including decorations for the Grace Chapel and twenty-four figures in the Congressional Library in Washington. A memorial exhibition at the Goupil Gallery in 1926 consisted mostly of landscapes and studies of atmospheric effects.

Anna Gruetzner, *Post Impressionism*, catalogue of an exhibition at the Royal Academy of Arts, London, 1979, pp.344-45.

206 The Convalescent
1887
pastel, 12 x 10¹/₈ in / 30.5 x 25.6 cm
Sheffield City Art Galleries

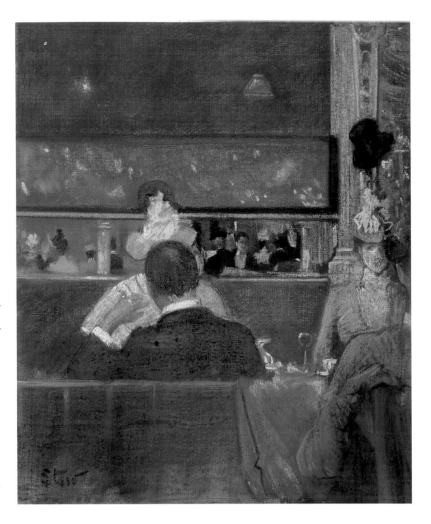

207 **Sidney Starr**
At the Café Royal 1888

In common with the other artists of his circle, Sidney Starr developed an interest in the use of pastel in the late 1880s, probably as a direct result of seeing the work of Degas.

207 At the Café Royal (ill. above)
1888
pastel on canvas, 24 x 20 in / 61 x 50.8 cm
inscribed bottom left, Starr
Private Collection, courtesy of The Fine Art Society, London

Exhibitions
1888 London, Grosvenor Gallery, first Pastel
 Exhibition (159).
1979 London, Royal Academy of Arts,
 Post-Impressionism (343).

Reference
Anna Gruetzner Robins in Norma Broude ed., *World Impressionism*, 1990, p.76(illus.).

At the Café Royal, was exhibited at the first Grosvenor Gallery pastel exhibition, after which Starr declined to show, believing that the bulk of the exhibitors there simply used pastel as they would oil paint. As Anna Gruetzner points out, there is a strong similarity here

between Starr's depiction of the assembled crowd and the treatment of music-hall subjects by Walter Sickert.

208 THE CITY ATLAS (ill p. 86)
1889
oil on canvas, 24 x 20 in / 61 x 50.8 cm
inscribed bottom right, Starr
NATIONAL GALLERY OF CANADA, OTTAWA, GIFT OF THE
MASSEY COLLECTION OF ENGLISH PAINTING, 1946

Exhibitions
1889 London, Goupil Gallery, *London Impressionists* (6).
1979 London, Royal Academy of Arts, *Post-Impressionism* (344).

References
Kenneth McConkey, *British Impressionism*, 1989, p.89 (illus.).
Anna Gruetzner Robins in Norma Broude ed., *World Impressionism*, 1990, p.77 (illus.).
Anna Gruetzner, *Post-Impressionism*, catalogue of an exhibition at the Royal Academy of Arts, London, 1979, p.211.

With this work Starr joined a group of artists, which included Mortimer Menpes, who developed the habit of travelling around London on the top of omnibuses in order to depict the bustling metropolitan life. Sickert had similarly worked from the cab man's seat on top of a hanson cab to record *The Burning of the Japanese Exhibition in Knightsbridge* in 1885. 'City Atlas' was the name of the horse-drawn omnibus from which Starr takes his viewpoint. Surveying the activity on the road at evening from behind a woman on top deck, recalls Degas and Edmund Duranty's belief that, painted accurately, a back view should be as capable of revealing age and social position as a portrait. Gruetzner Robins has suggested that the young woman is in fact a servant girl, since she occupies one of the cheaper seats on the top deck. Working on

a red ground, Starr applies oil paint in a manner which gives the appearance of pastel.

Philip Wilson Steer 1860-1942

Steer was born in Birkenhead where his father, also Philip, was a painter. He studied under John Kemp at Gloucester School of Art from 1878 to 1880, then spent the following year at the South Kensington Drawing Schools. From 1882 to 1883, he was registered at the Académie Julian under Bouguereau, and he proceeded to the Ecole des Beaux-Arts in 1883, where he spent a year under Cabanel. The introduction of a French language examination at the Ecole precipitated Steer's return to England the following summer, and he then began the first of his many painting expeditions to Walberswick in Suffolk. Initially the paintings he produced there, such as *Girl at the Well*, reflected the influence of Bastien-Lepage, but in Steer's case this was a short-lived interest. He was a founder-member of the New English Art Club in 1886, and during the next eight years he experimented with various types of Impressionism, gravitating from Whistler to Monet and almost to *pointillisme*. In spite of his radical posture, he was appointed to the Slade as one of Brown's assistants in 1893. Throughout these years, up to his first one-man exhibition at the Goupil Gallery in 1894, Steer was consistently attacked by the more conservative art critics. Yet increasingly, with controversial works such as *Boulogne Sands*, he gained support from more enlightened individuals like his friends D.S. MacColl and George Moore, who were then writing in such journals as *The Spectator* and *The Saturday Review*. By the mid 1890s, he had modified his style considerably in what may be seen as the search for a kind of romantic arcadianism. This led him, during the early years of the new century, to revisit the countryside of his youth in places like Ludlow and Chepstow. Painting expeditions like these extended to sites such as Richmond in Yorkshire, and were also a conscious following in the footsteps of Turner; Steer often carried a copy of the *Liber Studiorum* in his pocket on those occasions. During these years he found greater popularity with a once hostile audience and was frequently spoken of as a successor to Constable. In the period leading up to the First World War he exhibited large impressive landscapes at the New English Art Club which illustrate his desire to revitalize the English tradition. In 1918 he was appointed Official War Artist and he produced a number of watercolours of the manoeuvres of the British Fleet. A series of one-man exhibitions were held throughout the inter-war period, as watercolour came to be his preferred medium. He retired from the Slade in 1930 and was awarded the Order of Merit the following year.

Robin Ironside, *Wilson Steer*, 1943.
D.S.MacColl, *The Life and Work and Setting of Philip Wilson Steer*, 1945.
Andrew Forge, *Philip Wilson Steer*, catalogue of an Arts Council exhibition, 1960.
Bruce Laughton, *Philip Wilson Steer, 1860-1942*, 1971.
Jane Munro, *Philip Wilson Steer: Paintings, Watercolours and Drawings*, catalogue of an Arts Council exhibition, 1985.
Ysanne Holt, *Philip Wilson Steer*, 1993.

209 **Philip Wilson Steer**
Boats on the Beach, Southwold
c.1888-89

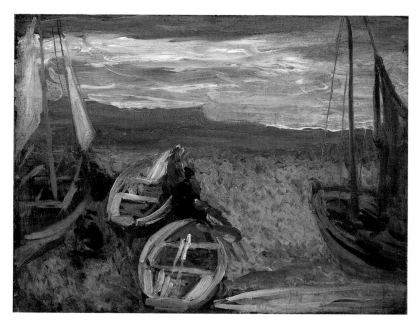

209 BOATS ON THE BEACH, SOUTHWOLD (ill p.193)
c.1888-89
oil on panel, 8 x 10¹/₄ in / 20.3 x 27.3 cm
inscribed lower left, P.W.S.
YORK CITY ART GALLERY, PRESENTED BY THE VERY
REVEREND ERIC MILNER-WHITE, DEAN OF YORK

Reference
Laughton, 1971, p.129.

Prior to 1894 Steer executed a number of small panel
sketches, like this one, which display the varied
techniques of contemporary larger works such as
Knucklebones. Although these were intended as nothing
more than rapid sketches, they nevertheless reveal an
extraordinary confidence and lucidity. Figures are
blobbed in, the sea is smeared in creamy horizontal
strokes and the sea and stones are stippled, in this work
and in others produced on the beaches of Southwold
and Boulogne. With these small oil panels Steer was
exploring the possible relations between sensation and
expression. They constitute a spontaneous and direct
record of his initial perceptions of a scene. At the same
time he would make quick sketchbook studies and write
down brief comments about colour and tone.

210 KNUCKLEBONES, WALBERSWICK (ill. p.28)
1888-89
oil on canvas, 24¹/₈ x 30¹/₈ in / 61 x 76.2 cm
inscribed bottom left, P.W. Steer
IPSWICH BOROUGH MUSEUMS AND GALLERIES

Exhibitions
1889 London, Goupil Gallery, *London Impressionists*
 (35).
1974 London, Royal Academy of Arts, *Impressionism*
 (133).
1979 London, Royal Academy of Arts,
 Post-Impressionism (346).
1985 Cambridge, Fitzwilliam Museum, *Philip Wilson
 Steer, 1860-1942* (8).

References
MacColl, 1945, p.37.
Laughton, 1971, pp.17-19.
Walter Richard Sickert, *The Whirlwind*, 12 July 1890.

One of the eight Steers to be shown in the London
Impressionists exhibition, *Knucklebones*, a study of a
group of children playing unselfconsciously on a beach,
proved problematic even for his most supportive critic,
D.S. MacColl. Painted on a visit to Walberswick with
Fred Brown, the artist's constant exploration of
technique revealed here not only a sophisticated under-
standing of Monet, but also what appeared to be an
experiment in the neo-Impressionist technique of
Seurat. MacColl attempted to refute this probability and
to view the broken texture of the handling of the shingle
as more likely a 'pre-raphaelite (sic) rendering of the
pebbles'. For Sickert, however, the unconventional
viewpoint and the spontaneous grouping of the figures
implied not just Monet's influence, but more particu-
larly the influence of Degas.

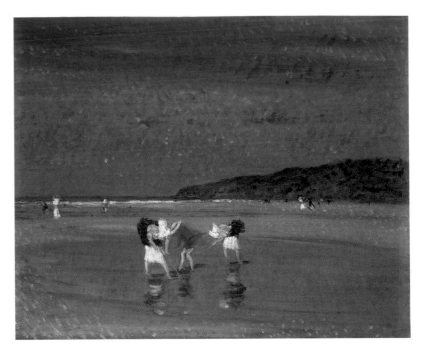

211 SOUTHWOLD
c.1889
oil on canvas, 20 x 24 in / 50.8 x 61 cm
TRUSTEES OF THE TATE GALLERY, LONDON,
PURCHASED 1942

Exhibition
1943 London, National Gallery, *Memorial Exhibition*
 (65).

Reference
Laughton, 1971, pp.16-17.

This picture of a yacht race bears several stylistic
similarities to *Summer at Cowes*, 1888. Nevertheless,
through a study of sketchbooks, it has been identified as
a Southwold painting of the same period. The fact that
Steer himself chose never to exhibit the work supports
the idea that this was a particularly courageous experi-
ment in the rapid brushstrokes and the brilliant Impres-
sionism with which he was concerned in the late 1880s.
It was with often less daring works than this one that
Steer, with Sickert, was felt to be responsible for the
notoriety of the N.E.A.C. at this time. A critic writing in
The Graphic a year later, (1889, p.702) commented that
Steer's 'Monet-inspired canvases reflect the most objec-
tionable peculiarities of the same painter's method'.

212 BOULOGNE SANDS: CHILDREN SHRIMPING (ill. above)
1891
oil on canvas, 18³/₄ x 22¹/₂ in / 47.6 x 57.1 cm
FERENS ART GALLERY, HULL CITY MUSEUMS, ART
GALLERIES AND ARCHIVES

Exhibitions
1910 Manchester, Royal Institution, Annual
 Exhibition.
1951 Birkenhead, Williamson Art Gallery,
 Wilson Steer (4).

212 **Philip Wilson Steer**
*Boulogne Sands: Children
Shrimping* 1891

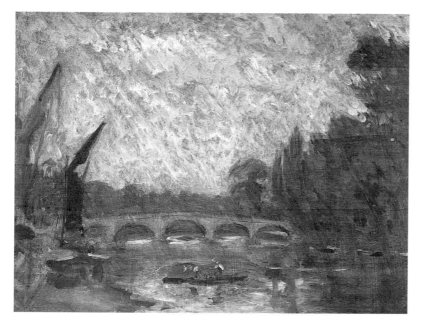

214 **THE THAMES AT RICHMOND** (ill. left)
c.1893
oil on panel, 8¼ x 10¾ in / 21 x 27.3 cm
AGNEW'S

This picture effectively signalled the beginnings of a fundamental change in Steer's paintings of landscape. A view of Richmond Bridge depicted in thin, muted tones, *A Classic Landscape, Richmond,* is reminiscent of the extreme atmospheric effects of some of Monet's Argenteuil paintings of the 1870s. But beyond this there is, in the setting and in the breadth of the work, a clear shift in interest to much earlier sources. There are indications of Claude and of landscape painting from the beginning of the nineteenth century, of Turner. In this respect Steer was seen to be returning to the very sources of Impressionism, and implicitly confirming the importance of an English tradition, at one and the same time. *The Thames at Richmond* seems likely to be the study from which *A Classic Landscape, Richmond* was painted.

215 **A PROCESSION OF YACHTS, COWES** (ill. p.55)
c.1892-93
canvas, 25 x 30 in / 63.5 x 76.2 cm
inscribed bottom left, Steer '93
TRUSTEES OF THE TATE GALLERY, LONDON, PURCHASED 1922

Exhibitions
1892 London, New English Art Club winter (96).
1894 London, Goupil Gallery, *Steer* (15).
1929 London, Tate Gallery, as *Yachts.*

References
MacColl, 1945, p.37.
Laughton, 1971, pp.29, 55.
Holt, 1993, p.56.

By 1892 Steer had completely assimilated the methods of neo-Impressionism. It is unclear whether he saw Seurat's pictures at the second exhibition of Les XX, where he himself showed, or if he saw his works at the Salon des Indépendants in Paris in 1891. In any case, acquaintance with Lucien Pissarro certainly encouraged his researches into systematic colour division. Steer spent the whole of the summer of 1892 at Cowes, where the position of the promenade allowed for a close observation of the yachts and provided a perfect setting for paintings reminiscent of Seurat's harbour scenes. Although in other works painted on the same visit, such as *Yachts lying off Cowes – Evening,* the influence appears to have been from Whistler. Steer would have seen the exhibition of Whistler's *Nocturnes, Marines and Chevalet Pieces* at the Goupil Gallery the previous March. In *A Procession of Yachts, Cowes,* however, the colour is clearly divided if rather thickly applied. MacColl seems to have overcome his objections to Steer's dabbling with the 'ridiculous shower of dots' here and, striking a musical analogy, equated the passage of masts to the 'phrasing between intervals of bars'.

216 **CHILDREN PADDLING, WALBERSWICK** (ill. p.56)
c.1889-94
oil on canvas, 25¼ x 36⅛ in / 64.8 x 92.7 cm
inscribed lower left, Steer '94
LENT BY THE SYNDICS OF THE FITZWILLIAM MUSEUM, CAMBRIDGE

1966 Arts Council Touring Exhibition, *Decade 1890-1900* (43).
1986 London, Christie's, *New English Art Club Centenary Exhibition* (30).

Reference
Laughton, 1971, pp.26-27.

Bought at an early stage by Augustus Daniel, this work was not shown during Steer's most controversial period. It belongs to a group of vivid studies of children playing on the beaches of northern France, which Steer visited on several occasions at this time. His preoccupation remained the representation of bright noonday sunlight, and his handling echoes both Monet and Seurat. Complementary colours have been applied with small vertical brushstrokes across most areas of the canvas, except where the lighter, summarily drawn figures of the three children make a stark contrast with the blue of the sky. General reaction to the work, had it been exhibited, would inevitably have been poor. Related pictures by Steer of this period were typically viewed as crude and eccentric travesties of nature.

213 **A CLASSIC LANDSCAPE, RICHMOND** (ill. p.58)
c.1893
oil on canvas, 24 x 30 in / 61 x 76.2 cm
inscribed bottom right, Steer '93
CHRIS BEETLES LTD., ST JAMES'S, LONDON

Exhibitions
1894 London, Goupil Gallery, *Steer* (28).
1943 London, National Gallery, as *Landscape with River and Bridge* (41).
1989 Cologne, Wallraf-Richartz Museum, *Landschaft im Licht* (189).

References
MacColl, 1945, p.48.
Laughton, 1971, pp.30, 56-57.
Holt, 1993, p.79.

Principal Exhibitions

1894 London, Goupil Gallery, *Steer as Children Paddling* (11).

1925 London, New English Art Club, *Retrospective* (125).

1967 Arts Council, *Decade 1890-1900* (42).

1974 London, Royal Academy of Arts, *Impressionism* (134).

1985 Cambridge, Fitzwilliam Musem, *Philip Wilson Steer, 1860-1942* (11).

References

Laughton, 1971, pp.27-28.
MacColl, 1945, p.185.

The subject matter here relates closely to that of the Boulogne pictures. Although not exhibited until 1894, it has been suggested that its varied handling and signs of reworking would date it from the late 1880s. The broken colour and the treatment of the shingle beach on the left are close to *Knucklebones*, and the paddling children have several equivalents in works such as *The Ermine Sea* of 1887. In all, this picture amounts to a summation of Steer's recollections of scenes of childhood innocence. A carefree vision, but with an atmospheric resonance. In 1892, George Moore described the vivacity and the optimistic quality of a similar painting, *Children paddling, Etaples*, 1887, as presenting a 'happy sensation of daylight', where the little children are 'conscious only of the benedictive influence of the sand and sea', (George Moore, 'Mr Steer's Exhibition', *Modern Painting*, 1898, pp.242-43).

217 **GIRLS RUNNING, WALBERSWICK PIER** (ill. p.57)
c.1888-94
oil on canvas, 25 x 36½ in / 69.2 x 92.7 cm
inscribed lower right, Steer 94
TRUSTEES OF THE TATE GALLERY, LONDON, PRESENTED BY LADY AUGUSTUS DANIEL, 1951

Principal Exhibitions

1894 London, Goupil Gallery, *Steer* (37).

1985 Cambridge, Fitzwilliam Museum, *Philip Wilson Steer, 1860-1942* (10).

1989 Nottingham, Castle Museum, *British Impressionism* (46).

Principal References

MacColl, 1945, pp.49, 155.
Laughton, 1971, pp.21-22, 28, 131.
Kenneth McConkey, *British Impressionism*, 1989, p.18 (illus.).

An extended dating may be proposed for *Girls running, Walberwick Pier* since notes for the figures appear in a sketchbook of c.1888-89. As with a number of Steer's major canvases shown at his Goupil Gallery exhibition of 1894, the present picture appears to have been reworked over a number of years. It incorporates a range of the most recent technical advances, including a knowledge of complementary colour contrasts, particularly visible in the painting of shadows. The most striking aspect of the picture is, however, its extraordinary composition and this has been commented upon by many writers. The two central figures, ranged parallel to the plane of the picture, appear like floating presences. Their weightlessnes, coupled with the colour intensity of their surroundings, have suggested a visionary intensity beyond that of the literal circumstances in which they are placed.

218 **LUDLOW WALKS** (ill. p.77)
1898
oil on canvas, 21 x 26 in / 53.3 x 66 cm
inscribed bottom right, P.W. Steer
SOUTHAMPTON CITY ART GALLERY

Exhibitions

London, Royal Academy of Arts, winter 1961 (227).
London, Arts Council, *Decade*, 1967 (48).

References

Laughton, 1971, p.83.
Holt, 1993, p.98.

By the mid 1890s Steer had begun his summer visits in search of the quintessential English landscape, often with a copy of Turner's *Liber Studiorum* in his pocket. Expeditions to sites in Yorkshire and along the Welsh borders were the result. His perceptions of those landscapes embodied the spirit of nostalgia and retrospection that informed so much of his work. That allusive quality found particular expression in his group of paintings of Ludlow in Shropshire, which began with this picture and continued until 1906-09, often worked from the same vantage point. This was in effect a return to the countryside of his own youth. In this imaginary scene of children playing, a variety of treatments and sources are in evidence which underscore his constant exploration of technique. In low-toned works such as this a range of influences from Turner to Corot and Constable reveal themselves, and it was this eclecticism which, in later years, unfairly led to accusations that he was simply a pasticheur.

219 **Philip Wilson Steer**
The River Teme, Evening near Ludlow 1906

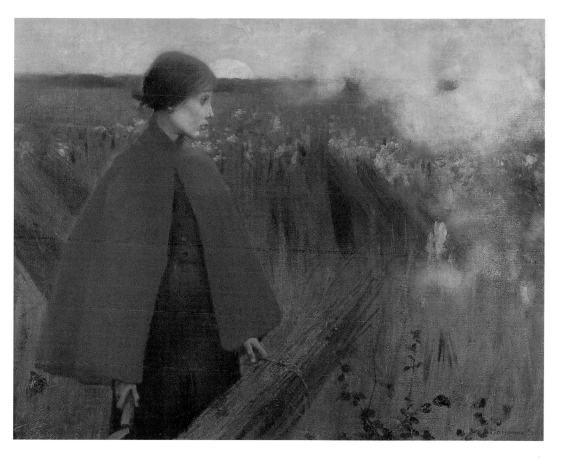

219 **THE RIVER TEME, EVENING NEAR LUDLOW** (ill. p.196)
1906
oil on canvas, 30 x 40 in / 76.2 x 101.6 cm
DUNDEE ART GALLERIES AND MUSEUMS

References
MacColl, 1945, p.208.
Laughton, 1971, p.145.

Two versions of the present work exist, both the same
size. That in the Tate Gallery appears less hazy than the
Dundee picture. Both display Steer's proto-Expressionist
manner, in which masses of paint are manipulated to
become mountains and foliage. By this stage the dogma
of Impressionism had completely disappeared from
his work and what remained was a more instinctive
approach, in line with his temperament.

Marianne Stokes 1855-1927

Marianne Preindlsberger grew up in Southern Australia.
Her training as an artist began in Munich under the
painter Lindenschmidt, and her talent was recognized early
on when she received a gold medal at Munich's most
important exhibition, the Glas Palast. She then travelled to
France, staying in Paris until about 1883 and earning an
honourable mention at the Salon of the following year.
While in France she married Adrian Stokes and for a time
she and her husband were pupils of Dagnan-Bouveret.
After their arrival in London in 1856, Marianne Stokes
exhibited regularly at the Royal Academy, Suffolk Street,
and several other venues. She painted a variety of subjects,
ranging from biblical themes to studies of children. The
latter were characterized by their lively, spontaneous
atmosphere, their unusual compositions and their overall
decorative quality. Stokes often worked in gesso and
tempera, which gave her work the appearance of fresco
and created similarities with works by Birmingham
painters such as Arthur Gaskin and Joseph Southall.

Harriet Ford, 'The Work of Mrs Adrian Stokes', *The
Studio*, vol. 19, 1900, pp.149-56.
Wilfred Meynell, 'Mr and Mrs Adrian Stokes', *The Art
Journal*, 1900, pp.193-98.
Alice Meynell, 'Mrs Adrian Stokes', *The Magazine of Art*,
1901, pp.241-46.

220 **THE PASSING TRAIN** (ill. above)
c.1890
oil on canvas, 24 x 30 in / 61 x 76.2 cm
inscribed bottom right, Marianne Stokes
PRIVATE COLLECTION

Exhibition
1971 London, Fine Art Society, *Aspects of Victorian Art*
(159).

Reference
Harriet Ford, 1900, p.155.

The Passing Train is one of the most extraordinary pic-
tures produced by Stokes prior to her conversion to Pre-
Raphaelitism. It takes the modern theme of the railway
and combines it with that of the fieldworker. Salon pain-

ters such as Georges Ferré had recently made this connection between the rural rhythms of sowing and harvest and modernity exemplified in the train. Stokes, through her contact with Dagnan-Bouveret, remained *au fait* with developments in the Salon. The young woman in this instance is, however, more than a reworking of Bastien-Lepage. Her red cape and detached appearance already suggest the direction which Stokes was soon to take.

Edward Stott 1859-1918

Stott was born in Rochdale and attended the nearby Manchester School of Art. He continued his training in Paris from 1880, enrolling first at the studio of Carolus-Duran and then, from 1882 to 1884, at the Ecole des Beaux-Arts under Cabanel, where Steer was one of his contemporaries. By the time he returned to England his work showed the considerable influence of Bastien-Lepage. He had seen the French painter's *Jeanne d'Arc* at the Salon in 1880, and his style continued to be informed by Bastien's work until the mid-1890s. From 1883 he began to show at the Royal Academy, and he was a founder-member of the New English Art Club in 1886. On several occasions he went on painting expeditions with Walter Osborne, and in 1889 he made the decision to abandon urban life altogether by settling at Amberley in Sussex, which became his own rural idyll. The extent of his close identification with his new environment gradually effected a change in the style of his work. The influence of Millet's biblical subjects increasingly came to bear on Stott's representations of the locals around Amberley. Although he retained his concern for the accurate rendering of

atmospheric effects, he increasingly worked from memory rather than directly in front of the motif. His technique of painting in small brushstrokes meant that some works of his later years appear to have been influenced by *pointillisme*. Stott was elected ARA in 1906.

Peyton Skipwith, *William Stott of Oldham and Edward Stott ARA*, catalogue of an exhibition at The Fine Art Society, London, 1976.
James Stanley Little, 'On the Work of Edward Stott', *The Studio*, vol. 6, 1895, pp.71-83.
A.C.R. Carter, 'Edward Stott and his Work', *The Art Journal*, 1899, pp.294-98.
Laurence Housman, 'Mr Edward Stott, Painter of the Field and of the Twilight', *The Magazine of Art*, 1900, pp.529-36.
Marion Hepworth Dixon, 'Edward Stott, An Appreciation', *The Studio*, vol. 55, 1912, pp.3-9.

221 THE HIGH GRASSES (ill. above)
1883
oil on canvas, 38 x 52 in / 96.5 x 132.1 cm
inscribed bottom right, Edward Stott, 1883
PRIVATE COLLECTION, USA, COURTESY OF THE FINE
ART SOCIETY, LONDON

Exhibition
1884 (?)Paris, Salon, as *Les Hautes Herbes* (2245).

A single figure surrounded by dense foliage in a kitchen garden became a compositional archetype for Edward Stott. Having studied the work of Bastien-Lepage he adopted standard plein-air naturalist practices, altering his handling from section to section within the picture.

Such a work might be compared with those of John Lavery and William Stott of Oldham, both of whom managed spatial transitions in a similar way. It is also closely related to a smaller picture entitled *A French Kitchen Garden* (Sheffield City Art Galleries), in which the grasses of the present work are replaced by cabbages.

222 THE COMPLETE ANGLER (ill. below)
1885
oil on canvas, 28 x 27 in / 71.1 x 68.6 cm
inscribed bottom left, Edward Stott
PRIVATE COLLECTION, COURTESY OF THE FINE ART SOCIETY, LONDON

Exhibition
1885 (?) London, Institute of Painters in Oil Colours.

With *The Complete Angler* Stott began to move away from the more mechanical aspects of plein-air painting and to adopt the more densely worked surfaces which characterize his later work. The motif of the country boy, seen in full-length, confronting the spectator had been treated by Bastien-Lepage in pictures such as *Pas Mèche* in which a homemade whip rests on the right shoulder, just like the fishing rod in *The Complete Angler*. Stott's contemporaries Clausen, Forbes and La Thangue painted similar figures and he too returned to a similar compositional format in later work.

223 ON A SUMMER AFTERNOON
1892
oil on canvas, 22 x 28 in / 55.9 x 71.1 cm
inscribed
PRIVATE COLLECTION, COURTESY OF THE FINE ART SOCIETY, LONDON

222 **Edward Stott**
The Complete Angler 1885

Exhibitions
1892 London, New English Art Club, spring (54).
1976 Oldham Art Gallery, Rochdale Art Gallery and The Fine Art Society, London, *William Stott of Oldham and Edward Stott ARA* (50).

Since the mid 1880s, when Alexander Harrison's *In Arcady* was shown at the Salon and the New English Art Club, the theme of bathers had consistently attracted British artists. By the early 1890s, when Stott was working away from the motif from oil studies and drawings, he was ready to tackle this somewhat more conceptual theme. He was not immune to the sort of criticism which had greeted Henry Scott Tuke when he exercized his preference for the depiction of male bathers. In this instance, as in *Noonday*, 1895 (Manchester City Art Gallery), the figures are country children innocently sporting themselves in a woodland glade. As if to answer critics Stott produced a similar work containing female bathers, *A Summer Idyll*, for the New Gallery in 1897.

224 BOYS BATHING, AMBERLEY WILDBROOKS
c.1892
oil on canvas, 11 x 13 in / 27.9 x 33 cm
inscribed lower left, Edward Stott
PRIVATE COLLECTION

This oil sketch has a similar compositional format and palette to *On a Summer Afternoon*. Its freedom of handling and vivid juxtapositions of colour typify Stott's work in his most thoroughly Impressionist period

William Stott of Oldham 1857-1900

William Stott studied first in Manchester. He travelled to Paris in 1879, where he trained at the Ecole des Beaux-Arts, under Gérôme and Bonnat. His summers were spent at Grez-sur-Loing, which had been recommended to him by his friend R.A.M. Stevenson and where he found himself among large numbers of British and American students. Frank O'Meara, who was also staying at Grez, was a particular influence on Stott at this time. Stott achieved considerable success with two works painted there, *The Ferry* and *The Bathers*. These two pictures earned him a third class medal at the Salon in 1882 and as a result he won the regard of a number of French critics. On his return to England he established a friendship with Whistler and in 1885 he was elected a member of the Royal Society of British Artists. The following year his large painting of *A Summer's Day* was exhibited there; its handling and the careful distribution of the three figures rendered it a work sympathetic to Whistler's own aesthetic. Friendship with Whistler cooled significantly, however, when Stott produced a nude portrait of Whistler's mistress as *Venus Born of the Sea Foam*. In 1890 he became a member of the New English Art Club.

Peyton Skipwith, *William Stott of Oldham and Edward Stott ARA*, catalogue of an exhibition at The Fine Art Society, London 1976.
Alice Corkran, 'William Stott of Oldham', *The Scottish Art Review*, 1889, pp.319-25.

R.A.M. Stevenson, 'William Stott of Oldham', *The Studio*, vol. 4, October 1894, pp.10-11.
'S', 'William Stott of Oldham', *The Magazine of Art*, 1902, pp.81-82.

225 THE QUIET POOL – STUDY FOR 'THE BATHERS'
c.1882
oil on canvas, 19½ x 28¼ in / 49.5 x 73 cm
PRIVATE COLLECTION, COURTESY OF THE FINE ART SOCIETY, LONDON

Exhibition
1976 Oldham Art Gallery, Rochdale Art Gallery and The Fine Art Society, London, *William Stott of Oldham and Edward Stott ARA*, 1976 (5).

The Quiet Pool was painted at Grez-sur-Loing in 1881 and has always been thought to be a study of the setting for Stott's major work for the Salon of 1882. Although apparently an unremarkable landscape, the picture is imbued with a poetic intensity which clings to the work produced at Grez. Stott altered the rood lines of the buildings and various other details between this and the final picture.

226 A SUMMER'S DAY (ill. p.35)
1886
oil on canvas, 52½ x 74½ in / 132.9 x 189.2 cm
inscribed bottom right, William Stott of Oldham
MANCHESTER CITY ART GALLERIES

Exhibitions
1886 London, Society of British Artists, winter (245).
1912 Manchester, Royal Institution, *Annual Exhibition* (110).
1976 Oldham, Rochdale and The Fine Art Society, London, *William Stott of Oldham and Edward Stott ARA*, (10).

Reference
Kenneth McConkey, *British Impressionism*, 1989, p.81 (illus.).

It is an indication of the importance he attached to being in the Whistler group that Stott of Oldham chose to exhibit *A Summer's Day* at the Society of British Artists and not at the Salon or the Academy. To some extent the broad simplicity of the work, its unmodulated stretch of sandy beach and cloudless sky, alluded to the abstract values which Whistler advocated. However, the picture was also a riposte to Alexander Harrison's *Bords de Mer* which had appeared at the Salon of 1885, which also depicted a group of carefully modelled boy bathers.

227 HOLLYHOCKS
c.1890
oil on canvas, 48 x 30 in / 121.9 x 76.2 cm
inscribed
OLDHAM ART GALLERY

Exhibitions
1912 Manchester (92).
1976 Oldham, Rochdale and The Fine Art Society, London, *William Stott of Oldham and Edward Stott ARA* (12).

Like Marianne Stokes, Stott of Oldham was to be drawn away from plein-air naturalism into Symbolism in the 1890s. Around the beginning of the decade he produced a number of pictures of densely foliated gardens in which the figure, as in the present instance, was almost submerged.

229 **Arthur Haythorne Studd**
Venetian Twilight c.1910

Arthur Haythorne Studd 1864-1919

Studd was born at Hallerton Hall in Leicestershire. Between 1889 and 1891, he studied at the Slade School under Legros, and he then moved to Paris where he attended the Académie Julian. In 1890 Studd was staying at Le Pouldu with a group of young American and British painters, including his friends Alfred Thornton and Hugh Bellingham-Smith. Thornton recounts how Studd at this time abandoned the top hat and frock coat of his London

228 **Arthur Haythorne Studd**
Washing Day c.1894

231 **Frank Meadow Sutcliffe**
The Rake's Progress c.1886

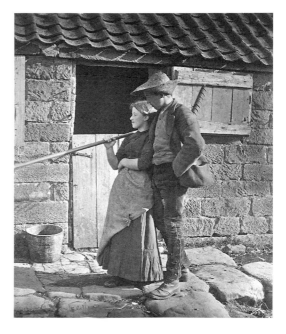

days and began to wipe his palette knife clean on his trousers. On this occasion he encountered Gauguin, under whose influence he travelled to Samoa and Tahiti in 1898. On his return to England from France he lived in Chelsea, where he was influenced in his work by his new friendship with Whistler. Two noteworthy exhibitions of his work were held, one at the Baillie Gallery in 1906 and the other at the Alpine Gallery in about 1925. Studd died in London.

Anthony D'Offay Gallery, *The English Friends of Paul Gauguin*, catalogue of an exhibition, 1966.
Alfred Thornton, *Diary of an Art Student of the Nineties*, 1938.

> 228 **WASHING DAY** (ill. p.200)
> c.1894
> oil on panel, 8½ x 6¼ in / 21.6 x 15.9 cm
> YORK CITY ART GALLERY, PRESENTED BY THE VERY REVEREND ERIC MILNER-WHITE, DEAN OF YORK

As a collector and follower of the work of Whistler, Studd produced numerous tiny *pochades* during the final decade of the century. These were invariably produced on the motif, and are characterized by the deft handling associated with his master.

> 229 **VENETIAN TWILIGHT** (ill. p.200)
> c.1910
> oil on panel, 5 x 8½ in / 12.7 x 21.6 cm
> YORK CITY ART GALLERY, PRESENTED BY THE VERY REVEREND ERIC MILNER-WHITE, DEAN OF YORK

Frank Meadow Sutcliffe 1853-1941

In his early years Sutcliffe worked as a portrait photographer in his native Whitby. As an off-season sideline he began to take pictures of local scenes and characters, with the result that he was at one time referred to as 'the pictorial Boswell of Whitby'. He developed a naturalist aesthetic, preferring to photograph his subjects unposed. To achieve his ideal he worked at all hours and in all conditions, employing a variety of different techniques for individual circumstances or desired effects. Sutcliffe wrote a good deal for professional periodicals and for the local press. In 1900 he issued a Statement in the *Linked Ring Papers*, in which he attacked those critics who tried to impose specific standards on the photographer, effectively making them reluctant to print works which might be considered under-exposed or wrongly developed.

Michael Hiley, *Frank Sutcliffe, photographer of Whitby*, 1974

> 230 **WATER RATS** (ill. left)
> 1885/86
> carbon print, 9 x 12 in / 22.9 x 30.5 cm
> THE ROYAL PHOTOGRAPHIC SOCIETY, BATH, GIFT OF IRENE SUTCLIFFE, 1941

Water Rats is one of the most frequently reproduced photographic images of the nineteenth century. It is impossible not to see it in the context of paintings of the period such as Stott of Oldham's *The Bathers*, 1882, and the numerous other treatments of the theme. What distinguishes *Water Rats*, however, is the busy estuary setting.

> 231 **THE RAKE'S PROGRESS** (ill. above)
> c.1886
> carbon print, 11½ x 9½ in / 29.2 x 24.1 cm
> THE ROYAL PHOTOGRAPHIC SOCIETY, BATH, GIFT OF IRENE SUTCLIFFE, 1941

In *The Rake's Progress* Sutcliffe again comes close to the painters of the period. His work draws upon a theme familiar to painters of peasant subjects from Millet onwards.

230 **Frank Meadow Sutcliffe**
Water Rats 1885/86

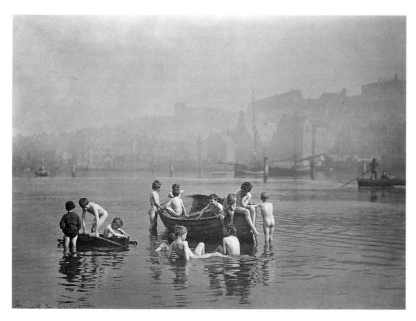

Algernon Talmage 1871-1939

Talmage came from Fifield in Oxfordshire. He studied first at Herkomer's Academy at Bushey, Surrey and then at St Ives, Cornwall. With Julius Olsson, he established the Cornish School of Landscape, Figure and Sea Painting at St Ives, and he lived there until 1907 when he moved to London. For the most part he painted plein-air landscapes and pastoral subjects in a restrained form of Impressionism. In 1909 Talmage held his first solo exhibition at the Goupil Gallery. He received substantial critical acclaim abroad, winning silver and bronze medals at Pittsburgh International Exhibitions and a gold medal at the 1922 Paris Salon. Critics in this country praised his work, which one found to be impressionistic in the best sense, unlike 'Impressionism' which the writer felt was better described as 'inarticulate occultism'. During the First World War, Talmage was employed as an Official War Artist by the Canadian Government. In the late 1920s he turned increasingly to etching at a time when that medium was undergoing a particular revival. The same year as his Salon success he was elected an ARA and he became an RA in 1929. He died at Ramsey in Hampshire.

A.G. Folliott Stokes, 'The Landscape Painting of Mr Algernon M. Talmage', *The Studio*, vol. 42, 1908, pp.188-93.
A.G. Folliott Stokes, 'Mr Algernon Talmage's London Pictures', *The Studio*, vol. 46, 1909, pp.23-30.

232 **THE PILLARS OF ST MARTINS** (ill. p.63)
1907
oil on canvas, 17 x 24 in / 43.1 x 61 cm
INSCRIBED BOTTOM RIGHT, A. TALMAGE 07
PRIVATE COLLECTION

In 1908 *The Studio* reported upon a new departure in Talmage's work. Previously familiar to Royal Academy visitors as a landscape painter, he had now turned to London scenes. These were, moreover, painted in a radical style, using a modified form of *pointillisme*. Talmage, like Hacker and Arnesby Brown was looking for a modern method with which to represent the modern metropolis. Throughout his experiments legibility remained an important factor.

George Thomson 1860-1939

Born in Towie in Aberdeenshire, Thomson began his career as an architect. He then trained at the Royal Academy Schools and exhibited at Royal Academy exhibitions from 1886, although he showed most consistently at the New English Art Club, of which he became a member in 1891. From 1895 to 1914 he taught at the Slade School, and his work reflects typical Slade concerns with both Spanish painting and Monet. After this time he went to live at Samer, Pas-de-Calais. Thomson developed a reputation for paintings of architecture and townscapes, although he produced landscapes as well and also wrote art criticism. In later years he established a particular interest in early Italian painting techniques. He died in Boulogne in 1939.

233 **ST PAUL'S** (ill. below)
c.1897
oil on canvas, 25 x 30 in / 63.5 x 76.2 cm
inscribed
TRUSTEES OF THE TATE GALLERY, LONDON,
PURCHASED 1920

Exhibition
1898 London, New English Art Club, spring (85).

Reference
'Art in 1898', *The Studio*, p.91.

Only in his architectural subjects did Thomson step out from under the shadow of Steer. *St Paul's* was, for instance, dispatched to the New English along with a picture described as a modern life subject, *The Toilet*, showing a young woman in her boudoir. It was a reprise of Steer's earlier *Japanese Gown* sequence of 1894-95. The originality of the powerful *St Paul's*, however, lay in its avoidance of the stylistic traits of others. As such it was regarded as 'sound' and 'unaffected'.

Alfred Henry Robinson Thornton 1863-1939

Born in Delhi, Thornton was educated at Harrow and Trinity College, Cambridge. In 1888 he trained at the Slade School under Legros. The following year, however, he was encouraged to go to France by Arthur Studd who was staying at Le Pouldu in Brittany. While there Thornton enjoyed a bohemian existence and developed his interests in the art of Monet and Manet. On returning to England he progressed to the Westminster School of Art, where he continued his training under Fred Brown. Thornton was a successful student, winning

233 **George Thomson**
St. Paul's c.1897

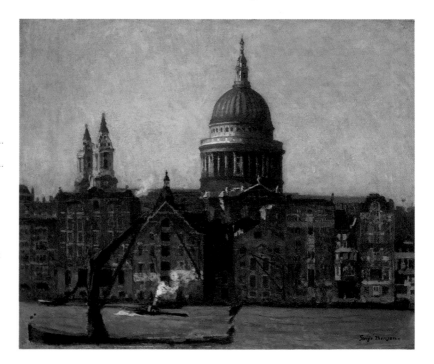

234 **Alfred Henry Robinson Thornton**
The Hayfield 1937

the New English Art Club, although he continued in the medical profession for another year, working as Demonstrator in Anatomy at the London Medical School. In 1892, however, Fred Brown was appointed Slade Professor and Tonks accepted his invitation to become Assistant Professor. From that point he entered the circle of Steer and Sargent and developed what amounted to a religious fervour for the importance of art and the need for sound instruction. As a result he evolved a formidable reputation as a drawing master and became famous for his withering criticisms and his ability to intimidate his students. In 1895 he was elected a member of the New English, and he found critical support from D.S. MacColl and George Moore, and a patron in A.M. Daniel. He painted landscapes on holiday expeditions with Steer, and in France with D.S. MacColl. His favourite subjects were perhaps his refined and often rather sentimental interior genre studies. With these, he reflected the taste for eighteenth-century Rococo painting which was also evident in Steer's work for a while in the 1890s. In 1905 he held his first solo exhibition, at the Carfax Gallery. At the time of Roger Fry's two Post-Impressionist exhibitions Tonks was remembered for his insistence that Slade students should stay clear of the ruinous effects of the influences of Cézanne and Matisse. As with MacColl, his critical appreciation of French painting extended no further than the art of Manet and Degas. During the First World War he returned to his medical background, helping in a Red Cross Hospital near the Marne and recording cases of plastic surgery. In 1918 he succeeded Brown as Slade Professor, a post he remained in until 1930. He declined an offer of a knighthood.

Henry Tonks, 'Notes from Wander Years', *Art Work*, vol. 15, no. 17, Winter 1929.
Joseph Hone, *The Life of Henry Tonks*, 1939.
Lynda Morris, *Henry Tonks and the Art of Pure Drawing*, catalogue of an exhibition at Norwich School of Art Gallery, 1985.

 235 **THE HAT SHOP** (ill. p.61)
1892
canvas, 26½ x 36½ in / 87.3 x 92.7 cm
inscribed bottom left, H.T. 1892
BIRMINGHAM MUSEUMS AND ART GALLERY

The Hat Shop is reminiscent of the *modiste* studies of Degas from the early 1880s, and reveals a similarity of approach in the handling of space and the relationships between figures and setting. A comparison with Degas' *The Rehearsal* is particularly apposite here. Tonks borrows Degas' *mise en scène*, using daylight filtered through muslin curtains to illuminate the shop interior. Unlike Degas' studies of hat sellers, however, which were mostly vividly coloured in pastel, this work is more of a study in tone. It reveals Tonks' fastidiousness which some critics, R.A.M. Stevenson in particular, found at times 'overly tasteful'. For D.S. MacColl, Tonks' vast knowledge about all the theories of picture making meant that his works often amounted to 'a little epitome of painting, a history of taste'.

 236 **SLEEPLESS NIGHT** (ill. p.204)
c.1898
oil on panel, 12¼ x 16 in / 32.4 x 40.6 cm
inscribed lower right, H.T.
COLLECTION MR AND MRS MALCOLM WALKER

prizes for landscape painting, and he stayed on when his training was complete to act as teaching assistant to Walter Sickert in the winter of 1893. In 1895 he became a member of the New English Art Club. He remained loyal to the Club for many years, becoming its Honorary Secretary from 1928 and later publishing an account of its first half century. He also became a member of the London Group in 1924. His involvement with these groups was conducted at a distance, however, as from 1908 he lived in Bath, and, later, Painswick in Gloucestershire. In 1938 Thornton published his personal reminiscences of his early student days.

Alfred Thornton, *The Diary of an Art Student of the Nineties*, 1938.
Alfred Thornton, *Fifty Years of the New English Art Club, 1886-1935*, 1935.

 234 **THE HAYFIELD** (ill. above)
1937
ink on paper, 9½ x 13½ in / 24.1 x 34.3 cm
inscribed, Thornton
TULLIE HOUSE, CITY MUSEUM AND ART GALLERY, CARLISLE

At the New English in the 1890s, Thornton exhibited pictures of the val de Seine, such as one painted at La Roche Guyon, in 1895 with Roger Fry. In later years he worked in Italy and in the area around Bath.

Henry Tonks 1862-1937

Henry Tonks' father was a foundry owner from Solihull, near Birmingham. After attendance at Clifton School in Bristol, Tonks had by 1880 begun medical studies in Brighton, which he continued at the London Hospital. In 1888 he was appointed Senior Medical Officer at the Royal Free Hospital. A visit to the Dresden Gallery had encouraged an interest in painting, and he enrolled at part-time classes at the Westminster Art School under Fred Brown. From 1891 Tonks exhibited consistently at

At the end of the 1890s Tonks produced a number of interiors including figures reclining on chaises-longues. These are among his most dynamic pictures, in that they draw their technique in part from Steer but also from Sargent. Tonks espoused the sketch aesthetic. He was *au fait* with the relevant Old Masters, such as Velázquez, but he also harboured an interest in English narrative genre painting of the 1860s which he communicated to his pupils and followers at the Slade.

Henri de Toulouse-Lautrec 1864-1901

Toulouse-Lautrec was born to an aristocratic family near Albi in south-west France. Having suffered severe damage to his legs as a child, he began painting watercolours while recovering from various medical treatments in the mid-1870s. In 1882 he started his training in Paris at the atelier of the painter Princeteau. Moving on, he enrolled next with Bonnat who did not admire his work, and finally at the Atelier Cormon, where his contemporaries were Louis Anquetin and Emile Bernard. By 1883-84, Lautrec was writing exhibition reviews, he had established his own studio in Montmartre and was gradually associated with the circle around Aristide Bruant's artistic cabaret 'Le Mirliton'. From now on it was an objective, but not necessarily a dispassionate, view of the café life and the prostitutes of the area that became his subject. These were not images to find favour at the Salon, to which he jokingly submitted a still-life of a camembert in 1886. That same year he came into contact with Van Gogh who, with a notable group of writers including Octave Mirbeau and Roger Marx, developed an increasing respect for his work by the later 1880s. In 1888 Lautrec was also included in the exhibition of Les XX in Belgium. His figure studies of the period reveal a progression from his short, criss-cross brushstrokes towards the more graphic style of his work of the early 1890s, and this was developed further in his poster designs for the Moulin Rouge and of Yvette Guilbert from around 1892. It was around this time that William Rothenstein, Conder and he developed their acquaintance, which had a marked influence on Conder's own choice of subject for a time. Lithography became an ever more important medium for Lautrec in the 1890s, resulting in the series of colour prints, *Elles*, published in 1896 and based on his observations of the women of the Paris brothels in which he lived. Alcoholism hampered his career as the decade progressed and, despite attempts at a cure, he died in 1901.

Hayward Gallery, London and Galéries Nationales du Grand Palais, Paris, *Toulouse-Lautrec*, catalogue of an exhibition, 1991.
H. Perruchot, *La Vie de Toulouse-Lautrec*, 1958.

237 **Portrait of Charles Conder** (ill. p.59)
1893
oil on canvas, 19¼ x 14⅞ in / 48.9 x 38.1 cm
inscribed lower left, Charles Conder, T-Lautrec 93
City of Aberdeen Art Gallery and Museums Collections

236 **Henry Tonks**
Sleepless Night c.1898

Exhibition
1991 London, Hayward Gallery and Grand Palais, Paris *Toulouse-Lautrec* (53).

The present work, a study of Charles Conder, relates to the role he plays in *Aux Ambassadors: gens chics*, an oil study which was illustrated in *Figaro Illustré* in 1893. It is a most incisive representation of the painter, even though he is not intended to be recognized as other than part of a fashionable couple at an open-air theatre.

Henry Scott Tuke 1858-1929

Tuke came from a devout Quaker family in York. His father, a doctor, suffered ill health and the family moved for a time to Falmouth. In 1875 Tuke enrolled at the Slade School, where he was a contemporary and friend of T.C. Gotch. Having finished his studies he travelled to Florence. There he was influenced briefly by the work of Arthur Lemon, and together they painted boys on the beach on the coast near Livorno. In Paris between 1881 and 1883, he attended the studio of J.P. Laurens and met Bastien-Lepage, later returning to England as one of his followers. By late 1883 Tuke had arrived in Newlyn, and he eventually settled in Falmouth. At this point he was producing works such as *Off to the Fishing Ground*, 1887, which came close to the style of pictures by his friend Stanhope Forbes. He was a founder-member of the New English Art Club, but in later years he showed increasingly at the Royal Academy. His many paintings of naked youths cavorting at the sea side earned him considerable notoriety, and his difficulties in finding local models meant that for a time he had to import a lad from London. This series culminated in his *August Blue*, 1894, which was nevertheless purchased via the Chantrey Bequest. By now Tuke had abandoned the grey tonality and the square brushes of the rustic naturalists and had been encouraged by a trip to the mediterranean two years earlier to adopt a much brighter palette and more fluid technique.

David Wainwright and Catherine Dinn, *Henry Scott Tuke: Under Canvas*, 1989.

Caroline Fox and Francis Greenacre, *Painting in Newlyn 1880-1930*, catalogue of an exhibition at the Barbican Art Gallery, London, 1985.

Maria Tuke Sainsbury, *Henry Scott Tuke – A Memoir*, 1933.

238 **THE PROMISE** (ill. above)
1888
oil on canvas, 22³/₈ x 26³/₈ in / 57.1 x 59.4 cm
inscribed H.S. Tuke, 1888
BOARD OF TRUSTEES OF THE NATIONAL MUSEUMS AND GALLERIES ON MERSEYSIDE: WALKER ART GALLERY

Exhibition

1888 London, New English Art Club (39).

In 1888 Tuke reinterpreted Clausen's *The Shepherdess* in terms of a tryst. Jack Rowling, his favourite model, posed for the boy and his sweetheart's sister, Jessie Nicholls, sat for the girl (Wainright and Dinn, p.41). As in other plein-air pictures there is a symbolism implied in the dense backdrop of foliage and blossom. In a world attuned to the poetry of Tennyson and the rose bowers of Burne-Jones, the activities of this rustic couple have more than ordinary significance.

239 **THE BATHERS** (ill. p.33)
1889
oil on canvas, 46 x 34 in / 116.8 x 86.4 cm
inscribed, H.S. Tuke
LEEDS CITY ART GALLERIES

Exhibition

1889 London, New English Art Club (33).

As a study of three nude boys bathing in full sunlight, the composition of *The Bathers* is clearly inspired by an earlier painting of the same title, that had been exhibited at the first New English exhibition. The apparent impropriety of this first, now unlocated work, is claimed to have caused Martin Colnaghi to withdraw promised support for the new venture. In the second work the setting has been changed from an outcrop of rocks in the sea to the deck of a fishing boat – probably the hulk, *Julie of Nantes,* which Tuke had recently acquired. However the naturalistic rather than pseudo-classical poses are similar to those in the earlier work, one back view, one upright and one crouching figure. The artist's real subjects here are the effects of brilliant sunshine and the play of light on the human form. As one writer later described, the work is an 'idyll of open air and warm light'.

240 **RUBY, GOLD AND MALACHITE** (ill. p.206)
1902
oil on canvas, 46 x 62¹/₂ in / 116.8 x 158.7 cm
inscribed and dated, H.S. Tuke
GUILDHALL ART GALLERY, CORPORATION OF LONDON

Exhibitions

1902 London, Royal Academy of Arts (739).
1985 London, Barbican Art Gallery, *Painting in Newlyn 1880-1930* (34).

A picture of local lads bathing on Newport beach, *Ruby, Gold and Malachite* was begun in the summer of 1901. It was purchased for the Guildhall in London by Hugh Lane from the Royal Academy exhibition of 1902. This work is symptomatic of Tuke's desire, stated in 1895, to 'paint the nude in the open air'. By the time it was painted the artist had broken his links with Newlyn and had abandoned the techniques associated with the painters around Stanhope Forbes. He had also travelled to the Mediterranean, bringing home a new attitude towards colour and the depiction of light, as well as a taste for Greek sculpture. These new interests had previously been clearly expressed in *August Blue*, shown at the Royal Academy in 1894, and in the disposition of the figures and the intensity of light reflected on forms, they reveal themselves here also.

Edward Arthur Walton 1860-1922

E.A. Walton came from Renfrewshire. He studied first at the Dusseldorf Academy and then at the Glasgow School of Art, where he met James Guthrie. In 1879 he painted with those who became the Glasgow Boys, Crawhall and

240 **Henry Scott Tuke**
Ruby, Gold and Malachite
1902

Guthrie, at Rosneath, and then from 1881 the same group, together with George Henry, painted at Brig O'Turk and Cockburnspath. Walton's work at that time followed a path typical of the Glasgow Boys as a whole, moving away from the influence of Bastien-Lepage and the Barbizon painters, towards that of Whistler. Works such as *The Daydream*, 1885, signal the end of his interest in naturalism. By the mid 1890s, Walton's new-found inspiration led him to leave Scotland and settle in Chelsea, where he was a neighbour of both Whistler and Lavery. By 1898 his involvement in Whistler's circle qualified him to take a leading role in the formation of the International Society. Although now based in London, he made several summer visits to Suffolk where he produced subtle landscapes in both oil and water-colour. At the turn of the century he was called back to Glasgow to execute a panel for the Corporation's Banqueting Hall and in 1904 he and his family returned to Scotland, living in Edinburgh. The following year Walton was elected RSA. He continued to travel, visiting Spain and Algiers with Guthrie and later working in Belgium. He was appointed President of the RSW in 1914, and shortly afterwards began a series of paintings of the countryside around Galloway.

James L. Caw, *Scottish Painting, Past and Present, 1620-1908*, 1908 (Kingsmead reprint 1975), pp.370-73.
Roger Billcliffe, *The Glasgow Boys*, 1985.

> 241 **JOSEPH CRAWHALL** (ill. left)
> 1884
> oil on canvas, 29 x 14¼ in / 73.7 x 36.2 cm
> inscribed upper right, Joe Crawhall/the Impressionist/ by E.A. Walton/the Realist/Madrid '84
> SCOTTISH NATIONAL PORTRAIT GALLERY, EDINBURGH

Reference
Billcliffe, 1985, p.125.

The inscription on this portrait, 'to Joe Crawhall the Impressionist by E.A. Walton the Realist', is an indication of the Glasgow artist's preoccupation with the

241 **Edward Arthur Walton**
Joseph Crawhall 1884

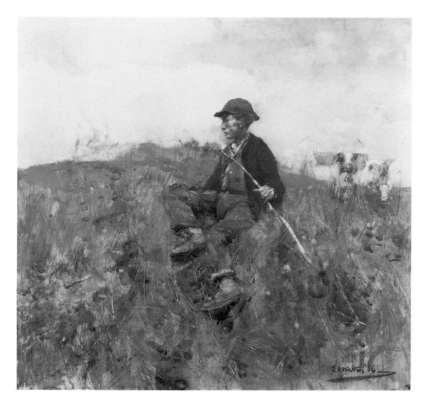

242 **Edward Arthur Walton**
The Herd Boy 1886

consorted with second generation realists like Legros and Fantin-Latour. He obtained notoriety when *Symphony in White, no. 1, The White Girl* was shown at the Salon des Réfusés in 1863, with Manet's *Déjeuner sur l'Herbe*. By that date Whistler had already moved to London and in the second half of the decade he devoted himself to developing a synthesis between classical subject matter and the art of Japan. Around 1870 he produced the first of his controversial nocturnes, one of which sparked off the lawsuit with Ruskin. A persistent polemicist, Whistler advocated the relationship between pictorial harmony and music, in a manner which challenged the Victorian art establishment. With *Arrangement in Grey and Black, no. 1, The Artist's Mother*, Whistler produced the first of a series of influential portraits which were very greatly admired by younger painters in Britain. Left bankrupt by the Ruskin trial, he was obliged to concentrate much more upon portraiture, and in the 1880s and 1890s a long series of important full-lengths were produced. During this period, the Whistler entourage in London grew, and aside from studio assistants like Walter Sickert and Mortimer Menpes it included a large following from the ranks of the Society of British Artists, of which he was President. In 1892 his retrospective at the Goupil Gallery brought him the critical favour in London which had long eluded him. In the last years of his life, as President of the International Society of Sculptors, Painters and Gravers, he was surrounded by a new group of followers who, like Lavery, had all been members of the Glasgow School.

debate on aesthetic issues. The extraordinary handling – painting in thick blocks of paint – tends to confirm this. As a student work dedicated by one painter to another it could afford to be daring. The degree to which it reveals an understanding of Impressionism and realism is interesting. Walton in 1884 was beginning to acquaint himself with Velázquez; he also may have seen the posthumous Manet exhibition in Paris,

> 242 **The Herd Boy** (ill. above)
> 1886
> watercolour on paper, 21 x 22½ in / 53.3 x 57.1 cm
> inscribed bottom right, E.A. Walton '86
> ANDREW MCINTOSH PATRICK

Reference
Billcliffe, 1985, p.132.

Many of Walton's watercolours of this period result from his summer visits to Cockburnspath, where Guthrie stayed. Typical of his style at this time, the works are tonal rather than brightly coloured,the handling is loose and sketchy and the paint is thinly applied. The suggestive rather than detailed observation of these watercolours was not always well received. Billcliffe cites one contemporary critic's condemnation of Walton's 'cheap cleverism' in his bid to suggest forms via a 'few daubs of paint' (p.127).

Elizabeth Robins and Joseph Pennell, *The Life of James McNeill Whistler*, 2 vols., 1908.
Andrew McLaren Young, M. MacDonald and H. Miles, *The Paintings of James McNeill Whistler*, 2 vols., 1980.

243 NOCTURNE IN BLUE AND GOLD: WESTMINSTER BRIDGE (ill. p.31)
c.1871

James McNeill Whistler 1834-1903

244 **James McNeill Whistler**
Sketch Portrait of Walter Sickert
c.1886

The son of a railway engineer, Whistler was born in Lowell, Massachussets. In 1855, attracted by the bohemian way of life, he went to Paris to become an art student. Although he registered at the atelier Gleyre he

oil on canvas, 18¹/₂ x 24¹/₂ in / 45.7 x 61 cm
Glasgow Museums: The Burrell Collection

Principal Exhibitions
1960 London, Arts Council and New York, Knoedler
 Galleries, *James McNeill Whistler* (28).
1977 Arts Council, *The Burrell Collection: 19th Century
 French Paintings*, as *Nocturne in Blue and Gold:
 Westminster Bridge* (42).

Principal References
Pennell, 1908, vol. 1, pp.199, 234.
MacLaren Young et al., 1980, vol.1, pp.88-89, no. 145.

Throughout the 1880s Impressionism in Britain tended
to be associated with Whistler, even though he would
not participate in the exhibitions of the group. His
radicalism was compounded for young artists by the
Ruskin trial, which focussed upon certain works in the
series of nocturnes produced during the 1870s. The
importance of a picture such as *Nocturne in Blue and
Gold: Westminster Bridge* lies in its insistence upon
abstact harmonies of colour and composition. Such
works fundamentally informed the early paintings of
Sickert, Roussel, Studd and Maitland.

> 244 **SKETCH PORTRAIT OF WALTER SICKERT** (ill. p.207)
> c.1886
> oil on canvas, 17¹/₂ x 13¹/₂ in / 44.5 x 34.3 cm
> HUGH MUNICIPAL GALLERY OF MODERN ART, DUBLIN

Exhibition
1960 London, Arts Council and New York, Knoedler
 Galleries, *James McNeill Whistler* (54).

Reference
McLaren Young et al., 1980, no. 350.

In a magnanimous gesture Sickert presented his portrait
by Whistler to the city of Dublin at the time of the form-
ation of the city's collection of Impressionist paintings
by Hugh Lane. The sketch dates from around 1886, at a
time when the sitter was attempting to reconcile his
conflicting allegiances to both Whistler and Degas. It is
an indication of Whistler's preliminary thoughts, which
might be scraped down and enhanced in subsequent
workings. Sickert in his later writings was critical of this
low-toned basis and described its effects upon the final
portrait as, in some cases, fatal. In this instance,
however, there is sufficient evidence of Sickert's
personality to convey his seriousness.

William Lionel Wyllie 1851-1931

245 **William Lionel Wyllie**
The Thames near Charing Cross
1892

Wyllie's childhood was spent in London. He trained first
at Heatherley's in 1865 and then at the Academy
Schools, where he achieved considerable success,
winning the Turner medal in 1869. He exhibited at the
Academy regularly from 1868. His great talent was as a
painter of marine subjects and seascapes, and for many
years after leaving the Academy he worked for the newly
established journal, *The Graphic*, providing drawings
like, for example, that of the sinking of *H.M.S Victoria*.

> 245 **THE THAMES NEAR CHARING CROSS** (ill. above)
> 1892
> oil on panel, 10¹/₂ x 13¹/₂ in / 26.7 x 34.3 cm
> inscribed bottom right, W.L. Wyllie 1892
> CITY OF NOTTINGHAM MUSEUM, CASTLE MUSEUM
> AND ART GALLERY

In the early 1890s, Wyllie was courted into the New
English Art Club. Although he had painted large marine
pictures for the Academy, it was as a London artist and
portrayer of industrial river scenes that he was favoured.
The delicate acuity of perception evident in *The Thames
near Charing Cross* was very much in accord with the
new directions at the Club.

Endnotes

Impressionism in Britain by Kenneth McConkey

Exiles and Art Schools

1. C.R. Leslie, RA, *Handbook for Young Painters*, 1854 (2nd ed. 1870), p.18. Augustus John, as a Slade student of the late 1890s, who spent his time in the galleries, found that he had loaded his 'mind with a confusion of ideas which a life-time hardly provides time to sort out', *Chiaroscuro*, 1954, p.25.

2. This was, of course, vastly different from Renaissance or seventeenth-century workshops. For reference to the Paris teaching ateliers see Albert Boime, *The Academy and French Painting in the Nineteenth Century*, 1971; see also, Jacques Lethève, *Daily Life of French Artists in the Nineteenth Century*, trans. Hilary E. Paddon, 1972.

3. See Bradford Museums and Art Galleries and Tyne and Wear County Council Museums, *Sir George Clausen RA, 1852-1944*, catalogue of an exhibition by Kenneth McConkey, 1980, no. 164 (a notebook containing notes on 40 lectures on the historical development of ornamental art from the Stone Age to the Renaissance by Dr G.G. Zerffi).

4. For George Clausen's lecture notebook see, Bradford Museums and Art Galleries and Tyne and Wear County Council Museums, *op.cit.*, no. 164. Studies of art history as an academic discipline in Britain have tended to neglect its primary purpose in the education of artists and designers.

5. For a fuller discussion of these issues see Christopher Frayling, *The Royal College of Art, One Hundred and Fifty Years of Art and Design*, 1987.

6. Quoted in The Hon. John Collier, *A Manual of Oil Painting*, 1891, (5th ed.) pp.51-54.

7. Edward Poynter, *Ten Lectures on Art*, 1880, p.107.

8. The Slade had been formed in 1871 as a consequence of the bequest of Felix Slade. From modest beginnings it grew to become London's principal art school and the only one which enjoyed a prestige equivalent to the Paris ateliers. For further reference see Charles Aitken, 'The Slade School of Fine Arts', *Apollo*, vol. 3, 1926, pp.1-13; Andrew Forge, 'The Slade', *Motif*, vol. 4, 1960, pp.29-43; Royal Academy of Arts, *The Slade, 1871-1971*, catalogue of an exhibition with introduction by Bruce Laughton, 1971; The Gallery, Brighton Polytechnic, *Made at the Slade*, catalogue of an exhibition by Julian Freeman, 1978. For discussions of the work of Legros, see W.E .Henley, 'Alphonse Legros', *The Art Journal*, 1881, pp.294-96; Arsène Alexandre, 'Alphonse Legros', *The Art Journal*, 1897, pp.105-08, 214-16; Sir Charles Holroyd and Thomas Okey, Alphonse Legros: Some Personal Reminiscences' *Burlington Magazine*, vol. XX, 1911, pp.273-76; Alexander Seltzer, 'Alphonse Legros: The Development of an Archaic Visual Vocabulary in Nineteenth-Century Art', Ph.D. thesis, State University of New York at Binghamton, 1980; Newcastle upon Tyne Polytechnic Art Gallery, *Peasantries*, catalogue of an exhibition by Kenneth McConkey, 1981; Musée des Beaux Arts, Dijon, *Alphonse Legros*, catalogue of an exhibition by Tim Wilcox, 1988.

9. Lecoq de Boisbaudran, *The Training of the Memory in Art and the Education of the Artist*, trans. L.D. Luard, with an introduction by Selwyn Image, 1911; for a modern appraisal of Lecoq's influence see Petra ten-Doesschate Chu, 'Lecoq de Boisbaudran and Memory Drawing, a Teaching Course between Idealism and Naturalism', in Gabriel P. Weisberg ed., *The European Realist Tradition*, 1983, pp.242-89.

10. For reference to this work see Gabriel P. Weisberg, *The Realist Tradition, French Painting and Drawing, 1830-1900*, Cleveland Museum of Art, 1980, pp.115-16; Dijon, *op.cit.*, 1988, no. 16; for reference to the British reception of the work see Newcastle upon Tyne Polytechnic Art Gallery, *op. cit.*, 1981, p.7.

11. For reference to the Edwards' patronage see National Gallery of Canada, Ottawa, *Fantin-Latour*, catalogue of an exhibition by Douglas Duick and Michel Hoog, 1983, pp.243-46; Wildenstein, New York, *From Realism to Symbolism, Whistler and his World*, catalogue of an exhibition, 1971, pp.87-88 [entries on Charles Keene].

12. Bradford Museums and Art Galleries and Tyne and Wear County Council Museums, *op.cit.*, pp.15-16.

13. *The Magazine of Art*, 1885, p.470.

14. Letters confirming this intention and reporting the hospitality of the 'excellent Edwards' were written to Zola and Fantin, see Galeries Nationales du Grand Palais, Paris and Metroplitan Museum of Art, New York, *Manet 1832-1883*, catalogue of an exhibition by Françoise Cachin and Charles S. Moffett, 1983, p.521.

15. For a full discussion of Camille Pissarro in London see John Rewald, *The History of Impressionism*, 1961 ed., pp.251-61; Arts Council of Great Britain, *The Impressionists in London*, catalogue of an exhibition by Alan Bowness and Anthea Callen, 1973; Martin Reid, 'Three Paintings of London of 1871: what do they represent?' *Burlington Magazine*, vol. CXIX, April 1977, pp.251-61; John House, 'New Material on Monet and Pissarro in London, 1870-71', Burlington Magazine, vol. CXX, 1978, pp.636-42; Ralph E. Shikes and Paula Harper, *Pissarro, His Life and Work*, 1980, pp.86-102; Martin Reid, 'The Pissarro Family in London: where did they live?' in Christopher Lloyd ed., *Studies on Camille Pissarro*, 1986, pp.55-64; Nicholas Reed, *Camille Pissarro at Crystal Palace*, 1987.

16. Arts Council of Great Britain, *op.cit.*, 1973, p.8.

17. John House, *op.cit.*, 1978, addresses these issues in a thorough examination of the evidence concerning this crucial visit. Although, for instance, there is visual evidence for suggesting a link between Monet and Whistler at this time, an idea long cherished by art historians, there is no documentary evidence.

18. John Rewald, *op.cit.*, p.261.

19. Ironically, in view of the circumstances of Durand-Ruel's flight to London, the rented gallery in New Bond Street was known as the German Gallery.

20. For further consideration of these exhibitions see Arts Council of Great Britain, *op.cit.*, 1973; For a discussion of Durand-Ruel's dealings with Impressionist painters at this time see Anne Distel, *Impressionism: the First Collectors*, 1990, pp.21-31.

21. John House, *op.cit.*, 1978, attempts to identify these works and notes the point at which works by Monet and Pissarro entered the Durand-Ruel exhibition, ex-catalogue.

22. The dealer concluded agreements with Degas in 1872 and, a little later, a substantial contract with Manet, see Anne Distel, *op.cit.*

23. *The Fifer* and *Woman with a Parrot*, both 1866, were shown in 1872, nos. 106 and 49; *The Ballet from 'Robert le Diable'* (Metropolitan Musem of Art version) and the *Dance Class at the Opera* were shown in 1872, but at different exhibitions, the latter picture being ex-catalogue.

24. Degas, for instance, visited Ernest Gambart who gave him Legros' address. He was also familiar with Deschamps, Gambart's nephew, and Durand-Ruel. For further reference see Denys Sutton, *Degas, Life and Work*, 1986, p.94.

25. Marcel Guerin ed., *Degas Letters*, trans. Marguerite Kay, 1947, p.30. Denys Sutton, *op. cit.*, pp.103-04, identifies this cotton manufacturer as William Cottrill, whose collection was dispersed at Christie's in 1873.

26. Louis Huth purchased *Dance Class at the Opéra*, see note 13 above; Barlow was a botanist and bleach manufacturer from Lancaster who owned works by Camille Pissarro. Around this time Charles Galloway of Thornyholme, Cheshire acquired Pissarro's *The Crystal Palace, London*, 1871, (Art Institute of Chicago). An illustrated inventory of the contents of Thornyholme was published in 1892. I am grateful to Edward Morris, Walker Art Gallery, Liverpool for drawing this publication to my attention.

27. For reference to the Hill Collection see Alice Meynell, 'Pictures from the Hill Collection' *The Magazine of Art*, vol.V, 1882, pp.1-7, 80-84, 116-21; Degas' works were identified in Ronald Pickvance, 'Henry Hill: an untypical Victorian collector' *Apollo*, vol. LXXVI, 1962, pp.789-91.

28. *ibid.*, p.82.

29. Neither artist exhibited in 1874, although Legros showed on one occasion only in 1876. Whistler's exhibition with Durand-Ruel in Paris in 1873 had produced no sales and this coupled with his ambition to stage a solo exhibition in London in 1874 must have discouraged the thought of his showing with the Impressionists. For a discussion of the 1874 enterprise see Robin Spencer, 'Whistler's First One-Man Exhibition Reconstructed', in Gabriel P. Weisberg and Laurinda S. Dixon eds., *The Documented Image, Visions of Art History*, 1987, pp.27-49.

30. Marcel Guerin ed., *op. cit.*, Oxford, p.39.

31. See for instance, Charles S. Moffet ed., *The New Painting, Impressionism, 1874-1886*, 1986; see also Joel Isaacson, *The Crisis of Impressionism, 1878-1882*, catalogue of an exhibition at the University of Michigan Museum of Art, Ann Arbor, 1980. For a stimulating reassessment of the crucial position of Degas, see Carol Armstrong, *Odd Man Out, Readings of the Work and Reputation of Edgar Degas*, 1991.

32. *The Academy* was a relatively recent literary review which started in 1870. For Philippe Burty see Gabriel P. Weisberg, *Philippe Burty and the Visual Arts of Mid-Nineteenth Century France*, 1993.

33. *The Academy*, 30 May 1874, p.616; quoted in Gabriel P. Weisberg, *op.cit.*, 1993, p.190.

34. *ibid.*, p.617.

35. Recent accounts of this visit are contained in Richard Shone, *Sisley*, 1992, pp.67-81; MaryAnne Stevens ed., *Alfred Sisley*, catalogue of an exhibition at the Royal Academy of Arts, 1992; Nicholas Reed, *Sisley and the Thames*, 1992 (2nd ed.); see also Arts Council of Great Britain, *op.cit.*, 1973, pp.59-65.

36. Richard Shone, *op.cit.*, p.67, quotes Kenneth Clark referring to this brief period as the 'perfect moment of impressionism'.

37. For reference to these works see Richard Shone, *op.cit.*, pp.67-83; MaryAnne Stevens ed., *op.cit.*, pp.130-41.

38. For reference to these works see Charles F. Stuckey and William P. Scott, *Berthe Morisot, Impressionist*, 1987, pp.65-69.

39. Denis Rouart ed., *The Correspondence of Berthe Morisot*, trans. Betty W. Hubbard, 1957, pp.89-93.

40. Bradford Museums and Art Galleries and Tyne and Wear County Council Museums, *op.cit.*, p.17.

41. *The Times*, 25 April 1876, p.5, quoted in Kate Flint ed., *Impressionists in England, the Critical Reception*, 1984, pp.36-37.

42. *The Architect*, 1 December 1877, p.298; the naivety of the references contained in this piece indicates that balance between intense curiosity and deep puzzlement over the aims of a modern French painter. For further discussion see Kenneth McConkey, *British Impressionism*, 1989, p.63.

43. Quoted from Henry James, *The Painter's Eye, Notes and Essays on the Pictorial Arts*, 1956 (University of Wisconsin ed., 1989), pp.114-15. James, in the early years of the century, perhaps under the influence of Sargent, reassessed his position vis-a-vis the Impressionists when it was evident how important they had become to American collectors.

44. James McNeill Whistler, *The Gentle Art of Making Enemies*, 1892 (Dover reprint, 1967), p.4. The trial has been recently discussed in Linda Merrill, *A Pot of Paint, Aesthetics on Trial in Whistler v Ruskin*, 1992, although no consideration is given to its effects on the art world.

45. In 1881, for instance, Constantine Alexander Ionides acquired Degas' *The Ballet Scene from Meyerbeer's Opera 'Robert le Diable'*, a work which entered the Victoria and Albert Museum in 1900. See Jonathan Mayne, *Degas' ballet scene from 'Robert le Diable'*, Victoria and Albert Museum Bulletin Reprint, 1969.

Plein Air Painting

1. For a discussion of Hone's student years see, National Gallery of Ireland, *Nathaniel Hone the Younger*, catalogue of an exhibition by Julian Campbell, 1991. For general reference to British students in Paris in the nineteenth century see Edward Morris and Amand McKay, Apollo, LXXXV, February 1992, pp.78-84.

2. For general reference to the contacts between British and French painters in the Whistler circle in the 1860s see Wildenstein and Philadelphia Museum of Art, *From Realism to Symbolism, Whistler and his World*, catalogue of an exhibition with an introduction by Allen Staley, 1971.

3. Hon. John Collier, *op.cit.*, p.58.

4. Clausen was 'horrified' by the 'sloppy paint' he found in Duran's atelier; see Bradford Museums and Art Galleries and Tyne and Wear and County Council Museums, *op.cit.*, p.16.

5. R.A.M. Stevenson, *Velázquez*, 1895 (1900 ed.) pp.104-06, describes the 'logic' of Duran's approach and his reasons for integrating drawing into the process of painting; 'he separated drawing from modelling with the brush as little as possible'.

6. Will H. Low, *A Chronicle of Friendships, 1873-1900*, 1908, pp.14-15.

7. R.A.M Stevenson, *op.cit.*, p.108.

8. For the account of a hapless English student at the atelier Julian see Shirley Fox, *An Art Student's Reminiscences of Paris in the Eighties*, 1909, pp.53-54; see also Walter Shaw-Sparrow, *John Lavery and His Work*, 1911, pp.38-39 for Lavery's account of similar experiences.

9. Morley Roberts, 'A Colony of Artists', *Scottish Art Review*, August 1889, p.73.

10. Walter Shaw-Sparrow, *John Lavery and his Art*, n.d., [1911], p.41.

11. Duez's *Three Weeks After*, was illustrated from the Hill Collection, see *The Magazine of Art*, 1881, p.84.

12. Provincial art societies which promoted an interest in progressive painting around this time have not been systematically studied. The Glasgow Institute of Fine Arts, which regularly had 'foreign loan' sections in its exhibitions, is referred to here. One could also cite the Dublin Sketching Club which staged a Whistler exhibition in 1884, see Ronald Anderson, 'Whistler in Dublin', *Irish Arts Review*, vol.3 no. 1986, pp.45-51.

13. For further reference see Kenneth McConkey, 'After Holbein: a study of Jules Bastien-Lepage's "Portrait of the Prince of Wales" ', *Arts Magazine*, October 1984, pp.103-07, Marie-Madeleine Aubrun, *Jules Bastien-Lepage, catalogue raisonné de l'Oeuvre*, 1985, p.162.

14. For a fuller discussion of this phenomenon see Kenneth McConkey, 'The Bouguereau of the Naturalists, Bastien-Lepage and British Art', *Art History*, vol.1, 1978, no. 3, pp.371-82.

15. *The Spectator*, 12 June 1880, p.751; quoted in Kenneth McConkey, *op.cit.*, 1978, p.374.

16. Emile Zola, *Le bon combat: de Courbet aux impressionistes*, 1975, p.206-07.

17. The arrival in 1881 of the Marion Miniature 'Academy' camera, a precursor of the Kodak, made it possible for the first time for artists to take instantaneous snapshots of the motif. For a discussion of the uses of photography in relation to naturalistic painting see Kenneth McConkey, 'Dr Emerson and the Sentiment of Nature', in *Life and Landscape, PH Emerson, Art and Photography in East Anglia, 1885-1900*, catalogue of an exhibition edited by Neil McWilliam and Veronica Sekules, 1986, pp.47-63; see also Gabriel P. Weisberg, *Beyond Impressionism, The Naturalist Impulse*, 1992.

18. Mrs Lionel Birch, *Stanhope A. Forbes, ARA and Elizabeth Stanhope Forbes ARWS*, 1906, p.60.

19. Harry Quilter, *Sententiae Artis*, 1886, p.163.

20. Walter Shaw-Sparrow, *op.cit.*, p.41.

21. *The Graphic*, 22 April 1882, p.394. The *quartier latin* escaped many of the direct effects of Haussmanization.

22. For reference to Stanhope Forbes' letters to his mother, recording his early years in France, see Caroline Fox, *Stanhope Forbes and the Newlyn School*, 1993, pp.11-16.

23. Kenneth McConkey, *Sir John Lavery*, 1993, pp.19-25.

24. Alice Cockran, 'William Stott of Oldham', *Scottish Art Review*, vol. 1, 1888, p.320.

25. Robert Louis Stevenson, 'Fontainebleau: Village Communities of Painters – IV' *The Magazine of Art*, 1884, p.345.

26. Robert Louis Stevenson, 'Forest Notes', *Cornhill Magazine*, 1876, p.552.

27. For further reference to O'Meara's sojourn at Grez-sur-Loing see Hugh Lane Municipal Gallery, *Frank O'Meara and his Contemporaries*, catalogue of an exhibition by Julian Campbell, 1989.

28. Arthur Fish, *Henrietta Rae, (Mrs Ernest Normand)*, 1905, p.69.

29. Thomas R. MacQuoid, 'Costumes and Characteristics of South Brittany', *The Magazine of Art*, vol. 2, 1879, p.93.

30. For reference to this work see, Francis Greenacre and Caroline Fox, *Artists of the Newlyn School, 1880-1900*, catalogue of an exhibition at Bristol and Newlyn, 1979, pp.73-74; see also Caroline Fox, *op cit*, 1993, pp.13-14.

31. Frederick Dolman, 'Mr. Stanhope Forbes ARA', *The Strand Magazine*, vol. xxii, 1901, p.492.

32. For further reference to these works see Caroline Fox, *op cit.*, 1993, pp.15-16; National Gallery of Ireland, *Walter Osborne*, catalogue of an exhibition by Jeanne Sheehy, 1983, p.54.

33. Bradford Museums and Art Galleries and Tyne and Wear County Council Museums, *op.cit.*, 1980, pp.37-38. Stanhope Forbes was delighted to hear that Clausen was joining the

British colony at Quimperlé in September 1882 and wrote to his mother, 'he is a really good painter and one of the sacred band whom even I admire'.

34. For consideration of the nuances contained in this work see Gabriel P. Weisberg, *op cit.*, 1980, pp.208-10 (entry by Kenneth McConkey).

35. George Clausen, 'Bastien-Lepage and Modern Realism', *Scottish Art Review*, vol.1, October 1888, p.114.

36. Sir George Clausen, 'Autobiographical Notes', *Artwork*, no. 55, Spring 1931, p.19.

37. Mrs Lionel Birch, *op.cit.*, p.29.

38. For further reference to the sites of Scottish art colonies see,. Roger Billcliffe, *The Glasgow Boys*, 1985, pp.81-174.

39. See Jeanne Sheehy, *Walter Osborne*, 1974; National Gallery of Ireland, *Walter Osborne*, catalogue of an exhibition by Jeanne Sheehy, 1983, pp.63-94.

40. For reference to Cullercoats see Laing Art Gallery, *A Romance with the North-East, Robert and Isa Jobling*, catalogue of an exhibition by John Millard, 1992; see also idem., 'North East Artists on the Coast' and Kenneth McConkey, '... a dapper medium-sized man with a watercolour sketching block', in Northern Centre for Contemporary Art, Sunderland, *Winslow Homer, All the Cullercoats Pictures*, catalogue of an exhibition edited by Tony Knipe, 1988. For Staithes see Nottingham Castle Museum, *The Staithes Group*, catalogue of an exhibition by Peter Phillips, 1993.

41. I am grateful to William H. Gerdts for first drawing my attention to Metcalf's work at Walberswick. See also Elizabeth de Veer and Richard J. Boyle, *Sunlight and Shadow, the Life and Art of Willard L. Metcalf*, 1987, pp 39, 194.

42. Jeanne Sheehy, *op.cit.*, 1983, p.69.

43. Peter Thomas and Richard Wood, *P.H. Emerson, Photographer of Norfolk*, 1974; Nancy Newall, *P.H. Emerson, the Fight for Photography as a Fine Art*, 1975; Ian Jeffrey, 'Peter Henry Emerson: Art and Solitude', in Victoria and Albert Museum, *The Golden Age of British Photography*, catalogue of an exhibition, 1984, pp.154-62;Neil MacWilliam and Veronica Sekules eds. *op. cit.*

44. Kenneth McConkey, *op.cit.*, 1986, pp.47-63.

45. For a full bibliography of Emerson's writings see Nancy Newall, *op.cit.*, 1975.

46. Emile Taboureux, 'Claude Monet', *La Vie Moderne*, 12 June 1880, quoted in Charles F. Stuckey ed., *Monet, A Retrospective*, 1985, p.90. Monet in later years would often work away from the motif, and was rattled at the suggestion that he was not true to his own precepts. In 1905, for instance, he wrote to Durand-Ruel, 'whether my Cathedrals or my views of London were painted from nature or not is nobody's business and of no importance at all'.

47. George Moore, *Confessions of a Young Man*, 1888, (1961 ed.), p.114.

48. For further reference to George Moore's Paris period see Joseph Hone, *The Life of George Moore*, 1936, pp.44-79; see also Ronald Pickvance, 'A newly discovered drawing by Degas of George Moore', *Burlington Magazine*, vol. CV, June 1963, pp.276-80; Denys Sutton, 'The Vase and the Wash-tub', *Apollo*, vol. CIII, March 1976.

49. For a modern discussion of Manet's social background see Theodore Reff, *Manet and Modern Paris*, catalogue of an exhibition at the National Gallery of Art, Washington, 1982.

50. For a fuller discussion of *George Moore at the Café* see Françoise Cachin and Charles S. Moffett,*op. cit.*, pp.424-27.

The National School in Peril

1. Ernest Chesneau, *The English School of Painting*, 1885, p.ix. Ernest Chesneau was, to some extent an establishment figure, having been secretary to the infamous Comte de Nieuwerkeke, Minister of Fine Arts in the Second Empire. In later years he wrote criticism for the *Constitutionnel*.

2. Frederick Wedmore, 'The Impressionists', *Fortnightly Review*, vol. XXXIII, January 1883, pp.75-82; quoted in Kate Flint ed., *Impressionists in England, The Critical Reception*, pp.46-55.

3. These exchanges are quoted from W.S. Meadmore, *Lucien Pissarro, Un Coeur Simple*, 1963, p.37. For the original French version of this correspondence see Anne Thorold ed., *The Letters of Lucien to Camille Pissarro*, 1993, pp.24-25.

4. George Clausen, 'Mark Fisher', in Leicester Galleries, *Memorial Exhibition of Works by the Late Mark Fisher, RA, 1841-1924*, catalogue of an exhibition, 1924, p.10 states, 'I remember him saying about forty years ago [ie c.1884] that the impressionists were the best men of the day. Corot, Manet, Daubigny, Monet were among his favourites and I think he had known Sisley and Lepère'. When he moved to Widdington, Essex in 1890, Clausen was Fisher's neighbour and in 1900 he painted Fisher's portrait (Royal Academy of Arts).

5. In his letters to his father, see note 3 above, Lucien Pissarro observed the degree to which Bastien-Lepage had swept the board in Britain.

6. Ernest Chesneau, *The Education of the Artist*, 1886, pp.216-17.

7. James D. Linton, 'The Practical Education of the Artist', *The Magazine of Art*, 1887, p.158.

8. Ernest Chesneau, 'The English School in Peril, a letter from Paris', *The Magazine of Art*, 1888, pp.25-28.

9. George Clausen, 'The English School in Peril: A Reply', *The Magazine of Art*, 1888, p.224.

10. This debate continued in *The Magazine of Art* (see 1889, pp.55-62, 101-04) and other journals. For further reference see Anna Gruetzner, 'Two Reactions to French Painting in Britain', *Post-Impressionism*, catalogue of an exhibition at the Royal Academy of Arts, 1979, pp.178-82.

11. George Moore tackles the subject of commercial success and academic standing in a chapter entitled 'Art Patrons' in *Modern Painting*, 1893, p.146-52.

12. For a fuller discussion of the Victorian art world see Paula Gillet, *The Victorian Painter's World*, Gloucester, 1990.

13. William J. Laidlay, *The Origin and First Two Years of the New English Art Club*, 1907; see also Kenneth McConkey, *op cit.*, 1989, p. 51; For further reference see Alfred Thornton, *Fifty Years of the New English Art Club, 1886-1935*, 1935; Birmingham Art Gallery, *The New English Art Club*, catalogue of an exhibition with introduction by Mary Woodall, 1952; Fine Art Society, London, *The Early Years of the New English Art Club*, catalogue of an exhibition, with introduction by Bevis Hillier, 1968; Christie's, London, *The New English Art Club Centenary Exhibition*, with an introduction by Anna Gruetzner Robins, 1986.

14. For a full discussion of the Grosvenor Gallery see Colleen Denney, *Exhibition Reforms and Systems: The Grosvenor Gallery, 1877-1890*, unpublished Ph.D. thesis, University of Minnesota, 1990.

15. These events are recounted by Elizabeth Robins / Joseph Pennell, *The Life of James McNeill Whistler*, 1908, vol. 112, pp.47-74.

16. *ibid.*, p.62.

17. quoted from James McNeill Whistler, *The Gentle Art of Making Enemies*, 1892, (New York ed., 1967), p.115.

18. *ibid.*, p. 143.

19. These views were apparent on a number of occasions, but perhaps most obviously when Whistler visited the International Exhibition at Antwerp with William Merritt Chase in 1887. Chase declared his admiration for Bastien-Lepage and his followers who were well represented. There was no mistaking the barb in Whistler's response, 'I'll say one word, Chase, ... the one word – *school*'. Elizabeth Robins and Joseph Pennell, *op.cit.*, vol. 2, p.31.

20. 'Art in May', *The Magazine of Art*, 1886, p.xxix.

21. Mortimer Menpes, *Whistler as I knew Him*, 1904, p.16.

22. *ibid.*, p.18.

23. Robert Emmons, *The Life and Opinions of Walter Richard Sickert*, 1941, p.62.

24. For a detailed discussion of the evidence concerning the Sickert/Degas friendship see, Anna Gruetzner Robins, 'Degas and Sickert: Notes on their Friendship', *Burlington Magazine*, vol. CXXX, March 1988, pp.225-29.

25. Jacques-Emile Blanche, *Portraits of a Lifetime*, 1937, p.45 indicates that Blanche was also familiar with the Francophile circle of Mr and Mrs Edwin Edwards, where he claimed he first met Sickert in the early months of 1885 before Sickert's marriage to Ellen Cobden. For further reference see Michael Parkin Fine Art Ltd., *Walter Sickert and Jacques-Emile Blanche and Friends in Dieppe*, catalogue of an exhibition, 1982; Musée de Dieppe, *J-E Dieppe, 1861-1942*, catalogue of an exhibition, 1992, (I am grateful to Etrienne Lymbery for drawing this

valuable source to my attention).

26. For Blanche's recollections of Manet at work in the studio, see Jacques-Emile Blanche, *Manet*, 1925 (trans. F.C. de Sumichrast), pp.59-60.

27. For reference to Sickert's Degas collection see Anna Gruetzner Robins, *op.cit.*, 1988; Blanche acquired Degas' *The Rehearsal*, 1874, (Burrell Collection).

28. *ibid.*, p.21.

29. Catalogue, *Exhibition of Pictures of The New English Art Club at the Marlborough Gallery, 53 Pall Mall*, 1886, n.p.

30. *Pall Mall Gazette 'Extra'*, no. 26, 1886, p.71.

31. *ibid.*

32. Anon, 'A New Art Club', *The Art Journal*, 1886, p.252

33. *The Times*, 12 April 1886.

34. See for instance Greiffenhagen's *Laertes and Ophelia* and Gogin's *Soothsayer*, both of which were praised by the same critics who commented upon Hacker's *Cradle Song*.

35. *The Magazine of Art*, 1886, 'Art Notes', p.xxx; quoted in Bradford Art Galleries and Museums and Tyne and Wear County Council Museums, *op.cit.*, 1980, p.42.

36. *ibid.*, quoted in Oldham Art Gallery, *A Painter's Harvest, H.H. La Thangue, RA, 1859-1929*, 1978, p.9. For further reference to *In the Dauphiné* and La Thangue's Bradford patrons see Bradford Museums and Art Galleries, *The Connoisseur, Art Patrons and Collectors in Victorian Bradford*, published in association with an exhibition at Cartwright Hall, 1989, n.p.

37. Unidentified local source c.1893; unidentified press cutting obituary, 1924. See also Oldham Art Gallery, *op.cit.*, 1978, p.10 and Bradford Museums and Art Galleries, *op.cit.*, 1989.

38. Butler Wood, 'The Maddocks Collection at Bradford', *The Magazine of Art*, 1891, pp.298-306, 337-44.

39. Charles exhibited the portrait of John Maddocks at the Royal Academy in 1888 (no. 794) although the two men had known each other since 1879. Contact with Abraham Mitchell must date from shortly thereafter, since the portrait of Mrs Tom Mitchell was shown at the Royal Academy in 1883 (no.525).

40. T. Martin Wood, 'The Paintings of James Charles', *The Studio*, vol. 40, 1907, p.49.

41. Bradford Museums and Art Galleries, *op.cit.*, 1989.

42. William J. Laidlay, *op.cit.*, p.67-68. La Thangue argued his case independently in 'A National Art Exhibition', *The Magazine of Art*, 1887, p.30-32.

43. *ibid.*, p.105.

44. For a general discussion of these issues see Julian Treuherz, *Hard Times, Social Realism in Victorian Art*, catalogue of an exhibition at Manchester City Art Gallery, 1987.

45. D.S. MacColl, 'Professor Brown: Teacher and Painter', *The Magazine of Art*, 1893, p.403 ff.

46. *ibid.*

47. Letters to Sir George Clausen, coll. Royal Academy of Arts, London.

48. Manet's *Olympia* had most recently been shown at the artist's posthumous retrospective at the Ecole des Beaux Arts in January 1884, no. 23; see Françoise Cachin and Charles S. Moffett, *op.cit.*, pp.174-83. For further reference to Roussel see Frank Rutter, *Theodore Roussel*, 1926; Margaret Dunwoody Hausberg, *The Prints of Theodore Roussel*, 1991.

49. Menpes staged an exhibition of his Japanese pictures at Dowdeswell's on his return and refused to sign himself 'Pupil of Whistler' on his return from Japan. He also contributed two articles recording 'A Personal View of Japanese Art' to *The Magazine of Art*, 1888, pp.192-99, 255-61.

50. For East's visit to Japan see The Fine Art Society, *Opening the Window, British Artists in Meiji Japan, 1880-1900*, catalogue of an exhibition, 1991. For Henry and Hornel see Scottish Arts Council, *Mr Henry and Mr Hornel visit Japan*, catalogue of an exhibition by William Buchanan, 1979.

Photo-realism and Impressionist paint-marks

1. These were listed as *Coast of Belle-Isle, Bretagne*; *Meadow of Limetz*; *Village of Bennecourt* and *Cliff near Dieppe*.

2. E.M. Rashdall, 'Claude Monet', *The Artist*, vol. IX, July 1888, p.195.

3. *Pall Mall Gazette 'Extra'*, 1886, p.71; The study was sold at Sotheby's, 8 Nov 1989, lot 48; see also, Bruce Laughton, *Philip Wilson Steer*, 1971, nos. 18 and 18a; Laughton's contention that

the study known as *Cellist*, formerly in the collection of James Charles, may be a fragment of *Andante*, seems unlikely.

4. For a full discussion of this event and its consequences see Trevor J. Fairbrother, 'The Shock of John Singer Sargent's Mme Gautreau', *Arts Magazine*, January 1981, pp.90-97.

5. NEAC, 1886, nos 17 and 37; *The Times*, 12 April 1886.

6. Mappin Art Gallery, Sheffield, *The Misses Vickers, the Centenary of the Painting by John Singer Sargent*, catalogue of an exhibition by James Hamilton, 1984.

7. For the consideration of atelier practice see Albert Boime, *The Academy and French Painting in the Nineteenth Century*, 1971.

8. Henry James, 'Our Artists in Europe', *Harper's Monthly Magazine*, June 1889, p.50; for further reference see Stanley Olson, Warren Adelson and Richard Ormond, *Sargent at Broadway, The Impressionist Years*, 1986; William H. Gerdts, 'The Arch-Apostle of the Dab-and-Spot School: John Singer Sargent as an Impressionist', in Whitney Museum of American Art, *John Singer Sargent*, ed. Patricia Hills, 1987, pp.111-45.

9. For further reference to *Reapers resting in a Wheatfield*, see Doreen Bolger Burke, *American Paintings in the Metropolitan Museum of Art*, vol.III, 1980, p.236.

10. For further reference see Richard Ormond, 'Carnation, Lily, Lily, Rose', in Olson, Adelson and Ormond, *op.cit.*, 1986, pp.63-75.

11. Roger Fry, 'J.S. Sargent as seen at the Royal Academy Exhibition of his Works, 1926, and in the National Gallery', *Transformations: Critical and Speculative Essays on Art*, 1926.

12. F. Wedmore, *Some of the Moderns*, 1909, p.25; quoted in McConkey, *op.cit.*, 1989, p.81.

13. Stanley Olson, *John Singer Sargent, his Portrait*, 1986, p.150; See also William H. Gerdts, *op.cit.*, 1987, pp. 111-45.

14. In 1887 Sargent acquired *Vagues à Manepport* [then known as *Rock at Tréport*] and *Bennecourt*, by 1889 he owned *Paysage avec Figures* and in 1891 he bought *Maison de Jardinier*; see D. Wildenstein, *Claude Monet, biographie et catalogue raisonné*, Paris 1978 et seq., nos. 1036, 1126, 867 and 1204 respectively. The Sargent sale catalogue (27 July 1925) lists two Monets, *Rock at Tréport* (lot 302) and *Bordighera*, (23 x 28, 1884, lot 303).

15. Quoted from Richard Ormond, *op.cit.*, p.40.

16. Richard Ormond, *John Singer Sargent, Paintings, drawings, watercolours*, 1970, p.41; Sargent may have revisited Monet the following summer, but he declined an invitation to go to Giverny in 1889. Ormond points out, p.42, that Monet gave his address as c/o J.S. Sargent when he exhibited at the New English Art Club in 1892.

17. René Gimpel, *Diary of an Art Dealer*, 1966, p.75; quoted in Richard Ormond, *op.cit.*, 1970, p.42; William H. Gerdts, *op.cit.*, p.120.

18. *The Times*, 18 April 1889, p.8.

19. A. Ludovici, 'The Whistlerian Dynasty at Suffolk Street', *The Art Journal*, 1906, pp.193-95, 237-39.

20. For a full discussion of Sickert's music hall themes see Anna Gruetzner Robins, 'Sickert "Painter-in-Ordinary" to the Music Hall', in Wendy Baron and Richard Shone eds., *Walter Sickert, Paintings*, catalogue of an exhibition at the Royal Academy of Arts, 1993, pp.13-24.

21. For further reference to this work see Wendy Baron and Richard Shone eds., *op.cit.*, p.64.

22. Sickert referred to this on many occasions in his writings and although he appreciated the value of the pochades, 'masterpieces of classic painting', he criticised Whistler's formalist portraiture because: 'these paintings were not what Degas used to call amenées – that is to say, brought about by conscious stages, each so planned as to form a steady progression to a foreseen end'. See Osbert Sitwell ed., *A Free House, or the Artist as Craftsman, being the Writings of Walter Sickert*, 1947, pp.18, 36.

23. Between 1887 and 1894 Sickert was active in the acquisition of works by Degas, see Anna Gruetzner Robins, *op.cit.*, 1988. Perhaps the most relevant work for the purposes of the present discussion is *Mlle Bécat aux Café des Ambassadeurs*, (private collection) which Sickert had purchased before 1891.

24. See Julian Treuherz, *op.cit.*, 1987.

25. George Moore, 'Degas, A Painter of Modern Life', *The Magazine of Art*, 1890, p.423.

26. Edmond Duranty, 'The New Painting: Concerning a Group

of Artists Exhibiting at the Durand-Ruel Galleries', 1876, quoted from Charles S. Moffett, *The New Painting, Impressionism, 1874-1886*, 1986, p. 44.

27. For a discussion of this work see Kenneth McConkey, *op.cit.*, 1989, p.88. See also Anna Gruetzner Robins, 'British Impressionism: The Magic and Poetry of Life around Them', in Norma Broude ed., *World Impressionism, The International Movement, 1860-1920*, 1990, p.78, surmises that the woman in *A City Atlas* may be a servant.

28. G.B.S., 'Picture Shows', *World*, 13 April 1887, p.5.

29. Robert Emmons, *The Life and Opinions of Walter Richard Sickert*, 1942, p.98.

30. Henry exhibited *Moonrise: November* at the NEAC in 1889, no.3, in the same show as Sargent's Impressionist figure-pieces.

31. For a discussion of these works see Roger Billcliffe, *op. cit.*, 1985, pp.200-01, 272-77; Kenneth McConkey, *op.cit.*, 1989, p.41

32. Kenneth McConkey, *op. cit.*, 1993, pp.42-46.

33. Lavery actually credited Bastien-Lepage with the spur to this acutely observed naturalism, portraying figures in dynamic movement.

34. Anna Gruetzner Robins, *op.cit.*, 1988, p.225.

35. The Goupil Gallery, *London Impressionists*, catalogue of an exhibition, 1889, pp.6-7.

36. Walter Sickert, 'Impressionism – True or False', *Pall Mall Gazette*, 2 February 1889; James McNeill Whistler, letter to his wife Beatrice, 11 June 1891, in Robin Spencer, *Whistler, A Retrospective*, 1989, pp.256-57, 273.

37. Walter Sickert, 'Modern Realism in Painting', in André Theuriet, *Jules Bastien-Lepage and his Art*, 1892, pp.133-43.

38. *ibid.*, p.140.

39. For further reference to Emerson's relationship with New English Art Club painters and Whistler, see Kenneth McConkey, *op. cit.*, 1986, pp.47-63.

40. For a fuller exposition of Emerson's pictorial theories in relation to his work see essays by Ellen Handy, Fiona Pearson and Ian Jeffrey in Mike Weaver ed., *British Photography in the Nineteenth Century, The Fine Art Tradition*, 1989.

41. In a black-edged notice, *The Death of Naturalistic Photography*, published in 1890, he denounced the medium.

42. For a discussion of Davison and his ideas see Brian Coe, 'George Davison: Impressionist and Anarchist', in Mike Weaver ed., *op.cit.*, pp.215-41.

43. See Margaret Harker, *The Linked Ring, The Secession Movement in Photography in Britain, 1892-1910*, 1979.

44. George Thomson, 'Henry Herbert La Thangue and his Work', *The Studio*, vol. xvi, 1896, p.177.

45. These opinions were not uncommon among former pupils of Gérôme, see for instance, H. Barbara Weinberg, *The American Pupils of Jean-Léon Gérôme*, 1984.

46. *The Speaker*, 1 May, 1897, p.483.

47. Walter Sickert, *op.cit.*, p.140.

Modern Life

1. George Moore, *Modern Painting*, (New Edition, Enlarged), 1898, pp.249-51, 254-55.

2. Quoted in D.S. MacColl, *Life, Work and Setting of Philip Wilson Steer*, 1945, pp.177-78.

3. Alfred Thornton, *The Diary of an Art Student of the Nineties*, 1938, pp.6-8; Joseph Hone, *The Life of Henry Tonks*, 1939; Professor Fred Brown, 'Recollections', *Artwork*, vol. VI, 1930, p.154.

4. D.S. MacColl, 'On Desert Islands', *Artwork*, Vol. VII, 1931, p.98.

5. C.W. Furse to D.S. MacColl, 'Schools of Art', 1892, quoted in Burlington Fine Arts Club, *Illustrated Memoir of Charles Wellingon Furse, ARA ...*, 1908, pp.51-53.

6. Charles Wellington Furse, 'Impressionism – What It Means', Burlington Fine Arts Club, *op.cit.*, 1908, p.46.

7. George Moore, *op. cit.*, 1898.

8. Anne Thorold, *The Paintings of Lucien Pissarro*, 1983, pp.50-51; see also Spink and Son, *Lucien Pissarro – His Watercolours*, catalogue of an exhibition by Christopher Lloyd, 1990, pp.24-25.

9. W.S. Meadmore, *op.cit.*, 1962, pp.60-61.

10. Two works by Monet were exhibited at the NEAC in the winter of 1891, three in the spring of 1893. MacColl noted that the Club had 'first included several groupings of what in France

would be called the 'Left', seems now to depend chiefly on the work of painters who have labelled themselves, for the convenience of those who dislike them, London Impressionists', *The Spectator*, 5 December 1891, p.809.

11. *The Spectator*, 10 December 1892, p.851; George Moore, *op. cit.*, 1893, .p.209. For further reference see, C. Lewis Hind, *Hercules Brabazon Brabazon, His Life and Art*, 1912; Leighton House, *Watercolours and Drawings by Hercules Brabazon Brabazon*, catalogue of an exhibition by Al Weil, 1971; Fine Art Society, *Hercules Brabazon Brabazon, 1821-1906*, catalogue of an exhibition by Al Weil, 1974; Chris Beetles Ltd., *Hercules Brabazon Brabazon, 1821-1906*, 1981; Chris Beetles Ltd., *Hercules Brabazon Brabazon, 1821-1906*, catalogue of an exhibition by Fiona Halpin and Al Weil, 1989.

12. *The Artist*, 1 June 1892, vol. 13, p.190; quoted in Kate Flint ed., *op.cit.*, p.106.

13. The *Westminster Gazette*, 25 February 1893, p.2. Whistler, following the success of his Goupil Gallery show in 1892, was now winning critical favour in London.

14. *The Speaker*, 3 March 1894, p.166.

15. *ibid.*

16. *The Spectator*, 11 March 1894, p.373.

17. John Rothenstein, *Modern English Painters*, vol. 1, 1952, p.64.

18. *The Saturday Review*, 24 November 1894; this picture is discussed in Wendy Baron, *Sickert*, 1973, no. 68, p.309; see also Anna Gruetzner, *op. cit.*, 1979, pp.208-09.

19. Wendy Baron, *op.cit.*, 1973, no. 67, p.309; for critical reference to this version of *l'Hôtel Royale, Dieppe*, see *The Studio*, vol. 1, 1893, p.80, where it was regarded as 'a pastiche' reflecting the 'faded fashions' of 'Whistler, Degas, Mr Steer and finally Mr Rothenstein'. The relationship with Aubrey Beardsley at this moment has been noted, although within a short time Sickert, in the later versions of *l'Hôtel Royale, Dieppe* reverted to a more orthodox impressionism.

20. C.L. Holmes, *Self and Partners (Mostly Self)*, 1936, p.168.

21. Robert Emmons, *The Life and Opinions of Walter Richard Sickert*, 1941, p.88.

22. George Moore, who visited Monet's exhibition at Durand-Ruel's gallery in the rue Lafitte, on one occasion 'with two artists', discusses Monet's view of Venice in comparison with that of Whistler and Guardi, see George Moore, *op.cit.*, 1898, pp.244-48.

23. *The Spectator*, 24 November 1894.

24. Alfred Thornton, *The Diary of an Art Student of the Nineties*, 1938, pp.22-35; important contemporary references are contained in George Moore, *op.cit.*, 1893, pp 234-36, D.S. MacColl, 'The Standard of the Philistine', *The Spectator*, 18 March 1893, pp.357-58; many other references are contained in Kate Flint ed., *op.cit.*, 1984; see also Kenneth McConkey, *op.cit.*, 1989, pp.109-13.

25. William Rothenstein, *Men and Memories*, 1931, vol.1, p.49. These very early landscapes appear not to have survived. Rothenstein stayed at the Hotel Baudy at Giverny 22 December 1889 – 4 January 1890, 24 January – 22 February 1890, 10 April – 13 May 1890 and 6 December-19 December 1890. I am grateful to William H. Gerdts for bringing the Baudy register to my attention. This has now been transcribed in his *Monet's Giverny, An Impressionist Colony*, 1993.

26. For a study of Conder's Australian years in the company of his mentors Roberts and Streeton, see Jane Clark and Bridget Whitelaw, *Golden Summers, Heidelberg and Beyond*, catalogue of an exhibition at the National Gallery of Victoria, Melbourne, 1985.

27. These were William Warrener and an unidentified artist named Curtis, William Rothenstein, *op.cit.*, pp.76-77; for further reference to Warrener see South Bank Centre, *Toulouse Lautrec*, catalogue of an exhibition by Richard Thomson, 1992, pp.264-65. Warrener showed three pictures at the New English between 1892 and 1895, two of which were painted at Grez. By 1893 he appears to have returned to his native Lincoln.

28. For further reference see John Rothenstein, *The Life and Death of Conder*, 1938, pp.60-62. A similar work by Steer entitled *Skirt Dancers*, dated by Laughton c. 1894, but possibly a year earlier, was sold at Christies, 11 March 1994, lot 69. Moore records that Steer, suffering from toothache, visited Paris with Charles Wellington Furse around this time, see George Moore,

Reminiscences of the Impressionist Painters, 1906, p.5.
29. For further reference see Richard Thomson, *op cit.*, pp.208, 246.
30. R.A.M. Stevenson, 'The Growth of Recent Art', *The Studio*, vol. 1, 1893, p.9.
31. *ibid.*
32. R.A.M. Stevenson, *Velázquez*, 1895, (1900 ed.), pp.121-22.
33. *Pall Mall Gazette*, 14 April 1895.
34. George Moore, *op. cit.*, 1906, p.6.
35. For further reference to this work see The Columbus Gallery of Fine Arts, *British Art, 1890-1928*, catalogue of an exhibition by Denys Sutton, n.d., no. 88; see also Max Rutherston, *Albert Rutherston*, catalogue of an exhibition, 1988, p.4; for reference to this sequence of pictures see Pyms Gallery, *An Ireland Imagined* ..., catalogue entry on Orpen's *The Refugees*, 1993, pp.44-47.
36. Wyllie had been exhibiting regularly since 1875. His *Toil, Glitter, Grime and Wealth on a Flowing Tide* was purchased by the Chantrey Trustees in 1883. He showed at the New English from 1889 to 1893.
37. Holloway showed at the New English from 1893 to 1897, Thomson from 1889 to 1910, although his London pictures were confined largely to the period from 1895 to 1900.
38. Oppenheimer exhibited at Goupil Gallery Salons in the first decade of the century. Talmage exhibited intermittently at the New English from 1901.
39. *The Studio*, vol. 37, 1906, p.67.
40. For a discussion of Whistler's response to the city see Robin Spencer, 'The Aesthetics of Change: London as seen by James McNeill Whistler', in Barbican Art Gallery, *The Image of London*, catalogue of an exhibition by Malcolm Warner, 1987, pp.49-69.
41. See John House, 'London in the art of Monet and Pissarro', *idem.*, pp.73-98.
42. Mrs H.M. Stanley, 'Bastien-Lepage in London', *The Art Journal*, 1897, p.56.

Edwardian Arcadia
1. For studies of this group see William H. Gerdts, *American Impressionism*, 1984; see also Musée Americain, Giverny, *Lasting Impressions – American Painters in France, 1865-1915*, 1992 and *Monet's Giverny, An Impressionist Colony*, 1993 by the same author.
2. William H. Gerdts, *op.cit.*, 1993, pp.222-27 transcribes the hotel register. I am grateful to Professor Gerdts for discussing this important document with me in 1990.
3. See for instance, Musée Americain, Giverny, *op.cit.*, pp.168-71.
4. John Rothenstein, *op.cit.*, p.67, letter dated 22 May 1891.
5. Denys Sutton ed., *Letters of Roger Fry*, vol. 1, 1972, pp.152-55. Fry was at this time drafting his first, unpublished article on Impressionism.
6. A. Lingfield, 'The work of J. Buxton Knight', *The Magazine of Fine Arts*, vol. 2, 1906, p.166.
7. For a discussion of these issues see Martin Weiner, *English Culture and the Decline of the Industrial Spirit, 1850-1980*, 1985.
8. For further reference to Stott's career see Fine Art Society, London, *William Stott of Oldham and Edward Stott ARA*, catalogue of an exhibition with a foreword by Peyton Skipwith, 1976.
9. See for instance, Laurence Hausman, 'Edward Stott, Painter of the Field and the Twilight', *The Magazine of Art*, 1900, p.531, see also A.C.R. Carter, 'Edward Stott and His work', *The Art Journal*, 1899, pp. 294-98; Marion Hepworth Dixon, 'Edward Stott: an Appreciation', *The Studio*, vol. 55, 1912, pp.3-10.
10. George Thomson, 'H.H. La Thangue and his Work', *The Studio*, vol. 9, 1896, p.163ff.
11. For further reference see Bradford Museums and Art Galleries and Tyne and Wear County Council Museums, *op.cit.*,1980, pp.50-63.
12. George Moore, *op. cit.*, 1893, p.122
13. *The Magazine of Art*, 1893, p.258.
14. George Moore, *op.cit.*, 1893, p.206; quoted in Helenburgh and District Art Club, *Helensburgh and the Glasgow School*, catalogue of an exhibition by Ailsa Tanner, 1972, pp.15-16.
15. For further reference see Oldham Art Gallery, *A Painter's Harvest, H.H. La Thangue, 1859-1929*, catalogue of an exhibition by Kenneth McConkey, 1978, pp.28-29.
16. Kenneth McConkey, *op. cit.*, 1993, pp.187-89.

17. *ibid.*, pp.189-90.
18. Percy Bate, 'Some Recent Glasgow painting', *The Magazine of Art*, 1904, p.309.
19. National Gallery of Ireland, Dublin, *Walter Osborne*, catalogue of an exhibition by Jeanne Sheehy, 1983, p.135.
20. Sargent's work of this period has been extensively discussed, see particularly Patricia Hills, 'Painted Diaries, Sargent's Late Subject Pictures', in Whitney Museum of American Art, *John Singer Sargent*, catalogue of an exhibition, 1987, pp.181-207. Sargent's entourage also included Adrian and Marianne Stokes.
21. For reference to de Glehn in these years see Laura Wortley, *Wilfrid de Glehn, A Painter's Journey*, 1989, pp.28-31.
22. *The Magazine of Art*, 1902, p.398.
23. *ibid.*, p.144.
24. *The Magazine of Art*, 1902, p.398.
25. *ibid.*
26. See for instance David Murray's *A Hampshire Haying, 1891*, (Bradford Art Galleries and Museums), shown at the New Gallery in 1892, which frankly drives from Constable's *Salisbury Cathedral from the Meadows, 1831*.
27. The opportunity for this reassessment was provided in a number ways. The Grosvenor Gallery winter exhibition in 1889, *A Century of British Art*, was mostly given over to Constable. Throughout the 1890s there was a lively trade in his work and at the end of the decade the dealer Leggatt obtained a large consignment of small oils from the artist's descendants. The contemporary esteem for Constable is best demonstrated in the Lane collection which, in addition to its representation of the Impressionists, contains seven small oils by Constable.
28. John Ruskin, *Modern Painters*, vol. 1, 1843, p.191.
29. More was probably made of this than ought to have been the case. See David Croal Thomson, *The Barbizon School of Painters*, 1890, pp.19-20. The contents of this publication had already appeared as a series of articles in *The Magazine of Art* in the preceding year. As manager of the Goupil Gallery, Thomson was Steer's dealer and his portrait was painted by Steer (Tate Gallery) in 1895. In February of that year Thomson presented a copy of his Barbizon book to Steer.
30. C.J. Holmes, *Constable and his influence on Landscape Painting*, 1902; Lord Windsor-Clive, *John Constable, RA*, 1903.
31. Julius Meier-Graefe, *Modern Art, being a Contribution to an New System of Aesthetics*, 2 vol., (trans, P.G. Konody), 1908; see especially, 'Constable and the Present', pp.136-43.
32. Marion H. Spielmann, 'Introduction', *Royal Academy Pictures*, 1896, p.ii.
33. Marion H. Spielmann, 'Preface', *Royal Academy Pictures*, 1903, p.ii; This point was continually restated – while there were no surprises, there was a 'subtle and healthy appreciation of nature' [1905, p.ii].
34. For a study of rural preservation issues see Jan Marsh, *Back to the Land: the Pastoral Impulse in Victorian England from 1880 to 1914*, 1982.
35. Alfred Austin, *Haunts of Ancient Peace*, 1908.
36. Sir Alfred East RA, *Landscape Painting*, 1906 [1919ed.], p.48.
37. C. Lewis Hind, *Landscape Painting, vol. 2, From Constable to the Present Day*, 1924, p. 185.
38. Osbert Sitwell ed., *A Free House! being the Writings of Walter Richard Sickert*, 1947, p.74.
39. R.A.M. Stevenson's review is quoted in Vincent Lines VPRWS, *Mark Fisher and Margaret Fisher Prout, Father and Daughter, A Record of a Hundred Years of Painting*, 1966, pp.20-23.
40. Osbert Sitwell ed., *op.cit.*, p.59.
41. Bruce Laughton, *Philip Wilson Steer*, 1971, pp.86-87; Hugh Lane had acquired three works by Monticelli by 1908.
42. C. Lewis Hind, *op.cit.*, p.198.
43. Osbert Sitwell ed., *op.cit.*, p.58.
44. *ibid.*, p.59.
45. Anon., *Modern Masterpieces of British Art*, n.d., (c.1920), p.161.

Impressionism and Modernism
1. For general reference to these trips see Arts Council, *op.cit.*, 1973; for Sisley see Richard Shone, *op. cit.*, 1992; for Pissarro see Nicholas Reed, *Pissarro in West London*, 1990 (3rd ed.); for Monet see High Museum, Atlanta, *Monet in London*, catalogue of an exhibition by Grace Seiberling, 1988; Boston Museum of

Fine Arts, *Monet in the Nineties*, catalogue of an exhibition by Paul Hayes Tucker, pp.253-67.

2. At this time the memory of the controversy over the acceptance of the Caillebotte Bequest, which finally went on show in the Musée du Luxembourg in 1897, must have been fresh. For further reference see Kirk Varnedoe, *Gustave Caillebotte*, 1987, pp.197-204.

3. E.R. and J. Pennell, *The Life of James McNeill Whistler*, vol. 2, 1908, p.223

4. There were for instance, two Monets, four Pissarros, two Renoirs and a Sisley shown in the second exhibition in 1899, but these efforts were overtaken by Durand-Ruel who took over the Hanover Gallery in the spring of 1901 for a show which included nine Monets, ten Pissarros, nine Renoirs and nine Sisleys.

5. MaryAnne Stevens ed., *op cit.*, pp. 252-57.

6. For further reference to these visits see, Ralph E. Shikes and Paula Harper, *op.cit.*, pp.265-66 and 296-97. See also Nicholas Reed, *op. cit.*, 1990.

7. The products of Monet's London sojourns have been extensively considered, see for example John House, 'London in the art of Monet and Pissarro', in Barbican Art Gallery, *The Image of London, views by Travellers and emigrés, 1550-1920*, catalogue of an exhibition by Malcolm Warner, 1987, pp.73-98; High Museum, Atlanta, *Monet in London*, catalogue of an exhibition by Grace Seiberling, 1988; Museum of Fine Arts, Boston, *Monet in the '90s, The Series Paintings*, catalogue of an exhibition by Paul Hayes Tucker, 1989, pp.256-67. Monet's three visits occurred September-October 1899, February-April 1900 and January-April 1901.

8. René Gimpel, *Diary of an Art Dealer*, 1992, p.73.

9. Frank Rutter, *Art in My Time*, 1933, p.114-16; see also Frank Rutter, *Sunday Times*, 22 January 1905, p.4, quoted in Kate Flint ed., *op.cit.*, pp.214-17, Frank Rutter, *Since I was Twenty-five*, 1927, pp.154-60.

10. Kate Flint ed., *op.cit.*, reproduces reviews from *The Times*, *Sunday Times*, *Manchester Guardian* and *Standard*.

11. Frank Rutter, *op.cit.*, 1933, p.106.

12. Valuable research on Lane's origins is contained in Barbara Dawson, 'Hugh Lane and the Origins of the Collection', in Hugh Lane Municipal Gallery of Modern Art, Dublin, *Images and Insights*, catalogue of an exhibition, 1993, pp.13-31.

13. Frank Rutter, *op. cit.*, 1927, pp.174-79. Rutter was introduced to Lane for the first time by Durand-Ruel in the Grafton Gallery in 1905.

14. Lane's letter to Lavery is contained in the Tate Gallery Archives (7245.30) and quoted in Kenneth McConkey, *op. cit.*, 1993, pp.149-50. For a brief account of Lane's ambitions for this exhibition see Kenneth McConkey, *A Free Spirit – Irish Painting, 1860-1960*, 1990, pp.13-16.

15. For further reference to Lane's and Orpen's adventures see Sir William Orpen RA, *Stories of Old Ireland and Myself*, 1924, pp.49-61; Bruce Arnold, *William Orpen, Mirror to an Age*, 1981, pp.124-29, 143-46.

16. The best short account of this sequence of events is given in Jeanne Sheehy, *The Rediscovery of Ireland's Past: the Celtic Revival, 1830-1930*, 1980, pp.107-19

17. *ibid.*, p.116.

18. Bruce Arnold, *op.cit.*, pp.227-36; Kenneth McConkey, *Edwardian Portraits*, 1987, pp.200-02; Pyms Gallery, *Orpen and the Edwardian Era*, catalogue of an exhibition by Kenneth McConkey, 1987, pp.9-11, 82-85.

19. George Moore, *Reminiscences of the Impressionist Painters*, 1906, pp.19-20.

20. See for instance Alice Meynell, who had reported on Captain Hill's collection for *The Magazine of Art* in 1882, (see chapter 1), but who made it clear that swallowing Impressionism was as far as she would go, see *Essays*, 1914 (1930ed.), pp.165-68.

21. George Moore, *op.cit.*, 1906, pp.14-17.

22. William E. Henley, *A Century of Artists*, 1888; Philip G. Hamerton, *The Present State of the Fine Arts in France*, 1892; Walter C. Brownell, *French Art, Classic and Contemporary*, 1901; Mrs Arthur Bell, *Representative Painters of the Nineteenth Century*, 1899; J.E. Phythian, *Fifty Years of Modern Painting, Corot to Sargent*, 1908; Haldane MacFall, *A History of Painting, The Modern Genius*, n.d. (c.1910); D.S. MacColl, *Nineteenth-Century Art*, 1902; George Moore, *Modern Painting*, 1893 and *Reminiscences of the Impressionist Painters*, 1906; John van Dyke ed., *Modern French Masters*, 1896.

23. Richard Muther, *The History of Modern Painting*, 1895; Julius Meire-Graefe, *Modern Art, being a contribution to a new system of aesthetics*, 1908, (trans. P.G. Konody).

24. J. Benedite, *Great Painters of the Nineteenth Century*, 1910; Camille Mauclair, *The Great French Painters*, 1903 and *The French Impressionists*, 1903.

25. John van Dyke, Mrs Arthur Bell and Richard Muther had included chapters or substantial sections on these painters. Later writers, as they singled out the Impressionists for special scrutiny, were obviously helping to create the phenomenon. In Mauclair's case he includes the modern academic painters in his companion volume, *The Great French Painters*, a somewhat jumbled account which gives priority to illustrations of the work of the Impressionists. The degree to which this understanding established its own consensus depended less upon a full appreciation of the contents of the Impressionist exhibitions as on a perception of advanced technique and a general interest in contemporary subject matter.

26. As when he declares that Monet's *Impressions* was shown at the Salon des Refusés in 1863 (Popular Library of Art ed. p.20).

27. *ibid.*, p.111.

28. Wynford Dewhurst, *Impressionist Painting, Its Genesis and Development*, 1904, was dedicated to Monet.

29. Wynford Dewhurst, 'What is Impressionism?', *Contemporary Review*, vol. XCIX, 1911, p.300.

30. 'Claude Monet, Impressionist', *Pall Mall Magazine*, June 1900; 'A Great French Landscapist', *The Artist*, October 1900; 'Impressionist Painting; its Genesis and Development', parts 1 and 2, *The Studio*, vol. XXXIX, April and July 1903.

31. Variously quoted and translated, John Rewald, *op.cit.*, p.258; the original letter, dated 6 Nov 1902, to Dewhurst is transcribed in *The Studio*, vol. XXIX, July 1903, p.94.

32. John Rewald ed., *Camille Pissarro Letters to his son, Lucien*, 1943, pp.355-56; see also Anne Thorold ed., *The Letters of Lucien to Camille Pissarro, 1883-1903*, 1993, pp.741-45, 766-67.

33. Wynford Dewhurst, *op.cit.*, 1904, p.61.

34. *ibid.*, pp.61, 80.

35. George Clausen, *Royal Academy Lectures on Painting*, 1913, p.128; John Rothenstein, *Nineteenth Century Painting*, 1932, p 178; Kenneth Clark, *Landscape into Art*, 1949, (Pelican ed., 1956), pp.86-107.

36. Wynford Dewhurst, *op.cit.*, 1911, p.296.

37. Anne Thorold, *A Catalogue of the Oil Paintings of Lucien Pissarro*, 1983, pp.72-84.

38. Malcolm Easton, 'Lucien Pissarro and his Friends at Rye', in Parkin Gallery, *Three on Holiday at Rye, 1913*, catalogue of an exhibition, 1980. See also David Buckram, *James Bolivar Manson, 1879-1945*, catalogue of an exhibition at Maltzahn Gallery, London, 1973.

39. It is possible that Sickert admired Lucien Pissarro's work precisely because of its conservatism. In 1910 he incorporated Pissarro into his artistic lineage: 'I am a pupil of Whistler, and, at one remove, of Courbet, and, at two removes, of Corot. About six or seven years ago, under the influence in France of Pissarro, himself a pupil of Corot, aided in England by Lucien Pissarro and by Gore' (Osbert Sitwell ed., *op.cit.*, 1947, p.4). He was even more effusive in 1914 when he wrote that Lucien was, 'an original talent ... the pupil of his father, the authoritative depository of a mass of inherited knowledge and experience, [he] has served us as a guide, or, let us say, a dictionary of theory and practice on the road we have elected to travel'.

40. Osbert Sitwell ed., *op.cit.*, p.4.

41. *ibid.*, p.15. Sickert had used the phrase *'la bonne peinture'* in 1891 in his essay on 'Modern Realism in Painting', to describe the methods of the ateliers.

42. Frederick Wedmore, *Painters and Painting*, 1912, p.189.

43. *The Burlington Magazine*, vol. XII, February 1908, pp.272-73.

44. Roger Fry, 'An Essay in Aesthetics', in *Vision and Design*, 1920 (Pelican reprint 1961), pp.29-30.

45. *Burlington Magazine*, vol. XII, March 1908, pp.374-76.

46. John Rothenstein, *op.cit.*, p.154.

The London Impressionists by
Anna Gruetzner Robins

* All works discussed in this essay were exhibited at the Goupil Gallery, with the exception of Gatti's *Hungerford Palace of Varieties*.

1. Herbert Vivian, 'Topical Interviews: IV – Mr Walter Sickert on Impressionist Art', *Sun*, 8 September 1889.
2. Seven of the twenty Monets at Goupils were 1880s seascapes.
3. *Sun*, 8 September 1889.
4. Walter R. Sickert, 'Paul Maitland', preface to an exhibition catalogue, The Leicester Galleries, London 1928, reprinted in Osbert Sitwell ed., *W. Sickert, A Free House, being the Writings of Walter Richard Sickert*, 1947, pp.273-/4.
5 Francis Bate, 'The Tendencies of Modern Art', *The Artist and Journal of Home Culture*, known as the *Artist*, June 1889, pp.5-6. The paper was read to the Liverpool Art Congress in December 1888.
6. Anon., 'The Gospel of "Impressionism". A Conversation Between Two Impressionists and a Philistine', *Pall Mall Gazette*, 21 July 1890.
7. It was a N.E.A.C rule that no pictures would be shown whether borrowed directly from the artist or not, without the agreement of the artist.
8. *Land and Water*, 7 December 1889.
9. See Anna Gruetzner, 'Degas and George Moore: Some Observations about the Last Impressionist Exhibition.', in Richard Kendall ed., *Degas*, 1985, pp.32-39.
10. For the new criticism see John Stokes, 'Its the Treatment not the Subject. First Principles of the New Art Criticism, *In the Nineties*, 1989.
11. *Artist*, 1 November 1889.
12. *Sun*, 8 September 1889.
13. See Hollis Clayson's exemplary study, 'A Failed Attempt' which plots this myth-making aspect in the critical reactions to the 1876 French Impressionist exhibition in Charles S. Moffet ed,. *The New Painting*, 1986.
14. Anon., 'Two Picture Exhibitions in London', *Leeds Mercury*, 3 December 1889.
15. Anon., probably R.A.M. Stevenson, 'The London Impressionists', *Saturday Review*, 21 December 1889, p.708.
16. George Moore, 'Impressionism', *Hawk*, 17 December 1889, p.670.
17. For the debate about Nationalism see Anna Gruetzner, 'Two Reactions to French Painting in Great Britain', *Post-Impressionism*, 1979-80, pp.178-182, and Kenneth McConkey in this catalogue.
18. *Sun*, 8 September 1889.
19. Signed G. T. but introduced as one of 'the group of London Impressionists', '"Impressionists" in London', *Pall Mall Gazette*, 29 November 1889.
20. See D.S. MacColl, *The Life, Work and Setting of Philip Wilson Steer*, London, 1945 pp.177-78 and also Y. Holt *Philip Wilson Steer*, Bridgend, 1992, pp.50-52.
21. Artist Unknown, (Initially Joseph Pennell but by late 1889 Elizabeth Robins Pennell), 'London Impressionists', *Star*, 3 December 1889.
22. Walter R. Sickert, 'The Whirlwind Diploma Gallery of Modern Pictures' 1, *Whirlwind*, 12 July 1890.
23. See Timothy J. Clark, *The Painting of Modern Life: Paris in the Art of Manet and His Followers*, 1984, Richard Shiff, *Cézanne and the End of Impressionism*, 1984.
24. *Pall Mall Gazette*, 21 July 1890.
25. Sickert's preface, 'A Collection of Paintings by London Impressionists', Goupil Gallery, London, December 1889. Reprinted Wendy Baron & Richard Shone, eds. *Sickert Paintings*, London 1992, pp.58-59.
26. Walter R. Sickert, 'The Royal Academy Exhibition', *Art Weekly*, 10 May 1890, p.36. *Art Weekly* was edited by Francis Bate and Arthur Tomson.
27. See Alex Potts, 'Picturing the Modern Metropolis: Images of London in the Nineteenth Century,' *History Workshop Journal*, autumn 1988, pp.28-56 for a discussion of an earlier response.
28. See Anna Gruetzner Robins, 'Sickert Painter-in-ordinary to the Music-Hall,' *Sickert Paintings*, pp.13-24.
29. *Music Hall*, 9 September 1888.
30. C. A. Gillig, *London Guide*, 1890.
31. See John House, 'The Impressionist vision of London', in I.B. Nadel and F. S. Schwarzbach eds., *Victorian Artists and the City*, 1980 pp.78-90 and John House 'London in the Art of Monet and Pissarro, *The Image of London*, ed. M. Warner, London 1987, pp.73-98.
32. See Griselda Pollock, 'Vicarious Excitements: London; a Pilgramage by Gustav Doré and Blanchard Jerrold,' *New Formations*, 4, Spring 1988 pp25-51 for a stimulating discussion of Doré's representation of this key site.
33. *Pall Mall Gazette*, 21 July 1890.
34. Henry James, *The Princess Casamassima*, 1982, p.51. The novel was first published in 1886. Its relationship to Whistler's painting is the subject of a forthcoming study.
35. See Robin Spencer, 'The aesthetics of Change, London as seen by Whistler' in Malcolm Warner ed., op. cit., pp.49-72.
36. Walter R. Sickert, 'The Whirlwind Diploma Gallery of Pictures 11', *Whirlwind* 19 July 1890, p.51.
37. C.R. Sims, *How the Poor Live*, 1883.
38. 'S', (M.H. Spielmann), 'The London Impressionists', *Echo*, 5 December 1889.
39. *Star*, 3 December 1889.
40,. Frederick Wedmore, *Academy*, 7 December 1889.
41. *Stock Exchange*, 14 December 1889.
42. *Sunday Chronicle*, 15 December 1889.

Bibliography

Monographs of individual artists are given in the catalogue. Magazine articles are cited, where relevant in the text. Dealers' catalogues, save for a few notable early exhibitions, are not listed.

Books

Bate, Francis, *The Naturalistic School of Painting*, 1887

Bell, Mrs Arthus, *Representative Painters of the Nineteenth Century*, 1899

Bénédite, Léonce, *Great Painters of the Nineteenth Century*, 1910

Billcliffe, Roger, *The Scottish Colourists*, 1990

Billcliffe, Roger, *The Glasgow Boys*, 1985

Boime, Albert, *The Academy and French Painting in the Nineteenth Century*, 1971

Brownell, W.C., *French Art, Classic and Contemporary*, 1901

Chesneau, Ernest, *The English School of Painting*, 1885

Chesneau, Ernest, *The Education of the Artist*, 1886

Clark, Kenneth, *Landscape into Art*, 1949

Clausen, George, *Royal Academy Lectures on Painting*, 1913

Collier, Hon. John, *A Manual of Oil Painting*, 1891 [5th ed.]

Cooper, Douglas, *The Courtauld Collection*, 1954

Dewhurst, Wynford, *Impressionist Painting, Its Genesis and Development*, 1904

Distell, Anne, *Impressionism: the First Collectors*, 1990

Farr, Dennis, *English Art, 1870-1940*, 1978

Flint, Kate, ed., *Impressionists in England, The Critical Reception*, 1904

Fox, Caroline, *Stanhope Forbes and the Newlyn School*, 1993

Fox, Shirley, *An Art Student's Reminiscences of Paris in the Eighties*, 1909

Frayling, Christopher, *The Royal College of Art, One Hundred and Fifty Years of Art and Design*, 1987

Fry, Roger, *French, Flemish and British Art*, 1951

Fry, Roger, 'An Essay in Aesthetics', in *Vision and Design*, 1920

Fry, Roger, *Transformations: Critical and Speculative Essays on Art*, 1926

Gerdts, William H., *American Impressionism*, 1984.

Gerdts, William H., *Monet's Giverny, An Impressionist Colony*, 1993

Gerdts, William H., *Lasting Impressions – American Painters in France, 1865-1915*, 1992

Gillet, Paula, *The Victorian Painter's World*, 1990

Gimpel, René, *Diary of an Art Dealer*, trans. John Rosenberg with an Introduction by Sir Herbert Read, 1966

Hamerton, P.G., *The Present State of the Fine arts in France*, 1892

Harker, Margaret F., *The Linked Ring, The Secession in Photography: 1892-1910*, 1979

Harrison, Charles, *English Art and Modernism, 1900-1939*, 1981

Henley, W.E., *A Century of Artists*, 1888

Herbert, Robert L, *Impressionism, Art, Leisure and Parisian Society*, 1988

Hind, C. Lewis, *Landscape Painting, Vol. 2. From Constable to the Present Day*, 1924

Holmes, C.L., *Self and Partners (Mostly Self)*, 1936

Jackson, Hobrook, *The Eighteen-Nineties*, 1913

James Henry, *The Painter's Eye. Notes and Essays on the Pictorial Arts*, with an introduction by John L. Sweeney, 1966

Laidlay, William J., *The Royal Academy, Its Uses and Abuses*, 1898

Laidlay, William J., *The Origin and First Two Years of the New English Art Club*, 1907

Lecoq de Boisbaudran, Horace, *The Training of the Memory in Art and the Education of the Artist*, trans, L.D. Luard, with an introduction by Selwyn Image, 1911

Leslie, C.R., RA, *Handbook for Young Painters*, 1854

Low, Will H., *A Chronicle of Friendships, 1873-1900*, 1908

MacColl, D.S., *Nineteenth Century Art*, 1902

MacFall, Haldane, *A History of Painting, The Modern Genius* n.d. (c.1910)

Mauclair, Camille, *The Great French Painters*, 1903

Mauclair, Camille, *The French Impressionists*, 1903

McConkey, Kenneth, *British Impressionism*, 1989

McConkey, Kenneth, *A Free Spirit – Irish Painting, 1860-1960*, 1990

McConkey, Kenneth, *Edwardian Portraits*, 1987

Meire-Graefe, Julius, *Modern Art, being a contribution to a new system of aesthetics*, 1908, (trans. P.G. Konody)

Moore, George, *Confessions of a Young Man*, 1888

Moore, George, *Memoirs of My Dead Life*, 1906

Moore, George, *Modern Painting*, 1893, and revised edition, 1898

Moore, George, *Reminiscences of the Impressionist Painters*, 1906

Muther, Richard, *The History of Modern Painting*, 1895

Phythian, J.E., *Fifty Years of Modern Painting*, 1895

Quilter, Harry, *Senteniae Artis*, 1886

Rewald, John, *The History of Impressionism*, (1961 ed.)

Rothenstein, John, *A Pot of Paint, The Artists of the 1890s*, 1929

Rothenstein, John, *Modern English Painters*, vol. 1, 1952

Rothenstein, John, *Nineteenth Century Painting*, 1932

Rothenstein, William, *Men and Memories*, 1931

Rutter, Frank, *Art in My Time*, 1933

Rutter, Frank, *Modern Masterpieces with an Outline of Art*, n.d.

Rutter, Frank, *Since I was Twenty-five*, 1927

Sheehy, Jeanne, *The Rediscovery of Ireland's Past the Celtic Revival, 1830-1930*, 1980

Sitwell, Osbert, ed. *A Free House, or the Artist as a Craftsman, being the Writings of Walter Sickert*, 1947

Spalding, Frances, *British Art Since 1900*, 1986

Stevenson, R.A.M., *Velázquez*, 1895

ten-Doesschate Chu, Petra, 'Lecoq de Boisbaudran and Memory Drawing, a Teaching Course between Idealism and Naturalism', in Gabriel P. Weisberg ed. *The European Realist Tradition*, 1983, pp.242-89

Thornton, Alfred, *The Diary of an Art Student in the Nineties*, 1938

Thornton, Alfred, *Fifty Years of the New English Art Club, 1886-1935*, 1935

Van Dyke, John, ed. *Modern French Masters*, 1896

Watney, Simon, *English Post-Impressionism*, 1980

Wedmore, Frederick, *Painters and Painting*, 1912

Wedmore, Frederick, *Some of the Moderns*, 1909

Weisberg, Gabriel P., *Beyond Impressionism, The Naturalist Impulse*, 1992

Weisberg, Gabriel P., *The Realist Tradition, French*

Painting and Drawing, 1830-1900, 1980

Wiesberg, Gabriel P, *Philippe Burty and the Visual Arts of Mid-nineteenth Century France*, 1993

Worley, Lana, *British Impressionism, A Garden of Bright Images*, 1989

Zola, Emile, *Le bon combat: de Courbet aux impressionistes*, 1975

Exhibition Catalogues

Birmingham, City Art Gallery, *The New English Art Club*, catalogue of an exhibition with introduction by Mary Woodall, 1952.

Bradford, Cartwright Hall, and Hull, Ferens Art Gallery, *English Impressions*, catalogue by Caroline Krzesinska.

Bradford, Museums and Art Galleries, *The Connoisseur, Art Patrons and Collectors in Victorian Bradford*, published in association with an exhibition at Cartwright Hall, 1989.

Brighton, The Royal Pavilion, Art Gallery and Museums, *The Dieppe Connection, The Town and its Artists from Turner to Braque*, with an essay by Anna Gruetzner Robins, 1992.

Brighton, The Gallery, Brighton Polytechnic, *Made at the Slade*, catalogue of an exhibition by Julian Freeman, 1978.

Bristol, City Art Gallery and Newlyn, Orion Gallery, *Artists of the Newlyn School, 1880-1900*, catalogue of an exhibition by Caroline Fox and Francis Greenacre, 1979.

Cologne, Wallraf-Richartz Museum, *Landschaft im Licht, Impressionistische Malerei in Europa und Nordamerika, 1860-1910*, catalogue edited by Götz Czymmek, 1990.

Columbus, Ohio, The Columbus Gallery of Fine Arts, *British Art, 1890-1928*, catalogue of an exhibition by Denys Sutton, n.d.

Dublin, National Gallery of Ireland, *The Irish Impressionists, Irish Artists in France and Belgium, 1850-1910*, catalogue by Julian Campbell, 1984.

Dublin, Hugh Lane Municipal Gallery of Modern Art, *Images and Insights*, catalogue of an exhibition, 1993.

Glasgow, Scottish Arts Council, *The Glasgow Boys*, catalogue by Alistair Auld et al., 1968.

Helensburgh and District Art Club, *Helensburgh and the Glasgow School*, catalogue of an exhibition by Ailsa Tanner, 1972.

London, Barbican Art Gallery, *The Image of London, views by Travellers and Emigrés, 1550-1920*, catalogue of an exhibition by Malcolm Warner, 1987.

London, Barbican Art Gallery, *Painting in Newlyn, 1880-1930*, catalogue by Caroline Fox and Francis Greenacre, 1985.

London, Christie's, *The New English Art Club Centenary Exhibition*, with an introduction by Anna Gruetzner Robins, 1986.

London, Fine Art Society, *Channel Packet*, 1969.

London, Fine Art Society, *The Early Years of the New English Art Club*, catalogue of an exhibition with an introduction by Bevis Hillier, 1968.

London, Hayward Gallery, Arts Council of Great Britain, *The Impressionists in London*, catalogue of an exhibition by Alan Bowness and Anthea Callen, 1973.

London, The Parkin Gallery, *The London Impressionists*, with an introduction by Michael Parkin, 1975.

London, Pyms Gallery, *Edwardian Impressions*, 1981.

London, Royal Academy of Arts, *Impressionism, its Masters, its Precursors and its influence in Britain*, catalogue by John House, 1974.

London, Royal Academy of Arts, *Post-Impressionism*, catalogue of an exhibition, (British section Anna Gruetzner) 1979.

London, Royal Academy of Arts, *The Edwardians and After, The Royal Academy 1900-1950*, catalogue by MaryAnne Stevens et. al, 1988.

London, Royal Academy of Arts, *The Slade, 1871-1971*, catalogue of an exhibition with introduction by Bruce Laughton, 1971.

London, Victoria and albert Museum, *The Golden Age of British Photography*, catalogue of an exhibition, 1984.

Marlow, the Studio, Lords Wood, *A Breath of Fresh Air*, 1974.

Melbourne, National Gallery of Victoria, *Golden Summers, Heidelberg and Beyond*, a catalogue of an exhibition by Jane Clark and Bridget Whitelaw, 1985.

New York, Wildenstein, *From Realism to Symbolism, Whistler and his World*, catalogue of an exhibition with essays by Allen Staley and Theodore Reff, 1971.

Newcastle upon Tyne, Polytechnic Art Gallery, *Peasantries*, catalogue of an exhibition by Kenneth McConkey, 1981.

Nottingham, Castle Museum, *British Impressionism*, catalogue of an exhibition by Hilary Taylor, 1989.

Nottingham, Castle Museum, *The Staithes Group*, catalogue of an exhibition by Peter Phillips, 1993.

Washington, National Gallery of Art, *The New Painting, Impressionism, 1874-1886*, catalogue of an exhibition by Charles S. Moffett, et al., 1986.

Index

This index covers the main text, pages 11 to 96, and the illustrations included in those pages.

l'*Absinthe* (*In a Café*) (Degas) 16-17, *16*, 57, 77, 96
The Academy 17, 88
Ackroyd, William 38
Adam, Patrick William 62
Agnew's 16
Allingham, Helen 74
Alma-Tadema, Lawrence 12, 13
Andante (Steer) 42, *42*
Les Andelys 82
 Château Gaillard 64
Anquetin, Louis 58
Apple Gathering, Quimperlé (Osborne) 25, *25*
Arcadian Art Club 38
The Architect 18
Argenteuil 57
Argenteuil (*Les Canotiers*) (Manet) 18, *19*
Armstrong, Elizabeth 87
Armstrong, Thomas 14
The Art Chronicle 82
Art Journal 36
Art Workers' Guild 53, 89
The Artist 55, 88
The Artist's Daughter, Nancy, as a Pierrot (Pryde) 6
Arts and Crafts Exhibition Society 50
Un atelier aux batignolles (Fantin-Latour) 11
Austin, Alfred, *Haunts of Ancient Peace* 74
An Autumn Morning (La Thangue) 52, *52*

La Baignade (William Stott) 22, 23
Le Baisser du rideau (Degas) 50
Baldry, Alfred Lys 88, 96
The Ballet from 'Robert le Diable' (Manet) 16
Barbizon 12, 23
 School 16, 30, 72
The Barge (Roussel) 93
Barlow, John Noble 63
Barlow, Samuel 16
Barnard, Polly and Dorothy 44
Bartlett, William Henry 22, *22*
Bastien-Lepage, Jules 13, 20-21, 22, 26, 27, 31, 32, 36, 38, 42, 47, 51, 63, 64, 66, 74, 85, 89
The Bat 88
Bate, Francis 87, 88, 96
Bate, Percy 68
Bathers (Tuke) 32, *33*
Baudelaire, Charles 14, 63, 93
Beach Scene Dieppe (Conder) *65*
The Beach, Walberswick (Steer) 90
Bell, Mrs Arthur 81, 82
Bellingham-Smith, Hugh 53
Bénédité, Leonce 81
Besnard, Albert 58
Blanche, Dr Emile 34
Blanche, Jacques-Emile 33, 34,

41, 48, 56, 62
Blue Thames, End of A Summer Afternoon, Chelsea (Roussel) 93, *95*
Blunt, Mr and Mrs Arthur 64
Boat-Building Yard (La Thangue) 36
The Boating Party (Sargent) 46, *47*
Bonnard, Pierre 78
Bords de Mer (Harrison) 46
Bouguereau, Adolphe 20
The Bow Net (Goodall) 28, *29*
Brabazon Brabazon, Hercules 55, 75
Bradford 36, 38, 74, 77, 82
 Art Guild 38
Bramley, Frank 36, 49
Bredon on the Avon (Parsons) 74
Breton Girl Carrying a Jar (Clausen) 26, *26*
Breton, Jules 19, 26, 31
Bretonnes au pardon (Dagnan-Bouveret) 78
The Bridge at Grez (Lavery) 25, *67*
The Bridge (Steer) 42
Brittany 25, 46, 54
Broadway, Worcestershire 43, 46, 67, 74
Brown, Fred 18, 38-9, *39*, 48, 53-4, 59, 87, 88
Brown, James 83
Brown, John Arnesby 62, 69-70, 73, 82
Brownell, Walter C. 81
The Browning Readers (Rothenstein) 62
The Budding Tree (Maitland) 96
The Burlington Magazine 84
Burne-Jones, Edward 50
Burty, Philippe 17
The Butcher's Shop see *Twilight*
Butin, Ulysse 61
Buveurs d'eau (Murger) 22
By an Old Mill Stream (Bate) 96
By the Sea (Thomson) 90

Cabanel, Alexandre 29
Calcot 46
Camera Club 51
Cancale 25
Carnation, Lily, Lily, Rose (Sargent) *frontispiece* 43-4, 74
Carolus-Duran, Emile 14, 20, 23, 46, 61, 82
Castagnary, Jules-Antoine de 17
Cazin, Jean-Charles 14, 75
Century Guild 50
Cézanne, Paul 77, 80, 84, 85
Chantrey Bequest 62, 74
Charles, James 36-7
Chatterboxes 42
Chepstow Castle 76
Chesneau, Ernest 17, 30, 31-2
Children Paddling, Walberswick (Steer) 55-6, *56*
Childwick Green 27
The Cinder Path (B. Sickert)

96
The City Atlas (Starr) 48, 87, 92
Clark, Kenneth 82
A Classic Landscape, Richmond (Steer) 57, *58*
Claude Lorrain 82
Claus, Emile 36, 82
Clausen, George *front cover* 11, 18, 20, 26, 27, 28, 32, 36, *36*, 38, 39, 65-6, *65*, 66, 67, 69, 70, 74, 82
The Close of Day (Legros) 14
Clouet, Jean 82
Cobden, Ellen 87
Cobden family 53
Cockburnspath 27
Cole, George Vicat 75
Collier, Hon., John 20
Colnaghi, Martin 32
Colnaghi's 80
Conder, Charles 58-9, *58*, 63-4, *64*, *65*
The Confessions of Claude (Rutherston) 62, *62*
Connard, Philip 64
The Connoisseur (La Thangue) 38
Constable, John 55, 64, 72, 75, 76, 82, 89
Cookham Dean 66
Corkran, Alice 23
Corot, Jean-Baptiste-Camille 30, 64, 75, 82
The Coster Girls (Rothenstein) 59, 60-61
Cotterel, de 16
Courbet, Gustave 14, 83
Couture, Thomas 20
Cowes 18
Cradle Song (Hacker) 36
Crome, John 82, 89
Cullercoats 28

Dagnan-Bouveret, Pascal-Adolphe-Jean, 36, 61, 65, 78, 82, 89
Dance Class at the Opéra (Manet) 16
The Dance Class (Degas) 16
Daniel, Augustus 53, 59
Daniel Tomkins and his Dog (Munnings) 69
Daubigny, Claude-François 15, 16
Davison, George 51-2, *51*
Dawson-Watson, Dawson 63, 64
de Glehn, Jane Emmet 68, 75
de Glehn, Wilfrid 64, 68, 75
Degas, Hilaire Germain-Edgar 12, 13, 16, *16*, 17, 19, 26, 30, 34, 35, 42, 48, 49, 50, 54, 59, 61, 62, 77, 78, 80, 88, 89, 90, 96
Delacroix, Eugène 11, 68
Dennemont 64
Dennis Miller Bunker at Calcot (Sargent) 46
Deschamps, Charles 18, 19
Dewhurst, Wynford 12, 64, 82, 83, *83*
Dieppe 62
 l'Hôtel Royal 53

Dolce far Niente (Sargent) 75, *75*
The Doll's House (Rothenstein) 62
Douglas, Lord Alfred 63
Dow, Thomas Millie 20
Dowdeswell's Gallery 30, 33, 42
Doyle, Arthur Conan 92
du Maurier, George 14
Dublin 11, 80
Dudley Gallery 32, 48, 52
Duez, Ernst-Ange 20, 42, 89
Dupeaux, François 79
Durand-Ruel, Paul 15-16, 18, 19, 30, 42, 78, 79-80, 81
Duranty, Edmond 17, 48
Duret, Theodore 15
Dutch Gallery 75
Dyce, Sterling 63

East, Alfred 12, 40, 64, 74, *74*, 75, *76*
East Molesey 18
The Echo 95
The Education of the Artist (Chesneau) 30, *31*
Edward, Prince of Wales (later Edward VII) 33
Edwards, Mr and Mrs Edwin 14
Eliot, T.S. 63
The Embarkment (Steer) 76, *76*
Emerson, Peter Henry 28-9, *29*, 51, 52
En Arcadie (Harrison) 46
The English School of Painting (Chesneau) 30
Eragny 76
Eva Gonzales (Manet) 11, *12*, 80
Evening Song (Clausen) 65, 66
l'*Ex-Voto* (Legros) 14, *14*
The Execution of the Emperor Maximilian (Manet) 78

La Falaise à Penarth, Le soir, marée basse (Sisley) 78
Fantin-Latour, Henri 11, 12, *12*, 14, 15
Farquharson, Joseph 38
Faure, Jean-Baptiste 18
February Fill Dyke (Leader) 75
Femmes d'Alger (Delacroix) 68
Fergusson, John Duncan 62
The Fifer (Manet) 16
Firmin-Girard, Marie François 36
Fisher, Mark 30, 38, 53, 63, 75-6
A Fisherman's Head (Forbes) 36
Fladbury 46, 67
Fletcher, Blandford 27, 28
Les Foins (Bastien-Lepage) 21, *21*
Fontainebleau 23, 74
Forain, Jean-Louis 58
Forbes, Elizabeth Stanhope 12, 21, 22, 25, *25*, 27, 36, 38, 65, 69, 70, 72, 87, 93
Fortnightly Review 30
Foster, Myles Birket 74
Fox Hill, Upper Norwood

(Pissarro) 16
Franco-Prussian War 15
Friant, Emile 65
Fry, Roger 44, 59, 64, 84-5
 An Essay on Aesthetics 84
Full Summer (Arnesby Brown)
 63, 70
Furse, Charles Wellington 53,
 54

Gainsborough, Thomas 32, 89
Galloway, Charles E., 38
A Garden in France (Lavery)
 67-8, 69
Garden Study of the Vickers
 Children (Sargent) 43, 44
Gatti's Hungerford Palace of
 Varieties: Second Turn of
 Miss Katie Lawrence (W.
 Sickert) 48, 91-2, 91
Gauguin, Paul 84
Géricault, Théodore 83
Gérôme, Jean Léon 52
Gervex, Henri 20, 34, 42
Gillig, Charles Alvin, London
 Guide 92
Gimpel, René 79
Giotto 89
Girls Running, Walberswick
 (Steer) 57
Giverny 11, 48, 58, 63, 79
Glasgow
 Institute of Fine Arts 78
 International Exhibition
 (1888) 50
 School 12, 13, 20, 27, 40,
 49, 50, 67, 78, 96
Glaspalast exhibition, Munich
 50
The Gleaners (Edward Stott)
 64
Gleyre, atelier 30
Gleyre, Charles 20, 22
Golden Autumn (East) 74, 75
Goodall, Thomas F. 28, 29
Gore, Spencer 83
Gosse, Edmund 44
Gotch, Thomas Cooper 36
Goupil Gallery 50, 87-8, 90,
 92, 95
 see also Impressionist
 exhibition, London
Government Art Training
 School 13-14
Grafton Galleries 57, 80
The Graphic 22, 34
Green Park, London (Monet)
 92, 93
Gregory, Edward John 19
Grey Weather, Finchingfield
 (Lucien Pissarro) 84
Grez-sur-Loing 23-5, 46
Grosvenor Gallery 20, 32, 36,
 42, 50, 74
Group Portrait (Rothenstein)
 54, 54
Guildhall 77, 80
Guthrie, James 49, 59, 67, 68

Hacker, Arthur 36, 62
Hall, Fred 36, 65
Hamerton, Philip G. 81
Hamilton, Maggie 67
Hammersley, Hugh 53
Hampton Court 18
Harbour Scene, Isle of Wight

(Morisot) 18
Hard Times (Fred Brown)
 38, 39
Hard Times (Herkomer) 38
Hardy, Thomas 70
Harmony in Blue and Gold
 (Whistler) 46
Harrison, Alexander 33-4, 46
Harvest-time (Fisher) 63, 64
The Hat Shop (Tonks) 59, 60
The Hawk 88, 89
Hawkins, Louis Welden 25
Haystacks, Giverny (Conder)
 64, 64
The Heart of the Surrey (Cole) 75
Helensburgh 27
Helleu, Paul 46, 67
Henley, W.E. 14-15, 59, 81
 London Voluntaries and
 London Types 63
Henry, George 40, 49, 50
Herkomer, Hubert von 38
Hill, Henry 16-17, 19, 57
Hind, Lewis 76
The Hireling Shepherd (Hunt)
 74
Hogarth, William 32, 59, 89
Holbein, Hans 89
Holl, Frank 34, 36
Holloway, Charles Edward 62
Holmes, C.J. 56, 72
Homage to Manet (Orpen) 11-
 12, 11, 80
Home Fields (Sargent) 43, 43
Hommage à Delacroix (Fantin-
 Latour) 11, 12, 15
Hone, Nathaniel 20
A Hopeless Dawn (Bramley) 49
Hornel, Edward Atkinson 40
l'Hôtel Royal, Dieppe (1893[?])
 (W. Sickert) 56, 56
l'Hôtel Royal, Dieppe (c. 1900-
 01) (W. Sickert) 53
Houses of Parliament, Effect of
 Fog (Monet) 79
Housman, A.E. 70
Hunt, William Holman 74
Huth, Louis 16
Hyde Park, London (Monet)
 15, 15

Impression, Sunrise (Monet) 89
Impressionist exhibition,
 London 50, 53, 54, 87-8,
 90, 92, 95
In a Café (Degas) see l'Absinthe
In an Orchard (Edward Stott)
 64
In Dunford Roughs (B. Sickert)
 90
In Kew Gardens (Thomson) 90
In the Dauphiné (La Thangue)
 36, 38
In the Heart of the West Riding
 (Priestmann) 77
In the Orchard (La Thangue)
 67
International Society of
 Sculptors, Painters and
 Gravers 50, 78

James, Francis 53, 87, 88
James, Henry 18-19, 43, 93
Jamieson, Alexander 12, 62,
 64
Japan 13, 40, 41

J.B.S. MacIlwaine (Osborne)
 69, 70
John, Augustus 11
Journal of Home Culture 88
Julian, atelier 20, 29, 38, 57, 64
Kahn, Gustav 88
Kay, Arthur 57
Keene, Charles 89
Kennedy, William 20, 25, 34,
 49, 49, 50
Kensington Gardens (Maitland)
 89
Kew Gardens (Thomson) 92
Khnopff, Fernand 78
Kinsella, Louise 64
Kipling, Rudyard 63
Knight, Buxton 64
Knight, Harold 70
Knight, Laura 12, 70
Knucklebones, Walberswick
 (Steer) 28, 28, 47, 48, 90

La Thangue, Henry Herbert
 11, 20, 25, 32, 36, 38, 49,
 52, 52, 65, 67, 69, 70, 82
Laidlay, William James 32, 38
Lane, Hugh 11, 12, 80
Langley, Walter 36
Larsson, Carl 25
Laurens, Jean-Paul 49, 82
Lavacourt under Snow
 (Vétheuil: Sunshine and
 Snow) (Monet) 81
Lavery, John 12, 20, 22, 25,
 49-50, 67-8, 69, 80
Lawson, Cecil 19
Le Gallienne, Richard 63
Leader, Benjamin Williams
 64, 75
Lecoq de Boisbaudran, Horace
 14
Leech, John 9
Leeds Mercury 89
Legros, Alphonse 14, 14, 16
Leighton, Frederic 12, 13, 14,
 32
Leslie, C.R. 13
Leyland (Whistler) 39
Lhermitte, Leon 14, 36, 78
Life and Landscape on the
 Norfolk Broads (Goodall
 and Emerson) 28
Lindsay, Sir Coutts and Lady
 Blanche 20, 32
'The Linked Ring' 52
Linton, James D. 31
Lion Comique (W. Sickert) 48
Little Dot Hetherington at the
 Bedford (W. Sickert) 92
The Little Flowers of the Field
 (Clausen) 66, 67
London 18, 62-3, 79-80, 91-6
 Battersea 93
 Brompton Oratory 62
 Charing Cross 91-2
 Charing Cross Bridge
 79
 Chelsea 93-5
 County Council 91
 Hyde Park 92-3
 Savoy Hotel 79
 Waterloo Bridge 79
The Looking Glass (Steer) 61-2
Loudan, Mouat 25
Luard, L.D. 14
Ludlow Walks (Steer) 76, 77

Ludovici, Albert, jun. 33

MacColl, D.S. 12, 38, 53, 54-5,
 56-7, 62, 64, 81, 96
McEvoy, Ambrose 62
MacFall, Haldane 81
Maddocks, John, collection 36,
 74, 82
The Magazine of Art 15, 38, 70
Maitland, Paul 34, 39, 87, 88,
 89, 90, 93, 95, 96
Manet, Edouard 11-12, 12, 13,
 14, 16, 18, 20, 30, 39, 44,
 51, 62, 78, 80, 83, 88, 89
Manet, Eugène 18
Manson, James Bolivar 83
Manual of Oil Painting
 (Collier) 20
The Marble Arch (Starr) 92, 93
Marlotte 23
Marne, river 23
Matisse, Henri 84
Mauclair, Camille 82
 The Great French Painters
 and The French
 Impressionists 81
Maufra, Maxime 82
Meier-Graefe, Julius, Modern
 Art 72, 81
Menpes, Mortimer 34, 35, 40,
 41
Metcalf, Willard Leroy 25, 28
Meunier, Jules-Alexis 65
Meynell, Alice 17
Midsummer (Guthrie) 67, 68
The Mill Stream (Steer) 90
Millais, John Everett 12, 30
Millet, Jean-François 21, 23,
 31, 48, 51
The Minister's Garden,
 Sandhurst (Lawson) 19
The Misses Vickers (Sargent) 43
Mitchell, Abraham, Tom and
 Herbert 38
Mme Gautreau (Sargent) 43
Molesey Weir, near Hampton
 Court (Sisley) 17, 18
Monet, Claude-Oscar 11, 13, 15,
 15, 17, 30, 31, 34, 42, 44-6,
 48, 49, 54, 56, 57, 59, 61,
 62, 63, 64, 66, 68, 75, 76,
 77, 78, 79-80, 79, 81, 82,
 84, 85, 87, 88, 89, 90, 92,
 93
Monet, Michel 79
Moniaive 27
Monticelli, Adolphe 76, 82
Moore, Albert 13, 88
Moore, Augustus 88
Moore, George 11, 29-30, 48,
 49, 53, 54, 55, 57, 62, 66,
 67, 68, 80, 81, 88, 89, 96
 Reminiscences of the
 Impressionist Painters
 80
Moore Hall, Co. Mayo 30
Morgan's Patent Plumbago
 Crucible Co. 93
Morisot, Berthe 18, 18, 77, 88
A Morning Walk (Sargent) 46
Morris, William 50
Mort et le bûcheron (Lhermitte)
 78
The Moulin Rouge (Conder) 58
The Mowers (Clausen) 66, 66
Mrs Cyprian Williams and her

two little Girls (Steer) 54
Mrs Frederick Barnard
 (Sargent) 43
Muhrman, Henry 78
Muirhead, David 53, 75
Munnings, Alfred 69
Mürger, Henri ('Paul') 22
Murray, David 74
Muther, Richard, History of
 Modern Painting 81, 82

Nabis 57
Nadar 17
National Art Training School
 14
National Gallery 80
National Temperance League
 95
Naturalistic Photography for
 Students of the Art
 (Emerson) 29, 51
The Neighbours (Bartlett) 22, 22
New Art Club 48
New English Art Club 11, 12,
 13, 32, 33, 35-6, 38, 39, 42,
 43, 47, 48-9, 53, 54, 56, 59,
 61, 62, 64, 75, 76, 77, 78,
 80, 84, 87, 88, 96
New Gallery 64, 74
New York Herald 50
New York Tribune 18-19
Newlyn School 12, 27, 36, 42,
 47, 49, 50, 65, 70, 96
Nicholson, William 59
Nocturne in Black and Gold:
 The Falling Rocket
 (Whistler) 19, 19
Nocturne in Blue and Gold:
 Westminster Bridge
 (Whistler) 31
Nocturnes (Whistler) 93
Normandy 25, 54
North Littleton 43
'Notes-Harmonies-Nocturnes'
 (exhibition) 33
La Nouvelle Peinture 48

October by the Sea (Osborne)
 46-7
An October Day in the Row
 (Thomson) 92
An October Morning (Osborne)
 27, 28
The Old Convent (Forbes) 25
The Old Plumbago Works
 (Roussel) 95
Olympia (Manet) 39
O'Meara, Frank 23, 25
On the Beach, Howth (Orpen)
 (front cover)
On the Pierhead (Steer) 42
The Onion Field (An Old
 Farmstead) (Davison) 51, 52
Oppenheimer, Joseph 62
Orchardson, Sir William 53
Orpen, William front cover, 11-
 12, 11, 59, 62, 80
Osborne, Walter 25, 25, 27-8,
 34, 46-7, 68, 69, 70, 80
The Outer Wall (Steer) 90
The Oxford Music Hall (W.
 Sickert) 92

Paddington (Starr) 34, 34
Paisley Lawn Tennis Club 67
Pall Mall Gazette 61, 88, 89

The Pall Mall Gazette 'Extra'
 36, 42
Pangbourne 43
Paris 11, 12, 13, 20, 21-2, 54,
 57, 58
 Ecole des Beaux Arts 30
 Ecole royale et spéciale
 du dessin et de
 mathématique (Petite
 ecole) 14
 Exposition Universelle
 (1867) 15
 Exposition Universelle
 (1878) 19
 Exposition Universelle
 (1889) 51
 Galerie Georges Petit 44
 Gare Saint Lazare 34
 Hôtel du Saxe 20
 Impressionist Exhibition
 (1874) 17
 Impressionist Exhibition
 (1886) 88
 Louvre 14
 Moulin Rouge 58
 Nouvelle Athènes café
 30
 Père Thomas' gallery 59
Parliament, Houses of 79
Parsons, Alfred 74-5, 74
Parton, Ernest 40, 63
Pas Mèche (Bastien-Lepage) 26
Pash, Florence 87-8
Le Passeur (The Ferry) (William
 Stott) 22-3, 23
Paul Helleu sketching with his
 Wife, Alice (Sargent) 46
Pegram, Fred 53
Penarth 79
Pennell, Elizabeth Robins 88,
 90, 96
Pennell, Joseph 88
Perry, Lilah Cabot 63
Phidias 89
Photographic Society's,
 Annual Exhibition, 1890
 52
Phythian, J.E. 81
The Picnic (Dewhurst) 82, 83
Piettes 30
The Pillars of St Martin's
 (Talmage) 62, 63
Pinder's circus 34
Pissarro, Camille 13, 15, 30,
 42, 55, 59, 62, 76, 77, 79,
 80, 82, 92
Pissarro, Lucien 12, 30, 48, 54,
 76, 79, 82, 83, 84
Plumbago Works, Raining
 Evening (Roussel) 93
Portrait of Charles Conder
 (Toulouse-Lautrec) 59
Portrait of Mortimer Menpes
 (Roussel) 39
Poussin, Nicolas 82
Poynter, Edward 14, 20
Pre-Raphaelites 13, 18-19, 32,
 36, 57, 72
Preparations for the Market,
 Quimperlé (Forbes) 25
Priestmann, Bertram 77
Primitives 13
Prinsep, Val 14
A Procession of Yachts, Cowes
 (Steer) 55
Proust, Marcel 82

Pryde, Mabel 6
The P.S. Wings in the O.P.
 Mirror (W. Sickert) 92
The Pub, Cheyne Walk
 (Roussel) 95
Purtud, Val d'Aosta 68
Puvis de Chavannes, Pierre
 20, 21, 58, 78

Quimperlé 26

The Reading Girl (Roussel)
 39-41, 40
The Red Shop (W. Sickert) 41,
 41
Redon, Odilon 78
Régamey, Frederic 14
Reid, Alexander 57
Reminiscences of the
 Impressionist Painters
 (Moore) 11
Renoir, Auguste 34, 62, 77, 78
Le repas des pauvres (Legros) 14
La République Française 17
La Revue Indépendante 88
Reynolds, Joshua 32, 54, 89
The River Bank (Arnesby
 Brown) 70
River Landscape by Moonlight
 (Henry) 49, 50
Roberts, Morley 20
Roberts, Tom 64
Robinson, Henry Peach 51, 52
Robinson, Theodore 63, 64
Roche, Alexander 20
Rossetti, Dante Gabriel 15, 20
Rothenstein, Charles 58
Rothenstein, John 82
Rothenstein, William 53, 54,
 54, 58-9, 61, 62, 63, 64, 85
Rotten Row (Roussel) 92
Roussel, Theodore 34, 39, 40,
 41, 87, 88, 90, 92, 93, 95,
 95, 96
Royal Academy 12, 14-15, 19,
 21, 30, 31, 32, 36, 38, 39
 43, 44, 49, 62, 65, 66, 70,
 73-4, 75, 77, 78, 89
 Schools 53
Royal Academy Pictures 72
Royal Architectural Museum,
 Westminster 53
Royal Institute of Painters in
 Oil Colours 32
Royal Institute of Painters in
 Watercolours 32
Royal Society of Arts 52
Ruskin, John 13, 18, 19, 20,
 30, 31, 32, 41, 72, 82, 83
 Elements of Drawing 82
 Modern Painters 14
Rutherston, Albert 62, 62
Rutter, Frank 80

Sarasate (Whistler) 39
Sargent, John Singer front
 cover 11, 43-6, 44, 46, 47,
 63, 66-7, 68, 74, 75, 76
The Saturday Review 56, 75, 89
The Seine Boat (Forbes) 70, 72
Seine valley 23, 25, 29, 36,
 75, 82
Setting the Bow Net (Emerson)
 29
Seurat, Georges 84
Sewing in the Shade (Lavery)

25, 25
Shaw, George Bernard 48
The Shepherdess (Clausen) 36,
 36, 74
The Shy Child (Clausen) front
 cover
Sickert, Bernhard 33, 87, 88,
 90, 96
Sickert, Walter 12, 30-31, 33,
 34, 35, 41, 41, 42, 48, 49,
 50-51, 52, 53, 53, 54, 56, 57,
 62, 63, 75, 76, 82, 83, 87,
 88, 89, 90, 91, 91, 92, 96
Signac, Paul 84
Sim, George, How the Poor
 Live 95
Sims, Charles 69, 69
Sisley, Alfred 13, 17-18, 17, 30,
 76, 77, 78-9, 78
Skredsvig, Christian E. 25
Slade School of Art 39, 53, 75
Slade School of Fine Art 14
Smith, Isaac 38
Société des Impressionistes
 88
Société Nationale 50
Society of British Artists 30,
 32-3, 42, 46, 48, 79
Le Soir (Les Illusions Perdus)
 (Gleyre) 22
Souvenir of Marlow Regatta
 (Clausen) 65
The Speaker 52, 88
The Spectator 21, 54, 96
Spielmann, M.H. 72-3
A Spring Evening in the Row
 (Thomson) 92
Staithes 28
The Standard 88
The Star 95
Starr, Sidney 33, 34, 34, 48,
 49, 87, 87, 88, 90, 92, 92-
 3, 96
Steer, Philip Wilson 12, 28,
 28, 35, 42-3, 44, 46-8, 50,
 53, 54, 55-6, 55, 56, 57, 58,
 59, 61-2, 76, 76, 77, 82, 83,
 87, 88, 89, 90, 96
Stevenson, R.A.M. 61-2, 75,
 81, 89
Stevenson, Robert Louis 23,
 74
Stirling Station (Kennedy) 49,
 49, 50
Stott, Edward 11, 27, 64-5, 70
Stott, William, of Oldham 22,
 25, 33-4, 35, 46
A Street in Brittany (Forbes)
 25, 25
A Street in Newlyn (Forbes) 36
Studd, Arthur 53
The Studio 52, 62
Study (Sargent) 43
Summer at Cowes (Steer) 47
A Summer's Day (William
 Stott) 34, 35
A Summer's Evening (Steer)
 46, 46, 47
The Sun 87
Sunday Chronicle 96
Symons, Arthur 59

Taboureux, M. 29
Talmage, Algernon 62, 63, 75
Tanagra 13
The Tannery (Steer) 96

Tate Gallery 74
Tayler, Albert Chevallier 36
Tea in the Garden (Osborne) 68, 70
The Tennis Party (Lavery) 49, 50
Thackeray, W.M. 62
Thames, river 63
Theodore Duret (Whistler) 39
Thomas, Mr and Mrs Brandon 53
Thomson, D. Croal 87
Thomson, George 52, 62, 87, 89, 90, 92
Thornton, Alfred 53
Three Public Houses, Morning Sunlight (Maitland) 95
The Times 18, 36, 43, 50
Tissot, James 16, 17, 18, 20, 42
Titian 39
Tonks, Henry 12, 53, 59, 60
The Top of the Hill (Sims) 69, 69
The Top of the Morning (B. Sickert) 90
Toulouse-Lautrec, Henri de

58-9, 59, 78
Trefolium (W. Sickert) 88
Tuke, Henry Scott 32, 33, 65, 69
Turner, J.M.W. 32, 55, 57, 72, 76, 82, 89
 Liber Studiorum 76
Twilight (*The Butcher's Shop*) (W. Sickert) 96

United Arts Gallery 32
Unwin, Fisher, family 53
Upper Norwood 15

Vagabond Musicians (Manet) 78
Vallaton, Félix 78
Van Dyke, John 81, 82
Van Gogh, Vincent 84
Velásquez (Stevenson) 61
Velázquez, Diego 20, 61-2, 89
Venice 56
Veronese, Paolo 89
Versailles 62
A Vestry Dust Wharf (Maitland) 93
Vétheuil 64

Vétheuil: Sunshine and Snow (Monet) 80
Victoria & Albert Museum 62
Vie de bohème (Mürger) 22
Vivian, Herbert 87, 89
Vonnoh, Robert 25
Vuillard, Edouard 78

Walberswick 28, 42
Walberswick Beach (Steer) 47
Walker Art Gallery, Liverpool 25
Walton, Hannah 67
Webster, Alfred 18
Wedmore, Frederick 30, 83, 88, 96
Westminster School of Art 53, 59
Weybridge Station (Starr) 92
What Next? (Farquharson) 38
When Nature painted all things Gay (Parsons) 74, 74
When the Setting Sun is Low (Fred Brown) 39, 39
The Whirlwind 87, 96
Whistler, James McNeill 12, 13, 14, 17, 18, 19, 19, 31, 32-

3, 34, 35, 39-40, 42, 43, 46, 48, 50, 52, 55, 57, 59, 61, 63, 78, 79, 83, 87, 89, 90, 93, 95, 96
Wilde, Oscar, *The Decay of Lying* 63
Williams, Mr and Mrs T. Cyprian 53
Wilson, Richard 89
Windsor, Lord 72
Woman with a Parrot (Manet) 16
Wood, T. Martin 37
The World 48
World's Fair, Chicago 50
Wyllie, William Lionel 62

Yachts lying off Cowes (Steer) 55
Yeames, W.F. 14
Yport 64
Yule, William James 53

Zola, Emile 21, 62
Zorn, Anders 78

List of Lenders

Barbican Art Gallery would like to thank all those lenders listed below, and those who wish to remain anonymous.

Canada
National Gallery of Canada, Ottawa

Portugal
Calouste Gulbenkian Museum, Lisbon

Republic of Ireland
Crawford Municipal Art Gallery, Cork
Hugh Lane Municipal Gallery of Modern Art, Dublin
National Gallery of Ireland, Dublin

United Kingdom
City of Aberdeen Art Gallery and Museums Collections
The Royal Photographic Society, Bath
Ulster Museum, Belfast
Birmingham Museums and Art Gallery
Blackburn Museum and Art Gallery
Bradford Art Galleries and Museums
Bristol Museums and Art Gallery
David Winter, Bristol
The Syndics of the Fitzwilliam Museum, Cambridge
National Museum of Wales, Cardiff
Tullie House, City Museum and Art Gallery, Carlisle
The Sir Alfred Munnings Art Museum, Dedham
Dundee Art Galleries and Museums
City Art Centre, Edinburgh
National Gallery of Scotland, Edinburgh
Royal Scottish Academy Diploma Collection, Edinburgh
Scottish National Portrait Gallery, Edinburgh
Glasgow Museums: The Burrell Collection
Art Gallery and Museum, Kelvingrove, Glasgow
Lord and Lady Macfarlane of Bearsden, Glasgow
McLean Museum and Art Gallery, Inverclyde District Council, Greenock
Hartlepool Museum Service
Ferens Art Gallery: Hull City Museums, Art Galleries and Archives
The University of Hull Art Collection
Ipswich Borough Council Museums and Galleries
Jeremy Caddy, Kent
Alfred East Art Gallery, Kettering
Kirkcaldy Museum and Art Gallery
Leeds City Art Galleries
Lincolnshire County Council: Usher Gallery, Lincoln
Board of Trustees of the National Museums and Galleries on Merseyside: Walker Art Gallery, Liverpool
Agnew's, London
Chris Beetles Ltd., St James's, London

Berkshire Associates, London
Courtauld Institute Galleries, London
Robert Fleming Holdings Limited, London
The Fine Art Society plc, London
Sir Alexander Graham, London
Richard Green, London
Martyn Gregory Gallery, London
Guildhall Art Gallery, Corporation of London
David Messum Gallery, London
Duncan R. Miller Fine Arts, London
Richard Nagy, Dover Street Gallery, London
The Trustees of the National Gallery, London
J.D. Orme, London
Andrew McIntosh Patrick, London
Pyms Gallery, London
Royal Academy of Arts, London
The Tate Gallery, London
The Taylor Gallery Ltd., London
The Board of Trustees of the Victoria and Albert Museum, London
Mr and Mrs Malcolm Walker, London
Manchester City Art Galleries
Laing Art Gallery (Tyne and Wear Museums), Newcastle upon Tyne
Northampton Museums and Art Gallery
Norfolk Museums Service (Norwich Castle Museum)
City of Nottingham Museum; Castle Museum and Art Gallery
Oldham Art Gallery
Visitors of the Ashmolean Museum, Oxford
Paisley Museum, Renfrew District Council
Plymouth City Museum and Art Gallery
Museum of Reading
Sheffield City Art Galleries
Southampton City Art Gallery
Sefton MBC Leisure Services Department, Arts Services Section, The Atkinson Art Gallery, Southport
Mr R.B. Anderson, Troon
Warrington Museum and Art Gallery
York City Art Gallery

United States of America
Yale University Art Gallery, Connecticut
Museum of Fine Arts, St Petersburg, Florida
Sterling and Francine Clark Art Institute, Massachusetts
The Detroit Institute of Arts, Michigan
Flint Institute of Arts, Michigan
The Newark Museum, New Jersey
The Brooklyn Museum, New York
The Metropolitan Museum of Art, New York
Philadelphia Museum of Art
Museum of Art, Rhode Island School of Design

Acknowledgements

Barbican Art Gallery would especially like to thank the following people for their advice and support:-

Magdalen Evans, Agnew's, London;
Chris Beetles, London;
William Darby, Browse & Darby, London;
Duncan Miller, London;
Richard Ingleby, Andrew McIntosh Patrick and Peyton Skipwith, The Fine Art Society plc, London;
Martyn Gregory, London;
David Messum and Carol Tee, The David Messum Gallery, London;
Richard Green and Victoria Law, Richard Green Gallery, London;
Ewan Mundy, London;
Alan Hobart, Pyms Gallery, London;
Spink & Son Ltd.;
Jeremy Taylor, London.

Photographic acknowledgements

Barbican Art Gallery would like to thank all those lenders to the exhibition who have kindly supplied photographic material for the catalogue. We extend particular thanks to the following:

The British Library
Courtauld Institute of Art
DSB Photography
Hunterian Museum and Art Gallery, University of Glasgow
Jonathan Morris-Ebbs
Musée des Beaux-Arts de Dijon
Paris, Musée d'Orsay
Sunderland Museum and Art Gallery, Tyne & Wear Museums
Tate Gallery Archive, London
University College Art Collections, London

bsis
Matching Arts
Sponsorship

Flemings is an award winner under the Business Sponsorship Incentive Scheme for its support of the exhibition *Impressionism in Britain* at Barbican Art Gallery, London. The BSIS is a Government scheme administered by ABSA (Association for Business Sponsorship of the Art

FLEMINGS

Exhibition sponsored in Britain by Flemings
19 January – 7 May 1995

Barbican Art Gallery would also like to thank its Corporate Members for their continued support:-

Barings Group

The Bethlem & Maudsley NHS Trust

British Petroleum plc

British Telecommunications plc

Chemical Bank

Levi's Red Tab Jeans

Nomura International

Norddeutsche Landesbank

Robert Fleming Holdings Ltd

Save & Prosper plc

Sun Alliance Group

TSB Group plc

Unilever

Barbican Art Gallery extends special thanks to **Flemings** for all their enthusiasm and encouragement.